American Photography

A CRITICAL HISTORY
1945 TO THE PRESENT

A CRITICAL HISTORY
1945 TO THE PRESENT
BY JONATHAN GREEN

American Photography

PICTURES SELECTED
AND SEQUENCED BY
JONATHAN GREEN AND
JAMES FRIEDMAN

For Louise, Raphael, and Benjamin

Many of the reproductions in this book have been made directly from prints produced with Polaroid Polapan 4×5 Type 52 and from Polaroid High Contrast 4×5 Type 51. This material was generously provided by the Polaroid Corporation as a service to photographic scholarship.

Portions of this book have appeared previously, most often in considerably different form, as articles or lectures. I am grateful to the publications and the institutions for inviting me to write or speak and for allowing me to use material copyrighted by them. Chapter 1 was first presented as a lecture at Wellesley College in 1977. The "Family Pictures" section of Chapter 2 appeared as an article in the *Journal of the University Film Association*, Fall 1978. Chapter 4 appeared as an article in *Afterimage*, March 1979. Chapter 5 was delivered as the Clarence White Jr. Lecture at Ohio State University in 1978. Chapter 12 was given as the opening lecture for the exhibit *American Images* at the Corcoran Gallery of Art in 1979.

Credit for each illustration is indexed at the back of the book. The author thanks the following for permission to use various quotations: From "Starting from San Francisco" by Lawrence Ferlinghetti, © 1961 by Lawrence Ferlinghetti, reprinted by permission of New Directions Publishing Corporation. From *Howl & Other Poems* by Allen Ginsberg, portions of "Howl," "America," and the back cover, © 1956, 1959 by Allen Ginsberg, reprinted by permission of City Lights Books. From *On the Road* by Jack Kerouac, © 1955, 1957 by Jack Kerouac, reprinted by permission of The Sterling Lord Agency, Inc. From "On the Road to Florida" by Jack Kerouac, © 1970 by Jack Kerouac, reprinted by permission of The Sterling Lord Agency, Inc., and Grove Press, Inc. From *U.S. Camera 1940*, © 1939 by T. J. Maloney, excerpts from an article by Elizabeth McCausland, reprinted by permission of T. J. Maloney. From *Mirrors Messages Manifestations* by Minor White, © 1969, 1982 by Aperture Inc., reprinted by permission of Minor White Archive, Princeton University.

PROJECT DIRECTOR: Robert Morton
EDITOR: Margaret Donovan
DESIGNER: Kenneth R. Windsor

Jacket and title page: James Friedman.
From *The History of the World*, 1983
Frontispiece: Mike Mandel.
Selection of cards from
Baseball Photographer Trading Cards, 1975

Library of Congress Cataloging in Publication Data

Green, Jonathan.
American photography.

Bibliography: p. 230
Includes index.
1 Photography—United States—History. I. Title.
TR23.G73 1984 770'.973 83-15532
ISBN 0-8109-1814-5

This project concerns photography, but like many complex human endeavors it has developed architecturally. It has involved the interaction and cooperation of many people who piece by piece have helped conceive, engineer, frame, and perfect the book you now hold in your hand. I am indebted to everyone who has participated in its construction. Each contribution has added in an important way to the success of this publication.

James Raimes, who was then at Oxford University Press, first encouraged me to write the book. As I began, he and his assistant, Anne Evers, provided the initial supportive intellect and eye. As with my other writings, my father, Rabbi Alan S. Green, patiently read and criticized the manuscript, provoking and challenging me time and again to reformulate and clarify my ideas and expressions. At times he also served as proofreader, chief counsel, and financial backer. Min and Nate Lockshin have encouraged me throughout the writing of this book. Our lively discussions helped shape my notions of American politics and political practice. Above all, I'd like to thank Louise.

It has been a great pleasure to work with the staff at Harry N. Abrams, Publishers. My editor, Robert Morton, guided this project with kindness, insight, and enthusiasm. Margaret Donovan skillfully helped me resolve issues of style. My notions of the integration of illustration and text have been fully realized through Ken Windsor's design.

I am indebted to all those photographers and artists, institutions, galleries, estates, and publishers who have so generously allowed access to and reproduction of copyrighted material. I am especially grateful to the many photographers who allowed me access to their Guggenheim Fellowship application statements, and to Stephen L. Schlesinger of the John Simon Guggenheim Memorial Foundation, who made these statements available to me. Peter Collins and John Szarkowski of the Museum of Modern Art provided me with a complete set of the Department of Photography's publicity releases, wall labels, and exhibition checklists. Gretchen Van Ness and Marianne Fulton provided me with an extensive printout of exhibitions at the International Museum of Photography at George Eastman House. All these materials formed the resource core of this book.

It would have been impossible to bring together the extensive reproductions in the book without the warm support of many friends and colleagues. I owe special thanks to Carole Kismaric of Aperture; John Pultz, Grace Mayer, and John Szarkowski of the Museum of Modern Art; Peter Bunnell of Princeton University; Marianne Fulton and Andrew Eskind of the International Museum of Photography at George Eastman House; James Enyeart and Terrence Pitts of the Center for Creative Photography; James Alinder of the Friends of Photography; Amy Baker Sandback of *Artforum;* Irene Schneider of Grove Press; Fred Canty of Wide World Photos; Daniel J. Allman of New Directions; Courty Andrews Hoyt of Life Picture Service; Shelley Dowell of Richard Avedon Incorporated; Xiliary-Twil of Flow Ace Gallery; Arnold Crane; and the staff of the Department of Photography at The Art Institute of Chicago. James Friedman, Jerome Liebling, John Hill, Shelley Baird, and Kent Bowser have allowed me access to rare books in their personal collections. Alfred Leslie generously helped me track down one of the few existing copies of his back cover for Robert Frank's Grove Press edition of *The Americans.*

Constance Sullivan of Polaroid and Joe Koncelik of the Industrial Design Department at The Ohio State University provided photographic material and equipment that greatly expedited the copying of many of the illustrations. Gary Paul and Cindy Harless of BiChrome Labs produced many of the copies from "impossible" originals.

My brother, David Green, first showed me the potential of using a personal computer in the preparation of the manuscript and the management of the myriad details of cataloging, indexing, and record keeping. The manuscript was first typed into the computer by Sue Shook from early drafts. This project could not have been accomplished without my trusty TRS-80.

I thank Andrew Broekema, dean of the College of the Arts at The Ohio State University, and my staff at the University Gallery of Fine Art for allowing me to arrange my schedule as gallery director so that I could work expeditiously.

James Friedman has aided me in every aspect of this work. I am indebted to his counsel and friendship. His insight into the essential relationships between images provided the basis for the running sequence of illustrations. Here, as in many things, we were influenced directly and unequivocally by Minor White.

Betty HAHN

Ansel ADAMS

Arnold Newman

Duke BALTZ

Mike BISHOP

Beaumont Newhall / Imogen CUNNINGHAM

Bill EGGLESTON

Laura GILPIN

Wynn BULLOCK

Harold JONES

Height: 5'8" Weight: 135 Born: Los Angeles Home: San Francisco Throws: Underhanded Bats: Depends FP: Zee FC: Santa Monica FF: exposed FD: Mark Eden FPh: Bunny Yeager — No. 9
Ellen Brooks
A piece off my bathroom wall!
"We have the same problems as the Titanic, but the Titanic had a band."
Gum by Topps Chewing Gum, Brooklyn / Litho by Mike Roberts, Berkeley ©1975 Mike Mandel

Bob FICHTER

Mike MANDEL / Eva Rubinstein

Arthur SIE...

Burk UZZLE

Height: 5'11" Weight: 150 Born: Philadelphia Home: Rochester Throws: Right Bats: Right FP: Whatever Ms. FC: Giroux..Dag. FF: Yeager uses FD: FPh: Bunny Yeager — No. 110
Bill Jenkins
On first receiving a request for a statement for this baseball card, I determined to write an amusing anecdote and to that end reconstructed the invention of photography by a frustrated painter who did it in order to lure girls into his studio. The anecdote was not funny in the least so I destroyed it. Now a hurriedly scribbled note from M. Mandel, "If you don't do it today..!" So I thought, why not tell him what happened?
Gum by Topps Chewing Gum, Brooklyn / Litho by Mike Roberts, Berkeley ©1975 Mike Mandel

Art SINSABAUGH

Aaron SISKIND

Joyce NEIMANAS

Bea NETTLES

Joan LYONS

Bill OWENS

Harry Callahan

Barbara MORGAN

Al COLEMAN

Fred SOMMER

Bunny YEAGER

Tom BARROW / Joel Meyerowitz

Nathan Lyons — It's all very interesting

Bill LARSON

BASEBALL PHOTOGRAPHER trading cards checklist

Jack WELPOTT

Pete BUNNELL

Grace MAYER

Minor WHITE

Duane MICHALS

John Szarkowski

Edmund TESKE / Naomi SAVAGE

Anne TUCKER

Jacob DESCHIN

Emmet GOWIN

Jerry UELSMANN

Bart PARKER

Hank SMITH

Margery MANN

Manuel BRAVO

Anne NOGGLE

Bob CUMMING

Bobby Heinecken / Joe DEAL

Ken Josephson

Don Blumbe...

Jim ALINDER

Height: 5'10" Weight: 148 Born: Brooklyn, N.Y. Home: Buffalo, N.Y. Bats: Right Throws: Right FP: Arches FC: Nikon FF: Tri-X FD: D-76 FPh: Harry Nussbaum — No. 36
Les Krims

Judy DATER

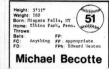
Height: 5'11" Weight: 160 Born: Niagara Falls, NY Home: Elkins Park, Penn. Throws: Bats: FC: Anything FF: appropriate FD: FPh: Edward Weston — No. 51
Michael Becotte

Ed RUSCHA

CONTENTS

Photography and the American Imagination

Archetypes and Experience

The central force behind the work of American photographers has been the reality of the American experience. Before the photographs were made, the photographers were provoked by the life of an emerging young country, the possibilities of unprecedented liberty, a workable political system, and a vast yet ever-receding frontier. More than other factors, more than the precedents of tradition in art and thought and more than the determinations of technique, lens, and process, were the presences of the land, the culture, the myths, and the symbols that defined America.

The work of Timothy O'Sullivan, Alfred Stieglitz, Paul Strand, Walker Evans, Edward Weston, Ansel Adams, and Edward Steichen defines a series of particular connections between the culture and land of America and the act of consciousness and creation we call photography. Their work serves well to chart a series of archetypal relationships that photographers have maintained with America. Although other photographers doubtless could stand as representatives of some of these attitudes and visions, these particular men have either made the best possible use of the land and subject matter that they have inherited or have defined in their work and careers the distinct and peculiar problems of photographing here. They have seen a world and been motivated by an experience that is distinctly American. They have approached

ALFRED STIEGLITZ. *Equivalent, Mountains and Sky, Lake George,* 1924

WALKER EVANS. *Brooklyn Bridge, New York,* 1929

their work with characteristic American spirit and intensity and have defined characteristically American styles and subjects. By their continual and genuine inquiry into the possibilities of making photographs in these United States and by the strength of their images and attitudes, they have set forth traditions that continue to dominate American photography, attitudes that the photographers of today have either followed or rebelled against. Their work has not been ignored.

As we look at the work of these men, we find that over and over again their photography seems to be deeply involved in one of, or a combination of, four major themes that recur with such regularity that they seem to take on the force of obsession and expectation. These are the themes that penetrate most directly to the essentials of the American imagination: the notion of Democracy; the idea of the Frontier; the Puritan heritage; and the demands of Utilitarianism. These concepts, ever strong in the popular imagination, have had the most decisive influence on what was to become the most popular American art form; they have determined the content, the form, and the values of American photography.

As a touchstone for this introductory discussion, I have frequently alluded to that quintessential embodiment of nineteenth-century American radical idealism, Walt Whitman. No one better sums up that curious sensibility produced by the powerful currents of egalitarianism, utilitarianism, Puritanism, and the frontier. I refer to Whitman not so much as a direct influence on these seven photographers (though at times his influence was decisive) but as a catalyst, progenitor, and prophet to whom they all relate, a poet who serves to define the world out of which they all grew. For we must remember that all seven were essentially nineteenth-century men. Five were born before the turn of the century; the other two, Adams and Evans, were born within the first three years of this century. Their attitudes are nineteenth-century attitudes and their photographs culminations of nineteenth-century dreams.

As with every critical and historical review there are two viewpoints here that the critic can take. One is to study the ideas and visions encapsulated in the images; the other, to examine interpersonal relationships and direct personal influences. Each is equally valid. In this book I have chosen to deal for the most part with the history the photographs themselves have made, not with the history or biographies of the photographers. But I hope the ideas implicit in the photographs of these men may move someone to look at the other side: the political and interpersonal side of actually living and making it as a photographer during these first important years in American photography.

Timothy O'Sullivan and the American Frontier

If this were a study of literature or the painterly arts, the truism that every artist represents the world as he or she sees it would scarcely bear repeating. But the intensity and objectivity of photography, particularly the early Western landscape photography of 1860 to 1885, is quite another matter. Much of this work has so burned itself into our national consciousness that we accept the photographs as almost anonymous, self-generated images, as pictures that have been called forth by the very land itself without the intermediary of the camera or a specific human eye and viewpoint. Faced with such apparent authenticity, we need to remind ourselves that these precise descriptions came from perceptions both very personal and greatly influenced by traditional models. When we look at this work from a historical perspective, it becomes clear that a great deal of its power derives from earlier visual styles and sources.

In Watkins's and Muybridge's photographs we find exact parallels to the pastoral landscapes prominent in European tradition. These two photographers constantly chose viewpoints and subject matter that were lush and picturesque. They gravitated to the Yosemite Valley with its rich contrasting elements—thick valley

foliage, mirror lakes, cascades, waterfalls, and snow-capped mountains—the very themes and visual motifs that made up the Edenic vocabulary of European and early American landscape painting. What is remarkable is not only that these photographers presented these motifs so exquisitely, but that an actual earthly paradise existed that contained so many aspects of this essentially literary, romantic vision.

After looking at Watkins's and Muybridge's work, it is startling to turn to the photographs of Timothy O'Sullivan and to come upon a series of photographs for which no obvious parallel can be found in the painting of the time. Rather than lushness, we are confronted by barrenness. Rather than the life-giving elements of foliage, water, and soaring mountains, we are overwhelmed with a brute, lifeless terrain. Rather than clearly articulated, dimensional description, we are shown abstracted, flat forms, often boldly torn from the real world of atmosphere and space.

The lack of the picturesque in O'Sullivan's photographs is partially explained by the fortuitous: the qualities of the actual land he explored as photographer on the government's Fortieth Parallel Survey and subsequent surveys; his financial and aes-

thetic dependence on meeting the needs of a geological survey; his lack of contact with more conventional, painterly models; and the influence, as Joel Snyder has forcefully argued, of Clarence King's belief in catastrophism, which suggested that the desolate landscape of the Fortieth Parallel was evidence of a divinely instituted geological upheaval occasioned to produce historical change. These facts do not, however, explain the consistency, care, or sophistication of his work.

In O'Sullivan's view of the West we have one of the first instances in which the inherent descriptive qualities of photography were used with startling frankness, intuition, and imagination. Instead of structuring his photographs to conform to the dictates of earlier visual production, O'Sullivan accepted wholeheartedly the way in which the camera saw and organized the world. Clearly realizing the enormous difference between the hot, colored, dimensional world that spread out before his lens and the stark, cold, abstracted world of the final print, O'Sullivan constantly sought out landscapes that would reinforce the camera's vision as well as satisfy the requirements of the survey.

O'Sullivan's achievement was twofold: the discovery and recording of the land itself and the discovery of the possibility of actively participating in, yet controlling,

EADWEARD J. MUYBRIDGE. *Valley of the Yosemite from Mosquito Camp*, Number 22, 1872

TIMOTHY H. O'SULLIVAN. *Untitled* (Vermillion Creek Canyon, Utah), c. 1868

the transforming power of the medium. While O'Sullivan's ostensible purpose was exploration and documentation of new land, his photographs are really as deeply involved in the exploration and discovery of new form. Their power comes from a singleness of purpose, a unity of vision that integrates physical exploration with visual experimentation, geological information with purely visual form.

O'Sullivan's acceptance of the straightforward recording powers of the medium is best seen in his treatment of the sky and in his use of extended surface texture. The wet plates of the day were sensitive to blue light only; for detail to appear on the ground, the sky would always be vastly overexposed. It would print a stark, empty tone. Rather than hedging on this unconventional rendition—as Muybridge did by printing in clouds from other negatives, or as Watkins did by consistently minimizing the width of the sky—O'Sullivan accepted the starkness. Again and again that blank, negative space intermeshes with the landscape below. The sky mirrors the earth, interpenetrating and interlocking with it to form a tight, unyielding whole. In such photographs as *Vermillion Creek Canyon, Utah* (c. 1868),

TIMOTHY H. O'SULLIVAN. *Green River* (Colorado), c. 1868

FREDERICK SOMMER. *Arizona Landscape,* 1945

and *City of Rocks, Idaho* (1867), this vigorous interaction of positive and negative forms, light and dark silhouetted spaces, is augmented by the use of an undifferentiated, intensely textured surface. Weston Naef has written that "for a parallel to this treatment of landscape one must look to the paintings of O'Sullivan's contemporary Cézanne, where foreground and depth are woven into a single, unbroken surface of brush strokes."

In these photographs, as well as in *Tufa Rocks, Pyramid Lake, Nevada* (1868), *Green River, Colorado* (1868), and the famous *Ancient Ruins in the Canyon De Chelle* (1873), there is almost no hierarchy of objects. Every square inch of the picture surface is equal in value and tone to every other. These photographs are not focused on a single subject but equate everything that lies within the picture plane. The feeling is distinctly abstract, almost surreal. For here O'Sullivan has dispensed with the common hieratic relationships that traditionally define the center of interest. An intricately woven matrix of tone and texture becomes the document of the encounter with the land.

This radical intertwining disposition of subject and space, this uncompromising starkness and flat field description, do not reappear in photography until the

experiments of Frederick Sommer, Aaron Siskind, and Harry Callahan and the younger photographers of the seventies, particularly Baltz, Deal, and Gossage.

For O'Sullivan the reality of the world was more important than the reality of the imagination. The reality of exploration and adventure was more immediate than the world of communication and intellect. O'Sullivan proposed no theories, he published no books. He did not openly theorize about documentation or exploration. As an artist he was a primitive in the full sense of the word: he photographed in the earliest period of the medium, he was the first to use the camera to record land no white man had ever seen before, he was unaffected by the basic visual vocabulary of the civilized world. He was the untutored son of immigrant parents, and from his few recorded statements he must also be called provincial and naive. His only education was photography, first at Mathew Brady's New York gallery, then in the Washington branch managed by Alexander Gardner. By the age of twenty-four he had made his photographs of the Civil War. By thirty he had completed his major Western landscapes. At forty-two he was dead of tuberculosis. A stranger to civilization,

living on its fringes, recording the war but not participating in it, recording the frontier as a technical genius of photography but leaving hardly a word of commentary on his experience, O'Sullivan was the embodiment of the self-reliant, intuitive man. Independent and culturally isolated, he worked on the frontiers of America and on the frontiers of sight.

The recording of the Western landscape begun by O'Sullivan and the other half-dozen men who worked this land initiated a tradition that continues to dominate American photography. Perhaps no other single idea has had such a pervasive influence on all of American civilization than the idea of the sprawling, incredible West. Almost every major American photographer has been challenged by a desire to explore and understand this land, to picture the West for its vastness and beauty as well as to record man's brutal intervention into its natural state. Even a brief survey of some of the major titles in American photography from the past twenty-five years would immediately reveal the almost obsessive concern with the land and wilderness: *Yosemite Valley* (1959); *This Is the American Earth* (1960); *In Wildness Is the Preservation of the World* (1962); *The Photographer and the American Landscape* (1963); *The New West* (1974); *Era of Exploration: The Rise of Landscape Photography in the*

ROBERT ADAMS. *Pikes Peak,* c. 1974

WILLIAM CLIFT. *La Mesita from Cerro Seguro, New Mexico,* 1978

American West (1975); *New Topographics* (1975); *The Great West: Real/Ideal* (1977); *Cape Light* (1978); *Photographs of the Columbia River and Oregon* (1979); and *American Frontiers: The Photographs of Timothy O'Sullivan* (1981). No other country has so eulogized and mythologized one particular aspect of its physical environment, nor evoked in such a single compelling image the continual possibility for adventure and exploration.

Alfred Stieglitz and the American Avant-Garde

O'Sullivan was the frontiersman, ignorant of European culture. Stieglitz, on the other hand, was a cosmopolitan. His genius was to fuse the European heritage with America's indigenous frontier spirit. His own photography, the causes and artists he championed, and the publications he edited bridged the Old World and the New. By synthesizing the frontier spirit with the older, borrowed European tradition, he defined the force that remains as the avant-garde in American art and photography.

MARIUS DE ZAYAS. *Stieglitz,* 1913

FRANK EUGENE. *Mr. Alfred Stieglitz,* 1909

FRANCIS PICABIA. *Ici, C'est Ici Stieglitz, Foi et Amour.* Cover of *291,* Number 5–6, 1915

It was Stieglitz's particular good fortune and brilliance to epitomize in his own life the conflicting forces of two different cultures. As a second-generation American of Jewish-German descent, he had deep roots in the cultural and intellectual life of Europe. He also knew firsthand the possibilities and advantages of commercial and cultural success in America. After the Civil War his father became an extremely successful woolen merchant and was able to give Stieglitz the finest New York education and later retire early to a grand summer home on the shores of Lake George.

At the age of seventeen, Stieglitz went to Germany and took up the study of engineering at the Berlin Polytechnic. He soon turned with a passionate interest to photography, but the significance of his nine-year European experience went well beyond his introduction to and first successes in that field. It was the intensity, expansiveness, and vitality of the *fin-de-siècle* cultural life of Europe and Berlin that had the greatest impact upon him. On his return to America he attempted to infuse that spirit first into his chosen medium, photography, and then into the concerns of all modern art and expression.

From Europe Stieglitz brought a sense of history and an insistence that present concepts be tested by the traditions of the past. From Europe he inherited a set of

exacting, unimpeachable standards of excellence and sophistication. Later in his life, as the first impresario of modernism in America, Stieglitz developed from European work an appreciation for an aesthetic formalism that minimized actual subject matter for the sake of pure structure. But all these perceptions were always tempered by an American romantic utilitarianism: a belief that focused on the continual acceptance of actual visual facts and natural symbols in the face of the European pressure for total abstraction. Stieglitz also possessed an aggressive self-confidence; a distinctly American belief in the possibilities of the American frontier animated his beliefs, pushed him again and again to discard the old and search out the bold, the unique, and the provocative. For Stieglitz art was more than a concern with form and expression. It became a socially redeeming, spiritually renewing force.

This seminal mixture of the Old World and the New is wonderfully evident in the role Stieglitz took up as high priest, educator, and prophet of photography and modernism. Surrounding himself with artists, intellectuals, and disciples, he took on the character of the Old World master, peppering traditional teachings with parables

and similes. Yet he was also the American frontier preacher and humorist: fiercely individualistic, irreverent, at times rough, homespun, colloquial. He was a curious cross between the old Hasidic teacher, the Baal Shem Tov, and Mark Twain.

Appropriately the artists and writers he championed frequently showed the same intermingling of national and cultural lineage. Some were Americans who had been greatly influenced by direct contact with Europe: Steichen, Marin, Hartley, Gertrude Stein, William Carlos Williams. Others were Europeans who were decidedly affected by the new American spirit: Picabia, de Zayas, Duchamp, Weber, Bluemner, Lachaise, Nadelman, Walkowitz, and Sadakichi Hartmann.

Though Stieglitz revered the expressive individual, his reconciliation of the European and the American was ultimately elitist and antidemocratic. American democratic culture is hostile to anything that smacks of special treatment. Art should be the expression of the masses, not the expression of the few. The camera itself in a direct way fulfilled the Whitmanian prophecy: every man possessed the tools for expression. And, in fact, photography has become the most democratic of all arts.

But Stieglitz denied the basic democracy of photography. He countered Eastman's slogan: "You push the button and we'll do the rest." For Stieglitz not every

ALVIN LANGDON COBURN. *Alfred Stieglitz, Esq.,* 1908

MARIUS DE ZAYAS. *Stieglitz,* 1910

PAUL STRAND. *Portrait of Alfred Stieglitz, Lake George,* n.d.

photographer was an artist, not every artist was an innovator. Whitman had extolled the virtues and powers of the common man. Whitmanian America was inclusive. Stieglitz's was exclusive. Stieglitz was disdainful of the uncultured, ignorant, scrambling masses. They might make fitting subjects for photography, but the eye of the artist was reserved for the chosen few.

Stieglitz's own work laid the foundation for almost all that would follow in American photography. During the first part of an incredibly productive career, his fascination with the techniques and processes of the medium often led him to radical experimentation. With a certain American bravado he prided himself on being the first to accomplish new technical feats—to photograph under the difficult conditions of rain, ice, snow, and night, for example. (The inhospitable conditions with which O'Sullivan and the other Western landscape photographers coped were not yet common knowledge.) He was the first to use the hand camera to describe in a lucid, direct manner the vitality of the New York street scene. During the middle 1890s, Stieglitz, as Atget was later to do in Paris, ranged the city from morning to night,

 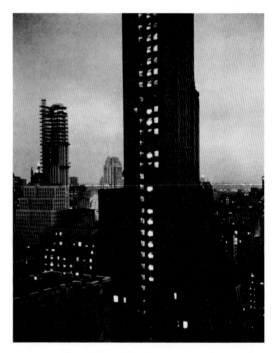

ALFRED STIEGLITZ. *Georgia O'Keeffe: Hand and Wheel*, 1933

ALFRED STIEGLITZ. *Night—New York*, 1931

producing the first series of deliberately composed New York documents. He created in these images the first photographs to consciously capture what Cartier-Bresson would later term the "decisive moment."

Stieglitz experimented with bromoil and other mixed media. He perfected the photogravure as a medium of original printing as well as of reproduction. He was one of the first to use the Lumière autochromes. Though much of this early work is decidedly pictorial, strongly influenced by the aesthetics of academic painting, it was precisely this finely developed pictorial quality that helped photography achieve its first acceptance as an art.

Stieglitz's second period was greatly molded by the new post-impressionist paintings he showed at his gallery, 291. The formal, abstract, cubistic tendencies of the paintings were given photographic treatment and form in his portraits and cityscapes of this period. And in his last, unprecedented works—a series of psychological portraits, personalized landscapes, and the famous, brooding cloud photographs, the "Equivalents"—Stieglitz explored the straight photograph's internal and metaphorical possibilities.

Stieglitz's passionate desire for growth and excellence made his work constantly

progressive, forcing him to resolve in more and more sophisticated ways the aesthetic possibilities of the straight photograph. His work was prototypically American in its unswerving belief in the power of the unmanipulated camera image and in its fascination with machinery and technique. Most important, his genius at translating moments in the external world into decisive spiritual and psychological moments initiated a whole tradition in American photography.

In utilitarian America avant-garde art has always had a precarious position. The American imagination much more readily accepts an O'Sullivan than a Stieglitz; an adventurer on the Western frontier is much more understandable than an adventurer on the frontiers of art and expression. Yet Stieglitz's elitism and intractable demand for excellence set a standard against which each successive generation of artists and photographers has had to measure itself. His legacy to American photography is great, probably the most pervasive of any single photographer.

Paul Strand and American Democracy

PAUL STRAND. *Blind Woman, New York,* 1916

LEWIS HINE. *Breaker Boys in Coal Chute, South Pittston, Pennsylvania,* 1911

In O'Sullivan's photographs we have what may be considered the first step in the adaptation of the photographic enterprise to the spirit and land of the New World. O'Sullivan took the new analytical and descriptive tool, photography, and applied it in a radical way to the unique Western landscape. Stieglitz's work and career represent the second step: the synthesis of the older European cultural concerns with a new frontier and a new explorative spirit. In the process, Stieglitz legitimized photography as a means of conscious artistic expression. It is upon this foundation that Paul Strand may be said to take the next two steps in the growing accommodation between photography and the American imagination. First, he successfully fused the formal concerns of abstract art and the factual accuracy of the camera. Second, he crystallized American democratic idealism in photographic form.

Strand's involvement in both aesthetic formalism and social idealism grows out of a force beyond Stieglitz's direct influence: it owes allegiance to Strand's first photography teacher, Lewis Hine, and even more fundamentally to the ambiance of the radical left-wing politics of New York intellectuals, specifically the visionary democ-

racy of the New York Ethical Culture Society. Strand first came into contact with photography in 1907, at the age of seventeen, as a student of Hine at the Ethical Culture School. Hine was just beginning his photographic career as a compassionate documentarian of the plight of immigrants and the underprivileged. Hine took Strand to the Little Galleries of the Photo-Secession, 291, to see the works of the Secessionists and to meet Stieglitz. While this crucial experience gave Strand an immediate vocational goal, it was from American social idealism as defined by the Ethical Culture Society that his deep moral attitude toward photography stems.

The Ethical Culture Society, founded in New York in the eighteen seventies, was one of the dozens of secular and religious groups and sects that surfaced after the Civil War in an attempt to adjust traditional beliefs to the new spirit of a cooperative commonwealth. It may be seen as a direct outgrowth of the American Transcendentalist movement. It was built on the decidedly American confluence of Puritanism and egalitarianism, to which it added its own dash of European Jewish





PAUL STRAND. *Young Boy, Gondeville, Charente, France,* 1951

PAUL STRAND. *Calvario, Patzcuaro, Mexico,* 1933

intellectualism. The society was a concrete realization of Whitman's democratic manifesto. In the 1855 Preface to *Leaves of Grass,* he had written:

> America does not repel the past or what it has produced under its forms, or amid other politics, or the idea of castes, or the old religions. . . . [It] accepts the lessons with calmness . . . while the life which served its requirements has passed into the new life of new forms. . . .
>
> This is what you shall do: Love the earth and the sun and the animals, despise riches, give alms to every one that asks, stand up for the stupid and the crazy, devote your income and labor to others, hate tyrants, argue not concerning God. . . .

Like Whitman, the society believed that moral tenets need not be grounded in religious dogma and that community effort was needed to promote social welfare. The society's three basic goals were sexual purity, donation of surplus income to the improvement of the working class, and continual intellectual development.

While Strand was to repudiate the society later in his life and speak of the

literature of Nietzsche and Edgar Lee Masters as sources for his work, the society's three tenets may be understood as the basis for his vision of the world. The society's injunction of sexual purity is translated in Strand's work to an aesthetic asceticism, rigorously prescribing the subjects of his images and their treatment. Whether the subject was a set of kitchen bowls, a New England farmer or building, a machine lathe, or a landscape, it was treated with a purity of means and an idealization that became the hallmarks of Strand's work. With the exception of the few early ruthless portraits of New York street characters, more influenced by Hine's subject matter than by his manner, Strand never returned to a harsh view of humankind. And even these portraits of impoverished men and women are as much concerned with formal purity as with physical and spiritual disability.

Of course Strand's early experiments with abstraction clearly derive from the painting he had seen on the walls at 291. From the work of Picasso, Braque, Hartley, Weber, and the other radically new artists, Strand appropriated an overriding con-

cern with spatial design, geometric form, patterning, and rhythmic decorative notation. Yet the power of even the most abstract of Strand's photographs goes beyond formal purity. For Strand, as for the Ethical Culturalists, artistic purity meant ethical purity: the artist was the producer and documentarian of the good, the joyous, and the beautiful. In the vast majority of the images he made after 1917, ugliness, disease, defeat, and death are eradicated or transcended.

If the first tenet of the Ethical Culture Society underlies, both actually and symbolically, Strand's concern with beauty and purity of form, then the society's socialistic tenet—the economic improvement of the working class—stands behind the political character of his photography and his idealization of all human endeavors. In the enormous numbers of portraits he produced, first of Americans and then of people from around the world, Strand expresses an inherited faith in the common man that had been successively purified as it was handed down from the Puritans to the Transcendentalists to Whitman. Here we have a socialism based not on institutions but on the sanctity of the individual. Strand's photographs of rugged New Englanders, Mexican peons, Hebrides islanders, and Egyptian fellahin are virtually

PAUL STRAND. *Postmistress and Daughter, Luzzara, Italy,* 1953

PAUL STRAND. *Mother and Child, Mexico,* 1933

interchangeable. In his portraits there is always a direct correspondence between the actuality of each individual photographed and that person's allegorical significance, between what that person is and what that person symbolizes. Like that of the Puritans, Strand's art is not the discovery of a new truth, but the elaboration of an accepted doctrine: the doctrine of the nobility and dignity of man.

Strand's aesthetic formula, derived from radical egalitarian politics, high-minded Puritanism, and the influence of the newly emerging Cubism, allowed him to give his photographs the illusion of real life without ever dealing directly with life as a historical process. Focusing these beliefs on the American scene, Strand looked directly at the people, the land they inhabited, and the objects and buildings they created. He turned to the city, not to explore urban injustice, as Hine had done, but to explore human form. He turned to rural America to show the perfection of the landscape and native architecture. Having settled in a single blow, as it were, the major problems of form and content that occupy the lifetime of most artists, Strand was free to devote the next sixty years to finding similar embodiments of his affirmative beliefs.

It is somewhat tragic, yet fitting, that Strand, the greatest photographer of American idealism, the photographer who most nearly approaches Walt Whitman in scope, message, and commanding presence, should finally lose his belief in the fulfillment of the American dream. Strand's realistic assessment of the limited possibilities of American society finally overwhelmed his idealism. He had tried in a series of films during the thirties and forties—*The Wave, The Plow that Broke the Plains,* and *Native Land*—to find another way of representing his heroic, splendid vision of America. But even these cinematic portrayals failed to convince Strand or his audience that such morality was actually possible in America. In 1949, beset by marital troubles and a sense of the impending move of the country to conservatism, Strand left for Europe. "The intellectual and moral climate of the United States was so abused and in some cases poisoned by McCarthyism that I didn't want to work in [America] at that time," Strand said shortly before his death. Even as he said this, his optimistic faith in America warmed and he added, "It was not in any way a rejection of America; it was a rejection of what was happening in America just then." But he never photographed in the United States again.

Strand's influence and the influence of the Whitmanian ethical tradition still endure. Strand's purity of form has come down to our own time through the lineage of Ansel Adams, Wynn Bullock, Minor White, and Paul Caponigro. And his singular fusion of the political statement with aesthetic elegance has been repeated in the photographs of the New York Photo League, in the work of W. Eugene Smith, and more recently in the photographs of Bruce Davidson. Indeed most of the recent photographs of social protest or of utopian vision find their way back to Strand's influence.

If O'Sullivan was the adventurer, and Stieglitz the experimenter, then the archetype of the humanist must be reserved for Paul Strand.

Walker Evans and the Anthropology of America

Strand, Evans, and Weston were the last great photographers who successfully refused to see alienation as a part of American civilization. Strand was the last photographer who could unabashedly idealize the American common man. Evans was the last who could isolate in the actuality of the American experience the myth of the purity and vitality of the rural and the small town. In fact, Strand's and Evans's visions are just the flip sides of the same coin. And that coin's currency was authorized, stamped, and minted by Whitman's visionary democracy. From Whitman, Strand inherited a utopian vision of the ideal attributes of man: nobility, beauty, strength, calmness, and dignity. Evans, too, was preoccupied with these virtues, but

in seeking to find them through the factual rather than through the ideal he appropriated quite another thing from Whitman: the poet's concentration on the minute particulars of the world.

Evans's factual vision has its roots in the work of two men he would later come to reject as being too "arty": Stieglitz and Strand. Stieglitz, in his early radical experiments of photographing in the street, had to look to his own intuition for aesthetic justification. Acutely aware that his own straight prints did not meet the dominant pictorial aesthetic of the day, he called them "snapshots" and "explorations of the familiar." Strand went even further in rejecting the accepted traditions of picture making and began to search out indigenous American facts, photographing native architecture, billboards, automobiles, and the peculiarities of regional costume and commercial art. In their early experiments both Strand and Stieglitz developed a specifically American vocabulary, a vocabulary of actual American facts and artifacts that Evans would soon appropriate and make his own.

Evans's work is much closer to Strand's than is generally conceded, so close at

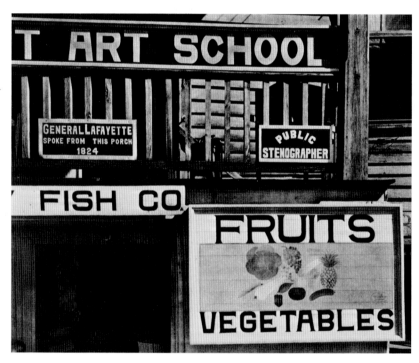

times that they are almost interchangeable. Even their methods of photographing were remarkably similar: both insisted on using the anachronistically large view camera, both sometimes used the prism lens to catch people unawares. There are several dozen photographs in each man's work that could be comfortably interchanged with the other's without the slightest hesitation. Strand's photograph *Truckman's House, New York* (1920), has virtually identical themes and content as half a dozen of Evans's images that concentrate on the interaction of native architectural forms and hand-lettered signs. The simplicity and elegance of architectural description in Strand's *Closed Door, Maine* (1945) recall Evans's *Doorway, 204 West 13th Street, New York* (about 1931). The complex, long spatial description of an urban scene in Strand's *Docks, New York* (1922) anticipates Evans's vistas of Bethlehem, Pennsylvania, of 1936. And the frontal, accurate documentations of the exteriors and interiors of poor American homesteads in Strand's *Time in New England* (1950) are remarkably similar to Evans's photographs from *Let Us Now Praise Famous Men* (1941).

Yet while Strand and Evans frequently photographed the same physical aspects of the world—ordinary, often poor, people, and buildings rich in history and design—

PAUL STRAND. *Truckman's House, New York,* 1920

WALKER EVANS. *Storefront and Signs, Beaufort, South Carolina,* March 1936

their intentions were antithetical. Strand's desire was to generalize, Evans's to particularize. Strand would find the whole as apprehended in the part, while Evans would elucidate each and every detail that constituted the whole. Strand's work moved toward the hieratic, Evans's toward the vernacular. Though they were both deeply moved by Whitman's optimistic politics, it was as if each had inherited only one side of Whitman's divided personality. Strand was the universalist, the visionary, the comrade walking arm in muscular arm with Whitman and the workers of the world. Evans was the realist, the secularist, the outsider, the anthropologist taking fastidious notes on the condition of the American soul.

Evans's direct, anthropological photography translates Whitman's syntax and vocabulary into the world of visual images. Evans's method of framing the world with his camera was conceptually similar to Whitman's method of organizing a poem. Rather than beginning with symbol or allegory, both started with an accumulation of simple, separate facts. These were compounded, piled up, cataloged, and ordered until they proliferated, forming the shape of the factual world. This ordering of facts,

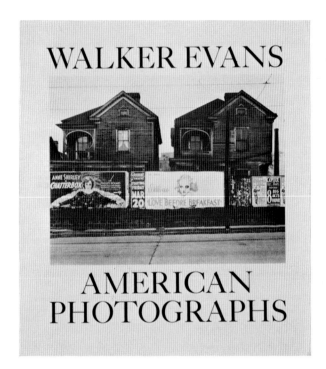

WALKER EVANS. *Photographer's Window Display, Birmingham, Alabama,* 1936

Cover of *American Photographs* by Walker Evans, 1975 edition. Photograph, *Billboards and Frame Houses, Atlanta, Georgia,* March 1936

as opposed to the ordering of symbols, remains the central differentiating factor between Evans and his two predecessors, Strand and Stieglitz. And it provided a stylistic device that gave the illusion of reality in the midst of artifice.

In paralleling Whitman's methodology in his own work, Evans takes another step in exploring the possibilities of photography in America. Like Strand's, his vision is formed out of the confluence of Puritanism and egalitarianism. (Lincoln Kirstein has written that "the most characteristic single feature of Evans' work is its purity, or even its puritanism.") To these two influences Evans adds the quintessentially American trait of pragmatic utilitarianism. He does this in both the content and the form of his photographs. First, following the general pragmatic American tendency, Evans focused his camera on indigenous goods, products, by-products, and buildings of commerce. All his photographs show man in relationship to the commercial products of American society. There is no "natural, primal man" in Evans's work as there is in Strand's. Second, Evans structured his photographs to imply actual, spontaneous American photographic documents—the snapshot, the postcard, and the newspaper shot—the anonymous vernacular folk art of photography.

There is nothing accidental or fortuitous in Evans's large camera work of the

thirties. These photographs are among the most exquisitely structured and composed work in all of American photography. Yet, by appropriating the haphazard edge of the snapshot as a manageable picture device, Evans allows, in such photographs as *Bucket Seat Model T, Alabama Town* (1936), and *Hardware Store, Southern Town* (1936), the abrupt fracturing of the edge by objects outside the frame. This manipulated candidness heightens our sense of straightforward, uneditorialized observation. We take art as truth.

Evans's photographs are packed with the *things* that make up one part of the everyday American experience. They are photographs about getting and spending, about traveling and soliciting, about the character of places and people as defined by commercial, public transactions. They are the photographic equivalent to the Sears, Roebuck catalog of the day. They are photographs of auto parts, farm implements, groceries, gasoline, oil, wrought-iron furniture, fresh meats, salt meats, sugar, tonic, patent medicines, model Ts, baking powder, calendars, snapshots, Mail Pouch tobacco, license plates, flowered wallpaper, mason jars, and the very places where these

things are seen, bought, and advertised: city streets, wrecking companies, living rooms, bedrooms, kitchens, gasoline stations, hardware stores, grocery stores, poolrooms, hotels, billboards, furniture stores, fish markets, rural post offices, and contractors' buildings. No commercial item is too mean, too trivial, too out of place for the world of Evans's photographs.

The effect of looking squarely at such things was shocking for his time. Most critics characterized his work with words like *wretchedness, disintegration, waste, chaos,* and *decay.* But like Whitman, Evans was trying to provide a new vision of reality by choosing a new vocabulary of facts. To intensify this vision, he chose objects that had not yet attained through repeated usage the status of icons, symbols, or metaphors. A gas station pump was a gas station pump, nothing more. Evans wanted to replace the romantic constellation of things insisted upon by his predecessors with a new Whitmanian catalog of the things of this world. However, in picturing these items so well, so lucidly, and so lovingly, he created a whole new iconography that would furnish the primary motifs for a new generation of photographers.

Photography, Evans once wrote, "is not cute cats, nor nudes, motherhood, or arrangements of manufactured products. Under no circumstances is it anything ever

WALKER EVANS. *Roadside Store between Tuscaloosa and Greensboro, Alabama,* 1936

WALKER EVANS. *Highway Corner, Reedsville, West Virginia,* June 1935

anywhere near a beach." This sarcastic slap at some of the objects pictured in his contemporaries' work—Stieglitz had nudes, Strand a cat or two, Steichen manufactured items on display, and Weston a great deal on and near a beach—defined by omission the objects Evans would place in his photographs. And these vernacular objects Evans would describe so well that one is tempted to accept them as the whole of reality itself.

Edward Weston and American Description

Photography, being a rather insular community, has tended to give too much credence to its own photographers, to its photographers' editors, and to the written word. Even the photographers themselves have allowed their editors to bend their intentions. Consider Ansel Adams. His books have been edited to produce what Tom Barrow has termed a "Wagnerian visual approach." Yet in Adams's work there exist radically abstract and darkly intimate images that seem to have been deliberately

EDWARD WESTON. *Tina, Glendale,* 1922

EDWARD WESTON. *MGM Studios,* 1939

suppressed. Perhaps the most radical photographic experiment of 1940, for example, Adams's serial *Surf Sequence,* received its first full publication only in 1976 and that, ironically, in a monograph on Harry Callahan.

When we come to Edward Weston, we are faced with a similar dilemma. Here is a man known more by his own writings than by his photographs, a man who has been so eulogized and mythologized by his editors, disciples, and admirers that it is hard to look at the work with any degree of objectivity. Indeed it has been Weston's posthumous fate to suffer the fatal kiss of rapturous appreciation.

Stieglitz, of course, had the same problem and now Walker Evans seems to be reaping the rewards of overadulation. Both these men will probably survive, but it almost did Weston in. Even Susan Sontag, who more than anyone else has helped bring the criticism of photography to its senses, has been drawn in by the Weston myth. She discusses him in terms of his supposed insistence on "so bland an ideal of beauty as perfection."

But the photographs themselves say something else. If one turns to them after first consciously purging the mind of the mystical terms *being* and *essence*, it is surprising and rewarding to discover that their most lasting quality lies in their ability

to be absolutely factual, actual, accurate, and brilliantly descriptive. Indeed, once we move beyond the early soft-focus pictorial work, the majority of Weston's photographs are crisp, clean, clear, and literal. It would be difficult to find another photographer of the first half of this century who has eliminated so completely all mystical, symbolical, and metaphorical claptrap. The only one who comes close is Walker Evans.

It is an unfortunate symptom of our Puritan background that the American imagination has always tended to equate clarity and purity of expression with spirituality. The desire to spiritualize the American earth is deeply rooted in a Puritan and romantic attempt to find in the new American landscape the religious sources that had been left behind in the Old World. The burden this has placed on Americans who have photographed the natural world has been overwhelming. It has been almost impossible to really see Weston's work through the haze.

In 1941 Weston traveled through the South and East photographing for a special edition of Whitman's *Leaves of Grass* published by the Limited Editions Book

Club. Weston was fifty-five and had only seven more years to photograph before Parkinson's disease would force him to put down the camera. He was, it seems to me, at the height of his visual powers. The great, discrete studies he had made in the twenties and early thirties of nudes, peppers, shells, rocks, and clouds had now been brought together into a more complex, integrated vision. Like Whitman, he was now able to apprehend the world "ensemble."

What we find in these photographs is a richly diverse catalog of the varieties of American landscape, architecture, people, and objects. Like the best of Whitman's poetry, the photographs speak with a distinctly American vocabulary, an idiom that is spontaneous, expansive, optimistic, yet factual. They show a perfect eye for the unique vantage point that defines without hyperbole or subterfuge the visual character of each place. There is the weird altarpiece in the Saint Roche cemetery, New Orleans, with its dangling doll arms and legs, which Clarence John Laughlin would depict in a wispy, apparitional image. Weston photographs the same subject with bold reality. There is the derelict New Jersey mansion which surpasses many of Evans's architectural studies in its sense of light and place. There is the breathtaking long view of the railway yards and station in Nashville, Tennessee, with its almost

CLARENCE JOHN LAUGHLIN. *The Unborn*, 1941. "Against a background in which the feeling of barrenness is intensively conveyed, the figure—with her neurotic hand, and emotionally starved face—becomes a symbol of the many women in whom the desire for children has been defeated by conditions within our society. Note how the tiny head suggests both the head of an old man, and that of a child—expressing the unrealized promises of an unborn generation."

EDWARD WESTON. *St. Roche Cemetery*, 1941

commercial, magazine objectivity. And there are the various American people and faces, ranging from the log cabin dweller, Mr. Fry Burnett of Texas, and the joyous black stone sculptor, William Edmondson, to the moneyed and sophisticated David McAlpin in New York.

These photographs give a much more accurate presentation of this era than Walker Evans's homey small town America delimited by country grocery stores and gasoline stations. It is indeed a curious twist of fate that Evans's most famous book should be called *American Photographs* while Weston, an equally articulate observer of these United States, should be immortalized by *My Camera on Point Lobos*.

To the 1941 photographs I would like to add a short list of others that should be included in Weston's most distinguished descriptive work. These photographs are included in the 1973 Aperture monograph *Edward Weston: Fifty Years*. This volume for the first time has allowed the public to see more than nudes and peppers. Among the photographs made at the MGM studio in 1939, for instance, are some of the most intricately composed, surreal, yet humorous photographs made in America.

EDWARD WESTON. *Ubehebe Crater, Death Valley*, 1938

WALKER EVANS. *View of Easton, Pennsylvania*, November 1935

They finally confirm Charis's remark that her husband loved Atget's photographs of reflections in store windows. Then there is a set of fine Western landscapes—*Ubehebe Crater, Death Valley* (1938), *Albion, California* (1937), *Eel River Ranch* (1937), *Tomales Ranches* (1937), *Ranch with Haycocks, Sonoma County* (1937), and *Corral at Pismo Beach, Oceano* (1935)—as well, of course, as the final photographs at Point Lobos. To these add the horse barn at Salinas (1939) and the Mexican architectural studies of 1924 and 1926. And for sheer mystery combined with literal description there is nothing in American photography that compares to the photograph of Charis floating nude in her father's swimming pool.

In these photographs the self-conscious artiness that marks the writing and some of the early images has vanished, and we are left with clearly defined subjects and forms. These photographs are rooted deep in Weston's intuitive recognition of the beauty and actuality of the American land and people. These boldly attest to the apotheosis of the spirit of California and the West Coast.

Although Weston's boyhood was spent in Illinois, his life and work were deeply affected by the West Coast mentality with its almost literal belief in Whitman's political, social, and sexual freedom. Except for O'Sullivan, all the photographers we

have discussed so far have looked at the world from an East Coast vantage point. Weston's work taps the potentials of the Californian and the Mexican revolutionary spirit. The clarity of his work stems in large part from the expansiveness of the region, the physical beauty and vastness of the land, the purity of shapes on the more elemental, more primitive coast. His social attitudes, and particularly his treatment of a broad range of people, may be related to his isolation from Eastern critics, politics, and cocktail parties and to his intimate knowledge of the Californian maverick, revolutionary, and anarchist.

It has been the common critical belief lately that Evans has been the primary influence on the new color and New Topographic photographers. This may be true in terms of iconography, but the overriding descriptive influence comes from Weston. For, what we finally feel in his tactile, volumetric, absolutely accurate photographs is a sense of the beauty of the literal fact and a renewed sense of the vigor and possibility of the American dream.

Ansel Adams and American Technology

In Ansel Adams's photographs of the Western landscape, the optimistic, pantheistic, romantic tendencies of nineteenth-century American imagination reach their apogee. For O'Sullivan, the Western landscape was a vast storehouse of geological information, its wondrous forms the incentive for visual experimentation. For Strand, New Mexico and Mexico provided a fitting place to explore in a brooding, heroic fashion the relationship between peasants, Indians, and primal nature. In Weston's mature work, the Western landscape provided sites for precise, photographic articulations of natural and man-made beauty. But in Adams's work all these previous relationships are worked through, purified, transcended. Here the West loses its geological relevance, its geographical specificity, and its human scale. It becomes a magnificent, sacred object—a visual metaphor and a catalyst for reverence, exaltation, and veneration. "My Southwest experience has been more or less continuous," Adams wrote in the introduction to a book of his Western photographs. "The images are arranged for flow of meaning rather than of location and time. *What* and *who* make small difference in the presence of the eternal world."

WALKER EVANS. *View of Morgantown, West Virginia,* June 1935

EDWARD WESTON. *MGM Studios,* 1939

Adams took over Stieglitz's vocabulary of natural symbols: the silhouetted landscape, the dark sky, the dramatic cloud formations. The meaning of these symbols changed radically, however, in their transposition from East to West, from the ordered, humanized landscape to the bold frontier. Elements that were for Stieglitz notations and quiet guides to an intimate, introverted world became for Adams the primary components of an extroverted, heroic vision. Stieglitz's nature photographs almost always contained some specific reference to the human scale. Even in the "Equivalents," fragile, delicate branches jut up into the frame, giving a sense of human significance before the infinite sky. And the hedges, grasses, and trees of Stieglitz's more abstract nature studies are tactile and graspable. In the majority of Adams's photographs all sense of human scale has been lost. The more subdued moments of earth and sky have given way to more spectacular moments: dawn and dusk, sunrise and moonrise, thunderstorm and spotted sunlight.

Adams's sensibility is clearly evident if we compare the two photographs he made in homage to O'Sullivan with O'Sullivan's originals: the pictures of the White

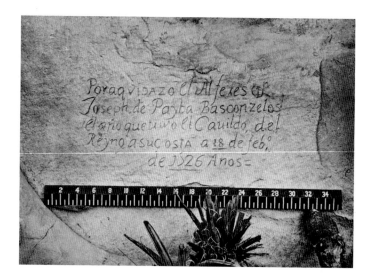

ANSEL ADAMS. *Spanish Inscription, El Morro National Monument, New Mexico,* c. 1948

TIMOTHY H. O'SULLIVAN. *Historic Spanish Record of the Conquest, South Side of Inscription Rock, New Mexico,* 1873

House ruins at Canyon de Chelley and the Spanish inscription at El Morro. In both of O'Sullivan's photographs specific reference is made to the human dimension and the accessibility of these remnants of older civilizations. In his photograph of Canyon de Chelley, O'Sullivan shows two figures perched on the ruins while two other explorers stand below. And in the photograph of Inscription Rock, O'Sullivan includes a ruler used by archeologists, juxtaposing the flowing script from the past with the stark, scientific lettering of the present. In Adams's photographs the older civilizations have been cleansed of their human origin; they have been absorbed into primordial nature itself. No men appear on the White House ruins. And the canyon wall, flat and actual in O'Sullivan's image, in Adams's sweeps dramatically away to the right to reveal a harsh, dark sky. The ruler has disappeared from Inscription Rock. Even the scrubby succulent in O'Sullivan's photograph has been reduced to a few elegant lines.

O'Sullivan's famous picture of his photographic van at Carson Sink is equally informative. Here, as in several other photographs, O'Sullivan is fascinated with his own image in the landscape. He seems delighted to show the viewer how he got there: the van sits squarely on the dune, the photographer's footprints in the sand

lead up to the camera's position. There *is* one rare picture by Adams in which he photographed his own and his camera's shadows against a canyon wall. But with few exceptions the intention of Adams's major work is mythic. The human presence is implied only by its absence.

In Adams's photographs the West is an abstract notion more appropriately understood in its transformation as photograph than in its actuality. Expression is more important than reality, idea more important than fact, the print more important than its subject. For it is only in the print that such magnificence can be unfailingly orchestrated. "Twelve photographs that matter in a year is a good crop for any photographer," Adams once said. An infinite number of visual confrontations with the landscape produces only twelve epiphanies.

For the early Western photographers the transformation from reality to print happened naturally and without premeditation. The nature of the photographic process determined the print's intrinsic color, range of contrast, and tonalities. When the early printing processes changed from calotype to albumen and then to chloride

and chloro-bromide, the surface and tonal qualities of the printed image shifted as well. These changes were made not for aesthetic or idealistic reasons but because of the availability, technical expediency, and relative permanence of each process. While some photographers had one or two technical tricks up their sleeves that helped give their prints a distinctive tonal character, it was not until Stieglitz began to champion photography as a fine art that photographers became conscious of the print as an aesthetic and controllable object. Stieglitz's abiding concern with "print quality" was passed on to Strand and Weston. Walker Evans looked with disdain on their concern with control and finish. "As in typography and printing," he said, "technique shouldn't arrest you." But for Adams, as for Stieglitz, "every print . . . is a new experience" requiring a special procedure to bring out its essential meaning.

The sense of the presence of the eternal world in Adams's photographs is achieved not only by his constant choice of sublime moments and viewpoints, but also by his legendary technical brilliance, which transforms an ordinary scene into a luminescent, fully realized, precious object.

To effect the formal purity and the transformations he desired, Adams developed the most careful, rigorously thought-out system of photographic control known

TIMOTHY H. O'SULLIVAN. *Desert Sand Hills near Sink of Carson* (Nevada), 1868

ANSEL ADAMS. *Sunrise Dunes, Death Valley National Monument, California*, 1948

to the field photographer: the Zone System. Adams wanted to go beyond conventional photographic recording, which, in his own words, is at best "acceptable though perhaps uninspired" and create a statement "acute and creatively expressive." In the Zone System, he engineered a technique by which the photographer could manipulate the photograph's internal tones without distorting essential photographic description. By means of filtration, development, and print controls, contrast could be heightened or softened and the placement of object values along the tonal scale could be predetermined by the photographer before the shutter was released. Thus a sand dune seen at sunrise could be transformed into an almost abstract composition of hard-edged black-and-white forms, a lone tree branch on the shore of Mono Lake could be made to stand out as if spotlit against a luminescent, floating background, and the north sky beyond Yosemite's Half Dome could be rendered a rich, velvet black. By using the Zone System, the photographer can darken those areas that in actuality provide an overabundance of distracting detail, lighten areas deep within natural shade, and intensify, simplify, or almost utterly obliterate the relationships

Garry Winogrand (1928-) spent two days in Rochester, New York, in October, 1970. On Friday, the 9th, he was the guest of the Rochester Institute of Technology. On Saturday, the 10th, he visited the Visual Studies Workshop, also in Rochester. The format was identical on both occasions: Winogrand, without comment, showed slides of his latest work and then answered questions from the student audiences. All in all, he talked for over five hours. The following transcript, edited from a tape recording of the proceedings, represents but one idea among the many ideas that were touched on.[2]

Rochester Institute of Technology, October 9, 1970.

I saw a photograph that—there's a photograph that had "Kodak" and there's a kid holding a dog—
 Yeah.

—and the people kind of wandering in and out. Now, it might be due to my own ignorance or something, but could you give me like a straight answer as to what you're trying to say in that photograph?
 I have nothing to say.

Nothing to say? Then why do you print it?
 I don't have anything to say in any picture.

Why do you print it if it has no meaning?
 With that particular picture—ah, I'm interested in the space and I maybe can learn something about photography. That's what I get from photographs; if I'm lucky, I can learn something.

Then you're trying to reveal something about space?
 I'm not revealing anything.

Detail of text from interview with Garry Winogrand in *Image, Journal of Photography and Motion Pictures*, International Museum of Photography at George Eastman House, July 1972

between land, clouds, sea, rocks, foliage, and sky. Adams found in this system the answer that pictorialists in photography had long been seeking: a means of controlling the optical, mechanical medium with the same finesse the painter managed with the brush and palette.

In Adams's work, then, the American vision of the spirituality of the West is realized through careful and conscious use of advanced technology. This union of technology, nature, and spirit derives from the nineteenth-century's belief that technology could be a means of achieving America's spiritual destiny. Art, technology, and religion joined in the common cause of controlling, defining, and recording nature in order to gain both economic advantage and spiritual truth. Adams's photographs derive their power by restating those grand aspects of the landscape that were already a part of American consciousness. Unlike Stieglitz, Strand, or Minor White, who would follow him, Adams does not use the new technology to search into the motives or forces behind the obvious. He seems oblivious to the exploitation, plunder, and technological destruction that made the West accessible to the white man. Rather, the grand and obvious are generalized to the point where they become the ideal.

The formalism that pervades Adams's work relates directly to his belief in

technology. For Adams, technology is redemptive. He can even sell automobiles on television with a straight face and a clear conscience. Indeed, it seems at times that Adams relies more on technology than on vision. Of all the major American photographers, he is the most inconsistent. When his work succeeds it is breathtaking. When it fails it becomes mere finger exercises in the Zone System, work that is decorative and cloying.

Adams's work is in the Puritan grain: straight and rigorously conservative. His obsession with technological control also displays another fundamental American trait—a trait we have also seen in Stieglitz's work and will see in Steichen's—an aggressive, acquisitive, inventive preoccupation with engineering and the practical uses of new technology. As de Tocqueville pointed out in a chapter of *Democracy in America* entitled "Why Americans Prefer the Practice Rather than the Theory of Science," the emphasis in the United States has always been on "useful knowledge." In the nineteenth century, America imported almost all of the major scientific ideas from Europe, but the widest applications of these ideas to common life were made

here. This was especially true in photography. At the birth of photography American daguerreotypists quickly became the most inventive practitioners of the new medium. Samuel F. B. Morse, the inventor and portrait painter, played a significant role in the introduction of photography into this country, and other major American inventors—Thomas Edison, George Eastman, and Edwin Land—made significant contributions to photography's capability and popularity. Today there is an unparalleled exploration by younger photographers into the image-generating possibilities of a variety of electronic, electrostatic, and mechanical reproduction methods.

Adams's concern with craft, technique, and reproduction quality helped initiate wide participation in expressive photography. He has shared his insights in numerous books and articles. His first technical manual, *Making a Photograph* (1935), contained the most accurate photographic reproductions since Stieglitz's *Camera Work*. And the *Basic Photo Series* (1948–1956) dispelled the atmosphere of alchemy surrounding photographic technique, allowing any photographer to produce a fine print.

Yet Adams's standardization of photography as a set of scientifically explainable and repeatable processes has also been strongly challenged. Much of the aesthetic

Article on Jerry N. Uelsmann by H. M. Kinzer, *Popular Photography*, May 1966

RICHARD ZAKIA AND JOHN DOWDELL. *Zone Systemizer for Creative Photographic Control,* 1973

ferment in the sixties can be seen as a response to Adams's teaching, particularly his notion of previsualization. For some photographers the use of the Zone System has been a badge of honor; others have questioned the whole idea. Jerry Uelsmann introduced the concept of postvisualization, in which the final photograph is synthesized in the darkroom from many negatives. And Garry Winogrand has cantankerously announced on many occasions, "I don't have anything to say in any picture. My only interest in photography is to see what something looks like *as* a photograph. I have no preconceptions."

In our gallery of archetypal heroes, Adams fits well into the role of the American nineteenth-century engineer. Like the great builders of that age, he uses his knowledge of science for the aesthetic and spiritual welfare of man.

EDWARD STEICHEN. *Self-Portrait with Brush and Palette, Paris, 1901.* Pigment print

PHOTOGRAPHER UNKNOWN. *Lt. Edward Steichen and his daughter, Mary,* c. 1916

Edward Steichen and American Success

In Whitman's America the artist is an entrepreneur, a contractor who undertakes to articulate and disseminate the feelings and beliefs of the ordinary American. His role is to celebrate the most common life, knowing that "the great master . . . sees health for himself in being one of the mass." The prototypical Americans in Whitman's world may be the mechanics, housewives, and tradesmen, but *their* idols are personified by the folk heroes and celebrities created by the self-same egalitarian dream. The poets, politicians, and prophets may praise the common man, but the common man sees himself and defines his ambition in relationship to the new heroes of the egalitarian state: the actor, the entertainer, and the high-fashion model. The hostility of the masses toward art paradoxically engenders an obsession with the celebrity, who is merely a common man himself, spotlit by the new technology of publicity.

Edward Steichen spent a lifetime pursuing, photographing, and cataloging those images, commodities, and celebrities that epitomized the dreams of the common American. And in the process, by helping to create the celebrity's image, he became a celebrity himself. This symbiotic relationship between photographer and

sitter is, of course, not unusual in our time. It will be repeated frequently, particularly in the work of American fashion and portrait photographers. The appeal of Karsh and Avedon certainly consists as much in their connections with other celebrities as in their own talents.

Steichen's relationship to the world was only once removed from that of the Whitmanian entrepreneur: Whitman sang the praises of the common man, Steichen made the images for the common man's dreams. He was an artist who dealt with image rather than substance. His photographs have a hybrid, international elegance and grace, a dramatic flair that marked them for Steichen—a poor boy from Milwaukee, Wisconsin—as the height of elegance, fashion, power, and prestige.

Early in his career, Steichen went to Europe to study painting. But after two weeks at the Académie Julian he gave up his professional art training and set out to make a series of photographs of the distinguished artists of the day. He photographed the American photographer F. Holland Day and the painters George Frederic Watts, Franz von Lenbach, and Alphonse Mucha as well as Rodin, Yvette Guilbert, and

Maeterlinck. And then in the famous self-portrait, dressed up in Day's neckcloth, Steichen made over his own appearance in the image of the great men and women he was photographing. These photographs—all highly manipulated, using gum printing and a great deal of hand retouching—were the most authentic and powerful Steichen ever made. The work itself immediately placed him in the forefront of the pictorialists of the day, and his contact, however superficial, with these distinguished artists gave him unprecedented prestige within the art world and the photographic community. Overnight, Steichen became a member of the European artistic circles at the turn of the century.

Back in America for the remainder of his photographic career, Steichen continued to photograph the celebrity and made one of the most complete records of America's entertainment stars and fashion beauties of the twenties and thirties. John Barrymore, Katherine Cornell, Lillian Gish, Martha Graham, Paul Robeson, Paul Muni, Maurice Chevalier, Fred Astaire, Greta Garbo, Charlie Chaplin, Gloria Swanson, Mary Pickford, Fredric March, Marlene Dietrich, Noel Coward, Jimmy Durante, Gary Cooper, and Isadora Duncan all posed for his camera.

In reading his autobiography, *A Life in Photography* (1963), one is amazed at

VICTOR JORGENSEN, LIEUT., U.S.N.R. *Steichen Photographing from the Catwalk, USS Carrier Lexington*, c. 1945. Photographic montage

PHOTOGRAPHER UNKNOWN. *Steichen at the White House with President Lyndon B. Johnson, Carl Sandburg, and Lynda Bird Johnson*, April 10, 1964

how little personal contact Steichen had with the majority of the people he photographed. "The first time [Charlie Chaplin] came to the studio, his secretary . . . said, 'Mr. Chaplin has another appointment, so he can only give you twenty minutes.' " And Steichen's previous contact with Garbo consisted of watching her "at work through a crack in the wall of the set on which she was performing. . . . Then I was given . . . a five minute interval for the shooting."

To work under such exigencies, Steichen quickly developed several formulas for photographing, formulas that would flaunt and flatter the star's physical beauty at the same time as they exhibited the photographer's prowess. These formulas relied on the dramatic use of artificial light. One setup used several light sources which threw multiple shadows on a neutral background. Another utilized an abruptly divided background, one half being pitch black, the other half emanating light. For men this background was most often divided vertically, for women, horizontally. Another set used a single prop, such as a chair or sofa, on which or over which the subject would face the camera. Several of the portraits that used these formulas were powerful, the ones of Alexander Woollcott and W. B. Yeats, for example. More often, these theatrical settings and dramatic lighting pared away the intrinsic differences between sitters. They legitimized fame by placing the sitter under the spotlight of public view. And, in their high-key drama, these images are virtually interchangeable. The formulaic stylization becomes evident when exactly the same setting and lighting are used for Thomas Mann as for the prizefighter Jack Sharkey.

In spite of the aura of glamour surrounding Steichen's sitters, his portraits were always eminently respectable. Puritanism consumes his work. From his early anonymous nudes to his later portraits of such vamps as Dietrich and Ann Pennington, Steichen's works, as the critic Sadakichi Hartmann keenly observed, were "nonmoral, almost sexless." While there were a few exceptions, such as the carefully provocative portrait of Joan Crawford, Steichen's morality was best summed up in his advertisements for Eastman Kodak's Snapshots. Real human encounters never take place in his photographs. His American dream exists only in disembodied, Victorian morality or in images that flash across the Hollywood screen.

Steichen's work concentrated on what has been sanctified as acceptable to the common man. All his photographs are rated "G." All his emotional insights are generalized. The tragic, Freudian realism of O'Neill's *Strange Interlude* becomes a cliché trick of photomontage in Steichen's hands. Unlike Stieglitz, Steichen would never look directly at the vitality or sensuality of the human body. Where Strand, Stieglitz, and Weston photographed their friends and lovers, Steichen only looked at people who had been publicly certified as beautiful. Stieglitz recorded and counted among his close friends men and women who actually helped shape history. Steichen concentrated with few exceptions on people he knew only marginally. And his portfolio was made up of few profound thinkers.

Like Evans and Adams, Stiechen was overwhelmed by pragmatism. But unlike Evans, who transformed this force into the mainspring of his art, and unlike Adams, who built out of utility the techniques for a genuine vision, Steichen could only draw from it the energies for commercial transactions. In his autobiography, Steichen states over and over again his role as a successful administrator of artistic affairs. He was the designer of Stieglitz's cover for *Camera Work*; the organizer and decorator for Stieglitz's gallery, 291; the founder of the "New Society of Younger American Painters" in Paris; the discoverer of the major Parisian painters; the man who influenced John Marin to add prismatic colors to his palette; the man who represented the American army at Rodin's funeral; the man who suggested his own position as Director of the Department of Photography at New York's Museum of Modern Art.

Steichen prided himself as much on his titles as on his actual photographic work. He was one of the first Americans to become a member of the English Linked Ring; in France he was made Chevalier of the Legion of Honor and received the

Medaille d'Honneur des Affaires Etrangères. In the United States Army he was Lieutenant Colonel, then he became Chief Photographer for Condé Nast, then Director of the U.S. Navy Photographic Institute, finally retiring with the rank of Captain. When he became Director of the Department of Photography at MOMA everyone continued to call him "Captain." And at the age of eighty-four he was awarded the Presidential Medal of Freedom by John F. Kennedy.

In Stieglitz's and Weston's work we witness the slow but continual growth of master artists who find their style from within themselves. In the work of Adams and Strand the initial, unique insights were developed through a lifetime of work. Both Evans and O'Sullivan had extremely short but intense periods of work—O'Sullivan's lasted slightly more than ten years, Evans's major work spans no more than eighteen months. But Steichen set out early to follow the fashion and the spirit of the times. He succeeded by dint of a tremendous ego and by an uncanny instinct for cultivating the right people, making the right photographs, taking the right vocational moves, making the right commercial transactions, and being involved in photography for more than sixty active years.

Steichen felt more at home with concrete facts than with the real stuff of art. Concerned more with utility than with expression, he was conventional in morality, generous both to his friends and antagonists, actually awkward at times in the role of artist but always comfortable in the world of business and administration. Steichen was certainly not Whitman's "passionate ego." But he was the apotheosis of the common American. His photographs and his career personified the great democratic dream: success. His greatest photographic creation was his own image.

U.S.A. Wynn Bullock

And God said, let there be light Genesis 1:3

The Family of Man

The greatest photographic exhibition of all time —503 pictures from 68 countries— created by Edward Steichen for

The Museum of Modern Art, New York

Photography as Popular Culture: The Family of Man

Family Pictures

In January 1955, Steichen's extensive theme exhibition *The Family of Man* opened at the Museum of Modern Art. The exhibition ran for 103 days, attracted unprecedented crowds both in New York and throughout the world, and appeared simultaneously in a variety of book forms. It immediately became the major photographic event of the fifties, perhaps of its generation. *The Family of Man* signaled a broad-ranging acceptance of photography as an art form by the museum world and by the American masses. It became the touchstone against which the next decade of photographers would have to measure their work.

The show opened to great critical acclaim. But, while only a few dissenting voices were heard in 1955, the strength of those voices has swelled over time. It is now the accepted critical stance to disparage the exhibition as romantic, sententious, and sentimental and to regard it as a mass-culture spectacle that avoided difficult truths by dealing in clichés and generalities. While much of this is true, the show remains of paramount importance because the traditions of documentary expression and the pictorial style that it evidenced have dominated, and continue to dominate, popular conceptions and uses of photography.

Inside front cover and title page of *The Family of Man*, 1955. Photographs by Wynn Bullock, *Let There Be Light*, 1954, and The Lick Observatory, *The Orion Nebula*, n.d.

Because of its short history, its inherent mechanical and optical nature, and the great democracy of its use, photography has always been tied to popular culture. In spite of many early predictions that the medium would become a high art form, the vast majority of photographers have not used it to explore and resolve the problems of form and expression that we have come to regard as the proper concerns of sophisticated art. Rather, photographs have been used most extensively as snapshots, as popular and commercial art, and as an essential visual means of recording the news. These three impersonal, publicly sanctioned ways of recording the world are neatly summed up in the headings frequently found in the photographic annuals of the first fifty years of this century: Family Pictures, Fine Pictures, and News Pictures.

Of these three areas, the endeavor which is the least conscious, the least discriminating and sophisticated, is undoubtedly also the most consistently vital, straightforward, and moving of all popularly produced images, namely the snapshot. Made out of almost total visual innocence, it is the photographic means of creating

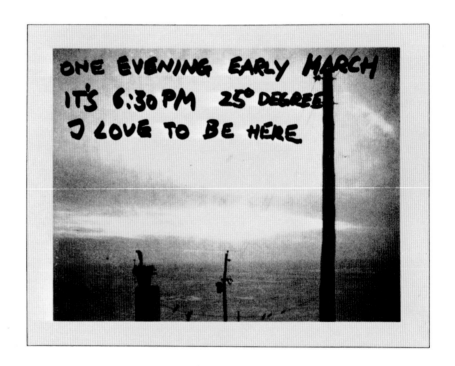

Title page from *The Snapshot,* 1974. Photograph from the collection of Wendy Snyder MacNeil

ROBERT FRANK. *Untitled,* 1971. Polaroid snapshot

private, family memorabilia and of recording the most ordinary, personal, and communal affairs. Snapshots are remarkably homogeneous in subject matter, social viewpoint, and visual style. They are made at eye level, from the front and center, from the middle distance, and generally in bright, outdoor light. Yet, because snapshooters are almost totally concerned with centering the subject, the forms at the edges are accidental, unexpected, unstructured, and—by any traditional standards—incorrect. Once having centered the subject, the snapshooter allows the camera to organize the picture plane on its own optical, mechanical, and chemical terms. Since the snapshooter interferes least with the photographic process, he tends to produce the most human and visually complex of all photographic images. As Lisette Model has commented, "The snapshot comes closest to truth."

This body of millions of evanescent photographic images—which for the snapshooters themselves are mere souvenirs—has been continually reexamined for clues about the nature of photographic seeing and image making. As mentioned in the last chapter, Stieglitz began to imitate these "explorations of the familiar." And the work of Walker Evans has strong ties to the "folk art" of the snapshot and the postcard. In our own time a host of photographers, including Wendy Snyder MacNeil, Nancy

Rexroth, and Emmet Gowin, have begun to consciously incorporate actual snapshots and snapshot styles into their own work. The haunting power of the snapshot came to exercise a profound impact on the sophisticated photography of the sixties and seventies.

In *The Family of Man* there are no snapshots. Steichen's selection ignores the most universally understood of all visual images. True to his past concern with the attributes of expression rather than expression itself, Steichen chose to show the family from the outside looking in rather than to use notations made by the insiders themselves. He was convinced that he could show the whole of mankind by using the other two major avenues open to the popular photographer: Fine Pictures and News Pictures.

If snapshooters photograph out of almost total visual innocence, "popular photographers"—people with a Sunday hobby, members of the Professional Photographers of America, and photojournalists—work within a cultural ambiance that has evolved its own ethical, social, political, and visual codes. Far from being naive, their

work adheres strictly to a particular set of visual rules. The popular photographer believes that his work must go beyond the blatant objectivity and vulgarity associated with the naive snapshot. Its unaltered picture of life must be replaced with a more decorous, stylized version. The actual world in which the popular photographer lives is not a dignified enough subject. His camera must be turned toward those subjects which the academic traditions of art have legitimized as suitable.

In form as well as content, this Fine Photography—or "art" photography, as it is known in some circles—is used to repeat and reiterate mass culture's conception of art. Fine Photographs are "beautiful" precisely because their subjects and forms are beautiful: sunsets, calendar girls, patchwork patterns, babies, pussycats. And even in the recording of news and events, the photographs of the pictorial journalist adhere closely to stereotyped notions of political relevance. Only in the rare spectacular photograph of a natural or man-made disaster do we find the breaking of traditional rules of structure.

To aid the popular photographer in simplifying the real world, a whole range of devices has been invented to thwart the all-encompassing eye of the camera: backdrops, lights, canvas-textured paper, and special costumes. Their use can be partially

Advertisement for the The Haloid Company. *American Annual of Photography*, 1938

Student work from Edward Kaminski's class at the Art Center School, Los Angeles. Published in *U.S. Camera*, 1940. Photographs by R. F. McGraw, Estelle Keech, P. E. Guerrero, Norman Lindblom, George F. Weld, Ken Pope, and P. Wynn Bullock

explained by the popular photographer's continued reliance on some of the technical and cosmetic tools that were needed in the early days of the medium to facilitate the long exposure required by slow emulsion. But these techniques have far outlasted the actual need for them.

For the popular photographer space becomes background rather than physical or moral environment. Bland tapestries and seamless papers carefully exclude any hint of actuality. The demands of American advertising, which grew up along with the expanded uses of photography, push the space of the real world further into the background. Advertising photographs surround people and objects with an illusionary world of sophistication, elegance, and wealth. This is the world that stereotypes time as childhood or old age rather than seeing it as temporal flux: it is ahistorical rather than actual. This outlook is strikingly indifferent to the minute-by-minute and day-by-day temporal setting.

In popular photography the American tradition of high ideals becomes trans-

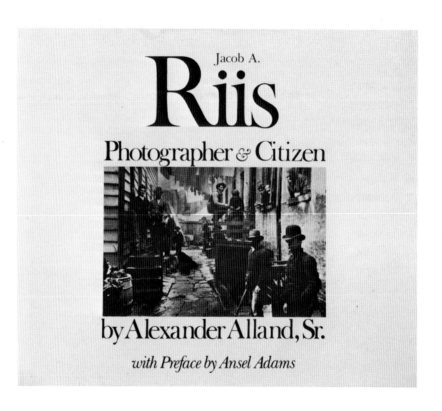

Dust jacket of *Jacob A. Riis: Photographer & Citizen,* 1974. Photograph, *"Bandits' Roost," 59 1/2 Mulberry Street* (New York City), c. 1888

lated into insistent confidence and yea-saying. It is a mode in which suffering, which rarely appears, is either foreign or exotic or occurs only in officially sanctioned places: the slums, the dust bowl, and the prison. American popular photography steadfastly refuses to deal with the actual. For popular culture the purpose of art is not to reveal the actual but to reaffirm the ideal. The making of "art" frees the popular photographer from any obligation to truth.

The Photo-Essay: Photography as Public Relations

Next to the conventions of the popular pictorial photograph, the most notable influence on *The Family of Man* was the tradition of the photo-essay. *The Family of Man* was based upon several exhibitions Steichen organized in the early forties for the Museum of Modern Art, including *Road to Victory* (1942) and *Power in the Pacific* (1944). These in turn were derived from the documentary books and magazines of the thirties which combined text and photograph to create the photo-essay genre.

The first book to bring words and photographs together appeared many years

earlier. In 1890 Jacob Riis published *How the Other Half Lives,* one of the first books to reproduce images by the new halftone process. As a journalist struggling to expose the misery of the New York slums, Riis used a camera and magnesium flash to present an intense and accurate documentation. Riis's photographs have no precedent in the history of American photography. Riis, like O'Sullivan, was a primitive who photographed intuitively. "I became a photographer," he once wrote, but quickly added, "after a fashion." He was not interested in art or self-expression. His aim was solely to initiate social change. His use of a biting—if at times racially prejudiced—prose and his raw, unflinching, direct flash snapshots helped to rid New York of its worst slums.

Riis's intention was to stimulate radical social and political action, to threaten the system that could allow such inhumanity to exist. The intention of the best-known photographic works of social comment in the thirties, on the other hand, was government propaganda. The Farm Security Administration's photography program

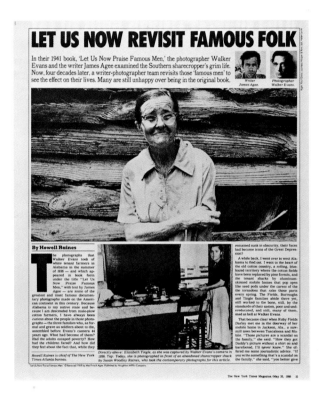

was above all a calculated attempt to win support for the new federal relief and resettlement programs; subordinate, and it seems almost incidental, was the goal of helping the people themselves. The most widely read documentary books of the period, such as Erskine Caldwell and Margaret Bourke-White's *You Have Seen Their Faces,* capitalized on the tenant farmer problem, a problem which had already received significant national publicity in the press and movies. Whereas Riis's photographic idiom had been direct, candid, and deadly accurate, the documentary style of the thirties—with the significant exceptions of the work of Walker Evans, Ben Shahn, and the best work of Russell Lee and Dorothea Lange—was pictorial and mannered. It was based on the same premise that controlled the work of the popular photographer. Its overtly dramatic visual style and its editorial content aimed at achieving mass appeal, spontaneous response, and easy readability. And it did just that by dealing in stereotyped renditions of poverty and the impoverished.

The most popular photographer of the thirties, Margaret Bourke-White, built her reputation on the dramatic and unusual viewpoint, the overly emotional and the ultimately superficial. But the work of the most enduring photographer of that era,

Cover of *You Have Seen Their Faces,* 1937. Photograph by Margaret Bourke-White, "I don't know whatever happened to the family that built this house before the war. A lot of families live here now. My husband and me moved in and get two rooms for five dollars a month," c. 1937

Page from *The New York Times Magazine,* May 25, 1980. Contemporary photograph (center) by Susan Woodley Raines. Photograph by Walker Evans (below), *Elizabeth Tengle, Hale County, Alabama,* Summer 1936. Photograph of James Agee (top left) by Helen Levitt. Photograph of Evans (top right) by Paul Grotz

Walker Evans, was cool and understated, visually elegant and complex. Evans photographed straightforwardly, without subterfuge. His images, like Riis's, have behind them the direct power of the snapshot. Like Riis's they come back to that ambiguous reality that lies untouched, unenhanced, and undiminished before the camera.

The differences between the documentary style of the thirties and Riis's style are significant and instructive. Riis's was a personal, moral response to an intolerable social condition. His photographs were documents of hard facts made out of personal experience, conscience, and anger. The FSA photographers, on the other hand, were hired to photograph the sharecroppers and the migrants. They were told what the public wanted and they were determined to give the public just that. Roy Stryker, who headed the FSA photography program, told his staff exactly what to find. "I know your damned photographer's soul writhes, but to hell with it," he wrote to Jack Delano in a note asking for picturesque autumn photographs. "Do you think I give a damn about a photographer's soul with Hitler at our doorstep? You are nothing but camera fodder to me." Stryker wanted his FSA photographers to disregard "the America of the unique, odd or unusual happening." They should photograph the general and immediately understandable. In 1942 he sent a shooting script to Russell Lee and Arthur Rothstein asking for

> Pictures of men, women and children who appear as if they really believed in the U.S. Get people with a little spirit. Too many in our file now paint the U.S. as an old person's home and that just about everyone is too old to work and too malnourished to care much what happens. (Don't misunderstand the above. FSA is still interested in the lower-income groups and we want to continue to photograph this group.) We particularly need young men and women who work in our factories, the young men who build our bridges, dams and large factories.

In modern terms, the political and economic situations of particular groups were used by the FSA and the other documentary photographers as "media events." Journalists, photographers, and editors capitalized on them and exploited them. Photographs of the poor and the migrant were not usually made for the direct benefit of the subjects themselves. They were made to sell magazines or promote government projects. The difference, then, between the thirties photographers and Riis was the vast gulf between public relations and personal commitment.

The photo-essay was a device developed to guarantee the promotion of the proper image. The strategy of the photo-essay, which reached its height in the thirties, left the viewer as little room for personal response as possible. The photo-essay represented the latest journalistic and technological step in conveying and popularizing the news: it told the story at a glance. The photographs invited the viewers' attention and convinced them of the story's accuracy. The words reinforced the apparent truthfulness of the photographs. Yet such a close relationship between words and images is tenuous at best. Headings and captions tend by their very nature to be simplistic and redundant. They communicate not so much by describing the picture as by identifying and confirming what the reader already knows. The use of an identifying caption—name, person, place, or event—thus becomes a mere tautology.

The photo-essay neatly solved problems of identification and description by ignoring them altogether. Most documentary presentations of the thirties used captions that were associative or politically relevant, captions that repeated what the mass audience either wanted to hear or what the editor thought they should know. The caption's relationship to the photograph was incidental. In *You Have Seen Their Faces*, for example, Caldwell and Bourke-White explain that "the legends under the pictures are intended to express the authors' own conception of the sentiments of the individual portrayed, they do not pretend to reproduce the actual sentiments of these people." Other books let free association wander even further, using the sen-

tentious and sentimental words of the President, the Congress, or prophets of culture to underscore the political relevance of the photographs. In Sherwood Anderson's *Home Town* (1940), a Marion Post photograph of cars in front of the town hall on a snow-covered Vermont street is given the caption "America must keep rolling." And ten years later Arthur Goodfriend generously sprinkled his anti-Communist photo-essay *What Can a Man Believe?* with quotations from Mahavira, Lao-tse, Buddha, Confucius, Christ, Mohammed, Lincoln, and Harry S. Truman—to name only a few. This book, a precursor of *The Family of Man* in organization and use of quotations, is perhaps the most blatant and ludicrous example of confounding the actual meaning of photographs and words.

Within the photo-essay, the captioned photograph diminishes the specificity and individuality of the person portrayed. By being inherently a generalizing device, it has no way of indicating exceptions to the rule, of noting the peculiar, the eccentric. Its purpose, as was so clearly stated in the manifesto published in the first issue of *Life* magazine in 1936, was "to see life; to see the world; to eyewitness great events;

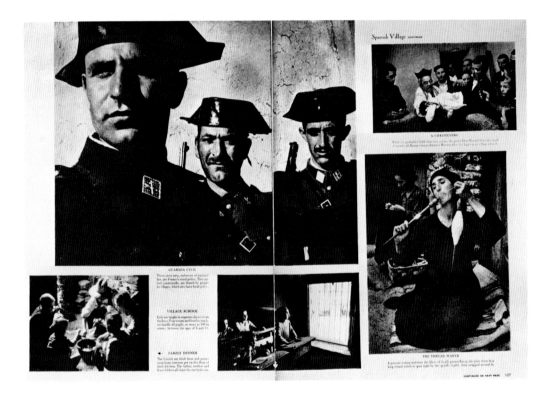

to watch the faces of the poor and the gestures of the proud." In short, it was to see what was already known or readily knowable. The idiosyncratic would be presented under the rubric of the exotic. Anything visually disturbing or ambiguous would be relegated to the back page, "Speaking of Pictures."

The photo-essay became a perfect vehicle for the breezy condescension, and condensation, that marked so many "human-interest" stories of the thirties and forties. The titles of *Fortune* and *Life* magazines' stories give the appearance of dealing with a specific individual: "Success Story, The Life and Circumstances of Mr. Gerald Corkem, Paint Sprayer at the Plymouth Motor Plant," "Family on Relief; The Life and Circumstances of Steve Hatalla, Who Lost His Job Four Years Ago," "The Private Life of Swyned Filling." Yet the combining of photographs and texts in these articles gives only the illusion of individuality. The individual is actually reduced to an indistinguishable Everyman. Only when the subject of the essay is indeed the elemental, when the people pictured seem to embody the Western notion of archetypal man, as in W. Eugene Smith's "Spanish Village," do the photo-essay's methods seem somewhat appropriate. Even "Spanish Village" would have been stronger had the text been deleted. No one today can remember—or needs to remember—the

W. EUGENE SMITH. Two-page spread from *Life*, April 9, 1951. From the photographic essay "Spanish Village"

pedestrian, reductive caption that went with the moving image of *The Thread Maker:* "A peasant woman moistens the fibers of locally grown flax as she joins them in a long strand which is spun tight by the spindle, then wrapped around it." Few could recite this caption. But few have forgotten the photograph.

In *Let Us Now Praise Famous Men,* perhaps the most intensely personal and truthful derivation of the photo-essay, Walker Evans and James Agee determined to allow each medium to communicate its full independent message. They separated the text from the photographs. Agee insisted that both writing and photography were "coequal, mutually independent, and fully collaborative." He understood that as long as photographs and text merely served as illustrations for one another, the power of each was substantially diminished. Yet this method of presentation was too demanding for a popular audience. The 1941 edition was virtually ignored by the general public: only 300 copies were sold. The book did not begin to gain popular acceptance until it was reprinted in 1960.

The photo-essay, rather than being as *Life* has stated, the "best and most complex product of photography . . . a distinct art form of great editorial complexity and sometimes profound emotional and aesthetic impact," was possibly photography's worst and easiest product. It sorely hindered the possibilities of individual expression since it obscured the photograph's power to provoke, challenge, or disturb. The photo-essay reinforced the popular notion of photography as simplistic, immediate, dramatic, and didactic, relegating photography's use to only the sensational or the pictorial. A great leveler of individual differences, it saw all people through sentimental eyes, as either degraded or noble.

Toward a Popular Aesthetic

The photo-essay, as it appeared in the books and magazines of the thirties, was enormously successful in crystallizing American facts and symbols. Photography was seen as a "universal language," without the slightest realization that its communicative power was dependent on American ideals and visual conventions.

This insistence on the general, the ideal, and the immediately identifiable is grounded in ways of looking at the world that are peculiarly American. Explicit in this heritage is a fear of the expression of private emotional experience. A concomitant belief is that the artistic resides exclusively in the beautiful. Both of these feelings are tied to that constantly haunting American suspicion that art is simply not a sufficiently serious or practical endeavor. This in turn generates that quintessentially American attitude: if art is to be created at all, it must be socially useful and politically relevant.

In America, popular photographers thus find themselves with only two avenues open for expression which are popularly acceptable: to seek out the traditional subjects of beauty, or to make "socially conscious" statements. The forces of American culture have subtly barred them from making radical use of the medium. In America, there is no tradition that would legitimize a search for "self-expression." With this element of personal individuality banished from their work, their photographs have usually resulted in clichés.

For the average photographer, photography is merely the pursuit of the good, the pleasurable, the exotic, and—since in pre-sixties America it was one of the few socially acceptable ways of dealing with sex—the erotic. I say "pursuit" because the daring involved in making these photographs resides in the adventure surrounding the act of photographing, not in the nature of the image itself. Popular photographers, like big game hunters, always aim at the same targets. Primary importance is attached to the machinery used and to the business of "getting there," not to the uniqueness of the subject or the special sensibility of the photographer. The war photographer Robert Capa expressed this popular conception of photography when

he said, "If your pictures aren't good, you're not close enough."

Yet as we have seen, these two very American ways of looking at the world provided the basis for the work of several major photographers. The most spectacular apotheosis of the beautiful occurred first in the photographs of the Photo-Secession and then twenty years later in the early work of Edward Weston. Weston's subject matter is essentially pictorial, identical to the subjects treated by the Sunday hobbyist: the nude, the landscape, the isolated beautiful object. His genius was to go beyond the levels of surface beauty and transform banal visual formulas into moments of authentic seeing. Similarly, Paul Strand and Walker Evans put their own intelligence and sensibility to the service of the "social" document. What saved their work from cliché was a reliance on personal insight, not social doctrines. What we finally feel in Strand's and Evans's work is their tremendous effectiveness at portraying local detail and wholly molding the world in their own terms. Unlike many of the FSA photographers, they did not shape the world in the propagandistic terms of a governmental agency.

One of the clearest statements of the popular aesthetic is given by Elizabeth McCausland in the 1940 edition of the *U.S. Camera Annual*. McCausland defines the popular photograph "in clean, neat terms, as it has been used during a hundred years on the American continent."

What are the criteria garnered from this century?

First: A good likeness, the daguerreotype. Truth to the subject, the sitter. Realism, honesty, the thing itself, not the photographer's subjective, introverted emotion *about* the thing.

Second: Fidelity to materials, textures, as hair, gravel, silk. A prime beauty of photography, the minute rendering of textures.

Third: A popular art. Dentists, tradesmen made daguerreotypes in their spare time. Millions of hobbyists today tote Brownies, Kodaks, Arguses.

Fourth: Constant technical growth. . . .

Fifth: Historical value. American Civil War. War—Spain, China; Europe. A baby crying in the streets. Sudden death from the skies. Missouri sharecroppers. Destitution on the rich American farmlands. Slums in the shadow of Wall Street. The future will be interested.

Sixth: Quality. . . .

Seventh: Truthfulness. Honesty, Fidelity. "The camera can not lie." But it can. Unless its user does not lie.

Eighth: Technical standards. . . .

Ninth: Subject matter. Objective reality. The world today, the world in the grip of powerful forces, the world played upon by death, war, and famine. The world confronting crisis.

Tenth: Multiple reproductions. The half-tone, the power press, the millions.

Eleventh: For the future. An Archive.

Twelfth: Propaganda: for peace; for better housing; for public health; for civil liberties.

Thirteenth: Science: for human betterment.

Fourteenth: The dimension of time: action, motion. The tempo of our century, the acceleration of history.

In the hands of the popular photographer, photography's virtues are precisely its failures: the photographic endeavor is reduced to a series of stirring and rhetorical moments. Realism is seen only as a repetition of those things already seen and known. The subjects are not things in themselves. Rather they are exaggerated and moralized political viewpoints. Fidelity to subject ostensibly means fidelity to those materials

which are both beautiful and which photograph beautifully. The purpose of photography, then, becomes thoroughly didactic and propagandistic.

Most important, and therefore appearing first on McCausland's list, is that the photographer has no obligation to deal with life from his own individual point of view, and is in fact enjoined from doing so. "Realism" is not "the photographer's subjective, introverted emotion *about* the thing," and the camera user must not lie. The riches of the visible world are available to the photographer only if they meet popular, objective approval. Under such terms art would never reveal individual feelings or become what Robert Frost called "a momentary stay against confusion." The proper audience for both the best and the worst of such photography is not the individual, or the family. It is the crowd.

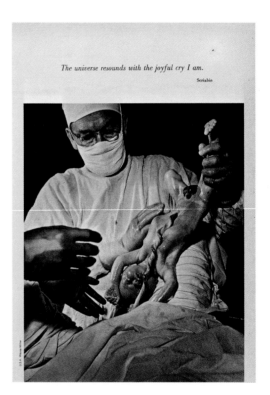

WAYNE MILLER. From *The Family of Man*, 1955

WAYNE MILLER. From *The Family of Man*, 1955

The Last and Greatest Exhibition of All Time

In *The Family of Man*, Steichen used other photographers' work to forge a composite statement that would appeal to the widest possible audience. *The Family of Man* was not organized to be attractive to the single viewer. Like the movies, it was to be experienced in the rush and press of the crowd. The photographs and the text were not intended for contemplation, but rather they were to be absorbed thematically, as parts of a larger orchestration. Although its theme was ostensibly the family, in actuality the exhibition did not describe the complex interconnectedness that makes up a human family. Smith's "Spanish Village" would have been a much more fitting example of an actual human community. There a specific group of people who shared place, culture, and traditions made up an actual family, and that real community could easily have been understood as a prototype for all human families.

Steichen's family is not made up of specific individuals but masses of people who through the sequencing and juxtaposition of photograph and text have lost their specific human identities and been reduced to undifferentiated members of a crowd. In *The Family of Man* individuals are related merely because they share the same

biological functions. They all partake of the same biological truths that T. S. Eliot listed so neatly: "Birth, and copulation, and death/That's all the facts when you come to brass tacks."

In Steichen's exhibition the viewer recognizes only the most elemental conditions of human existence. Steichen has made virtues out of universal necessities. The exhibition avoids the personal and private. There is no sense of the varieties of expression, the realities of personal failure, the breadth of intellectual endeavor, the possibilities of the contemplative or speculative mind. In *The Family of Man* there are no poets, painters, writers, philosophers, craftsmen, or social scientists. Ironically, there are no photographers. There are very few representatives of the highest civilized activities. Rather, to quote Carl Sandburg from the Prologue to the exhibition, *The Family of Man* is made up of lovers, drinkers, workers, loafers, fighters, players, gamblers, ironworkers, bridgemen, musicians, sandhogs, miners, builders, jungle hunters, landlords, the landless, saints, sinners, winners, and losers. This is not a

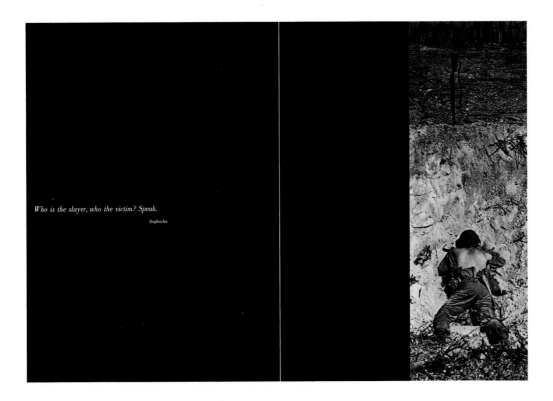

Who is the slayer, who the victim? Speak.
Sophocles

catalog of the most notable human accomplishments. But it is sufficiently vague and archetypal for every viewer to recognize some aspect of himself in the photographs.

The major themes of the exhibition were listed by Dorothy Norman, who chose the captions under Steichen's direction: "creation, birth, love, work, death, justice, the search for knowledge, relationships, democracy, peace, and opposition to brutality and slaughter." In reality, the effect of the exhibition is to reduce these themes to an even more basic primitive sequence. Lovers move from romance to marriage to bed to birth to infants at the breast. Childhood needs maternal affection. Children mimic fathers and have brief moments of loneliness and anxiety. The family is seen only as a unit in which people eat and dance together. Work is the primary ethic and duty of mankind. Education takes place in the field, on the job, and only at the most rudimentary level (although a few study at Princeton's Institute for Advanced Study). Grief follows death. Religion and human compassion bring comfort. Political strife is overcome by justice, the United Nations, and the ballot box. And the future is bright as little children delight in the joy of life and light.

Taken individually, many of the photographs are more complex and ambiguous,

RAPHEL RAY PLATNICK. From *The Family of Man*, 1955. Photographed at Eniwetok for the United States Coast Guard

but any richness or depth is eradicated by the presentation as a whole. Throughout the exhibition the images are secondary to the themes, which are announced with unmistakable rhetoric. The exhibition begins with a text from Genesis: "And God said, Let there be light." It then goes on to quote from Exodus, Deuteronomy, Proverbs, and Second Kings. It invokes the wisdom of the classics, Euripides, Plato, Homer, Virgil, Sophocles, and Ovid; the wisdom of the East, the *Bhagavad-Gita*, Lao-tse, and Lui Chi; the great Americans Thomas Paine and Thomas Jefferson; a few moderns, Anne Frank, Einstein, James Joyce, and Bertrand Russell; the Charter of the United Nations; verses from four Indian tribes, the Pueblo, Kwakiutl, Sioux, and Navajo; and, of course, Shakespeare. It ends with a text from St. John Perse: "A world to be born under your footsteps." These quotations, like the captions of the photo-essays of the thirties, are reductive, pretentious, and sentimental. Popularizations of profound thought, they do not represent the men who spoke or wrote them. Both the photographs and the text have been predigested to spare the viewer any effort at thought or feeling. The exhibition provides a shortcut to the pleasures of art.

In *The Family of Man*, Steichen attempted to define the world's family in much the same way that the documentarians of the thirties had attempted to define America. On close reading, the exhibition turns out in fact to be a programmatic, socialistic statement. The hero of the exhibition is not the family but the common man, the common worker. It is not family unity but the health, sanity, brute strength, and inherent good sense of the worker that hold the promise of peace, freedom, and prosperity. Steichen's concept of photography and of the photographic exhibition is deeply, if unconsciously, tied to the social realism of the thirties. Indeed, the exhibition can be read as the final, grand reappearance of the WPA mural projects. By ignoring the subjective idiosyncracies of individuals, by attempting to make the exhibition attractive to as large an audience as possible, by presenting the visual image in its simplest possible terms, Steichen recreated the social realism of the thirties, which shunned the bourgeois in favor of the noble proletariat. The workers of the world en masse have epic significance. The exhibition played to and for the very people it idolized.

Steichen saw his role at the Museum of Modern Art not as archivist, historian, or curator but as public events coordinator. When he was first appointed Director of Photography he proposed the erection of a structure eighty feet square in the garden—a permanent Photorama. He felt that the more lavish the installation, the larger the public. Steichen had experimented with elaborate installations before, particularly in MOMA's wartime photography show *Road to Victory*. But the installation of *The Family of Man* was the most spectacular ever conceived, more spectacular than the photographs themselves. For the masses that saw the exhibition—almost 3,000 a day in New York and over nine million in the forty countries around the world—the photographs were almost less important than the joy of winding their way through the carnival-like atmosphere of the display. The critic Rollie McKenna described the experience of viewing the exhibition as a trip through a fun house. One began with the birth sequence, which was

> displayed on a raised dais surrounded by virginal white gauze. Pictures of children throughout the world playing ring-around-a-rosy are contorted into trapezoids and mounted on a circular metal construction. In another instance a man is chopping wood high in a tree top. This undistinguished photograph has been mounted horizontally over the spectator's head. To see it properly he has to get in the same position as the photographer who took the picture, on his back! Further on, four unfortunate Australians have been severed from their land and made into free standing black silhouettes. Photographs grow from pink and lavender poles, dangle from the ceiling, lie on the floor, protrude from the wall. Some happily, just hang. In case the point has not yet been made,

toward the end of the exhibit there is a group of nine portraits arranged around—yes, a mirror.

It is somewhat surprising that MOMA went along with these shenanigans. But then it must be remembered that 1955 was the height of Abstract Expressionism and the height of the public's hostility to abstraction in particular and modern art in general. In 1955 there was also the lingering suspicion that the avant-garde was disloyal, un-American, and a Communist conspiracy intended to show the world that Americans were "despondent, broken down or of hideous shape." Modern art, according to Congressman Busby, was "a revolution against the conventional and natural things of life." The museum, unsure of its acceptability, was not beyond making a grandstand play for a mass audience. *The Family of Man* would demonstrate that an institution usually responsive to the urbane, the privileged, and the cultural elite could reach out to the millions.

More than this, in spite of its early acknowledgment of photography, the Museum of Modern Art and its various curators of photography until this time—Beaumont and Nancy Newhall, Willard Morgan, and Steichen—had never really resolved the major questions of photography's place within the museum. What kind of photography should be shown and collected? What should be the nature of the galleries and the presentations? The Newhalls favored the art photographers and a conservative presentation derived from Stieglitz's galleries. Morgan favored the popular photographer. In 1944 he presented *The American Snapshot*, a show that did not include a single vernacular snapshot but was made up of the idealized, family-centered photographs upon which Kodak and the other photographic manufacturers built their ads. Steichen was drawn, in his own words, to "the most promising and most vital area of photography, the field of documentary photojournalism." And he consistently chose to use the exhibition gallery as a forceful medium in itself. Out of this variety of viewpoints a path of least resistance emerged. Almost all the major photography shows from 1937 to 1955 were devoted to photography as a utilitarian recording device. These major shows were political or descriptive in intent: *War Comes to the People, A Story Written with the Lens* (1940); *Image of Freedom* (1941); *Road to Victory* (1942); *Airways to Peace* and *Tunisian Triumphs: War Photographs* (1943); *Manzaanar: Photographs by Ansel Adams of Loyal Japanese-American Relocation Center* (1944); *Power in the Pacific* (1945); *Music and Musicians* (1947); *Photographs of Picasso by Mili and Capa* (1950); *Korea: The Impact of War in Photographs* and *Memorable* Life *Photographs* (1951); and *The Family of Man* (1955).

The museum regarded photography as a sociopolitical instrument. While it did hold a series of art exhibitions that related to the war effort, these did not demean the original work by translating artistic intention into political message. But a single photograph could easily be placed in that awkward position of being both a creative endeavor and propaganda for democracy. Burdened by such institutional confusion, the viewer came to regard photography as a form of communication in which no discontinuity existed between art and life. The museum's photography shows certified mass cultural values as fine art. Unlike the other art that hung on the museum's walls, photography was not a representation of reality but reality itself. Photography, in Steichen's words in the Introduction to *The Family of Man*, was "a mirror of the universal elements and emotions in the everydayness of life."

As Director at the museum, Steichen attempted to show a range of photographers and a variety of styles. He was the first to show Lisette Model, Harry Callahan, Ralph Steiner, Frederick Sommer, Aaron Siskind. Yet his sympathy was clearly with the popular document, the exterior event, and the pictorial bias. In spite of the personal and experimental nature of some of his own work, Steichen consistently hedged his bets on the photographers who saw their art as personal, idiosyncratic expression. As Director he seemed to have little understanding for the concerns of

the avant-garde. He thought manipulation inexcusable: "None of the photographers uses mechanical tricks of angles, focus or developing," he wrote in praise of Bravo, Evans, Sander, and Strand. He doubted the validity of abstraction: "When young photographers come to the Museum to show me their abstract photographs," he wrote in 1963, "I told them they must realize that they might be working along a blind alley." He saw Callahan's formally complex, radically descriptive work as mere patterning: "The precision of his pattern and design are an innate, integral part of his photography." And in the work of the most visceral, speculative, and metaphoric photographer of the day, Sommer, Steichen saw "a calm, dispassionate approach that might be expected only from a man on another planet." Steichen's range of emotional response seemed limited to universal platitudes.

It is not surprising then that the photographers in *The Family of Man* were mainly photojournalists of the old school, photographers who had worked out their styles and subject matter on assignment for the magazines and picture agencies. Their

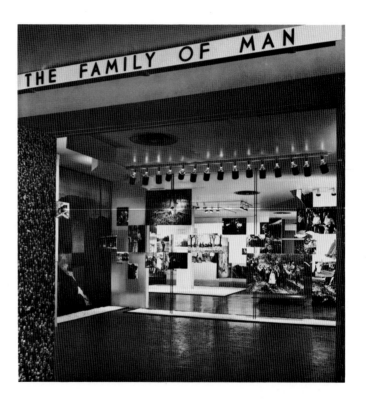

EZRA STOLLER. *The Family of Man Exhibition,* Museum of Modern Art, 1955. Exhibition design by Paul Rudolph

concern was the literal and the anecdotal. Their photographs attempted to convey a mood or show an exotic costume or custom. Their work was narrative: show the common man to the common man. Three of the four most important American photographers of the first half of the century—Stieglitz, Strand, and Evans—were absent from the exhibition. Edward Weston was represented by only one atypical photograph, two friends resting on the rocks at Point Lobos. Adams was represented by his most famous image, a Cecil B. DeMille shot of Mount Williamson blown up the size of a whole wall.

No single photographer dominated *The Family of Man*, though Steichen's assistant, Wayne Miller, had more photographs in it than anyone else. Alfred Eisenstaedt's happy, dynamic storytelling photographs demonstrated popular photography at its best. His photograph of the high-stepping drum major leading a line of gleeful kids rivaled Eugene Harris's *Piper* as the theme image for the exhibition. On the other extreme, Bourke-White's photographs illustrated starvation, death, and poverty in their most brutal, easily accessible forms. To counteract this hyperemotionalism, two Frenchmen, Henri Cartier-Bresson and Robert Doisneau, in photographs more

tightly packed than most, reveal as human, witty, ironic, or beautiful those same subjects the other photographers more often saw as quaint, colorful, and exotic. And perhaps the most mawkish photograph W. Eugene Smith ever made, *The Walk to Paradise Garden* (1946), provided the grand finale for the exhibition.

There are some photographs in *The Family of Man* that were more radical in their approach: some bolder in subject matter, others more daring in composition and use of the medium. Photographs by Ernst Haas, Eddy Van der Elsken, Lisette Model, Wynn Bullock, William Garnett, Garry Winogrand, Robert Frank, and Harry Callahan come to mind. Yet these photographs had little impact, for they were lost within a context controlled by juxtaposition and superficial resemblances. Their meaning was overshadowed by the grandness of the theme. Or, as in the case of Callahan's photograph of his wife, Eleanor, swollen pregnant and ripe as an ancient fertility symbol, the image proved too uncomfortable and was removed before circulation and publication.

Nevertheless, a generation of Americans and people from around the world believed the message of *The Family of Man*. They wanted to see hope and unity, they wanted to have an art that would speak immediately without recourse to the values of high culture, they were hungry for a diversion from the real fears of an uncertain and increasingly anxious age, they wanted to participate in some sort of affirmative activity. Steichen in photography—just as his brother-in-law, Carl Sandburg (who had given him the title for the exhibition), in poetry, Norman Rockwell and Maxfield Parrish in painting, Clifton Fadiman in literary commentary, *The Saturday Evening Post* in literature, and Norman Vincent Peale in religion—provided the mass audience just what it wanted.

WAYNE MILLER. Steichen looking at scale model for the Museum of Modern Art's *The Family of Man* exhibition, c. 1954

The Search for a New Vision

The Photograph as Interior Drama

AARON SISKIND. *Gloucester, Massachusetts,* 1944

"Last year I spent the summer at the famous New England fishing village of Gloucester, and made a series of photographic still-lifes of rotting strands of rope, a discarded glove, two fishheads, and other commonplace objects which I found kicking around on the wharves and beaches. For the first time in my life, subject matter, as such, has ceased to be of primary importance. Instead, I found myself involved in the relationships of these objects, so much so that these pictures turned out to be deeply moving and personal experiences. . . . these photographs are psychological in character. They may or may not be a good thing. But it does seem to me that this kind of picture satisfies a need. I may be wrong, but the essentially illustrative nature of most documentary photography, and the worship of the object *per se* in our best nature photography is not enough to satisfy the man of today, compounded as he is of Christ, Freud, and Marx. The interior drama is the meaning of the exterior event. And each man is an essence and a symbol." With this statement, written in 1945, Aaron Siskind calmly announced an alternative to the popular photograph and the documentary style. Rather than readability, accessibility, or social utility, Siskind's new work would emphasize symbol, ambiguity, private experience, abstraction, and art. His was a viewpoint antipodal and incomprehensible to popular culture, yet it would gradually come to define one of the mainstreams of contemporary photographic expression.

Siskind's statement touched almost every issue and intention that would become central to his own work and to the work of the two other major photographers who consciously broke with the dominant documentary aesthetic, Harry Callahan and Minor White. A year after Siskind's statement, Callahan would write about his work in much the same tenor: "Photography is an adventure just as life is an adventure. If man wishes to express himself photographically, he must understand, surely to a certain extent, his relationship to life. I am interested in relating the problems that affect me to some set of values that I am trying to discover and establish as being my life. I want to discover and establish them through photography." And in 1952 Minor White would state: "The photographer is probably more akin to the sculptor in wood or stone than to painters, as far as his mental creative state goes. The whole visual world, the whole world of events are wraps and coverings. . . . One feels, one sees on the ground glass into a world beyond surfaces. The square of glass becomes like the words of a prayer or a poem, like fingers or rockets into two infinities—one into the subconscious and the other into the visual-tactile universe. . . . When [an

CLARENCE JOHN LAUGHLIN. *The Insect-Headed Tombstone*, 1953. "A memorial wreath made of aluminum foil, lace, ribbons, and carnations. It has an extraordinary fantastic quality (probably because the subconscious mind is active in much of this rural folk art)—and suggests the head of a huge multi-eyed insect."

AARON SISKIND. *Martha's Vineyard, Massachusetts*, 1950

image] was seen on the ground glass, anything separating man and place had been dissolved."

The verbal styles of these statements are substantially different, reflecting major differences in voice and temperament. Siskind's is lucid, almost eloquent; Callahan's is somewhat awkward, redundant, yet absolutely clear; White's is complex, romantic, verging on the mystical. The men behind the words are singular and distinct. They came to photography from different educational, economic, and social backgrounds and inherited different photographic traditions. Yet the uses to which they would put photography, now seen from the distance of over thirty years, were remarkably similar.

Each photographer was determined to push his work beyond public documentation. In spite of over ten years' experience as a Photo League documentarian, Siskind was dissatisfied with recording the exterior event: "For some reason or other there was in me a desire to see the world clean and fresh and alive, as primitive things are clean and fresh and alive. The so-called documentary picture left me wanting something." Callahan was later to repudiate the "literal value which has never been satisfying to me." And White was to call the document a "heartless witness, sadistic

critic, legal being . . . the social document shows to society less than it is and to people only a fraction of what they are."

More than this, each photographer was convinced of the possibility of ordering and understanding his personal life through photography. Though only White would go so far as to call photography "a way of growth," this concept was implicit in each man's work. For Siskind, photography had "shifted from what the world looks like to what we feel about the world and what we want the world to mean." He once said, "To me, to make a picture is a necessity. The reason I'm making pictures is out of a necessity to order the world, which is really ordering myself." Callahan saw photography "as a means of expressing my feelings and visual relationships to life within and about me. . . ." And White as early as 1940 set as his goal "self-discovery through the camera."

Each man was dedicated to the notion of photography as a consciously expressive art, as an act of more than ordinary significance. Most important, each saw photography as an act of transformation. "Walker Evans was essentially interested in

recording a fact," Siskind has said. "I am completely interested in transformation or transfiguration. He was very anti art and I am very pro art. I want you to know it is a work of art." In 1940 White could write: "Straight photography, tight as sonnet-form, is all the scope I need. . . . Photography is the transforming act of the photographer—as a caterpillar eats green leaves and is changed into a butterfly—his body is turned into a body of photographs—the 'corpus.' " And Callahan wrote: "I'm interested in revealing the subject in a new way to intensify it."

Words do not produce photographs. Yet this collage of quotations is a testament to the concerted attention and consciousness with which each of these men chose to work. These statements are also a measure of the relative isolation in which each man found himself. The popular photographer working in accepted modes seldom needed so precisely to articulate for himself or his audience the nature of his work. Few photographers of the day understood the goals these three men were pursuing. Nor was a photographic literature available which would legitimize their work. The work of the seven men discussed in the first chapter was known only to a select few. O'Sullivan was considered—if he were considered at all—merely a recorder of the Civil War. Stieglitz's "Equivalents" were understood only by the cognoscente. Wes-

MINOR WHITE. *Tar & Sandstone,* August 1960

HARRY CALLAHAN. *Chicago,* 1949

ton was virtually unknown. Strand was perhaps better known for his films than his photography. Evans was considered the least relevant of the FSA photographers. Only Adams by his prints of the majestic West and Steichen by his administrative visibility had acquired anything that approached a popular reputation. Siskind, White, and Callahan would eventually meet and take up the momentum from one or another of these major figures, but this was only after their styles and intentions had emerged almost full blown from their own impulses and intuitions.

Though the specificity of each man's work is indisputable, all three used remarkably parallel means to achieve individual expression. In seeking to find a means for private expression, each turned to several basic notions of photography. The first notion was that straightforward, traditional photographic technique exerted unequaled and compelling power. Though each man was to vary from the perfectly "straight" approach from time to time, each one's images are deep-rooted in an abiding belief in the evocative force of literal description. Whether or not the final product was immediately recognizable was less important than the fact that it had originated in and was a reference to the objective world. The subjective power of

FREDERICK SOMMER. *Untitled* (Amputated Foot), 1939

AARON SISKIND. *Chicago,* 1952

their work undeniably stems from the tension set up between literal reference and personal vision. Unlike the popular photographer, who often softened and distorted the reality before the camera, these three photographers apprehended the world directly.

Their second point of agreement was implicit in their straight use of the medium: all three were determined to construct their images out of ordinary and commonplace material. White was certainly the most traditional in his choice of subject matter, yet he expressed for all three an attachment to everyday experience when he wrote that a photographer walking an ordinary "block in a state of sensitized sympathy to everything to be seen . . . would be exhausted before the block was up and out of film long before that." Seen in this way, the world, rather than being a limited storehouse of facts and narratives, became an infinite storehouse of forms and metaphors.

It was the detail and the fragment that provided each photographer with an inexhaustible stimulus and medium for personal expression. The essence of the work of all three may be said to lie in a redefinition of and a pulling away from the long, classic viewpoint. There are significant exceptions to this, but it was mainly through a concentration on the detail that each photographer achieved a vocabulary of sym-

bols for private feelings. The world of Siskind, Callahan, and White is often the world of synecdoche, in which a simple visual fact stands for a complex internal experience.

The final notion shared by these photographers was that the photographic process, when used with imagination and craftsmanship, could generate significant, if at times unanticipated, forms and meanings. Infrared materials, multiple exposure, extreme under- and over-exposure and under- and over-development provided radical yet inherently photographic means for new expression. "Taking [these pictures of weeds in the snow] was a standard photographic problem," Callahan wrote. "I doubled the normal exposure on the snow and over developed the negative. . . . This was an experiment, not new probably, but new to me which was the exciting part of it." These experiments did not contradict straight photography. Rather, they derived from an implicit belief in the generative nature of photographic material itself. Instead of forcing the medium to duplicate the mannerisms of other arts, each of these photographers took advantage of photography's unique way of recording the world. Using a sharp lens, frequently a large camera, fine grain film, and careful develop-

ment and printing, each photographer utilized the inherent richness of the medium. And their final prints received a luxurious finish that gave them great physical and psychological presence.

HARRY CALLAHAN. *Chicago*, c. 1949

MINOR WHITE. *Moon & Wall Encrustations, Pultneyville, New York*, 1964

The central issues to which Siskind, Callahan, and White return again and again may be summed up in those two terms that Stieglitz had used both explicitly and implicitly many years earlier to define the possibilities of photography: abstraction and equivalence. These terms—quite revolutionary in Stieglitz's time and equally baffling in the heyday of the photo-essay—meant, first, that formal coherence and abstract relationships could generate intense emotional response and, second, that the photograph of a literal, unmanipulated public event could be used to allude to a profound life experience.

Minor White

The most obvious examples of these *visual* issues are seen in Minor White's *photography*. I emphasize *visual* and *photography*, for in White's case it is particularly difficult to separate the actual work from the man and from the philosophies, psychologies, and mysteries he brought to photography. In the next chapter I will look

at his role and the role of *Aperture* in supporting creative photography in the fifties. Here I wish to speak as clearly as possible only of White's photographs. This is a bit awkward since White saw himself not as a traditional photographer but—like Stieglitz, whom he admired and emulated—as a medium and catalyst for all intensely personal, emotional, spiritual, and mystical expression. The majority of White's photography was done in service to matters of the spirit or the psyche. To this it owes both its weakness and its strength.

White's photographs may be divided into two major categories, both having their basis in the concept of equivalence. While the line between these categories is often thin, we may term them simply the detail and the long view. In the first category I would place those closeup records and transformations of fragments and details which provided him instant access to metaphors and signs. Here White strove for a mimetic symbolism in which one clearly discernible natural fact is made to allude to another visible reality. In the second category I would place the view and landscape photographs made out of the traditional pictorial vocabulary inherited from Stieglitz, Weston, Adams, and the popular photographer. In these photographs White at-

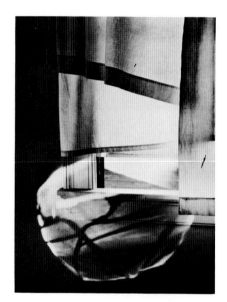

MINOR WHITE. *Front Street, Portland, Oregon,* 1939

MINOR WHITE. *Windowsill Daydreaming,* July 1958

tempted to convey not only grandeur and perfection but to find moments of personal revelation and psychic correspondence. White is much better known today for his equivalent details, which have had an incalculably great influence, but the generally earlier photographs of vistas, cityscapes, and landscapes constitute his more powerful and lasting work.

White began his photographic career in the late thirties taking cityscapes— "documents by nostalgia" he called them—of iron-front buildings and historic mansions in Portland, Oregon, for the Works Progress Administration. By the mid-forties, however, at just about the time Siskind turned to the details of Gloucester, White too became increasingly preoccupied with abstraction. While he never totally relinquished the long view, the move toward the detail gave White much greater formal and emotional control over the picture plane, allowing him to experiment aggressively with the psychological uses of the natural detail.

The major turning point in White's work may be traced to 1946, the year in which he met for the first time both Stieglitz and Weston and formed a close relationship with Adams. All three of these photographers encouraged in their own way White's growing concern with the presentation of natural analogies. From Adams he learned the possibilities of intensifying the meaning of the photograph by extreme

control of the development process. From Weston he learned to look directly at small, isolated natural objects and to follow his own visceral intuition. And Stieglitz reinforced and confirmed his most basic belief that photography could serve his psychological, physical, and spiritual needs.

The first extended series of detailed photographs was made of rock forms at Point Lobos in July 1949. These photographs, explicitly sexual in form and implication, were the first of many analogical images that White continued to make right up until his death. In these images White is not a symbolmaker but an anthologist, carefully cataloging the myriad repetitions of single universal facts. Frost on a window pane becomes a giant ocean wave or a mouth howling in pain and rage. A dilapidated, snow-covered boat becomes a fish. Eroded rock formations become sculptures of a Madonna and Child or unmistakable, physiologically accurate representations of human genitals. In these photographs, we are not looking at ambiguous Rorschach tests. On the contrary, White's images in this vein are so carefully contrived that no viewer could escape from seeing exact correspondences between the forms in the photographs and other natural and human forms. Weston succeeded in

MINOR WHITE. *Ice in Light & Shadow,* 1960

MINOR WHITE. *Birdlime & Surf,* 1951

hinting at the similarities between the volumes and contours of nudes, sand dunes, shells, and peppers. Yet Weston indicated only general resemblances; White revealed exact correspondences. His intention was to discover the main, animistic features of the universe and man as they were revealed in simple natural facts and human gestures. White took literally Siskind's hyperbolic statement that "every object, to me is a very alive thing. In Gloucester, one summer, the rocks began to seem so animate I could hardly bear to walk over them."

This basic level of animism and analogy runs throughout White's work. Even when the object photographed is unrecognizable, the analogical reference is perfectly clear. Such references are embedded in even the most complex formal patterning: a burnt piece of wood becomes a landscape with a pale moon, gnarled tree trunks become grotesque human arms. All visual form alludes to all other cosmic and natural forces and forms: White's work is filled with hints of fire, stars, galaxies, sexual congress, flowing water. In perhaps the most beautiful photograph of the 1951 series at Point Lobos, bird droppings on surf-pounded rocks become metamorphosed into the sea tide and sea flow itself.

Infrequently, White would allow a more ambiguous, less analogical symbolism to occur. This happens in an early series, *Intimations of Disaster,* in the photographs

of doors that open the 1969 monograph, and in those images made partially as "reading" exercises. These images point inward to hidden and less benign regions of the psyche and are packed with hints of confusion, alienation, and fear.

Fragments and details are almost of necessity private, original, emblematic, and unique. White's real genius, however, lay in discovering and presenting this same personal intensity through the long view. White had an uncanny ability for transforming the public world that had been photographed by Adams and millions of summer tourists into a world of internal, introverted landscapes. In these photographs he is able to see not only magnificence but also sensuousness, darkness, and intimations of estrangement, death, and disaster. In these literal photographs, White seems to approach the divine mysteries more directly and more persuasively than through the fragment and the detail. Many of his long views are among the most haunting landscapes and cityscapes in photography. His earliest photographs are among the most compelling: the iron-front Portland buildings of 1939; the grain station with a passing train of 1941; the image of fog over San Francisco of 1951; and the Grand Ronde Valley ranch of 1941. Later, in the mid-fifties, in a group of photographs depicting the landscape and architecture of upper New York State, White again turned to the long view and, using both panchromatic and infrared film, produced the mysterious photographs *Two Barns and Shadow* (1955) and *Cobblestone House, Avon* (1958).

White was also able to translate the photo-essay form into a personal series of related images that mirrored private rather than public feeling. It is in these "sequences," as he called them, that White generated a form of which he still remains the unchallenged master. Together with Agee and Evans's *Let Us Now Praise Famous Men,* White's sequence stands as one of the few vital derivations of the popular photo-essay. Only in Harry Callahan's El Mochuelo Gallery monograph of 1964 do we find a sequencing of photographs that rivals White's in aesthetic and psychological coherence and intensity.

White's sequences are a hybrid of the popular photo-essay and Stieglitz's "series" photographs (the "Equivalents" and the O'Keeffe portraits). White first used the photo-essay to document quite literally a YMCA ski trip in 1942. During the war he began a series of portraits of soldiers which later, tied together with poetry and metaphorical photographs, became *Amputations.* His first unique series of photographs, *Song Without Words,* was completed in 1947, the year after Stieglitz's death. This sequence, White's most lyrical, is in patterning, content, and print size a direct descendant, tribute, and homage to Stieglitz's "Equivalents." Even the name derives from Stieglitz's title for his 1924 exhibition. Of that exhibition Stieglitz wrote: " 'Songs of the Sky—Secrets of the Skies as revealed by my Camera,' are tiny photographs, direct revelations of a man's world in the sky—documents of eternal relationship—perhaps even a philosophy. 'My' camera means any camera—any camera into which his eye may look." This preface serves White's *Song Without Words* equally well. The transposition from sky to sea may also have been influenced by Adams's *Surf Sequence* (1940), which also greatly affected Callahan. But Adams was primarily interested in the evolution of serial form; White, like Stieglitz, was concerned with evocation.

Of the myriad groups, panels, slide sets, and portfolios that White produced, three other series stand out as superb realizations of the sequence form. The exquisite *Sequence Eight* (1950–64) moves back and forth between medium view and detail, building up a disturbing, sexually suggestive relationship between flesh and rocks, darkness and light, and natural and human forms. *The Sound of One Hand Clapping* (1957–59) is organized more formally around circular shapes. Constructed almost entirely by photographing ice crystals and frost, it is White's most successful exploration of cosmic order and ambiguity. And *Slow Dance* (1960–66)—a double-screen color slide presentation—follows the rhythmic progression of rock forms down a can-

yon wall, through a stream bed, out into a swirling torrent of ocean spray. *Slow Dance* is an incredibly beautiful ordering of simple forms. It was a sequence White showed to audiences many times during the last years of his life. It affirmed his commitment to dance and flow with the discoveries of time.

The best of White's photographs and sequences do give intimations of other realms of consciousness and being. They accomplish this by lyrically organizing the most elemental natural, human, and symbolic forms, forms which in all Western art have related to the occult, sexuality, and the psyche: the circle, the sphere, wounds, rings, windows, doors, pools of water, triangular and oval geometric shapes, mouths, eyes. White's primary visual world contains the most primitive natural elements: light, fog, sea, clouds, mountains, trees, frost, and human gesture. It is a vocabulary and grammar as old as man. To these visual elements, White frequently added—not unlike the captions in the photo-essay—rhetorical phrases, sexual entreaties, poems, and prayers that narrowed, compounded, contradicted, and expanded the range of interpretation:

Come to eat of me
do you expect to escape my hunger

No matter how slow the film, Spirit always stands still long enough for the photographer It has chosen.

All the way to Heaven
Is Heaven
For He said
I AM the Way.

Love is only also
The upright Ax in furrowed field
The tender parting of flesh
The desparate separations
That make a woman turn
For tenderness
To the broad Ax blade of a Child

ALFRED STIEGLITZ. *Equivalent, Music Number 1, Lake George,* 1922

MINOR WHITE. *Black Cliff & Waves, Matchstick Cove, San Francisco,* 1947

If battle gives me time
It is my will
To cut away all dear insanities
I get in War
Or if I live
To amputate the pain
I've seen endured

In the last days of his life, White posed for a series of bizarre photographs. He called the series *Lives I've Never Lived* (published 1983), dressing up before the camera in drag, in outlandish "punk" costumes, making masturbatory gestures. These photographs, taken by the young photographer Abe Frajndlich, were White's final salutation to those "two infinities"—the subconscious and the divine—to which he had devoted his life. By participating in them, he consciously followed the practice of dying Zen masters who on their deathbeds make ambivalent, quixotic gestures. On one hand, White was determined to purge himself and his audience of the image

ABE FRAJNDLICH. Contact sheet, 1975, with notations by Minor White. Published in *Lives I've Never Lived*, 1983

of spirituality that surrounded him, to blatantly show his earthly, sensuous, humorous nature. On the other hand, he wanted to make clear that the body which could be photographed was only an ephemeral, transitory, costumed mannequin. At the end of his life, weak, dying, unable to photograph, White finally became the subject of all his photographs. Analogy was no longer necessary. He became the image.

White died as he had photographed best: as a metaphysician, poet, and showman, a graceful juggler of facts, metaphors, and sensuous perception.

Aaron Siskind

The symbolic visual world of Aaron Siskind is much more ambiguous and complex than White's. Rather than dealing with the spectrum of natural analogies, Siskind's abstractions tend to be equivocal, denser, and less romantic. Where White points in one direction, Siskind points in three. His work has variable and alternative meanings. Of the three photographers discussed here, Siskind's work has been the least popular. For it is the least literal, the least accessible, the least overtly sensual or spiritual. Of the three, he is the one most involved in exploring the formal possibil-

ities of literal description. His most powerful images tread very gingerly between literal representation and total obscurity. Siskind's work, more than White's, fulfills White's own dictum for abstract photography: "The spring-tight line between reality and photography has been stretched relentlessly, but it has not been broken. These abstractions . . . have not left the world of appearances; for to do so is to break the camera's strongest point—its authenticity."

On one level, Siskind's images may be approached as experiments in form and gesture that are strongly related to the concerns of the Abstract Expressionists, in whose circle he moved in the forties and fifties. Indeed, in black-and-white reproduction it is at times very difficult to distinguish a Franz Kline or Robert Motherwell painting from a Siskind photograph. Siskind's photographs are photography's foremost example of what the art critic Thomas Hess has called "the ethics and aesthetics of the picture plane."

Like White's abstractions, Siskind's photographs refuse to withdraw totally from the representational world. Like the Abstract Expressionists, he hints at the

figurative and dimensional behind the graphic and thus imparts tension and humanity to the work. Siskind at his best is a virtuoso performer. His is an act that dares approach as close as possible to the edge of obscurity without ever falling into the abyss. His photographs simultaneously reach out and pull back. They are gestures of partial disclosure, fascinated with the opacity and the transparency of literal dissolution and deterioration. They are derived from the medium's ability to transform, dissolve, and decay the objects placed before the camera's eye. Siskind's work shows at times a drastic simplification of form and content, a reduction of the full tonal range to just black and white, and a dismissal of the full literal event for only the faintest hint of actuality.

There is a great deal of evidence embedded in White's words and photographs on how they should be "read." There is little of this in Siskind's work—but there is enough. These hints are contained in the readable fragments that do appear in the photographs: the torn and disintegrating letters, the dissolving, lichen-covered remains of Roman statuary, the religious icons almost totally buried in the darkness of the prints. Siskind's flat world is a world of broken circles, arrows, hidden messages, conversations between marks, and dancing, two-dimensional forms. These are "forms,

AARON SISKIND. *Rome, Appia Antica 3,* 1963

AARON SISKIND. *Dancers at the Savoy Ballroom,* 1937

63

totems, masks, figures, shapes"—the words are Siskind's—from an unreadable, emerging language. They are attempts at communication either thwarted by lack of a shared vocabulary or intensified by our participation in that primitive vocabulary of human gesture, rhythm, and line. If White's work is at times a study of natural symbolism, then Siskind's is a study in the nature of symbolic communication itself.

Having begun photography with an overwhelming concern for the document, Siskind was no stranger to the photo-essay. Like White, he knew the inadequacies of captioned images and sociological texts. White's solution was to turn prose into poetry and the document into poetic vision, occasionally including an actual sign or graffiti scrawl as part of the image. Siskind took a more radical step. He began making photographs that were about the act of language itself. His images are essentially calligraphic. He moves beyond the world of documentary expression in which pictures and words are interchangeable, and beyond White's analogical world in which pictures and words are only "mirrors, messages, manifestations," into that most primitive world where pictures and words are inextricably one. Siskind's most powerful images are as potent and as primitive as any found on the Lascaux cave walls. They are ideograms produced during the ancient yet continually renewed magic ritual of art: art as exorcism, art as self-discovery, and art as formal discovery. As such, Siskind's work not only internalized photography but liberated it completely from the traditional methods, styles, and contents of pictorial structure.

Siskind's work expanded Stieglitz's and White's notion of equivalence beyond analogy to encompass causes, tokens, events, and coincidences. They are photographs, in Siskind's own words, "of a terrific amount of feeling."

Harry Callahan

While it is clearly out of fashion to speak of photography in mythic terms, there is really no other critical perspective that allows us to discuss Callahan's images. To discuss them only on formal grounds, as so many critics have done, is to lose their very substance. For Callahan manages to do explicitly what White does only implicitly and what Siskind does only with covert, yet eloquent disguise. Without obscurity or analogy, Callahan shows us a series of human epiphanies: actual moments in which the underlying forces of his world, and ours, are revealed.

Though the formal structure of Callahan's work is sophisticated and frequently complex, ultimately it is not the form but his insistent concentration on the actual events that comprise his life—his wife and child, family, travels, city houses and city streets, the easily available natural worlds of park and beach—that makes his photographs so powerful. Even before he joined the faculty of Chicago's Institute of Design (founded in 1939 as the New Bauhaus), Callahan seems to have intuitively reconciled the structural tendencies of European aesthetics with his own desire for a literal description of everyday life. Callahan's work, more than that of any other major photographer of his time, is anchored in the American home snapshot. It is precisely because of this commitment to the vernacular tradition that we are never surprised or put off by even his most experimental use of photographic materials or his most obtuse shooting viewpoint. For in Callahan's work experimentation is never used for its own sake, but each new technical possibility leads toward a more finely controlled means of description. From his high-contrast abstractions of weeds against the snow, through the fully tonal images, to the complex multiple exposures that unite different times, places, and subjects, Callahan matched the means with the meaning, uncovering with each new technique deeper layers of significance. His photographs so refine and purify the snapshot tradition that his specific experience takes on universal meaning.

Yet Callahan's photographs, when viewed collectively—as is possible in the marvelous El Mochuelo monograph and in the recent Aperture monograph—become

even more than a paradigm of the human condition. They imply the mythic world behind that condition. Callahan's world is repetitive, obsessive, cyclic, ultimately turning back on itself. It is partially because of this repetitive character that, unlike those of any other major photographer, Callahan's prints are at times impossible to date by appearance alone. In both form and feeling, the beach at Cape Cod in 1972 is the beach at Lake Michigan twenty years earlier. The walls of Cuzco, Peru, in 1974 are the walls of Chicago in 1947 and 1949. The weeds in the snow of Detroit of 1943 become the seaweeds in the sand of Horseneck Beach in 1975. The double exposures of buildings and the collages of the middle fifties have their counterpart in the straight details of New York skyscrapers of 1974. And his wife, Eleanor, among the autumn trees of Chicago becomes his daughter, Barbara, between the autumn trees of Aix-en-Provence. Just as the inevitable passage of time alternately reveals and conceals in Callahan's work—at one moment disclosing the child within the woman, at another, the woman within the child—so the formal structures of his vision alternate between revelation and concealment, between wide, pellucid vistas of few ob-

jects and dark interstices of multiple forms. Callahan's world moves from the openness and calmness of the beach and the woods to the tense enclosures of the city. Or he reverses the pattern, seeing clarity in the city and darkness in the natural world, only to return once again to quiet and spacious summer and autumn landscapes.

HARRY CALLAHAN. *Eleanor, Indiana,* 1948

HARRY CALLAHAN. *Cape Cod,* 1972

Callahan sometimes orders his world by filling the whole frame of the photograph with webs of the most intricate forms; then he will simplify it by formal psychological reduction, paring away from already vacant landscapes those last residual superfluities. Of such photographs John Szarkowski has written: "They [are] full of grace, antiseptically clean, cold as ice, and free of human sentiment—as distant and elegant as a Shaker chair or an archaic Venus."

Not quite. Free of sentimentality perhaps, but not "human sentiment." For Callahan's work is too literal, too believable to be free of essential feelings. It is the common world of warm and cool mornings, of the park, of overcast afternoons at the seashore, of sunlit rooms in summer cottages, of dense thickets and grasses, of the sudden shafts of light within the canyoned city, of the blankness and isolation on the faces of passing strangers, of the city's splendid as well as terrifying visages and facades. Like home snapshots, Callahan's photographs have about them the sus-

tained inevitability of remembered experience. Memory acts as a filter that obscures the unimportant and highlights the essential. Cultural anthropologists tell us that collective memory—the source of myth—functions by the reduction of events to categories and the elevation of actual personages to archetypes. In a similar way, Callahan's prints preserve only the essential visual qualities of an experience. His photographs seem to well up from within, and, like some retrieved forgotten snapshot, pervade as a compelling memory the very inner core of our being.

This aspect of Callahan's work is most readily apparent in the photographs of Eleanor, pictured by her husband in situations rich in archetypal meaning. Sherman Paul, in his introduction to the 1967 Museum of Modern Art monograph, lists some of Eleanor's appearances: "Emerging from the water Eleanor dominates this world. She is the center of the landscape, the woman among the trees, on the dunes, at rest in the sumac glade, the living statue in the park, herself a natural fact." In terms of the visual vocabulary of the Western world, these situations have "meanings" external to their specific details, meanings that belong to their iconographical posture. Cal-

HARRY CALLAHAN. *Eleanor,* 1953

HARRY CALLAHAN. *Eleanor,* 1951

lahan thus simultaneously projects upon the situation before the camera the obsessions of Western man's mythic and historic consciousness as well as the essential tendencies of his own thought.

In the photograph of Eleanor rising from the water, we experience the *fons et origo* of all the possibilities of existence. Eleanor becomes the Heliopolitan goddess rising from the primordial ocean and the *Terra Mater* emerging from the sea: the embodiment and vehicle of all births and creations. Similarly, lying in the sumac glade, she is seen to be in the sacred woods of the *axis mundi,* the primordial meeting point of heaven and earth. Realizing this archetypal quality, Peter Lacey wrote of this photograph "She is there but remote—not to be disturbed, like some mythical being. We have come upon her unawares, and should she sense us, she will vanish."

This sense of mythic creation is again experienced in Callahan's multiple exposures. In one we see a reclining nude who rises out of her own side, recreating herself as Eve was drawn out of the sleeping Adam. In another, an image of Eleanor within an egglike form, Callahan has discovered a complex image of rebirth and fertility. Eleanor becomes here the catalyst for the transformation of the urban world into a realm of trees and light. Eleanor is contained within an oval she herself ra-

66

diates. As an *oval*, it is the perfect vehicle for penetrating through the city into a richer natural world. As an *ovum*, it encloses Eleanor, who is both seed and egg; the amniotic substance waiting to be reborn and the *Magna Genetrix*, the great mother of life itself.

Over and over again, Callahan sees Eleanor in the context of creation: she has become for him the elemental condition of existence, she is essential womanhood, a force rather than an embodiment, an energy rather than a substance. As such she appears cold and inaccessible, beyond the human passions of lust or grief. She is the word made flesh.

This mythic identification of the feminine and the natural world is made unabashedly in the series of photographs showing Eleanor's nude torso double-exposed upon the fields of Aix-en-Provence. These photographs are more than just studies in superimposition. They provide a truly integrated image of nature and sexuality, intimacy and intricacy, the delicacy of grasses, weeds, flowers, leaves, trees, and a woman's finely curled pubic hair.

One does not have to be excessively Freudian to see in the work of Callahan, Siskind, and White attempts at defining and understanding their own sexuality. Photography offered these men the possibility of using their sexual imagination. The recurring tone of darkness in each man's photographs refers, certainly, not only to all unsatisfied and unresolved desires, but specifically to those sexual, generative emotions which could never be safely depicted. In his work White constantly attempted to understand and justify his own homosexuality and ultimately to fuse erotic and divine love. The iconographical postures of Siskind's configurations hint at a range of sexual relationships and anatomical shapes. Callahan's world is inhabited almost exclusively by women. Indeed, the case could be made that Callahan's entire photographic endeavor is dominated by notions of the maternal, the matriarchal, and the feminine. Yet, where White—at least in his published work—and Siskind deal with sex only metaphorically, Callahan is willing to be explicit and direct. His photographs tell of a relationship that is at once physical and metaphysical, actual and metaphorical. With the exception of the little-known photographs of Walter Chappell, it was not until the late sixties and the work of Arbus and Krims that the photographer would again deal so directly with nakedness, fantasy, and the world beyond erotic response.

HARRY CALLAHAN. *Eleanor, Aix-en-Provence, France,* 1958

HARRY CALLAHAN. *Eleanor, Wisconsin,* 1958

FOR REAL
For real

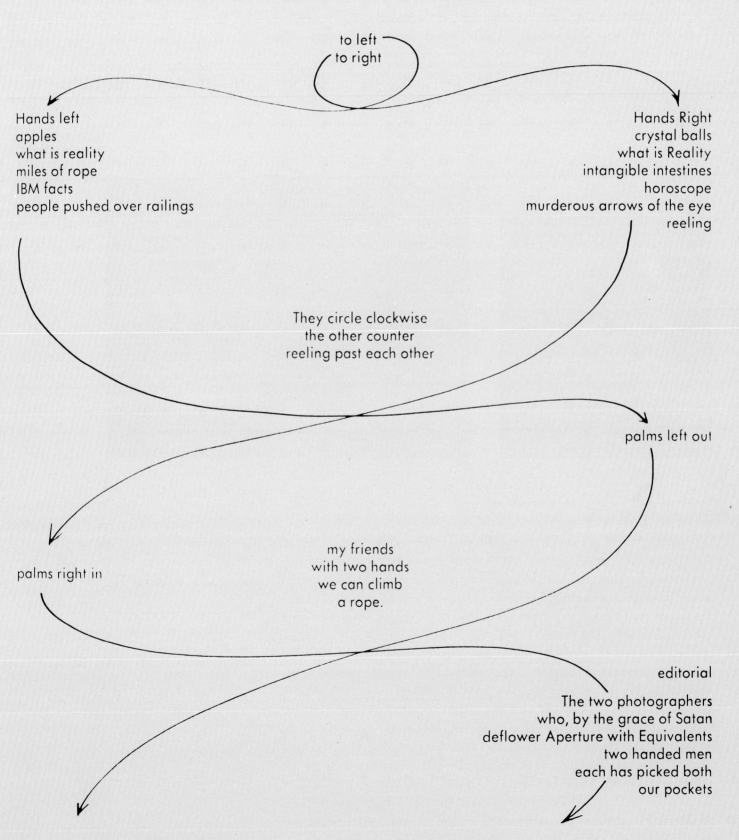

Friends, point cameras and hands

to left
to right

Hands left
apples
what is reality
miles of rope
IBM facts
people pushed over railings

Hands Right
crystal balls
what is Reality
intangible intestines
horoscope
murderous arrows of the eye
reeling

They circle clockwise
the other counter
reeling past each other

palms left out

palms right in

my friends
with two hands
we can climb
a rope.

editorial

The two photographers
who, by the grace of Satan
deflower Aperture with Equivalents
two handed men
each has picked both
our pockets

Aperture in the Fifties: The Word and the Way

Mirrors and Windows

MINOR WHITE. Frontispiece from *Aperture*, Volume 9, Number 1, 1961

Minor White relished the infallible logic of hidden meanings and chance occurrences. He would have been delighted that the most controversial publication in photography of 1978, John Szarkowski's *Mirrors and Windows*, paid more than direct homage to his name. Szarkowski chose as his book's title a phrase that echoed White's own words regarding the nature of the medium. Had not White entitled his major monograph of 1969 *Mirrors Messages Manifestations*, and had he not, as early as 1951, in an article "Are Your Prints Transparent?" spoken of photographs as windows?

In the book's essay, Szarkowski states that "the three most important events in American photography during the fifties were the founding of *Aperture* magazine (1952), the organization of 'The Family of Man' exhibition (1955), and the publication of Robert Frank's *The Americans* (1959)." Though the founding of *Aperture* precedes the other two events, it was integrally connected to them. For *Aperture* evolved as a reaction to the popular photographic sensibility that would be embodied in *The Family of Man*. And *Aperture* helped foster the radical vision that ultimately made Frank's work available to America.

The *Aperture* quarterly of the fifties was a quiet manifesto for the work of the metaphorical and expressionist photographer. Though it was thoroughly dominated by White's sensibility, it did introduce, through carefully chosen essays and photo-

graphs, alternatives to the popular photographic aesthetic. *Aperture*'s audience was small, but the quarterly became the first significant critical forum of photography since Stieglitz's *Camera Work*. *Aperture* lacked *Camera Work*'s urbanity, cosmopolitanism, sophistication, and cultural breadth, yet it did have a curious, at times adolescent, eloquent vitality.

Aperture's personality was the personality of Minor White. Where else could one find all rolled into one publication the finest possible photographic reproduction; White's eclecticism and gawky humor and Henry Holmes Smith's hard intellectual analysis; the historical perspective of the Newhalls and the aphorisms of White's alter ego, Sam Tung Wu; Lyle Bonge's photographs made and viewed under the influence of mescaline; portfolios by Adams, Bravo, Bullock, Caponigro, Cunningham, Eisenstaedt, Hyde, Jones, Lange, Weston, Stieglitz, Siskind, Sommer, and Charles Wong; serious essays on photographic styles and schools and on the photographic consciousness; reviews of photographic books as well as of Boleslavsky's *Acting: the First Six Lessons* and Herrigel's *Zen in the Art of Archery*? Who else but White would dare to comment on *The Family of Man*: "How quickly the milk of

 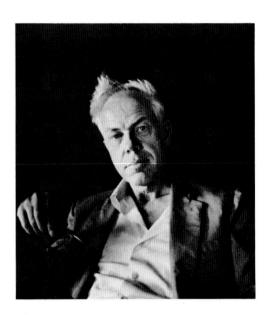

Cover of *Afterimage*, March 1979, showing *Aperture*, Volume 1, Number 1, 1952. Photograph by Dorothea Lange, *Aspen*, 1951

IMOGEN CUNNINGHAM. *Portrait of Minor White*, 1959

human kindness turns to schmaltz"; call the prestigious *U.S. Camera Annual*: "the juke box level of American taste"; and describe Cartier-Bresson's post-1947 photographs as examples of "the journalistic photograph out of context that drifts into the travelogue"? Who else would use such a colophon as "Reading photographs requires so much salt that we like to get pickled before we start"? Or follow one issue's serious editorial on recapturing innocence of vision with an editorial in the next issue on the need for gravestones that "disintegrate beautifully"? What other publication would place such a personal ad: "For photographers who wish an overhaul of their seeing habits Minor White is available for individual instruction. . . ."? And only White could have published such an outraged, uncomprehending reader's protest to his whole endeavor:

> And this preciousness—this is the thing above all . . . I want to spend my life fighting against. . . . The high flown language, the collector in inverted commas, the beautifully framed engraving, the postage stamp size; all kinds of snobbery; these are the things I want killed dead. . . . Your magazine to someone not living on the West Coast or Eastman House looks more than a little parochial.

More than Ideological Symbols

Aperture began in 1952 as the jointly subsidized venture of Dorothea Lange, Beaumont and Nancy Newhall, Ansel Adams, Barbara Morgan, Ernest Louie, Melton Ferris, Dody Warren, and Minor White, who was chosen editor and production manager. By the second issue the original backers were already pulling away from supporting White's direction. Adams wrote White:

> . . . images are much more than ideological symbols; they are both immensely human and immensely beyond categories. I agree that . . . perhaps, all photographs have meanings because of conscious or unconscious connotations [but] the connotations *imposed* by the photographer, or by groups of photographers, are questionable. I have been guilty as anyone in thinking about categories and "classifying" photography in intellectual and functional compartments. I realize now the dangers and futility in so doing. Why create self-conscious barriers between the heart and the world around us?

By 1954, after only seven issues had been published, the founders voted to

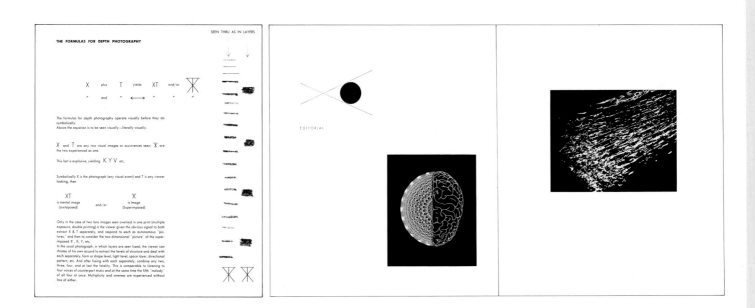

discontinue the quarterly. White, however, was just getting started. Determined to carry on, he engaged the financial assistance of Shirley C. Burden, a dedicated photographer and wealthy investor from Beverly Hills. Burden's support continued to aid *Aperture* throughout the years.

White was committed to the advancement of photography both as an art and as a medium of personal growth and expression. He was determined by trial and error, philosophical exchange, discussion, and debate to develop a theory of photography that was relevant to his own time. The theory he developed would not be one of style and form, but would be centered, as it had been for his mentor, Stieglitz, around the central issues of expression. The final form of the image was of less importance than its evocative meaning. White set out to define the nature of photography's emotional content and to discover methods by which that content could be perceived. *Aperture* moved ahead quickly to crystallize White's maturing ideas about the intentions of the photographer and the function of photography. Two major ideas emerged. The first was that photographs could be "read." The second was that photography could serve as a fitting medium for psychological and spiritual contemplation.

In issue 2:3 (1953), Henry Holmes Smith described the basic problem that

MINOR WHITE. Frontispiece from *Aperture*, Volume 9, Number 3, 1961

MINOR WHITE. Editorial from *Aperture*, Volume 10, Number 2, 1962. Photograph (right) by Walter Chappell

would occupy *Aperture* for the next six years:

> One of the most important steps in training part of the general audience is to help any interested person realize the rewards of staying with a difficult photograph. I think *Aperture* could usefully publish the experience of someone who has noted the way he first responded when he saw a photograph he had not seen before, and then has compared this response with what happened when he subsequently saw the photograph a day, a week, a month and even several years later. Perhaps a small section in *Aperture* should be devoted to methods for the detailed reading of photographs.

White picked up the suggestion, and using analytical methods drawn from the New Criticism (again first suggested and used by Smith) as well as from romantic theory, Gestalt psychology, Wölfflinian terminology, Zen meditation techniques, and any other method or trick he happened to hit upon, he began to put together a philosophy—one that insisted on the intrinsic value of the photograph, focusing attention on the individual image or sequence of images as an independent unit of meaning unrelated to biography, camera technique, or precedents of photographic history.

Aperture's stand on "reading" photographs was developed in a series of articles, editorials, and reproductions. The quarterly's major concerns were well expressed by some of the titles of these articles: "Photographing the Reality of the Abstract," "The Subconscious of the Camera," "The Masks Grow to Us," "Image, Obscurity and Interpretation," "Substance and Spirit of Architectural Photography."

What emerged from these articles was a series of premises by which a photograph could be "read." First, a photograph's meaning is not exhausted by mere identification of its subject matter. A photograph's significance lies deeper than that which can be comprehended by an immediate response. This first tenet contradicts the popular notion, in White's words, "that any picture that cannot be totally grasped in less than 1/100th of a second is needlessly obscure, private, meaningless." "The lay public," Henry Holmes Smith wrote, "is utterly blinded by identification. If they can identify a subject, they are satisfied that the photograph has communicated all its secrets."

Second, a photograph is not different from but is closely related to other forms of aesthetic experience. From the beginning, *Aperture* was committed to appropriating for photography the same seriousness of purpose and interpretation that had been reserved for the other arts.

Third, a photograph, like any work of art, is a complex whole composed of similes, metaphors, symbols, and forms that refer both to the visual world and to the perceptions and feelings of the photographer. A photograph differs from work in the other arts chiefly in the manner in which it is produced, not in its inherent meanings and intentions nor in the consciousness of the individual who made the image. The primary aesthetic values of insight, intuition, control of form, and personal expression are as much a part of photography's birthright as the inherently photographic virtues of documentation and description.

Fourth, a photograph may be understood as a new experience. There is no necessary relationship, link, or memory between the object photographed and the meaning of the finished print. This premise so boldly contradicted the documentary tradition that it was taken to be a credo for abstraction and photographic expressionism. "Social needs," Frederick Sommer wrote, "are not central to the problems of photography as an art."

Fifth, the accidental photograph may reveal the world in a new way. For White, the unfailing, mechanical nature of the recording process could be used as "automatic writing," which when carefully scrutinized had the possibility of "lifting the veil from the surface of familiar objects. . . ."

Sixth, and last, the viewer's experience of a photograph could be translated from the realm of visual thinking into that of verbal expression. The experience of art was communicable in words. White shared the poet's belief that words could make one see more clearly. It was on this premise that the possibility of "reading" photographs rested. Though White had a mystical turn of mind, he never patronized the ineffable. A translation of some sort could always be found. Even the most extreme and unusual experiences could be communicated. On his deathbed, a few moments before his heart stopped, White asked his last visitor, "Do you have any questions?" He wanted and was willing to tell all.

If photographs were to be "read" they had to be readable. For White this meant they had to push beyond the concerns of documentation, the pictorial, and the informational. The most fitting photograph for "reading" was a visual *koan:* a photograph that provided almost no information, that asked more than it answered, an enigma that forced the viewer to exhaust and abandon the analytic intellect in favor of intuition and direct experience. It is significant that *Aperture* never "read" a Cal-

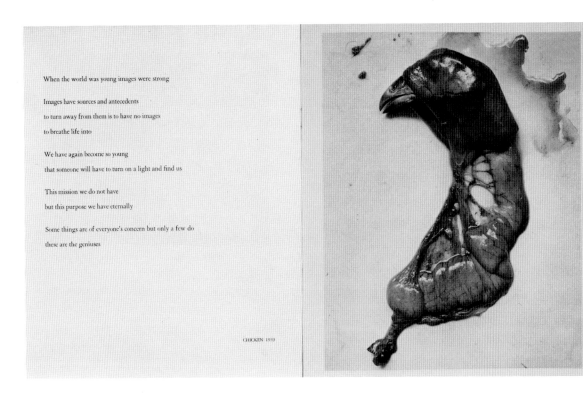

When the world was young images were strong

Images have sources and antecedents
to turn away from them is to have no images
to breathe life into

We have again become so young
that someone will have to turn on a light and find us

This mission we do not have
but this purpose we have eternally

Some things are of everyone's concern but only a few do
these are the geniuses

CHICKEN 1939

FREDERICK SOMMER. Two-page spread from *Aperture,* Volume 10, Number 4, 1962. Photograph, *Untitled,* 1939

lahan photograph. Callahan's work was too literal. Even White's own work and Siskind's—which provided the first examples for readings—were perhaps too concerned with correspondences and intellect. It remained for Frederick Sommer to contribute those photographs that were the most eminently open to scrutiny.

Sommer's images were reproduced in *Aperture* in 1956, 1957, 1960, and 1961. And in 1962 *Aperture* published a comprehensive collection. These images were more darkly and perversely psychological than White's; more fiercely mythic and inventive than Callahan's; more assiduously concerned with mortal corruption than Siskind's. Those individuals who put down their reactions for *Aperture* knew where Sommer stood. "In a world of disturbing images," Henry Holmes Smith wrote, "the general body of photography is bland, dealing complacently with nature and treating our preconceptions as insights. Strange, private worlds rarely slip past our guard. . . . Sommer has elected to show us some things we may have over-looked. . . . Sommer charges an ironic or absurd artifact . . . with the force of an ancient idea." White wrote: "Sommer makes no concessions to the casual observer . . . a superficial glance at his pictures reveals about as much as a locked trunk of its contents. . . . He contemplates his fragments until they are the intimates of his living mind. . . . Frederick

73

Sommer of Arizona is the rare one who takes time to work in the sun and in the dark, in the desert and in the camera." And Jonathan Williams summed it all up: "With Sommer we enter the world of the incredible and somebody locks the Doors of Perception behind us. . . . This is simply what happens when the eye is free to see. . . ."

The Way Through Camera Work

Sommer's work was exceedingly satisfying to "read." Yet for White "reading" was only one way toward the more important goal of spiritual perception. Over and over again, embedded in *Aperture*'s responses to photographs were references to the contemplative and the otherworldly. The notion of photography as a spiritual endeavor is most dramatically indicated in the central *Aperture* issue of the period, issue 7:2 (1959). In the previous issue White had announced that "the Spring issue will be devoted to 'Photographs for Contemplation,' a subject *Aperture* has been leading up

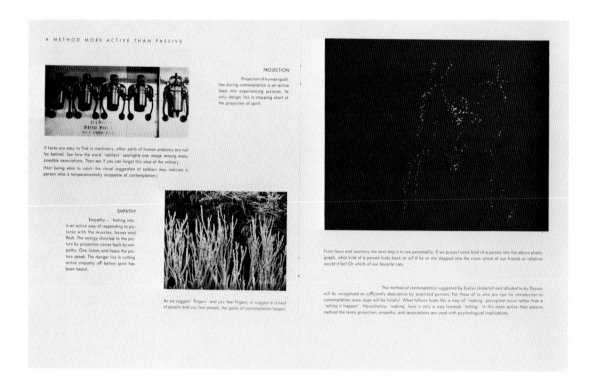

Two-page spread from *Aperture*, Volume 7, Number 2, 1959. Photographs by Minor White (left, above and below) and Aaron Siskind (right)

to for some time." When that issue appeared, it was entitled *The Way Through Camera Work*. The mystical beliefs that had been quietly flowing beneath the surface of all of *Aperture*'s work now became explicit. The issue used as its frontispiece the Chinese calligraphic character *ch'i*, which relates to the first canon of Mai-Mai-Sze's *Tao of Painting* and means "the breath of heaven," "spirit," and "vital force."

In the issue White goes beyond the "reading" of photographs and begins to describe photography in terms of the extraphotographic rituals and philosophies he had begun to study in depth during the fifties. White's concern with the spiritual seems to have blossomed around 1955 when he renewed his close relationship with Walter Chappell, whom he had first known in Portland about 1941. Chappell, always on the lookout for the psychological, the erotic, the occult, and the mystical, introduced White to the *I Ching* and to the Gurdjieff philosophy, which, though not outwardly discussed as much as other sources, became the primary spiritual center of White's life. Evelyn Underhill's *Mysticism*, introduced to him by Barbara Morgan, Herrigel's *Zen in the Art of Archery*, suggested by an *Aperture* reader from Santiago, Chile, and Huxley's *Doors of Perception* were also major forces behind *The Way Through Camera Work*.

The issue includes quotations from Stieglitz, Dessoir, Underhill, *The Book of Tea*, Meyer Schapiro, D. T. Suzuki, Sigfried Giedion, Laurence Binyon, Weston, Dorothy Norman, Jacques Maritain, Herrigel, *The Tao of Painting, Buddhist Aesthetics*, Alfred Korzybski, Cartier-Bresson, Richard Neutra, and Syl Labrot. These quotations are interspersed with White's prose poems and instructions for contemplation. Significantly, of the twenty-four photographs used, well over half are by the major photographers of the metaphysical, metaphorical school: White, Caponigro, Chappell, Siskind, Welpott, Callahan, and Lyons.

The Way Through Camera Work was White's first major theme publication. It may be seen as his esoteric, internalized, sacred answer to the popular aesthetic of *The Family of Man*. Although the basic photo-essay technique was used, White employed extended quotations, not just aphorisms, and he allowed the photographs to be as dreamlike, luminescent, evocative, psychological, and enigmatic as possible. This was the spiritual center largely obscured in *The Family of Man*. Beyond the rush and loudness of Steichen's grand show, *Aperture* was the still, small voice crying

for—and perhaps achieving—a measure of quiet revelation. *Aperture*'s relationship to the more public traditions of photography is perhaps best summed up in White's use of a quotation by Cartier-Bresson: "Of all the means of expression, photography is the only one that fixes forever the precise and transitory instant." To which White replies, "Cartier-Bresson is over-optimistic with 'forever,' forgetful of Sumiye painting with 'only,' but some of his photographs show that 'precise' is another word for spirit."

Two-page spread from *The Family of Man*, 1955. Photographs by Ralph Crane, Eddy Van der Elsken, George Strock, Leonti Planskoy, Wayne Miller, and Ronny Jaques

The Underground

To many of *Aperture*'s own readers and certainly to the popular photographer who wholeheartedly accepted the ethos of *The Family of Man*, the direction that White and the quarterly were taking—particularly in *The Way Through Camera Work*—must have seemed strangely obtuse, cultic, and antiestablishment. For *The Way Through Camera Work* was not only intellectually shocking to the conservative high culture of the fifties, it was also a distinct departure from the styles and manners sanctioned by complacent popular opinion. Though *Aperture* always stayed to the right of that thin line between respectable culture and the underground, between

comprehension and obscurity, its roots go back to the same sources that spawned the alternative cultures of the fifties, particularly the Beat movement.

White's relationship to Stieglitz is always rightly emphasized. Yet his closest contemporary spiritual allies in the fifties were the same as Robert Frank's: the major Beat poets—Kerouac, Ginsberg, and Snyder—and the older members of the San Francisco and West Coast intellectual community—Kenneth Rexroth, Alan Watts, Gerald Heard, Christopher Isherwood, Aldous Huxley, Mark Tobey, and Morris Graves—who for years had been interested in Oriental religions and had been continually pursuing the contemplative life. Though *The Way Through Camera Work* appeared after White had left San Francisco for Rochester, its origins stem from the Oriental teachings that had long established themselves in California. It was not based on the European idea of active intelligence, but on the Oriental tradition of passive intuition. *The Way Through Camera Work* quickly left behind Henry Holmes Smith's cerebral temper for "reading" photographs. It distrusted and almost dismissed Smith's belief in the explicit, isolated intellect, favoring instead religion, self-

ROBERT FRANK. *Portrait of Franz Kline,* 1956

investigation, and meditation. This Californian culture nurtured the seeds of White's polyglot, eclectic gathering of beliefs and teachings. It was by way of California that White ultimately incorporated Gestalt therapy, sensitivity training, the preliterate relationship between artist and audience, and, above all, the Japanese, Chinese, and Indian religions into his notions of photography.

Aperture itself was just as surely a product of the San Francisco renaissance and bohemian ambiance as Ferlinghetti's City Lights publications. *Aperture* was one of the little magazines of the fifties, which, together with *Big Table, Chicago Review, San Francisco Review, Contact, Origin, Choice, Yugen, Black Mountain Review, The Jargon Society, Neon,* and *Evergreen Review,* gave America its first indication that something radical in thought and action was occurring beneath the surface of respectable culture.

The Beats, seen through the exaggerations of the movements and people they inspired—the beatniks, Norman Mailer, the hippies, the yippies—have become popularly associated with violence, sexuality, drugs, and insane adolescent foolishness. Although these charges cannot be totally denied, there was much more to the major Beat writers. They are closely tied to the underground mystical and romantic tradi-

76

tion that has permeated American thought and imagery, clearly appearing first in the work of the Transcendentalists and Whitman, then in the work of Stieglitz's circle, and again with Hart Crane and Agee. This is the tradition that has shunned popular mentality and searched for direct, mystical, religious contact and experience. The Beats used the rough experience of life itself as the confessional medium for a new vision; *Aperture* used photography as the medium that could seek out the truths and essences that lay behind the accepted culture of the fifties. Both *Aperture* and the Beats, in their own way, stood for an art of revelation, of individuality, of loud or quiet protest, of message, of beatitude.

The sources to which *Aperture* and the Beats turned were identical. Kerouac read D. T. Suzuki's essays on Buddhism, Zen stories, *The Life of Buddha* by Ashvagosa, Dwight Goddard's *Buddhist Bible.* Ginsberg followed Buddhist Sutras, Yoga precepts, Vedic hymns, Chinese philosophy, and the Tao. Neal Cassady read Gurdjieff and Ouspensky.

The paths of the major members of the new tumultuous literary generation,

ROBERT FRANK. *Portrait of Willem de Kooning,* 1957

ROBERT FRANK. *Portrait of Allen Ginsberg,* c. 1955

the avant-garde painters, and the major photographers crossed with startling frequency. While White himself seems to have stayed on the sidelines—even though he taught in San Francisco at the California School of Fine Arts at the same time as the painters Clyfford Still and Mark Rothko—*Aperture* sympathetically parallels the concerns of the avant-garde. It is Siskind, Callahan, and Sommer who make the personal ties. The painter Hugo Weber during the fifties was a close friend to both Kerouac and Callahan. The old Cedar Bar in New York became the hangout for Siskind and the Abstract Expressionists as well as for Ginsberg, Corso, Seymour Krim, and occasionally Kerouac. And some of these men might also have been found at Helen Gee's *Limelight* coffeehouse, the first and most important New York photographic gallery in the fifties. One of the leading sympathetic critics of Abstract Expressionism, Harold Rosenberg, wrote the introduction to Siskind's first monograph. And the Six Gallery, one of the initial homes of Abstract Expressionism in San Francisco, became the place where Ginsberg first read *Howl* and launched the Beat movement. Black Mountain College hosted or published Siskind, Callahan, Jonathan Williams, Kerouac, Ginsberg, Burroughs, Snyder, and many more of the major poets, musicians, and painters of the vanguard.

It was these personal connections and the trading of ideas, images, thoughts, and meeting places that, for the first time since *Camera Work* and Stieglitz's circle, put avant-garde photography in the same context as the avant-garde in the other arts. Siskind, Callahan, and eventually Sommer, Frank, and other antiestablishment photographers soon found their portraits of the author or even their abstract photographs appearing as cover illustrations for some of the most radical books of the day. Indeed, in the fifties and early sixties, it was these new, crisp black-and-white photographic jackets that gave the New Directions Paperbooks, the Grove Press Evergreen paperback series, and some of the Jargon Society and City Lights paperbacks their distinctive, contemporary look. The move from the more conservative, four-color artwork to the harder graphics of the photograph signaled all that was fresh, experimental, and remarkable in a literature that was in revolt against conventional styles and euphemistic speech. (This hard-edged, direct graphic presentation would become the hallmark of the modern photography book as well.)

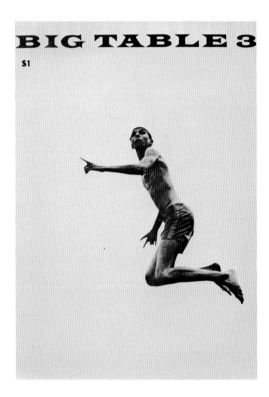

Cover of *Big Table,* Number 3, 1959. Detail of photograph by Aaron Siskind from *Pleasures and Terrors of Levitation,* 1954

Besides the book jackets, outside of *Aperture* itself, it was the other little magazines that began to publish the work of the more radical photographers. Eight Siskind photographs appeared with an introductory note by Jonathan Williams in the *Black Mountain Review* of 1955, together with poetry by Robert Creeley, Paul Goodman, and a host of others. In 1957 the *Black Mountain Review* published eight Callahan photographs in an issue that also contained Kerouac's "Essentials of Spontaneous Prose," Ginsberg's "America," and a poem by Snyder. The same year, *Evergreen Review* used a Robert Frank photograph on its cover. In 1958 the *Chicago Review* published two Siskind photographs in their major issue on the new San Francisco poets. And Siskind again appears both on the cover and in portfolio in *Big Table,* the little magazine whose name was suggested by Kerouac and which appeared after the University of Chicago suppressed the *Chicago Review* for publishing excerpts from Burroughs's *Naked Lunch.*

The most important parallel and antecedent to *The Way Through Camera Work* appeared in the summer 1958 issue of the *Chicago Review,* two issues before the magazine was judged pornographic. As the *Aperture* of a year later would be

devoted to Zen and photography, this *Chicago Review* was devoted to Zen and American literature and thought. Its lead article by Alan Watts, "Beat Zen, Square Zen, and Zen," touched on the affinities between Zen and the Beat writings. In his revised version of this essay, published by City Lights a year later, Watts even related Zen to photography.

It is the Tao that becomes the primary word and symbol for the major efforts of Frank, Kerouac, and *Aperture* in the fifties: *The Americans, On the Road,* and *The Way Through Camera Work. The Road* and *The Way* became the central images in the search for new directions. The Tao symbolizes all the energies, traditions, heresies, and goals for which the prevailing culture had no use, especially the visionary and evangelical, the unconscious and the automatic. It became a method to "listen to the rhythm of your own voice . . . proceed intuitively by ear," as William Carlos Williams told the young Allen Ginsberg. It became the process behind Charles Olsen's projective verse.

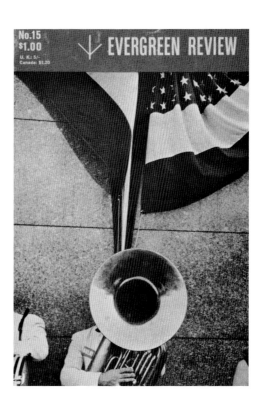

Through *Aperture,* White was looking for the Tao of photography: the way to see clearly beyond the superficial, the intellectual, the pictorial. In *The Way Through Camera Work,* White at first defined the word quite literally: "Tao . . . symbolizes something both moving and unmoving, for example a Throughway which lies on the ground and so stands still, yet leads somewhere and so has movement." Yet Tao, like *Aperture* itself, was a continual affirmation of expansion and consciousness. And in *The Way Through Camera Work,* White offers a second definition, taking particular delight in explicating the hidden, sacred meaning: "The word *Tao* . . . also means much as did St. Catherine of Siena, 'All the way to heaven is Heaven, for He said: I am the Way.' "

Cover of *Image and Idea* by Philip Rahv. New Directions Paperbook Number 67, 1957. Cover design by Ivan Chermayeff. Detail of photograph by Harry Callahan, *Eleanor,* 1953

Cover of *Evergreen Review,* November–December 1960. Detail of photograph by Robert Frank, *Political rally, Chicago,* 1955–56

Port Gibson, Mississippi; in front of the Highschool September 1955

Kids: What are you doing here? Are you from New York?

Me: I'm just taking pictures.

Kids: Why?

Me: For myself—just to see.

Kids: He must be a communist. He looks like one. Why don't you go to
 the other side of town and watch the niggers play?

The Americans: Politics and Alienation

A Disembodied Burrowing Eye

For Minor White the Tao became the essence of philosophy and photography. For Robert Frank the physical facts of the American roadside generated the very shape and content of photography. Frank's world of the mid-fifties is Walker Evans's world of the mid-thirties stood on end and plunged into the quiet desperation of existential America. In form, content, size, and presentation, *The Americans* of 1959 is a direct descendant of Evans's *American Photographs* of 1938. The superficial resemblances between the two books are obvious and most probably intentional. *American Photographs* contained eighty-seven images, *The Americans* contained eighty-three. Each book contained a memorable essay by a hard-hitting author of its day: Lincoln Kirstein for Evans's book and Jack Kerouac for Frank's. Each book offered a revolutionary, antiestablishment look at the America of its time:

> The photographs are social documents. In choosing as his subject-matter disintegration and its contrasts, he has managed to elevate fortuitous accidents of juxtaposition into ordained design. . . . They are serious symbols allied in disparate chaos. . . . Photographing in New England or in Louisiana, watching a . . . funeral or a Mississippi flood . . . stepping cautiously so as to disturb no

ROBERT FRANK. Page from *The Lines of My Hand,* 1972. Photographs, Port Gibson, Mississippi, September 1955

dust from the normal atmosphere of the average place, [the photographer] can be considered a kind of disembodied burrowing eye, a conspirator against time and its hammers. His work, print after print of it, seems to call to be shown before the decay which it portrays flattens all. . . . Here are the records of the age before an imminent collapse.

The words are Kirstein's, but they would serve as well to introduce Frank's book. For both Frank and Evans came back to subject matter that was popularly considered beneath notice: images of the roadside, automobiles, gasoline stations, American flags in out-of-the-way places, barbershops, bums, billboards, luncheonettes, political posters, public monuments, and cemeteries. In these books, both men offered their allegiance to the most ubiquitous and consistently powerful source of American imagemaking, both in photography and in painting: the visual vitality of the peopled American landscape, American subcultures, the derelict populations of little American towns and urban boweries, and the sometimes joyous, more often callous urban realities.

But here the similarity ends. For Evans these facts had accrued the rich and romantic associations that Whitman had once given them:

> I do not doubt but the majesty & beauty of the world are latent in any iota of the world . . .
> I do not doubt there is far more in trivialities, insects, vulgar persons, slaves, dwarfs, weeds, rejected refuse, than I have supposed. . . .

Evans was an American, reflecting idealistically, and at times nostalgically, on the beauties inherent in the most commonplace. Frank was an outsider, with no tie to the American tradition of egalitarian optimism. Where Evans idealized, Frank was boldly critical, biting, ironic, detached, inviting outrage as well as compassion. Where Evans patiently, lovingly, and formally composed in broad, bright, hard sunlight even the meanest of American facts, Frank took his photos on the run, often in the dim light of dusk, dark interiors, and rainy days.

Yet Evans himself was the first to recognize the strength of Frank's vision. "This bracing, almost stinging manner is seldom seen in a sustained collection of photographs," Evans wrote in the *U.S. Camera Annual* of 1958, the first major review and publication of Frank's work. Evans continued with a nasty jibe at *The Family of Man,* "It is a far cry from all the woolly, successful 'photo-sentiments' about human familyhood; from the mindless pictorial salestalk around fashionable, guilty and therefore bogus heartfeeling."

Frank understood the potential of seeing America as an outsider. Applying for the 1955 Guggenheim Fellowship that enabled him to make the photographs in *The Americans,* he wrote:

> It is fair to assume that when an observant American travels abroad his eye will see freshly; and that the reverse may be true when a European eye looks at the United States.

Then, adding a catalog of American facts so overwhelmingly banal that they surpassed even Evans's notion of the commonplace, he continued:

> I speak of things that are . . . everywhere—easily found, not easily selected and interpreted . . . a town at night, a parking lot, a supermarket, a highway . . . advertising, neon lights, the faces of the leaders and the faces of the followers, gas tanks and post offices and backyards.

These are the views of a country that first present themselves to a traveler. An inhabitant has neither the concern nor the leisure to notice the configuration of signs at an intersection or the variety of gestures of people sitting at a lunch counter. For

the observant traveler, however, subtle changes in faces, in dress, in street activities, and in gaits become messages from the interior, external hints of more deeply hidden truths.

Frank was such a traveler. He had spent most of the ten years preceding 1955 moving from country to country, peering and photographing from the windows of moving cars and trains, seeing reflections of humanity in shop windows, monuments, and public signs and in the movement of people on the street and in parades. Frank was bound neither by political nor visual constraints. He was on the road, always on the move. He was the archetypal stranger, the carefully observant onlooker. And Frank has continued to this day to look at society from the outside. First as photographer for the Beat generation, then as avant-garde filmmaker, then as chronicler of the Rolling Stones, Frank has always maintained his distance from established culture. Now living far north in Cape Breton, he has made his physical and spiritual home on the literal outskirts of civilization.

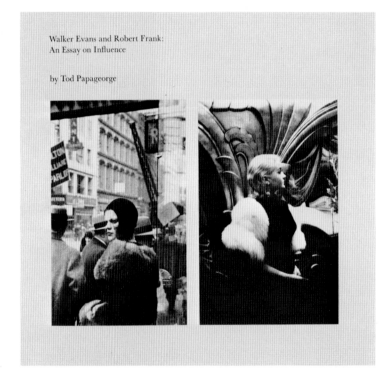

The shock of self-recognition that O'Sullivan and Brady had given America with their photographs of the Civil War and that Walker Evans had produced with his photographs of the thirties would now be repeated in Frank's work. "Robert Frank, Swiss, unobtrusive, nice," the observation is from Jack Kerouac's famous introduction to *The Americans,* "with that little camera that he raises and snaps with one hand he sucked a sad poem right out of America onto film, taking rank among the tragic poets of the world."

Frank had come to the United States first in 1947. By 1953 he was part of the New York avant-garde circle. He had met Walker Evans, Herbert Matter, Willem de Kooning, Franz Kline, and Allen Ginsberg. Nevertheless, Frank seems not to have known Kerouac's unpublished, yet already mythologized work when he made his cross-country trip of late 1955 and 1956. Nor did he know Ginsberg's *Howl,* which was written in the fall of 1955 and was not published until a year later. Kerouac's *On the Road* would not finally see print until late in 1957. It was not until 1958, after the Paris edition *Les Américains* appeared, that Frank met Kerouac and asked him to write the introduction to the American version of his book. "I don't think

Dust jacket from *American Photographs,* 1962 edition. Photograph by Walker Evans, *Wooden Houses, Boston,* 1930

Cover of *Walker Evans and Robert Frank: An Essay on Influence,* 1981, by Tod Papageorge. Photographs by Walker Evans, *Girl in Fulton Street, New York,* 1929 (left), and Robert Frank, *Movie premiere, Hollywood,* 1955 (right)

that I traveled on the Beats' path," Frank remarked recently, "but it seems we've heard each other."

Heard each other, indeed. For Frank's version of America was precisely the same America that haunted the desperate insiders, the strangers in America's midst, the men who were travelers and outsiders in their own country. Kerouac, growing up in industrial Lowell, speaking only Canadian French until grade school. Ginsberg, the outcast, suffering through years of self-confrontation, political struggle, and dissident ideology; in his own haphazard catalog a continual traveler: "Columbia College, merchant marine, Texas and Denver, copyboy, Times Square, amigos in jail, dishwasher . . . Mexico City . . . Satori in Harlem, Yucatan and Chipas . . . West Coast . . . Arctic Sea trip, Tangier, Venice, Amsterdam, Paris." William Burroughs, the exile in Mexico, North Africa, Europe, who once wrote Ginsberg: "The most dangerous thing to do is to stand still." Corso, who spent most of his life in orphanages and jail. Cassady, the wild rider of freight trains, speeding joyrides, obsessively determined to be on the move. Frank's America was that visual environment

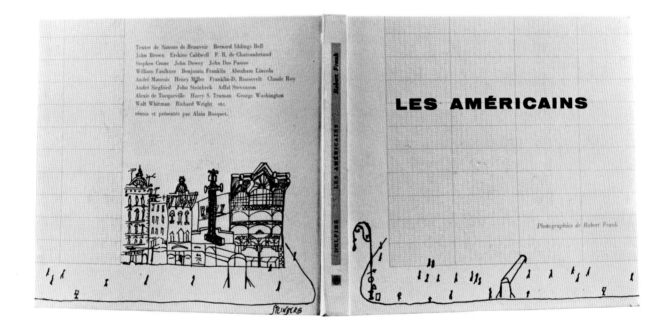

Cover of *Les Américains* by Robert Frank, 1958 French edition. Drawing by Saul Steinberg, n.d.

known, loved, and despised by these men who took the term *beat*, which originally meant "poor, down and out, dead beat, on the bum, sad, and sleeping in subways"— the definition is Kerouac's—and elevated it first to a gesture of defiance and then to a virtue and a prophecy.

Theirs was the invisible America of the fifties. It was the hidden country. It had neither the pathos of the dust bowl, the glamour of Hollywood, or the scientific determinism demanded by Cold War politics. America at times seemed thoroughly foreign to them. Frank voiced both his own and the Beats' sentiments when he remarked in 1958: "I should imagine, though I've never been to Russia, that America is really more like Russia, in feeling and look, than any other country in the world . . . the big distances, the faces, the look of families traveling."

This was not exactly what any red-blooded American would want to acknowledge in the midst of the Cold War and in the wake of McCarthyism. But it was the scruffy world that lay by the side of the road, and Frank was determined to put it down as he saw and felt it.

What he put down was received even less kindly than Evans's *American Photographs*. It was not until the book was first published in Paris that even the avant-garde Grove Press agreed to publish an American edition. Once it did come out in 1959 it sold poorly, but still outraged the critics. Where the critics had been content to accuse Evans of wretched subject matter, Frank's personality itself became the basis of critical attacks. Bruce Downes called Frank "a liar, perversely basking in the kind of world and the kind of misery he is perpetually seeking and persistently creating." Les Barry felt that it was "only logical to conclude that his book is an attack on the United States." Arthur Goldsmith diagnosed Frank as suffering from "intense personal vision marred by spite, bitterness, and narrow prejudices. . . ." The reviewer for *The San Francisco Chronicle* called Frank's photographs "merely neurotic . . . dishonest." Although *Aperture* was one of the first American publications to review Frank and support his work—giving *Les Américains* a full discussion in 1959, publishing an extensive portfolio with a sympathetic essay by Edna Bennet in 1961, reissuing *The Americans* in 1969 and again in 1978, and presenting an evocative

selection of Frank's work in 1976 as its first volume in the Aperture History of Photography Series—Minor White himself could not deal with the book's underlying pessimism: "No matter how true the fraction, when the jukebox eye on American life is presented as a symbol of the whole, a lie is the flower of truth. A gross lie is ground in with a vengeance."

Paradoxically, through *Aperture*, White helped foster what little climate of acceptance there was initially for Frank's vision of America. But White failed to understand that Frank, just as surely as Callahan, Siskind, and he himself, had abandoned the public document for private vision. "My view is personal," Frank stated, and with this simple acknowledgment rejected the same iron-clad tradition of the American documentary essay that had repelled White, Siskind, and Callahan.

The Old Going Road

The quickness of Frank's vision and the objects he photographed are nowhere better described than by Kerouac, who in 1958 traveled with Frank to Florida:

Dust jacket of *The Americans* by Robert Frank, 1969 edition. Photograph, *Trolley—New Orleans*, 1955–56

Back cover of the dust jacket of *The Americans* by Robert Frank, 1959 edition (damaged). Collage by Alfred Leslie, c. 1958

I didn't see anything in particular to photograph, or "write about," but suddenly Robert was taking his first snap. From the counter where we sat, he had turned and taken a picture of a big car-trailer with piled cars, two tiers, pulling in the gravel driveyard, but through the window and right over a scene of leftovers and dishes where a family had just vacated a booth and got in their car and driven off, and the waitress not had time yet to clear the dishes. The combination of that, plus the movement outside, and further parked cars, and reflections everywhere in chrome, glass and steel of cars, cars, road, road. . . . Outside the diner, seeing nothing as usual, I walked on, but Robert suddenly stopped and took a picture of a solitary pole with a cluster of silver bulbs way up on top, and behind it a lorn American Landscape so unspeakably indescribable, to make a Marcel Proust shudder . . . how beautiful to be able to detail a scene like that, on a gray day, and show even the mud, abandoned tin cans and old building blocks laid at the foot of it, and in the distance the road, the

86

ALLEN GINSBERG. *Gregory Corso and Allen Ginsberg,* c. 1955

PHOTOGRAPHER UNKNOWN. "Neal [Cassady], a good company man. Jack [Kerouac], the Communist. S.F. 1949." Caption by Allen Ginsberg

JOHN COHEN. Robert Frank and Jack Kerouac during filming of *Pull My Daisy,* 1959–60

old going road with its trucks, cars, poles, roadside houses, trees, signs, crossings. . . .

"The old going road . . . trucks, cars, poles, roadside houses, trees, signs, crossings." This is the essential iconography repeated again and again in the work of the Beats. It is the barren American landscape Ferlinghetti saw in *Starting from San Francisco:*

Later again, much later,
one small halfass town,
followed by one telephone wire
and one straight single iron road
hung to the tracks as by magnets
attached to a single endless fence,
past solitary pumping stations,
each with a tank, a car, a small house, a dog,
no people anywhere. . . .

It is the vision of madness, speed, and the road seen in Ginsberg's *Howl:*

> who barreled down the highways of the past journeying to each other's hotrod-
> Golgotha jail-solitude watch or Birmingham jazz incarnation,
> who drove crosscountry seventy-two hours to find out if I had a vision or you
> had a vision or he had a vision to find out Eternity. . . .

And it is the public metaphor for what Kerouac, like Whitman, had proposed as "the noble ideal American open-mind sensibility, open road, open energy."

More than this, the road and the automobile took on hieratic meaning. "What is the meaning of this voyage. . .?" Ginsberg asks in Kerouac's *On the Road.* "What kind of sordid business are you on now? I mean, man, whither goest thou? Whither goest thou, America, in thy shiny car in the night?" Frank's answer to Ginsberg's question is given in the same tone in which it is asked: it is given in distinctly religious terms. *The Americans* shows the quest for the values of the ideal life trans-

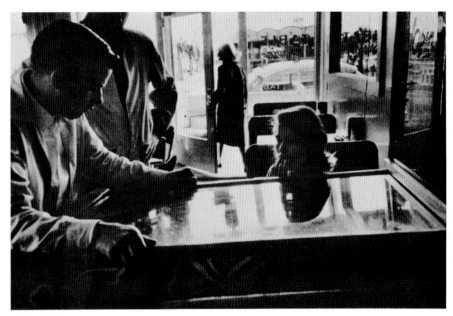

lated and relocated in commercial advertisements, on billboards, and in store windows at the roadside. The sacred has become totally secular. In *The Americans,* the spirit, the quest, tawdry advertising, and the road have become one. Religious rites have been usurped by public signs. The world of spirit exists only in the world of things: *SAVE* proclaims the giant sign standing amid the silent, worshiping gasoline tanks at Santa Fe; *Awake!* headlines the magazine proffered by the evangelist in the business suit in Los Angeles; *Remember Your Loved Ones 69 cents* hawks the sign above the rows of Styrofoam crosses and plastic wreaths in the department store in Lincoln, Nebraska; *Christ Died For Our Sins* announces the card taped to the back of a shiny Chevrolet in Chicago.

What remains of the old sacred rituals has become occult in this cold, highway world. In *On the Road,* Kerouac described one such mystery:

> The car was going over a dirt road elevated off the swamps that dropped on
> both sides and drooped with vines. We passed an apparition; it was a Negro
> man in a white shirt walking along with his arms upspread to the inky firma-
> ment. He must have been praying or calling down a curse.

Top
Page from *Evergreen Review,* January 1970

Left
ROBERT FRANK. *Untitled,* c. 1960

Right
ROBERT FRANK. *Untitled,* c. 1960

Perhaps ten years later Frank appears to find the same apparition—again described by Kerouac:

> . . . the Negro priest squatting underneath the bright liquid belly *mer* of the Mississippi at Baton Rouge for some reason at dusk or early dawn with a white snowy cross and secret incantations never known outside the bayou. . . .

Directly after this image, Frank presents two more images of crosses, linking inextricably the automobile, salvation, and death. In the next photograph a bleak stone Saint Francis grants perfect absolution to an Esso gas station in the heart of smoggy Los Angeles. And in the following photograph three grim, backlit crosses mark the place of death on U.S. Highway 91.

Just as the American highway leads to cheap salvation and death, so the American political process becomes an equally vacuous journey. From Frank's point of view, political authority, patriotism, and their attendant emblems have become stripped of their original meanings. The human involvement in government, just as the involvement in religion, has become merely rhetorical. Politicians, parades, and

ROBERT FRANK. *Santa Fe, New Mexico,* 1955–56

ROBERT FRANK. *St. Francis, gas station, and City Hall, Los Angeles,* 1955–56

conventions are at best entertaining, at worst malevolent. There are no statesmen in Frank's America, only politicos. The "leaders and followers" Frank named in his Guggenheim application are consistently portrayed, if not as evil, then as powerless, anonymous, even frighteningly headless. Eisenhower's portrait becomes a decapitated head reeling from the torso in a formal-wear window in Washington, D.C. The tuba player's head at the Stevenson rally in Chicago is transformed by Frank's wry viewpoint into the large bell of a sousaphone. And in the opening photograph of the book, that most essential of all American symbols, the flag, flies in the face of a parade viewer.

Jasper Johns during this same period began to work with the American flag as a painterly problem of stars and bands. In Johns's paintings the flag is both nationalistic and ironic, for its elaboration as pattern is both visually brilliant and isolated from reality. In Frank's world irony alone prevails. The flag alternately hides the actual from the viewer, or, as in the photograph of the Fourth of July at Jay, New York, it becomes a patched, torn, gauzy curtain. It looks out over listless activity, not celebration. In other photographs it hangs, a molded plastic light above a dimly lit barroom, or rises, as Szarkowski has observed, like "a comic-strip balloon" out of a tuba player's horn. Robert Frank's America of 1956 is exactly that devouring political

identity Allen Ginsberg addressed in the same year:

> America I've given you all and now I'm nothing.
> America two dollars and twentyseven cents January 17, 1956 . . .
> America . . .
> Are you being sinister or is this some form of practical joke? . . .
> I'm addressing you.
> Are you going to let your emotional life be run by Time Magazine? . . .
> America how can I write a holy litany in your silly mood? . . .
> America this is quite serious.
> America this is the impression I get from looking in the television set.
> America is this correct? . . .

For Frank this impression was correct. The few moments of genuine energy he perceived within America were distinctly un-American. They came from a world beyond conventional expectations and attitudes, beyond the narrow alternatives offered by the establishment's culture. They came from the vitality of America's sub-

cultures and countercultures rather than from the image Ginsberg saw on the television set. There is more human intensity, joy, meditation, and grief in the photographs of blacks than in the photographs of whites. There is more feeling emanating from the omnipresent jukebox than from the entertainments of high culture. And the cocktail parties and restaurants of the rich are sterile compared to the sometimes desolate, sometimes violent, sometimes dreamlike eateries of railroad stations and corner drugstores. "Anybody doesnt like these pitchers dont like potry, see?" Kerouac challenged. "Anybody dont like potry go home see Television. . . ." The dichotomy was absolute. The vigor in Frank's world is distinctly *Beat*.

Most significantly, the road itself and those who follow it possess a demonlike intensity. They are, in Kerouac's words, "madroad driving men . . . the crazed voyageur of the lone automobile." But they are also Ginsberg's "Visionary Indian angels who *were* visionary Indian angels." Belted, buckled, astride their chrome, mirrored motorcycles, moving down the road or lovemaking by their cars in an Ann Arbor park, these new voyagers have power, beauty, and brute energy.

ROBERT FRANK. *Department store, Lincoln, Nebraska,* 1955–56

ROBERT FRANK. *Chicago,* 1955–56

The True Blue Song of Man

There is of course another kind of vitality in *The Americans:* the vitality of the idiom in which Frank saw the world. It was a way of seeing that matched the Beats' writings, a style that effectively placed the everyday rhythms of speech and jazz into visual form. It was an idiom that transformed despair into a detached cosmic humor. It was a style that created a crackling energy out of the drabness of cars, storefronts, signs, and disenfranchised peoples. It was a personal vision that converted an impersonal world into a divine comedy.

The Americans has often been seen as being all-of-a-piece. Although the tone of the book is remarkably coherent, this uniformity of feeling is underwritten by a variety of pictorial styles and an intuitive, psychological continuity in picture sequencing. Frank has imposed on picture after picture precisely the most appropriate form and design. And in the relationship of one photograph to another he has found a way of presenting images as if they had spontaneously flashed through his mind with all the coherence and rhythmic shifting of actual sight. The power of *The*

ROBERT FRANK. *Candy store, New York City,* 1955–56

ROBERT FRANK. *Cafe, Beaufort, South Carolina,* 1955–56

Americans derives from a willingness to allow the camera itself to seize the most telling form and then to allow that form to become endlessly associative and generative. In *The Americans* each photograph grows out of the preceding image. The book has a flow that overrides content and geography. It comes on, as Kerouac wrote of Ginsberg's poetry, like Dizzy Gillespie on the trumpet "in *waves* of thought, not phrases." The three unnumbered sections of the book—all beginning with a reference to the American flag—are pure improvisation on the motifs of the road, the automobile, the flag, the jukebox. The book's counterpoint rhythms are wit and fact. Its low obbligato shows neither polite restraint nor euphemism. It realizes its sustained crescendos on the themes of salvation, despair, and death. Its antecedents are Joyce and stream of consciousness, Kerouac and spontaneous prose, and the long, breathless line of a mournful saxophone.

It was Frank's genius and good fortune—as it had been Stieglitz's half a century earlier—to revitalize American photography by way of the European tradition. It was Frank who crossbred native facts and the optimistic idiom of Walker Evans and the early Strand with the tougher, ironic *verité* of Atget, Solomon, Kertész, Brassaï, Brandt, and Cartier-Bresson.

The Americans is a small encyclopedia of photographic forms and styles. There

is no other example in the history of photography in which a photographer has so successfully mixed idioms, varied styles, and developed new pictorial schemes with such monumental effect. Cartier-Bresson's *The Decisive Moment* is a distant second, but his pictorial structuring soon becomes predictable. Frank's photographs are alternately elegant or graceless, luminescent or grim, immaculately focused or fuzzy, apparently casual or excessively mannered. Their shape is dictated by an unswerving commitment to accuracy of feeling and description. Frank used the small camera to mirror the surprise and tenuous balance of the actual world.

Where White, Siskind, and Callahan followed the dictum "no art but in ideas," Frank evidently heard William Carlos Williams—"no ideas but in things." Where the other three showed their allegiance to the dominant trends in American modernist abstraction, Frank fell back on the essential qualities of photographic rendition and the camera's ability for spontaneous organization. He wanted, he wrote in his Guggenheim application, "to produce an authentic contemporary document, the visual impact should be such as will nullify explanation." He brought to photography Kerouac's definition of the new American poetry: "The discipline of pointing out

 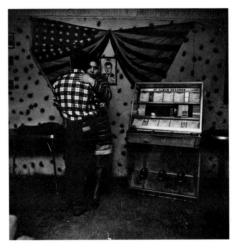

things directly, purely, concretely, not abstractions or explanations, wham wham the true blue song of man."

ROBERT FRANK. *Bar, New York City,* 1955–56

BRUCE DAVIDSON. From *East 100th Street,* 1966–68

Frank's images run the gamut of compositional possibilities, ranging from densely packed renditions to vast open, empty spaces. There are flat frontal elevations and deep perspectives. The photograph's horizon may lie squarely across the picture plane or run wildly off-kilter. There are photographs of intentional concealment, with one object obscuring another, and there are photographs that reveal with breathtaking swiftness and clarity. All combinations and permutations of density, angle, perspective, and placement may be found in Frank's work. There is the photograph of the Detroit drugstore counter with its ragged washed-out edges, restaurant paraphernalia, truncated bodies: a veritable jungle of commercial chaos. There is the photograph of the backyard in Venice, California: an image of such immense optical complexity that in piling up line upon line it almost becomes indecipherable. There are the photographs of eavesdropping, constructed around unrecognizable backs and shoulders abruptly thrust into the foreground. One such image is taken in Convention Hall, Chicago, another in the Club Car en route from New York to Washington. Still another is formed by literally shooting from the hip in a bar in Gallup, New Mexico.

At the other extreme, Frank's photographs can be lean, frontal, as tight and spare as any Walker Evans or even Harry Callahan ever made, but so much more lonely: the nighttime shot of the formal-wear window with Eisenhower's poster; the bright, mysterious car covered with a tarpaulin in the low light of a Long Beach afternoon. And Frank is just as adept in setting up compositional tensions across empty space: the gaming table in Butte, Montana, with its background of election posters; the sweep of U.S. Highway 285 in New Mexico; a pole and mailbox along Highway 30 in Nebraska.

Almost every major pictorial style and iconographical concern that will dominate American straight photography in the late sixties and throughout the seventies can be traced back to one or more of the eighty-two photographs in *The Americans.* The work of White, Callahan, and Siskind virtually—but not entirely—used up the potential inherent in Stieglitz's concept of equivalence. Frank's photographs, on the other hand, laid the groundwork for endless experimentation. The list of major photographers who go back to White, Siskind, and Callahan is surprisingly short, but

ROBERT FRANK. *Restaurant, U.S. 1, leaving Columbia, South Carolina,* 1955–56

JOEL MEYEROWITZ. *Untitled,* 1966

the list of those who derive from Frank is impressive and continually growing. Even Callahan's recent work owes something to Frank's vision.

Frank's cross-country pilgrimage will be repeated time and time again. The picaresque view of America from the road will appear in Lee Friedlander's *The American Monument* and *Self Portrait,* Charles Harbutt's *Travelog,* Burk Uzzle's *Landscapes,* Danny Lyon's *The Bike Riders,* Nathan Lyons's *Notations in Passing,* Michael Becotte's *Space Capsule,* Steve Fitch's *Diesels and Dinosaurs,* as well as in the work of many of the Photo-Realist painters.

Frank's images of the starlets at movie premieres and the opening of the New York City Charity Ball are matched before his time only by the caustic photographs of Weegee. But it was through Frank, not Weegee, that a series of critical, sometimes compassionate, more often cruel, descriptions of people in public places found their way into the mainstream of American photography. Echoes will turn up in Friedlander's party photographs, Mark Cohen's close-ups, and Winogrand's *Public Relations.* And in Frank's dime-store cowboy, New York transvestites, sardonic Jehovah's Witness, and dolled-up older Miami Beach couple lies the basis for Diane Arbus's world.

Specific Frank photographs will sometimes be quoted directly. His isolated TV

set in the deserted luncheonette has become an obsessive image of depersonalization. It will be found again in the portfolios of Friedlander, Davidson, Meyerowitz, Winogrand, and Mertin. And Frank's image of violence on the drive-in movie screen in Detroit is pushed to unbearable intensity by Friedlander. Here America's cold fascination with the automobile and death becomes acute. Anonymously peopled cars line up to watch on the outdoor screen the most traumatic car ride of all: John Kennedy's final motorcade through Dallas.

Most significantly, Frank's willingness to seek radically new ways to present the relationship between content and form, style and subject, marked an end in serious photography to popular notions of composition and subject matter. Frank initiated a tradition dedicated to a most aggressive exploration of the structuring of visual information.

ROBERT FRANK. *Drive-in movie, Detroit,* 1955–56

LEE FRIEDLANDER. *New York,* 1963

The First Viceroy of Photography

John Szarkowski

One of the favorite pictures of John Szarkowski, the Director of the Department of Photography at the Museum of Modern Art, is a photograph by John Runk. Few have ever heard of Runk and, but for this one picture Szarkowski borrowed from the old photographer while on a visit to his run-down studio in Stillwater, Minnesota some 20 years ago, few are likely to hear of him again. Made at the end of the logging era in that part of the Midwest, it shows a rude and ruddy workman with high . . .

Surrogate Reality

Szarkowski and Winogrand: The Curator and Photographer as Theorist

Frank rarely commented upon photography. The great influence he had on the medium stemmed from the power of his images themselves. In the sixties, however, the single most pervasive influence on American vanguard photography was not a body of photographic work, but the written and spoken commentary of John Szarkowski and Garry Winogrand.

Szarkowski had been appointed Director of Photography at the Museum of Modern Art in 1962. Two years later, in his first major "downstairs" exhibition—an exhibition that corresponded with the opening of the permanent photography galleries upstairs—Szarkowski chose as his theme the aesthetic premises of the medium itself. *The Photographer's Eye* was Szarkowski's radical response to his predecessor's *The Family of Man.* Where Steichen had generalized the photographic endeavor, Szarkowski was determined to indicate its specificity. His theme was also clearly chosen to challenge the expressionists, who by now had won some measure of establishment support. In organizing the show, Szarkowski chose "to epitomize the visual and pictorial concepts which are peculiar to the photographic medium." He selected photographs drawn from the fine-art history of photography as well as anonymous vernacular images. Conspicuous by their absence from his selection were Stieglitz

Two-page spread from *American Photographer,* Premier Issue, June 1978. Photographs by John Runk (left) and Lee Friedlander (right). Article by Sean Callahan, "The First Viceroy of Photography, A full-length portrait of MOMA's John Szarkowski"

and Adams, whose monumental *Mount Williamson* had dominated *The Family of Man.* Equally conspicuous by the emphasis given their work were Lee Friedlander, Henri Cartier-Bresson, Robert Frank, André Kertész, and Edward Weston.

Szarkowski's choice of the Weston images was particularly indicative of the aesthetic he wished to support. Three of the six Westons in the show were more reminiscent of Evans. *Hot Coffee, Mojave Desert* (1937); *Storm Arizona* (1941); and *Ivanos and Bugatti* (1931) had little relationship to the typical Weston photographs published and displayed up to that time.

The exhibition contained no photographs of private truths, no photographs, to use Szárkowski's words, which "expressed in a style heavy with special effects: glints and shadows, dramatic simplicities, familiar symbols and idiosyncratic techniques."

The Photographer's Eye, both as an exhibition and as the subsequently published book of 1966, did reach both photographers and the public. But it was perhaps Winogrand, who, as an aesthetician, had the most direct impact on photographers

PAUL B. HAVILAND. *Passing Steamer,* c. 1912

JOHN SZARKOWSKI. *The National Farmers Bank, Owatonna, Minnesota,* c. 1950. Louis Sullivan, architect

themselves, for he spoke not as a critic or curator, but from the point of view of a practitioner. Winogrand, in almost every aspect of his commentary on photography, echoes Szarkowski's position. But where Szarkowski possesses an urbane, witty, cosmopolitan voice, Winogrand speaks in the rough and bristly voice of a street corner philosopher. Where Szarkowski's style is eloquent, Winogrand's awkward and provocative speech has the gruff energy of a commonsense, Lower East Side, Jewish intellectual. Winogrand has chosen to comment on photography in a much less systematic way than Szarkowski, electing the role of provocateur rather than teacher, refusing to discuss his own work, preferring to talk about the nature of photography in general, but at the same time indicating a strong suspicion and antagonism for theory itself. Yet, despite Winogrand's reluctance to systematize his thoughts, what has emerged from his numerous lectures, interviews, and social exchanges is an extremely well conceived, almost abstract argument on the nature of photographic description. Winogrand left photography two legacies in the sixties and seventies: his own images and the scattered but cohesive foundations of a significant photographic aesthetic.

Szarkowski's and Winogrand's philosophy is in some ways an extension of the aesthetic theory initiated by the expressionist photographers. Both philosophies would insist on the transformational power of the medium. Both wished to liberate the photograph from its traditional role as document and to insist on the primacy of the photographer and of the medium itself. The expressionists, however, approached these issues from the standpoint of content—the photograph's theme, emotion, symbol, metaphor, and meaning; Szarkowski and Winogrand would emphasize representation and form. Their writings and comments would remain skeptical of the moral imperative embodied in Frederick Sommer's statement: "Fact is only fact when we have taken its spiritual measure." And they would remain openly hostile to the romantic solipsism of Henry Holmes Smith's declaration: "The intensely felt subjective image is always the reason for making a first rate picture."

Unlike their immediate predecessors, who had seen photography as an art of self-discovery, Szarkowski and Winogrand regarded it as an art of description and

GARRY WINOGRAND. *Untitled*, c. 1962

formal discovery. While the expressionists moved toward abstraction, Szarkowski and Winogrand held out for an unequivocal realism. The expressionists spoke of intention and meaning, while Szarkowski and Winogrand spoke of fact and seeing. "Photography," Winogrand wrote, "is Perception (seeing) and Description (operating the camera to make a record) of the seeing."

Szarkowski and Winogrand derive their approach from a bold integration of realist and formalist positions. This stance, which recognizes the paradox at the heart of photography—its representative yet abstract nature—had been articulated twice before. First, it was tentatively advanced in the 1890s by the English photographer and theorist P. H. Emerson, the leader of the Naturalistic School. Then in a brilliant, if ungainly, analysis of the inherent qualities of the straight photograph, Marius De Zayas, writing in *Camera Work* in 1913, anticipated in both concept and vocabulary Szarkowski's and Winogrand's arguments of fifty years later:

Photography is the plastic verification of a fact. . . . When man uses the camera without any preconceived idea of final results, when he uses the camera as a

means to penetrate the objective reality of facts, to acquire a truth, which he tries to represent by itself and not by adapting it to any system of emotional representation, then, man is doing Photography. Photography, pure photography, is not a new system for the representation of Form, but rather the negation of all representative systems, it is the means by which the man of instinct, reason and experience approaches nature to attain the evidence of reality. Photography is the experimental science of Form.

To complement De Zayas's discussions, *Camera Work* published during this period some of the first significant photographs based on careful observation and an understanding of photographic description rather than on imitation of other media. Among these were Paul Haviland's *Passing Steamer*, J. Craig Annan's *The White House*, Stieglitz's *Going to the Start* and *The Steerage*, and Paul Strand's *The White Fence*. Yet acknowledgment of these perceptions and images was short-lived, for they came

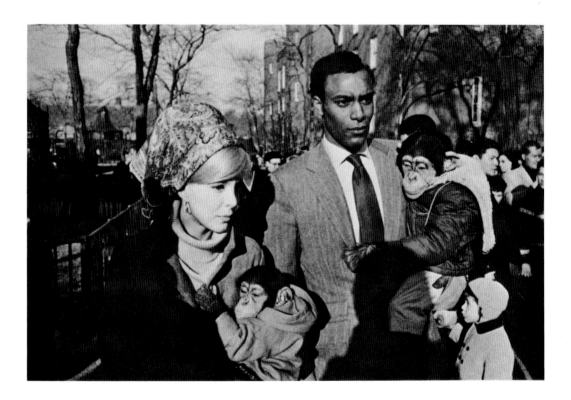

GARRY WINOGRAND. *Central Park Zoo, New York City,* 1967

from a hybrid European-American sensibility too far ahead of its time. During the next fifty years, American pragmatism would insist on representation, on fiction, or on form. One aspect or another, but not all three.

By contrast, Winogrand and Szarkowski would insist on the interdependent nature of the photograph's representational, fictional, and formal qualities. Taken individually, these three qualities are quite obvious. First, a photograph does have the ability to render the world in meticulous detail; it functions as a record of a particular time and place. Second, while the world is dimensional, colorful, in flux, and visible from infinite vantage points, the black-and-white photograph is flat, monochromatic, motionless, contained within a frame, and descriptive of only a single point of view. In fact, the medium so radically alters the world that the photographic image may be understood to have more in common with fictional descriptions than with tangible facts. Finally, because of characteristics of optics, chemistry, and mechanical framing, photography necessarily imposes its own formal order on the photograph.

While these qualities may be obvious taken separately, the corollaries that Winogrand and Szarkowski derive from their interdependence are frequently obscure. For Winogrand the photograph is the "illusion of a description of what the camera saw." And Szarkowski has called photographs "irreducible surrogates for the experience they pretend to record." Each of these statements emphasizes the simultaneity of fact and artifact, belief and disbelief, reality and illusion. Szarkowski and Winogrand are saying that our experience of a photograph is not unlike our experience of the world, but it is not our experience of the world, it is our experience of the photograph. Although these statements are based on a notion of transformation similar to those employed by the expressionists, Szarkowski and Winogrand strip that notion of any symbolic significance, substituting instead an almost mathematical statement of inequality. The camera cannot lie, neither can it tell the truth. It can only transform. The very nature of the medium forces a disjuncture between the photograph and the world, yet the habits of perception—our everyday use of photography—force us to see

"The way I understand it, a photographer's relationship to his medium is responsible for his relationship to the world is responsible for his relationship to his medium."

—Garry Winogrand

PHOTOGRAPHER UNKNOWN. Final page from *Public Relations,* 1977. Photograph of Garry Winogrand at opening

the image as a surrogate reality. *Disjuncture* yet *resemblance* are photography's defining characteristics.

For Winogrand and Szarkowski, form and content are not the exclusive province of the camera or the world or the eye but arise from the intersection of all three. The final resolution of these entities as a photograph is beyond the photographer's total control, because the interaction that generates the image is changeable and organic, defying absolute preconception. Each shift in the world or in the camera produces a new image; each shift presents the possibility of discovering radically new subjects and ways of seeing. "A change in form is a change in content," Szarkowski wrote. "Every frame will define a subject different from any defined before. . . . Only the description itself identifies the thing described." And Winogrand declared in his most famous statement, "I photograph to find out what the world looks like photographed."

The central photographic problem, then, for Szarkowski and Winogrand is the constant adjustment of the inequities in subject, camera, and intuition so as to allow

the medium to generate in Szarkowski's words, "the seamless coherence of its description." This involves operating the camera to simultaneously explore and reformulate the photograph's three prerequisite qualities—representation, fiction, and form—without having one of these aspects "overwhelm" another. The goal is to keep all in balance. The process succeeds when, in Winogrand's words, "the photograph is the most transparent . . . where there's the least evidence of the hand . . . where the photographer seemingly exists the least."

This subtle equilibrium is easily upset. If the form becomes too mannered or stylized, the photograph will lose its authenticity as representation, becoming too much like art. "Robert Frank's work winds up as much a strategy as anybody else's. It's self-defeating in that sense," Winogrand remarked. On the other hand, if the content becomes too provocative, too dramatic, it tends to draw the viewer away from the photograph's subtleties as form and fiction. "There's the question of the tension again," Winogrand said about his own photograph of an interracial couple walking

ANSEL ADAMS. *Alfred Stieglitz and Painting by Georgia O'Keeffe, at An American Place, New York,* 1944

PAUL HUF. *Edward Steichen and John Szarkowski,* c. 1967

in Central Park holding a pair of chimpanzees. "Does the content overwhelm the form, or doesn't it? I really don't know. I still don't trust it, but I'm interested in it."

While the traditional painter was concerned with placing his signature on a painting by idiosyncratic style and manner, the photographer should minimize personal interference with the medium. Szarkowski says that in photography, "wit," "grace," and "intelligence" are demonstrated through the utmost objectivity and descriptive accuracy. These three virtues provide a photographer with his own distinctive signature, identifying a body of work as a singular vision. The most advanced photographers use these qualities to hold in suspension scenes of great diversity and complexity. The greater the complexity of elements integrated into photographic coherence, the greater the achievement of the photographer. "Consider the photographs of Garry Winogrand," Szarkowski wrote in *The New York Times* in 1975. "They are virtuoso pieces, showing us with precision three times as much as we would have thought relevant, but they also seem something more. Possibly they are celebrations of the moment when a skillful juggler is about to overreach himself, and put one fragile plate too many in the air."

Still Photography: Witness and Artifact

The expressionists divided the photographic enterprise into pieces of a pie, calling these documentary, pictorial, informational, equivalent, and abstract. They saw a photograph's meaning as ultimately tied to its extraphotographic connotations. The photograph's content was extrapolated back to the real world and discussed as symbol, culture, reflection, or expression. Szarkowski and Winogrand renounced such definitions. The effect of this renunciation was to synthesize two traditionally antipodal aesthetics: photography as witness and photography as artifact. Perceiving the photograph not as the world but as an addition to the world denied the traditional distinction between genres. For Szarkowski and Winogrand, the documentary photograph could be defined as fictional, the abstract photograph as representational, the metaphoric photograph as realistic. The radicalness of such definitions lies in the fact that in all cases Winogrand and Szarkowski see the photograph as dealing solely

with the literal, representational world. "What photograph is not a snapshot, still life, document, landscape, etc.?" Winogrand wrote. "Neither snapshot, document, landscape, etc. are descriptions of separate photographic aesthetics. There is only still photography with its own unique aesthetic. *Still photography* is the distinctive term."

JERRY N. UELSMANN. *Beaumont Newhall,* 1968. Combination photograph

JUDY DATER. *Minor White,* 1975

 Winogrand's statement not only obviates the distinction between genres but also represents that prototypical American skepticism for anything but the most pragmatic. Szarkowski and Winogrand believe that a photographer whose intention is meaning rather than description will ultimately be defeated by the process. The nature of photography precludes editorializing. It is primarily an art of description, not ratiocination. As a sophisticated game, it is a discipline, in Szarkowski's words, of analytic, not synthetic, intelligence.

 Szarkowski and Winogrand do not totally deny meaning to the photograph. Szarkowski has written some of the finest commentary "attempting to translate these appearances into words." But for him, this "is surely a fool's errand, in the pursuit of which no two fools would choose the same unsatisfactory words." Even Wino-

grand, usually more antagonistic to meaning ("I don't have anything to say in any picture"), has admitted, "But you do, from your experience, surmise something. You do give a photograph symbolic content, narrative content. . . . But it's nothing to worry about! It doesn't have to do with taking pictures! God forbid you should have all this mumbo-jumbo in your head when you're working! But it's interesting to try to understand."

Szarkowski's and Winogrand's antimeaning position is clearly a reaction to the excesses of the expressionists' obfuscating rhetoric. It is the product of the more taciturn, formal, detached mood in art during the sixties and seventies. But it also springs from a fundamental belief that the problem of meaning in photography was literally too complex to tackle. The meaning of a photograph was too deeply embedded in the medium itself. "The meanings of words and those of pictures are at best parallel, describing two lines of thought that do not meet," Szarkowski has written. "If our concern is for meanings in pictures, verbal descriptions are finally gratuitous."

The strength of each man's position in the photographic community has given his pronouncements great leverage. Winogrand, by setting forth an aesthetic and then demonstrating it, has provided concrete examples of a theory at work, and many young photographers have followed his lead. Szarkowski, by virtue of his directorship at MOMA and his clear decision to act as essayist, curator, collector, and proselytizer for his beliefs, has functioned as a tastemaker of unmatched influence. There are few places one can turn in contemporary photography where one does not meet directly his voice or viewpoint. He has been the most commanding critical presence in photography for the last twenty years. Szarkowski has inherited that position, which—in spite of photography's egalitarian base—has always been the province of one man. Stieglitz held it at the turn of the century, Steichen for the next several decades, and now Szarkowski. Only Beaumont Newhall and Minor White, and to a far lesser extent Nathan Lyons and Peter Bunnell, have approached the range of power and influence at Szarkowski's command.

Szarkowski's and Winogrand's influence can be felt in several distinct areas. First, they helped create a climate for an unprecedented exploration of the straight aesthetic, particularly in hand camera work. The photographs of many young photographers can be traced to their influence, support, and direct encouragement: Tod Papageorge, Henry Wessel, Jr., Bill Zulpo-Dane, William Eggleston, Stephen Shore, Nicholas Nixon, Robert Adams, Chauncey Hare, Lewis Baltz, and William Christenberry, to name only the most prominent. Second, their concern for form and objectivity has encouraged a photography and, indirectly, a painting of topographical description. Third, their theories can be found at the core of conceptual photography, which takes as its strategy the parodying and radical exploration of the straight practice. Fourth, their emphasis on the medium itself has encouraged renewed and sophisticated interest in flash photography and color photography, basic components of everyday photography which had been slighted by previous generations. Finally, their theory helped to precipitate the almost total disappearance in the seventies of the traditional documentary photo-essay.

Taken to its logical conclusions, Szarkowski's and Winogrand's theory goes too far. In their attempt to counter the excesses of their predecessors, they have created their own excessive ideology. Their notion of the characteristics of the medium has provided a new mystification for the very art they had hoped to demystify. At times, though, the breadth of their concerns has partially redressed this overstatement. The stringencies of Szarkowski's theory have been tempered by his ability to write and speak well about photographic content, history, and meaning. The stringencies of Winogrand's comments have been tempered by the fact that his photographs— despite his protestations to the contrary—have a rich, available meaning.

Nevertheless, during much of the seventies the words *form, content, description,*

and *fiction,* among others, became obligatory in photographic discussions. They were used with a religiosity reminiscent of Stieglitz's *equivalent,* Weston's *essence,* and White's *light.* Now, however, after a decade of use, this vocabulary, rather than breeding new information, has tended to become sterile; rather than pointing out significant differences, it has tended to homogenize. Seeing photography as an aesthetic event, Szarkowski's and Winogrand's admirers have raised their mentors' concepts to the level of a critical litany. In their short introductory statements to *New Topographics,* an Eastman House exhibition of 1975, Nicholas Nixon, Lewis Baltz, and Robert Adams repeat Szarkowski and Winogrand almost verbatim. For these young photographers, as frequently for Szarkowski, the formulaic vocabulary and the well-turned phrase have obscured rather than revealed and have uncomfortably restricted the range of work that will fit the definitions.

In their attempt to promote a clearer awareness of the camera's inherent qualities, Winogrand and Szarkowski have urged an emotional detachment from the world. Ironically, the very works on which their notions are based—the photographs of Atget, Evans, Frank, Friedlander, and Winogrand himself—derive their power from the persuasiveness of their commentary on the real world. The photographs of these men are certainly about photography. But they make statements that are emotional as well as formal, that concern life as well as art.

2, look equally inept in a different foreground figures loom huge, ite and vague against an infernal as they do in the worst kind of hotographs; the tiny background rge from the darkness all shiny yeballs; everyone's gestures and s are frozen forever in grinning

ily photographs that first brought win fame are more formal in their ns, but only in an amateur snap-Most of them are posed portraits that can be found in anyone's otograph album, with a lot of ous clowning and mugging in camera. Stephen Shore's views an cities are equally distant from ideas of good photography. They semble the kind of commercial tcards that are sold in small town , though they are, it is true, usu-composed. And then there is en. Cohen's large black-and-ts announce that they are art by nanding presence, but in other ey look like object lessons in be-eptitude. When Cohen gives us, skipping rope, he cuts off the head d shows the legs, arms and torso e may reverse the procedure and legs and feet only. Or, he may eople altogether and give us a

Garry Winogrand, *American Legion Convention, Dallas, Texas, 1964*. "I don't have anything to say in any picture," he states.

Szarkowski and the Museum of Modern Art have come in for a lot of abuse for their support of these and other kinds of photog-raphy that could equally well be called "anti-formalistic." In 1973, under the title "From the Picture Press," the Modern mounted a major exhibition of the kind of journalistic photographs that are published in tabloid newspapers. The exhibition was carefully designed to deflect interest from the subject matter of particular photographs to certain general themes, but all the same most of the New York critics looked down their noses at it. These "non-art" photo-

photographic tradition." However, wit one exception, John Gruen, the critics ig nored the show.

The Modern is not, however, the onl museum to show an interest in expandin our sense of the photographic tradition There is widespread interest in anti formalistic photography in museums and a centers all across the country. Eggleston' first major exhibition was not at the Moder

Straight Shooting in the Sixties

The Practice of Theory: Lee Friedlander and Garry Winogrand

As the critic Leo Rubinfien has pointed out, Winogrand "owns the 1960s, in the special sense in which it is commonly said that Robert Frank owns the 1950s, and Walker Evans the 1930s." Winogrand's is a major body of work in the tradition of documentary photography as a literary art: it provides commentary. Culminating the major documentary tradition of Atget, Evans, and Frank, it describes a political, social, and cultural world.

Lee Friedlander's work, on the other hand, initiates a more radical means of using the same public subject matter. His photographs are perhaps the most successful embodiment of Szarkowski's and Winogrand's aesthetic. More than Winogrand himself, Friedlander pushes this aesthetic to its limit. His work moves beyond anecdote, journalism, and history to provide statements more clearly linked to theory—statements that involve the processes of observation and description themselves.

The line between Friedlander's and Winogrand's photography is often thin, at times indistinguishable; there are images by each man that could easily have been taken by the other. But each is working close to, yet on opposite sides of, the position that Szarkowski and Winogrand articulated. Each photographer has chosen to em-

Detail of a page from *ARTnews*, April 1978. Article by Gene Thornton. Photograph by Garry Winogrand, *American Legion Convention, Dallas, Texas,* 1964

**CONTEMPORARY PHOTOGRAPHERS
TOWARD A SOCIAL LANDSCAPE**
BRUCE DAVIDSON LEE FRIEDLANDER GARRY WINOGRAND
DANNY LYON DUANE MICHALS EDITED BY NATHAN LYONS

NEW DOCUMENTS

DIANE ARBUS · LEE FRIEDLANDER · GARRY WINOGRAND

Cover of *Contemporary Photographers: Toward a Social Landscape,* George Eastman House, 1966. Photograph by Gary Winogrand, *San Marcos, Texas,* 1964

Cover of *New Documents,* Museum of Modern Art, 1967. Exhibition catalog. Photograph by Diane Arbus, *Triplets in their bedroom, N.J.,* 1963

LEE FRIEDLANDER. Cover of *Self Portrait,* 1970. Photograph, *Tallahassee, Florida,* 1970

phasize antipodal aspects of the straight aesthetic. In his desire for transparency and in his antipathy to the "arty," Winogrand necessarily deals in real-life meanings. His work is constantly in danger of having, in his own words, the "content overwhelm the form." Friedlander, though, has no compunctions about exploring unconventional forms, trick shots, and odd angles. His work treads carefully near that line where form overwhelms content. Winogrand, in the midst of great disorder, strives for clarity. He is the acknowledged master at discovering simplicity, coherence, and the unencumbered viewpoint amid unimaginable chaos. Friedlander, on the other hand, consistently chooses viewpoints that obscure and heighten the complexity and ambiguity of the image. His photographs play an elaborate game of hide-and-seek with the world.

Friedlander's work is predicated on the belief that photography is primarily an aesthetic activity to be played with deadpan humor. He takes at face value Winogrand's remark that photography is not about the world, but about the world photographed. Where Winogrand emphasizes photography's relationship to sight, Friedlander emphasizes its relationship to art. Where Winogrand attempts to create the illusion of literal description, Friedlander makes no pretense of conventional sight. His images are artifice. Both imply the radical proposition that eye sight and photographic sight are not the same. Their photographs make us aware that the effects of compression, equal density, sharpness, and juxtaposition are the province of the medium, beyond the scope of the human eye and habitual seeing. Their world is precisely that world described by the wide-angle Summicron lens of a Leica stopped down in bright sunlight or strobe light.

As a documentarian, Winogrand has made the camera an extension of his eye. Friedlander's achievement is more extreme: his eye has become an extension of his camera. His photographs show a world that was unprecedented, unknown, and inconceivable before it was photographed. Although Winogrand has significantly extended our understanding of observational and pictorial possibilities, Friedlander has taught us an altogether new way of seeing. His photography exists as a cross between Muybridge's visual experiments describing the previously unseen world of animal locomotion and Winogrand's images of extraordinary yet direct observation.

Winogrand's and Friedlander's first significant impact on American photography came through a series of exhibitions in which they were paired together. In 1966 they appeared together first in *Twelve Photographers of the American Social Landscape*—the exhibition that coined the term *social landscape*—organized by Thomas Garver for the Rose Art Museum, Brandeis University. Then in December of 1966 they appeared with Bruce Davidson, Danny Lyon, and Duane Michals in *Toward a Social Landscape,* organized by Nathan Lyons for George Eastman House. A year later, Szarkowski exhibited them with Diane Arbus (her first major show) in *New Documents* at the Museum of Modern Art.

This early pairing and the titles of the exhibitions have tended to imply that the two work exclusively in a social-documentary aesthetic. Yet each photographer may be seen as deriving from distinctly different lineages. Each in his own way, through a marvelous interchange of pedigrees and paternities, recapitulates the major traditions of straight photography.

Friedlander and Winogrand continue the main thrust of American photography: the personalizing of the documentary aesthetic, the shifting of the delicate balance between record and interpretation toward expression. Ten to fifteen years earlier, documentary photography had taken the grand purview. Its subjects were *The Family of Man, The World of Henri Cartier-Bresson,* and *The Americans.* Now, as the qualifying adjectives *social* and *new* indicated, documentary work became hybrid in nature. The new documentary photographers would move beyond photography in the service of social cause and would use the urban setting—just as the expressionist photographers had used the natural landscape—as the raw material for personal,

formal, and metaphorical statement. This hybrid of the documentary and the personal would become the defining quality of American street photography.

Lee Friedlander: Fragments, Documents, and Metaphors

Friedlander's closest ally in art is not a photographer; it is the painter Robert Rauschenberg. Like Rauschenberg, Friedlander views his photography as a synthesizing activity: the photograph is an environment constructed like a collage. Like a Rauschenberg painting, a Friedlander photograph is made up of apparently fragmented, discontinuous parts. But where Rauschenberg pieces the parts together, Friedlander grasps them in a single, coherent moment.

Friedlander's more direct photographic lineage may be traced first to Edward Weston and Walker Evans and then to Robert Frank. American straight photography has been a continual debate between the aesthetics of pure form and the aesthetics

of apparent formlessness, between order and disorder. The classic photographers of the first part of this century—Stieglitz, Strand, and Weston—perceiving the world not as evidence but as form, opted for exaggerated order. Evans, on the other hand, considered such stylization overly mannered and chose a more casual ordering. Friedlander's sense of description derives from both attitudes. From Weston, he inherited an obsessive sense of order and an abiding sense of the world as aesthetic object. From Evans, he acquired a quotidian vocabulary, a willingness to tamper with the traditional picture edge, and a sense of the beauty of natural light on the architecture of the American small town. Robert Frank provided Friedlander, as he did Winogrand, with a radical approach to form. And Frank extended Evans's vocabulary, passing on to Friedlander a public vocabulary spoken at street level in an urban world. The icons in Friedlander's work are borrowed directly from Evans and Frank. They are the essential symbols of proletarian democracy: the American flag, the American military and political monument, and the American political poster.

Friedlander may have inherited his sense of ideal form and description from Weston and Evans and his subject matter and vocabulary from the documentary

ROBERT RAUSCHENBERG. *Estate*, 1963. Oil and silkscreen ink on canvas, 96 × 70". Original in color

LEE FRIEDLANDER. *Santa Fe, New Mexico*, 1969

photographers, but it is the work of Callahan, Siskind, and White that most closely parallels his fundamental attitude toward photography. Like these expressionists, Friedlander is more concerned with defining himself and his vision than with revealing the nature of society. In his photographs the self appears overtly or covertly as the ultimate metaphorical presence. It presides as the photographer's shadow on the landscape or reflection in the mirror. His work's basic theme is the strength and idiosyncrasy of individual sight and the power of sight to organize, contain, and explain the world.

Like the expressionists, Friedlander has a profound respect for the detail, a belief in the descriptive beauty of light and luminosity, and a tendency toward metaphor and abstraction. In recognition of these ties, Szarkowski, in *The Photographer's Eye*, paired him not with Winogrand but with Minor White. On facing pages, Friedlander's angry dog in a store window, *Jersey City, New Jersey* (1963), growls at White's *Sand Blaster* (1949).

Finally, to this paternity the work of Atget, Kertész, and the Sunday snap-

LEE FRIEDLANDER. *New York City*, 1974

EDWARD WESTON. *Salinas*, 1939

shooter must be added. From Atget, Friedlander derives a fascination with reflections and framing. With Kertész he shares perversity and wit, a delight in the ambiguities and oddities discovered by the hand camera. And to the snapshooter Friedlander's debt—as is Winogrand's—is incalculable.

In his search for a subject matter appropriate to contain the complex forms that his eye extracts from the world, Friedlander has investigated the desolate inner city, the architectural elegance and chaos of the city itself, and the more lyrically complex entanglements of the suburbs. These three areas of inquiry are not chronologically distinct; Friedlander has moved back and forth between them for over twenty years. Nevertheless, the movement from the confinement of the city to the more open suburbs has been generally continuous. This slowly changing emphasis is more than a change of content, it is a metaphorical journey as well. For at the heart of Friedlander's complex formal structuring lies a psychological odyssey of self-definition not unlike Callahan's and White's. But where the expressionists used metaphors derived from Stieglitz's "Equivalents," Friedlander's metaphors stem from the documentary tradition.

Friedlander began the sixties with a solipsistic quest for his own image, at-

tempting to find the necessary evidence in the literal world. "I suspect it is for one's self-interest that one looks at one's surroundings and one's self," he wrote in 1970 in the introduction to his first book, *Self Portrait*. In this early work, it seems at times that Friedlander himself becomes one of the protagonists of a Frank or Evans photograph. Both as a persona in the image world and as the human presence behind the camera, Friedlander becomes one of the poor and dispossessed. He is the itinerant traveler, the frequenter of cheap hotels, tawdry small towns, second-hand stores, and burlesque theaters. His early work in particular sums up all the sadness and loneliness of the American documentary tradition. This is a world of impending terror and sexuality: Friedlander's shadow threatens a woman on the street or waits menacingly in the corner under the sign "Girls Wanted" as the feet of two high-heeled women enter the darkened pavement of the picture. In another image the gaudily framed portrait of an attractive brunette blossoms from the shadow of the photographer's thigh.

In photographing this world, Friedlander does not show the class condescen-

sion or mockery that Winogrand frequently demonstrates. Winogrand leers at the rich and is haughtily indifferent yet amused by the maimed and the poor. Friedlander is always one with the walkers of the street.

LEE FRIEDLANDER. *Jersey City, New Jersey,* 1963

MINOR WHITE. *Sandblaster, San Francisco,* 1949

In Friedlander's photographs of the city, the issues of self-definition are extended to an investigation of the human presence in the urban landscape. For Friedlander the city is an environment of continual framing which duplicates the photograph by constantly incorporating forms and people into rectangular frames. The window, the showcase, the mirror, the door, the telephone booth, and each new vantage point offer the possibility of totally unprecedented juxtapositions, containments, and superimpositions. They provide the photographer with an endless series of ready-made, framed portraits. Friedlander's city is peopled by images of images. The photographic portrait becomes the great leveler of individual differences. Friedlander sees the inhabitants of the city as reproducible visual forms. They become merely presences: surrogates for the photographer himself or visual elements in an architectural landscape.

Frequently the human presence has been reduced to the two-dimensional plane even before Friedlander clicks the shutter. The photograph itself appears in Fried-

lander's work framed behind glass, on drive-in movie screens, taped across the Los Angeles skyline, on political posters, and as a disembodied image on the TV screen. Even when people are apprehended directly, they are imprisoned in a photographlike world: through a file-card cutout in a New York street window, a man, overcome and crushed by the city, lays his head on folded arms.

The equality of all these portraits is stressed both by visual facts and by visual puns. In a single storefront window display, photographs of Lyndon Johnson and Hubert Humphrey are framed alongside those of burlesque queens. There is essentially no distinction between the celebrity and the common man. By finding the proper vantage point, the photographer becomes the most famous American: standing in front of a political poster for JFK, Friedlander allows his own reflection to complete the Kennedy portrait. Compared to Frank's and Evans's political posters, the images of the politician and celebrity have come full circle. After innumerable photographic reproductions, the reproduced image itself becomes a mere mask. It can be worn by anyone. It is Everyman. For Friedlander the stereotypical American

GARRY WINOGRAND. *Hollywood Boulevard, Los Angeles,* 1969

GARRY WINOGRAND. *Untitled* (Central Park Zoo, New York), c. 1968

is not the burly, flesh-and-blood, flag-waving demonstrator of Winogrand's photograph, but the American transformed into reproducible, photographic form.

In Friedlander's project *Gatherings*—a series of flash photographs taken at parties and singles bars—he once again removes the corporality of his subjects by blanching them out in an explosive burst of light. More recently, in a cooler vein, he has made an epic series of American monuments. Here, forgotten statues in small towns and decaying cities become part of an elaborate picture puzzle. Often hidden in the frame, they force the viewer to search for that cold definition of the human presence in the landscape.

Friedlander's city contains no hierarchy of places, people, or objects. No single item is given increased social, political, or cultural weight. His visual strategy makes all people and all places virtually interchangeable. His photographs are, in Szarkowski's words, "fake documents of place." Friedlander, revoking the specificity of the documentary tradition, entitles one photograph *Somewhere in Mid-America* (1969).

In Friedlander's set of suburban and garden views, images generally more recent in date, the irony, the artificiality, and the biting visual pun have been replaced by a softer, more lyrical rendering of the world. His complex, matrixlike organization

remains, but terror and adolescent self-searching have given way to a much more generous acceptance of the self and of the world. These images, in tenor not unlike Callahan's latest pictures or the last images of Weston and Evans, reflect great mastery of the medium and an unencumbered joy in the potentials of photographic description.

Garry Winogrand: Quick Takes and the Demotic Eye

If Friedlander synthesized the documentary and expressionist traditions, then Winogrand synthesized the documentary and photojournalist traditions. Indeed his own background includes working for almost twenty years as a free-lance photojournalist for *Sports Illustrated, Fortune, Look, Life, Collier's,* and *Pageant.* Winogrand's noncommercial photographs come from that same public world which is the province of photojournalism. In newspaper jargon, his photographs are a series of "quick takes." They have the look and feel, the looseness and spontaneity of an "honest" shot. They

111

are essentially narrative images of "human interest." Tod Papageorge has called them "proverbs, fables, jokes." They are "stoppers": provocative shots that "catch and hold the reader's eye." They show "more than meets the eye." Because of their humanity, they could easily be used to build up a picture story. Because of their wit, it would not be surprising if they turned up as *Life*'s last spread: "Speaking of Pictures."

The fastidious intelligence that informs Winogrand's pictures comes not from photojournalism, however, but from his classic predecessors. From Atget and Evans, Winogrand learned an abiding respect for lucidity within complexity and for clear, coherent description. Atget convinced Winogrand of the need for truth; in Evans's work Winogrand first recognized the distinction between photography and the world. From them and from Frank, Winogrand learned the compatibility of documentation and the personal viewpoint. It was Frank who showed the visual possibilities of the wide-angle lens and radical camera orientation. Winogrand's tilt, rapid firing, and camera agility parallel Frank's willingness to follow the hand camera's own unprecedented framing. It is also Frank, of course, who first explored Winogrand's essential subject matter: the inhabitants of the American city and the American street.

Winogrand has acknowledged his debt to Evans and Frank, but there is also

GARRY WINOGRAND. *Hard-Hat Rally, New York,* 1969

GARRY WINOGRAND. From *Stock Photographs: The Fort Worth Fat Stock Show and Rodeo,* 1974–77

an unacknowledged debt to the New York Photo League. From this group, which stressed the use of photography as a social document and vehicle for change, Winogrand inherited his commitment to social observation and commentary. Winogrand's images contain constant echoes of the radical journalism and form that defined Aaron Siskind's *Harlem Document* of the late thirties, Sid Grossman's snapshotlike images of Coney Island, and the images of the streets of New York by Sol Libsohn, Arthur Leipzig, and Winogrand's early friend Dan Weiner.

Rounding out Winogrand's lineage are the Europeans Brassaï and Cartier-Bresson and the American photojournalist Weegee. From Brassaï and Weegee and from scores of anonymous newspaper photographers, Winogrand derived the merciless, primitive power of the flash, an eye for the disreputable and the dispossessed, and a sensitivity for caricature and subtle violence. It is indeed to Weegee that one must look to find an equally raw, concise, tabloid view of American life. Cartier-Bresson, too, has shown Winogrand the possibilities of moving beyond social comment to social satire. Winogrand's "decisive moment," like Cartier-Bresson's, is fre-

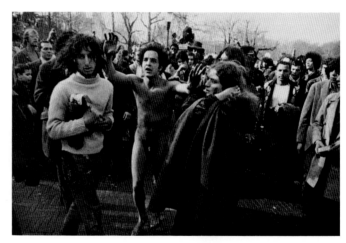

GARRY WINOGRAND. *Centennial Ball, Metropolitan Museum, New York,* 1969

GARRY WINOGRAND. *Easter Sunday, Central Park, New York,* 1971

quently tragicomic. But where Cartier-Bresson's wit, grace, and nuance are peculiarly French, Garry Winogrand's temperament is fiercely American.

For Winogrand, street photography is a Rabelaisian enterprise of broad, coarse humor and uncomfortable confrontations. Winogrand's tragicomic world emphasizes extreme human types and situations. He constantly juxtaposes the well-formed and the misshapen, the well-bodied and the diseased, the human in the animal and the animal in the human, the ordinary and the extraordinary. His viewpoint exaggerates the peculiarities of visual form and character, almost but not quite turning his subjects into caricatures. His photographs contain a casting inventory of the essential city of modern experience: the Madison Avenue executive, the cripple, the little old lady, the beggar, the celebrity, the artist, the photographer, the tourist, the astronaut, the demonstrator, the vice-president, the governor, the policeman, the nubile girl, the dwarf, the secretary, the shopper, and the crowd. Winogrand's people inhabit those places and participate in those events that define American urban history: they are seen on the street, in the park, at the zoo, in shopping malls, museums, press conferences, political demonstrations, athletic events, rodeos, and airports. There is no

112

private world in Winogrand's photographs. And though there is frequently a sense of desolation and emotional distance, there are few empty landscapes. Winogrand's world is a world of social contact. Not since Whitman has an American artist described so teeming an environment.

Winogrand's principal descriptive measures are inclusion and comparison. His vision is predicated on his ability to discover the coherence and simultaneity of multiple actions, gestures, and relationships. His intelligence multiplies comparisons: one relatively simple visual occurrence—a glance, a stare, an animated gesture—alludes to another and then another, building up incredibly intricate but ordered structures. Such virtuosity holds great risk. Perhaps no other major American photographer has produced—or at least chosen to show—so many trivial, banal, and repetitive photographs. One only wishes he had found, as Thomas Wolfe, a Maxwell Perkins to bring his prodigious and uneven output into manageable proportions. As of this writing, he is the only major photographer of the sixties to be without a comprehensive and coherent monograph or exhibition.

Winogrand's achievement has been to take the haphazard world of the conventional news photograph and give that world coherence. Where the majority of viewers have dismissed the backgrounds of such images as irrelevant visual noise, Winogrand has trained himself and a new generation of viewers and photographers to find interconnectedness and unity in an ungainly world. When he succeeds, Winogrand adds immeasurably to our knowledge of both art and history.

The Sixties as Subject

The Public Record

"For me the subject of the photograph is always more important than the picture. . . . I really think what it is, is what it's about," Diane Arbus commented. In spite of the advanced theory and practice of Szarkowski, Winogrand, and Friedlander, photography in the sixties continued to exist for the public as subject matter. The photographers and photographs that were most widely known and discussed were those whose primary concern was new content, not new form. For instance, Arbus's work in *New Documents* almost eclipsed that of her coexhibitors. And it was Arbus, not Friedlander or Winogrand, who in 1972 became the first American photographer to have a large selection of work exhibited at the Venice Biennale. The public was fascinated with photography not as the illusion of literal description or even as literal description. The public was fascinated with *literal fact*.

History, of course, has no real beginnings or endings. But it is convenient and emblematic to consider the sixties enclosed in the parentheses of two unforgettable news photographs: Malcolm Browne's photograph of June 11, 1963, of the Buddhist monk burning himself to death in Saigon, and Nick Ut's photograph of June 8, 1972, of a naked South Vietnamese child just sprayed by napalm running screaming down the highway. From June 1963 to June 1972 the traumatic impact of events and pho-

EDDIE ADAMS. Brigadier General Nguygen Ngoc Loan executing the suspected leader of a Vietcong commando unit, Saigon, Vietnam, February 1, 1968

tographs seemed unrelenting. The most powerful news photographs of this time became the searing, public visual icons of the decade. These photographs include the stills made from the Abraham Zapruder film of John Kennedy's assassination in November 1963; Bob Jackson's picture of Ruby shooting Oswald, made two days after the assassination; photographs made in Vietnam by Philip Jones Griffiths, Donald McCullin, Larry Burrow, and Horst Faas; photographs of civil rights marches and student demonstrations by Bruce Davidson, James Karales, Bob Adelman, and Danny Lyon; the Bolivian government's official picture of the dead Che Guevara, made public in October 1967; Eddie Adams's photograph of General Loan executing a Vietcong officer in February 1968; and John Filo's record of the Kent State killings of May 1970.

These images memorialized the public history of the decade. And just as Joe Rosenthal's 1945 photograph of the Marines raising the flag at Iwo Jima was later cast in epic bronze, serving as a tribute to American victory—and naiveté—many of these journalistic photographs became models for sculpture in the sixties. Duane Hanson's astonishingly realistic sculptures *Vietnam Scene* and *Race Riot* (both 1969)

STEPHEN FRANK. Diane Arbus during a class at the Rhode Island School of Design, 1970

HUYNH CONG (NICK) UT. Trang Bang, Vietnam, June 8, 1972

are reconstructions of the decade's most traumatic photographs. And George Segal's *Bus Riders* (1964), *The Execution* (1967), and the controversial *In Memory of May 4, 1970, Kent State* (1978) are all correlative to photographic imagery.

The strongest photographs to come out of the war, the civil rights movement, the student confrontations, and the assassinations, unlike ordinary news photographs, needed no captions. The facts they contained were clear, indelible, and irreducible. They rendered death and suffering beyond the interpretations of politics and aesthetic consciousness. The most powerful of these were well made and coherent, yet they overwhelmed us with their content, not with their form. Where the basic tenet of art is plurality, the basic tenet of reportage is specificity. These photographs worked so well because they lacked all ambiguity. Winogrand kept his brand of photojournalism on the level of art by building in a complexity that insured uncertainty. He used a baffling array of forms, suppressing content to the point where it became ambiguous, tentative, plural. And though he photographed public events he emphasized public relations rather than history. His aim was art, not journalism.

The battlefield photographer could not afford such luxury. No matter how well constructed his image, it was always constrained by the necessity of explicitness. The journalist uses the basic fact of photographic response—our inclination to first see

facts rather than forms—as the immediate source of the strength of his photography.

The exceptional, beautifully conceived photographs of the Welsh-born photographer Philip Jones Griffiths represent some of the best of these journalistic images. Griffiths's work, following in the tradition of Cartier-Bresson, employs the long, horizontal 35mm format to set out before the viewer a tableau vivant in which a complex, unrelentingly tragic or violent drama is played out. It is a drama in which evil is inescapable, and suffering, violence, and death inevitable. It moves away from isolated human detail and away from the clichés of battle-line photography. Instead, these photographs show suffering as it exists in the profusion of people and things thrown up in the wake of the struggle. This plentitude of detail gives Griffith's photographs exceptional veracity without either indulging the viewer's appetite for the sensational or exploiting the people photographed. Griffiths's images, the most moving of Vietnam War photographs, frequently contain onlookers, unwitting participants who through gestures of disbelief or unconcern, validate the image's authenticity. In these photographs we feel, perhaps even more than the presence of the photographer's eye, the eyes and reactions of the participants. In some of the images, it is the juxtapo-

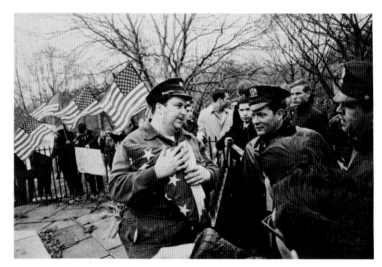

sition of an unconcerned world and an agonizing central action or subject that makes the image so devastating. In others, the faces of the bystanders are more horrific than the image of death or suffering itself.

It is precisely the nature of our response that distinguishes these journalistic photographs from Eugene Smith's photographs of the poisoned Japanese fishing village, Minamata, or from Josef Koudelka's photographs of the Czechoslovakian gypsies, both made during the same decade. Our responses to Smith's and Koudelka's images are predicated on their visual analogies to art. They remind us of ritual, of depictions of the Pietà, the Annunciation, or the Last Judgment. Our response to the journalistic images derives, on the other hand, from a mixture of fascination, incredulity, horror, and disdain.

At their worst, the photographs of the war abroad and the revolutionary activities at home became generalized statements, mere replays in both subject matter and form of the sentimental, melodramatic images that underwrote *The Family of Man*. At their best they moved beyond stereotype, polemic, and pathos, describing with characteristic photographic clarity individual people at a momentous time in a specific place. The best of this work will continue to function more as history than tragedy; it will memorialize the facts rather than the emotions.

JOHN FILO. Kent State University, Kent, Ohio
May 4, 1970

GARRY WINOGRAND. *Peace Demonstration, Central Park, New York,* 1969

Personal Journalism

The sixties was a decade built on and remembered through visual images. No previous decade drew such a narrow line between the news photograph and the fine arts photograph, between the dispassionate observer and the expressive artist. Unlike earlier decades that had been studied with a camera, the sixties acquired a historical image that was not the exclusive province of political, military, or economic events. And not since the thirties had images of fact been so freely accepted as images of art. The same photographs appeared in the press, in history books, in photography books, and on museum walls. By the end of the decade, photographs of politics and war had become psychological metaphors while personal observations took on the character of historical fact.

The best-known personal photojournalists were Diane Arbus, Bruce Davidson, Danny Lyon, Les Krims, Max Waldman, Larry Clark, Eugene Meatyard, and the rediscovered E. J. Bellocq. At first glance, these may seem to constitute an unlikely group, but they share more similarities than differences. Their photographic styles

PHILIP JONES GRIFFITHS. Wounded girl awaits medical help, Bantangan peninsula, Vietnam, 1967

AILEEN and W. EUGENE SMITH. *Tomoka and Mother,* 1972. From the photographic essay *Minamata*

ranged from the sophisticated to the primitive, from the factual to the pictorial, from the reserved to the expressionistic, and their diversity paralleled the contradictions and complexity of the period. Yet they were all committed to a documentation that would act as a genuine visual assault upon their audience.

The photographic community attempted to make subtle distinctions between public and private realities, between the photographer who shot politics and war and the photographer who photographed counterculture activities, calling the first "The Concerned Photographer" and the second "The Photographer of the Social Landscape." Yet the energy and content behind both were the same: no matter how aestheticized, the subject matter was the tumultuous, contradictory, unparalleled life of sixties America. The world, it seemed, had never offered so readily such dramatic material to photograph, and photographers, aroused and incited by this material, had never been so willing to photograph everything that was occurring.

It was consistent with the social and psychological upheavals of the sixties that a documentary focus should emerge that looked at the less newsworthy, internal aspects of the new culture. The photographers of this culture had more in common with the photojournalists than with either the classic documentary or landscape pho-

tographer. Their work was "personal journalism": it evoked the pretense of reportage while in fact describing the world from a significantly personal, subjective viewpoint. These personal journalists, like their peers the photojournalists, were on the lookout primarily for sensational subject matter. Their determination to find the most radical and shocking subject matter paralleled Winogrand's and Friedlander's determination to discover the most radical form. Their quest was just the flip side of Szarkowski's and Winogrand's formalistic coin.

These photographers, like the photojournalists, echoed many of the concerns and manners of the classic social documentary photography of the thirties. Photographers of both the sixties and the thirties wished to share their perceptions of the conditions and expectations of the age. Both sought to further provoke the viewer in an already passionately political climate. And for both the means of giving form and connection to their analysis was frequently the photo-essay.

But the distinctions are more telling. The move from the documentary photography of the thirties to the public and private documents of the sixties was a move

from a style of detachment to a style of intimacy. The historical, ideological, and overt political issues of the earlier photographs are replaced by moral, individual, and psychological issues. A view of America that was sanctioned by both governmental policy and popular belief gave way to views that initially found little popular acceptance. A socialist view that proclaimed the brotherhood and nobility of man gave way to a Freudian view that recorded individual aberrations, individual violence, and individual need. Where the thirties photographers asked the audience to identify with the subject, the sixties photographers more frequently asserted the subject's essential difference from the viewer. The subjects of the thirties were publicly proclaimed as shocking but privately dismissed as cruel yet commonplace; the subjects of the sixties were truly outrageous and painful.

The obsessions of sixties photography were ruthless: alienation, deformity, sterility, insanity, sexuality, bestial and mechanical violence, and obscenity. The icons of the sixties had few redeeming features: the dwarf, the freak, the prostitute, the disenfranchised, the outlaw motorcyclist, the drug addict, the insane, the retarded, the prisoner, the napalmed child, the brutal cop, the assassin's assassin. Their collective subject matter was the unseemly, the outcast, the dangerous, the forbidden, the exotic, and the bizarre.

DIANE ARBUS. *Child with a toy hand grenade in Central Park, N.Y.C.,* 1962

ROBERT JACKSON. Jack Ruby shooting Lee Harvey Oswald, Dallas, November 24, 1963

To deal with this terrifying world, the photographer put himself in constant danger. Both the photographer on the battlefield and the photographer at home constantly reiterated in words and actions Robert Capa's defiant and swaggering remark, "If your pictures aren't good you're not close enough." Donald McCullin, the combat photographer, wrote:

> I look for everything. I look for the worst. . . . I looked around and I saw . . . a grenade . . . and I wanted to look at it. The guy on the extreme right was shouting at me to get my arse down and what the hell was I playing with.

Diane Arbus commented:

> Everything is so superb and breathtaking. I am creeping forward on my belly like they do in war movies. . . . God knows, when the troops start advancing on me, you do approach that stricken feeling where you perfectly well can get killed.

Horst Fass, the photojournalist, wrote:

> Then the mob came in to finish the execution with their trampling feet. . . . But I think it was our job to report all that happened. And I hope and pray no AP man has to see such horror again.

The editors of *The Instant It Happened* wrote:

> Robert Kennedy sinks to the floor and Boris Yaro begins shooting pictures and the lady next to him in the hysteria of the instant, pulls his arm, shouting, "Don't take pictures. I'm a photographer and I'm not taking pictures." Boris Yaro yells, "Let go, lady. Godammit, this is history!"

Bruce Davidson wrote:

> I slowly brought the Leica to my eye, made a couple of exposures, and stood there looking at the ground, hoping they would not attack us.

Danny Lyon commented:

> I made a point always to go where the state of imprisonment was the severest. . . . Also, it was something obviously difficult to do, you know, it was a kind of . . . forbidden fruit.

The American Freak Show

Where the archetype of the thirties was the migrant mother, the archetype for the sixties was the deformed person. On the war front it was the napalmed victim. At home it was the freak. This fact was recognized not only by photography but by popular slang. Hippie culture, with its drugs, rock groups, sexual encounters, and psychedelic art was a culture of "freaks." And the most outlandish and antiestablishment bohemians of the sixties were the rock freaks, the speed freaks, the bike freaks. Intense involvement in any counterculture activity often caused one to "freak out," to suffer a complete psychic breakdown or even death.

The camera, reaching only skin deep, is forced to take physical proportion and physiognomy as emblematic of psychological state. The most radical subject for the sixties was the ultimate minority: the traumatized self. And the most persistent image of that trauma was the dwarf. The dwarf became the dominant image for alienation, for the grotesque and the repulsive. He was the walking human contradiction: part myth, part person, the visual embodiment of all our cultural fears of disease, difference, and deformity. He was a creature known to exist but psychologically difficult to confront or acknowledge. The dwarf was the prototypical social outcast, partaking

in human life without a normal human shape.

The dwarf appears in the late fifties in one of Davidson's first photo-essays. Here he is treated romantically, compassionately, and naively:

> I first saw the dwarf standing outside the tent in the dull mist of a cold spring evening. His distorted torso, normal-sized head and stunted legs both attracted and repelled me. . . . When I finished the photographs of him, I gave [him] a small camera that could fit into his hands.

The circus made the dwarf's presence acceptable and understandable. Society had sanctioned the "big top" as a fitting home for the unusual and bizarre. Winogrand, though, finds the dwarf and midget on the street where his presence is more threatening and inexplicable. Here he is a curiosity, one of the incredible visual facts of Winogrand's world. In Arbus's work the dwarf appears as a traumatic, psychological fact:

> Freaks was a thing I photographed a lot. It was one of the first things I photographed and it has a terrific kind of excitement for me. . . . Most people go through life dreading they'll have a traumatic experience. Freaks were born with their trauma. They've already passed their test in life. They're aristocrats.

IRVING PENN. *Rock Groups, San Francisco, 1967 (Big Brother and the Holding Company* and *The Grateful Dead)*

Meatyard, whose photographs are almost extinguished in blackness, dressed up his children and friends in repulsive Halloween masks, creating for the camera a family of shriveled gnomes. His masked, costumed reality exists on the edge of age, death, and deformity in spite of the fact that the terror is often relieved by a strange, deep sweetness.

The similarities between Meatyard's and Arbus's work are striking. It is surely more than coincidence that these photographers, who concentrated on the masks and costumes of difference and deformity, should have chosen the same format. Significantly, they remain the only photographers of the sixties consistently presenting their work in the square frame. The long, horizontal frame of the 35mm was too broad, too speculative for their visions. The square insistently centered and narrowed their world, reducing the natural horizontal purview of human vision to a concentrated

look at the "other" world which exists within the one we already know. In both cases, as well, the square format recalls strongly the old box camera snapshot. Meatyard thought of his photographs as family pictures and assembled them in a snapshot album, *The Family Album of Lucybelle Crater*, published posthumously in 1974. Arbus, too, as has been frequently remarked, was ostensibly assembling a scrapbook for a sixties version of *The Family of Man*.

The ties between these two photographers go far beyond their use of a similar frame. Both loaded their images with a visual intensity pitched at the point where moral knowledge and mortal frailty explode into black humor and anguish. Both emphasized the mask as the equivocal signature of stifled hilarity and terror. In their most terrifying images, we see behind the false mask not a normal human face but another mask, the mask of defectiveness and insanity, the mask of the idiot. Both discovered during their psychic photographic explorations that they were dying:

BRUCE DAVIDSON. From *The Dwarf*, 1958

RALPH EUGENE MEATYARD. *Romance (N) from Ambrose Bierce*, Number 3, 1962

Meatyard from a long-hidden terminal cancer; Arbus (a suicide at forty-eight) perhaps from an overdose of evil.

In Max Waldman's theater photographs, the dwarf reappears, not in a stunted physique but in the contorted, disturbed faces of the inmates at the asylum of Charenton in Peter Weiss's play *The Persecution and Assassination of Jean-Paul Marat . . . under the Direction of the Marquis de Sade*. Distorted bodies and faces are seen in Waldman's photographs of members of The Living Theatre and of the productions *Dionysus in 69* and *Bluebeard*. Under his lens even Shakespeare's *A Midsummer Night's Dream* and Zero Mostel as Tevye in *Fiddler on the Roof* turn fearsome and deformed. Like Arbus, Waldman portrays a gallery of freaks and a variety of relationships all severed from familiar human interaction. He transforms the players into characters of an equivalently psychotic and sexually perverse world. But where Arbus photographs her actors and actresses in the surreal calm of the dressing room, Waldman shoots them on the frenzied reality of the stage. His dark, heavy, charcoal-like prints reveal only highlight and shadow, forcing the viewer of the print even more than the viewer of the play to become the voyeur. Peering into the darkness of the

print, we cannot know what is really occurring. As with Arbus's work, the look generated by these photographs is not the glance but the wide, uncomprehending stare.

Dwarfs are again a subject for Les Krims in *The Little People of America* (1971), a seemingly legitimate documentary essay. Here they are seen doing the most conventional things: teaching Fido to sit and beg, ironing the clothes, touring on vacation, hamming it up before the camera, dressing up for a costume party, showing off home snapshots. Yet Krims's carefully chosen environments and camera angles, the harsh flash light, and the exaggerated presentation of the images—they were printed on excessively grainy Kodalith paper and packaged as a set in a small five-by-six-inch boxed folio—belie their journalistic nature. The photographs are ultimately propaganda, not for justice and understanding of the "little people" but for the absurd and the comic. In this essay Krims is not compassionate or even neutral;

he is condescending and quietly mocking. His photography subtly exaggerates rather than minimizes differences and deformities. Where Arbus dealt with dwarfs as an existential fact, Krims sees them as comic relief.

Nevertheless, *The Little People of America* and *The Deerslayers* (1972), a photo-essay which contrasts the fallen animals tied to the hoods of big American cars with their grinning killers, were important in opening up additional forbidden subject matter to the American photographer. More provocative, though, were the "fictional" works that Krims began during the same years. In these he chose even more outlandish and uncouth themes, allowing his early semiseriousness to degenerate into a teasing buffoonery as he deliberately sought out as subject matter anything that was not supposed to be photographed. Krims's work in this vein was perhaps a tonic relief to an overly anxious search for profundity and distress. In the folio *Mom's Snaps* (1971) and the book *Making Chicken Soup* (1972), using his amply sized mother, braless and in panties, Krims makes direct but gentle mockery of Jewish mothers and family albums. In *The Ultimate Archival Print* (c. 1974), a nude female photography instructor parodies the pretensions of the photographic establishment.

DIANE ARBUS. *Untitled (7)*, 1970–71

MAX WALDMAN. From the series on Peter Brook's production of Peter Weiss's *Marat/Sade*, 1966

The actual dead animals of the earlier *Roadside Deaths* (c. 1970), the sensuously arrayed victims of *The Incredible Case of the Stack O'Wheats Murders* (1972), and the grotesque charades and horrific faces and bodies of *Fictcryptokrimsographs* (1975) are more disturbing. They not only parodied significant themes, serious journalism, and the integrity of the medium, but appeared during years that witnessed the resurgence of feminine consciousness, photographs of the Tet Offensive and the My Lai massacre, and color photographs of napalmed victims. On one hand, these images functioned as grotesque and comic escape valves for moral issues too difficult to confront. More significantly, however, they manifested a deep social blindness that supported an immoral war and the inferiority of women. In a world that was giving thought to the realities of victimization, inequality, and the abuse of women, Krims's images were curiously out of step. It was not unreasonable to regard them as reactionary, as sheer bigotry, sexual exploitation, and the last bastion of aggressive masculine machismo.

In a group of photographs published in 1975 Krims pictured several children with Down's syndrome, each wearing a sign he had prepared: "Diane Arbus Lives

DANNY LYON. Page from *Conversations with the Dead,* 1971

DANNY LYON. *Hoe sharpener and the line,* 1967–69

In Us." The wheel had come full circle. Rather than defining new possibilities, Krims was building an art out of undermining, mocking, and devaluating older models.

Krims's boisterous work brought him instant acclaim and undoubtedly helped liberalize the subject matter of photography. Some of the work is indeed funny, but most of it is more important for its gesture of defiance than its pictorial value. Krims's photographs become a theater of the ridiculous, employing an adolescent sexuality, burlesque slapstick, and scabrous comedy that shocks and entertains by the coarsest possible puns and situations. His photographs are more juvenile than perverse. The much-reported gunpoint abduction of a Memphis gallery director's son by a kidnapper who demanded as ransom the removal of four Krims photographs from a group exhibition is more indicative of the adolescent accessibility of the work than of its psychosexual power. The kidnapper understood only too well the basis of the work: he was enraged by sexual explicitness. "Satire which the censor understands," said the Austrian satirist Karl Kraus, "deserves to be banned."

Danny Lyon's and Larry Clark's freaks were not defined by genetics but by common parlance and the sixties revolutionary freak show. They were the costumed, freaked-out, hoodlum bikeriders, the dope- and sex-crazed drug freaks, the prostitutes

and the convicts. To make their own lives and their photography more convincing, Lyon and Clark participated in the activities they photographed: Clark had been and continued to be a junkie, Lyon became in turn a civil rights activist, a motorcycle outlaw, and a penitentiary convict (just visiting).

Lyon's work, from its first appearance in the early sixties, was intended as social commentary. Photographing the least acceptable members of society, he constantly offered their vigor and independence as a paradigm for the growing anti-establishment sentiment. "To me these people might live on the edge of existence, more extreme lives than others, but they also have more feeling and more reality about them." In the early sixties Lyon became an official photographer for the Student Nonviolent Coordinating Committee, photographing the first confrontations and marches. These photographs were subsequently published in *The Movement* (1964). In the mid-sixties he joined the renegade Chicago Outlaw Motorcycle Club, the Midwest version of Hell's Angels. Out of this experience he published *The Bikeriders* (1968). During the same time he also photographed brothels and prostitutes in Santa Marta, Colombia. His most reserved and classic book, *The Destruction of*

Lower Manhattan (1969), was at once a political statement for the preservation of historic urban neighborhoods and a socially redeeming view of the urban worker in all his guises: the truckdriver, steelworker, housewrecker, street looter, and maintenance man. In 1967 and 1968 Lyon photographed the inmates of the Texas Department of Corrections system, producing the texts and images for *Conversations with the Dead* (1971).

The overt militancy of the themes, the support of liberal causes, and Lyon's early association with Robert Frank—the two formed their own film company, Sweeney Films, in 1969—made Lyon the most extravagantly praised young photographer of the decade. His social commentary mirrored the New Left's fantasies of adventurous egalitarianism, crosscultural communality, and revolutionary machismo. His work followed the long-honored American tradition of making the cultural outcast the cultural hero. His personal journalism made him appear as the sixties answer to Robert Frank.

Unfortunately it didn't pan out. What Frank was able to do in a single book, Lyon could not approach in four. In retrospect his vision seems uncomfortably conservative: sound and fury based on radical subject matter that never materialized either as successful photojournalism or as art. It was a measure of those times—and

LARRY CLARK. Cover of *Tulsa,* 1971

LARRY CLARK. From *Tulsa,* 1971

a lesson in the vicissitudes of critical judgment—that the viewers and critics were so overwhelmed by the thematic radicalness that we failed to see that Lyon never found a form that complemented or contained the subject. Lyon, initially regarded as the most radical of this group of personal journalists, must now be acknowledged as the most pictorially conservative.

The Bikeriders and *Conversations with the Dead* are powerful books, but it is the tape recorder and the Xerox machine that give them substance. In the photographs, Lyon stereotypes and choreographs. The camera, it seems, is the least authentic witness. Only the text, made up from actual transcripts, letters, drawings, and bureaucratic reports, restores life to the characters. As in the strongest documents of the thirties, it is the nuance, the locution, the awkward prose that convinces and terrifies.

Larry Clark's *Tulsa* (1971) shows the quiet atrocities of a very real war. Tulsa is the battlefield. For Clark it was "shaking" with violence, guns, sex, and drugs, and he was determined "to get the action." The needle, the vein, the penis, and the

E. J. BELLOCQ. *Untitled* (Storyville, New Orleans), c. 1912

breast were the weapons. The stakes were life and death. Clark's rawness is convincing where Lyon's manneredness was not. Because there is no pretense at social statement, Clark more readily than Lyon creates visual and visceral social facts.

Larry Clark is a photographic primitive whose work is based on intuition and limited photographic technique. His photographs are generated by an obsessive fascination with a single subject. Photography appears to be for him a form of psychic and erotic release as well as a visual celebration of the forbidden. His photographic project of the seventies, *Teen Age Lust,* continues this primitive relationship to the medium. Clark's work, much as Arbus's, succeeds as an individual triumph not of art, stylization, or intellect but as a triumph of the directness of intuition. It is a testament to the nature of the photographic process that photography can be used so successfully by individuals whose greatest relationship to the medium is one of psychic need.

Arbus, Krims, Waldman, Clark, and Lyon chose to photograph not sexuality or sexual titillation but the dark underside of the new love culture. Their photographs moved beyond the popular erotic photography of the time exemplified by Hugh Hefner's nude playmate of the month and Richard Kirstel's images of heterosexual and

lesbian love in *Pas de Deux* (1969). Hefner's centerfolds were hardly more daring than the traditional American airbrushed pinup; they were just the latest example of the American puritanical ethic. Kirstel's photography, while darker and more daring, nevertheless used the cover of "creative photography" to indulge a more Victorian taste for voyeurism. Arbus and Waldman, though, were not as concerned with the erotic as with the costumes of sex, the sexually forbidden, and the line between sexual survival and insanity. Lyon and Clark studied the tie between sexuality, hallucination, and violence. Krims, rigorously antifeminist in his work, used sex as an instrument of aggression and subversive humor.

This work might have signaled the death knell to the photographic romanticization of sex had it not been for the rediscovery by Lee Friedlander of E. J. Bellocq's photographs of Storyville prostitutes. With unparalleled swiftness, these photographs, which date from about 1912, were immediately granted the status of art. They hung for three months at MOMA, then traveled to nine other museums around the country, received publication in book form in 1970, and inspired the movie *Pretty Baby* (1978). The immediacy of this response—particularly to a subject that a decade earlier would have remained hidden, exotic pornography—was certainly due to the new visual permissiveness and to the inherent elegance, complexity, and indisputable authenticity of the images. The accidental beauties of the prints produced from old, broken, and chipped glass plates hinted at contemporary experiments in mixed media. But their effect was also, anachronistically, one of tenderness, nostalgia, and gracefulness. They offered a relief from the sexual extremes defined by Hefner and Arbus. Only Bellocq could be said to have achieved that direct, open, easy confrontation and display which in the romantic tradition had been the primary ingredients of love and sexual arousal.

Though the women pictured by Bellocq appear without physical defect, we are continually aware of the historical fact that Bellocq himself was described as being misshapen and dwarfed. Undoubtedly it was his physical deformity that allowed such seemingly nonjudgmental communication and camaraderie with the demimonde. It is an odd twist of fate that a dwarf photographing prostitutes in the early part of the century should provide the most sensual photographic portrayals of women for the freaky, liberated sixties.

Bruce Davidson: The Triumph of Sentiment

Bruce Davidson is the last great romantic photojournalist. His reportage culminates the idealistic traditions in photography. It derives from the formal elegance and idealism of Stieglitz and Strand, the social conscience of Lewis Hine, the ethical aesthetic of the fifties photo-essay form, and the humanitarianism of Davidson's predecessors at Magnum Photos: Cartier-Bresson, Robert Capa, David Seymour, Werner Bischof, Dan Weiner, and Eugene Smith. Davidson's work does not burst the traditional molds but reuses and reshapes them, restructuring the form and content to hold an image of a restless age.

Davidson's achievement is that he found the means to apply old-fashioned idealism to the more radical subject matter and form of a less sanguine decade. He is *The Family of Man* photographer come of age in the Age of Aquarius. Davidson's work, though appropriately complex, lacks the virtuosity of Winogrand's or Friedlander's photographs. It lacks the bite, the edge, the irony, and the leer of an Arbus or a Krims. His has been instead a quiet yet compelling voice amid the more strident utterances of the time. He has continually managed to dance that narrow path between sentimentality and mawkishness, creating in the process the most classic body of straight photography in the sixties.

Like the other personal journalists, Davidson chose as subject matter the outcast, the dangerous, and the disinherited. In extended photo-essays, he documented

a dwarf; a Brooklyn teenage gang; the civil rights Freedom Riders; the construction of the Verrazano Narrows Bridge; the plastic environments of Los Angeles and Yosemite National Park; Welsh coal miners; waitresses and dancers at a topless restaurant; the members of the Royka family, who live by picking metal from the dumps of the New Jersey Meadowlands; the inhabitants and buildings of New York's most notorious slum, East 100th Street; the old people who eat at the Garden Cafeteria; and most recently New York City subway riders. In each case Davidson has remained the outsider, always "the picture man." In each case he has recorded loneliness and disenfranchisement but has also tempered this view with a record of the lyric beauty of the landscape and the dignified human presence.

It is not that Davidson refuses to acknowledge the unseemliness of contemporary life. In Yosemite, where Ansel Adams saw only the Half Dome, Davidson shows us the clutter of automobile campers, with their folding chairs, portable stoves, radios, and endless trash. In *East 100th Street* (1970), we are shown not only nobility and the beauty of youth but also squalor and degeneration. The block contains both

CARLETON E. WATKINS. *Yosemite Valley from the "Best General View,"* Number 2, c. 1866

BRUCE DAVIDSON. *Yosemite,* 1966

spiritual entombment—a depressed child huddled close upon his bed—and affirmations of life: the picnic by the river, the kite flying from the rooftops. In the *Welsh Miners* (1965), a series of photographs very reminiscent of Strand, Davidson shows both the lyrical, humanized countryside and the rugged, dehumanizing work.

This astonishingly true, uncondescending mixture of despair and delight, sadness and joy, is revealed in Davidson's own commentary on the essays. His words show his eminent capacity for response and parallel the breadth of human emotion and interaction expressed in the photographs. His words also reveal a working method that moves effortlessly from visual fact to human feeling:

> The next morning I saw the bloodstained seat, shattered glass fragments and skid marks where her car had gone off the road. The violence in the South had reached into me deeper than my personal pain.

Where Winogrand had gone out to find representative "fictions," Davidson, still believing in the medium as authentic witness, strove to find representative truths.

It is instructive to compare Davidson's work with that of two of his most notable colleagues at Magnum, Charles Harbutt and Burk Uzzle, who were also making

their own version of America during the same decade. Davidson's work is distinguished by its almost total lack of pretense. In Uzzle's and Harbutt's, one is always aware of the craft that squeezes out of the photograph every last inch of design, relationship, and form. Next to Davidson's their work, especially Harbutt's monograph *Travelog* (1974) and Uzzle's monograph *Landscapes* (1973), seems overly staged and dramatic, and too easily graphic. They lack the visual intelligence and wit that define Friedlander's work or the individual consciousness and visual transparency that define Davidson's. Their photography is too arty, too chic, too cool, and ultimately is neither art nor documentation.

Davidson, like his spiritual godfather Paul Strand, has constantly used people from various lands and cultures as the basis of a highly subjective way of seeing. With Strand, Davidson could affirm a photography that "means a real respect for the thing in front of him," at the same time acknowledging a subjectivity "born of the emotions, the intellect, or both." "Honesty," Strand wrote, "no less than intensity of vision, is the prerequisite of a living expression."

129

To achieve this balance, Davidson, like Strand, consistently prints so as to utilize the full photographic tonal range, expressing the world before the camera, as Strand wrote, "in terms of chiaroscuro . . . through a range of almost infinite tonal values which lie beyond the skill of human hand." The Harvard University Press's *East 100th Street* ranks with the El Mochuelo Gallery's *Photographs: Harry Callahan* (1964) and the Aperture Book *Edward Weston: Fifty Years* (1973), as one of the most finely printed, designed, and sequenced photography books ever produced. More than any other personal journalist of the sixties, Davidson has allowed the medium's inherent tonal intensity to buttress and contain his perceptions.

But in the end, the medium disappears. Davidson's photographs always lead away from themselves, revealing a world carefully crafted yet unimpeachably realized. Behind Davidson's photographs there is a constant, authoritative presence. And that presence—sometimes compassionate, sometimes joyful, sometimes deeply vulnerable—has a very human pair of eyes.

PAUL STRAND. *The Family, Luzzara, Italy,* 1953

BRUCE DAVIDSON. From *East 100th Street,* 1966–68

The Painter as Photographer

Robert Rauschenberg: The Found Image

Perhaps the most important, and least acknowledged, photographer of the past decades is Robert Rauschenberg. Rauschenberg's position in the world of painting has so overshadowed his role as a photographic innovator that he is usually overlooked in discussions of the history of photography. Yet his achievement as a painter is essentially photographic in method. His painting recapitulates the sensibility of the major photographers of the fifties, parallels photography's preoccupations of the sixties, and anticipates the "mixed media" and conceptual work of the seventies.

Since the early fifties Rauschenberg has integrated photographs into his work. More significant than the photographic images themselves, however, is Rauschenberg's early involvement in the strategies of photography. Only one other American artist, Joseph Cornell, through his mysterious and quixotic boxes composed of elegant bric-a-brac and old photographs, shows a similarly acquisitive photographic sensibility. Cornell was, however, too reclusive and his constructions too elegant to have immediate impact on American art and photography. It was left to Rauschenberg to affirm in painting the photographic notion that the making of an image consists in the act of combination.

ROBERT RAUSCHENBERG. *Buffalo,* 1964. Oil and silkscreen ink on canvas, 96 × 72"

Rauschenberg's work stresses the belief that creation resides in the act of making choices. This attitude is basic to the photographic sensibility, which emphasizes the camera's ability to select and extract forms that already exist rather than the painterly prerogative to compose and arrange unprecedented forms. For Rauschenberg, as for the vanguard photographer, the world is essentially a storehouse of visual information. Creation is the process of assemblage. The photograph is a process of instant assemblage, instant collage.

This premise is antithetical to the traditional notion of the photograph as single-image art, and in fact many of the photographic explorations of the last thirty years have tended to negate the arbitrary imposition of a single moment on the photograph. Rauschenberg's notion of art as a synthesizing, combining, and collecting activity helped finally to liberate photography from its use as duplicate and document.

Rauschenberg first used photography in a giant, life-size photographic blueprint of a nude in 1949. Later he incorporated actual photographs and photographic

ROBERT RAUSCHENBERG. *Untitled,* 1955. Combine painting: oil, pencil, fabric, paper, photographs, cardboard on wood panel, 15 × 21 × ½"

FRANK EUGENE. *Adam and Eve,* c. 1900. Photographic print from manipulated negative

reproductions as elements in collage (*Factum,* 1957) and as sculptural objects (*Odalisque,* 1955–58). He has experimented with and perfected the transfer method, the photosilkscreen, and the photolithograph as means of producing photographic images on canvas and paper. In 1959 his illustrations for Dante's *Inferno* used newspaper reproductions as the source of transfer images. Here Virgil appears as Adlai Stevenson, centaurs as racing cars, and demons as gas-masked riot troops. The suite of silkscreen paintings of the early sixties—*Retroactive, Windward, Estate, Buffalo, Axle*—obsessively repeats photographs of Kennedy, oranges, a parachutist, the Statue of Liberty, the rooftops of New York, Rubens's *Venus with a Mirror,* and Gjon Mili's stroboscopic nude dancer. And in 1967 Rauschenberg produced the largest hand-pulled photolithograph ever made, a life-size X-ray self-image, *Booster.*

Rauschenberg does not take his own photographs for his paintings. (Though ironically the first Rauschenberg works acquired by MOMA in 1952 were several photographs made as a student at Black Mountain College.) Rather, he collects them from every imaginable source: magazine and newspaper reproductions (especially action photos of sporting events), reproductions of master paintings, and photos of

famous people. He also uses snapshots, postcards, X-rays, discarded photoengraving plates, photographic contact sheets, radarscopes, aerial photographs, Harlem street scenes, and even a few "fine art" photographs. Every type of photographic production and the photographic detritus of modern culture have found their way back into his paintings, combines, and constructions. The impact of this work has forced us to alter the classic definition of a photographer from "one who makes photographs" to "one who uses photographs to make images." Under this new definition, Rauschenberg becomes the most synoptic photographic presence of the last decades. His work accomplishes the most sophisticated rapprochement between painting and photography since the Photo-Secession and Eugene's etched negatives and Steichen's painterly gum prints.

Although Rauschenberg's color, brushstroke, and gesture derive from the Abstract Expressionist idiom, his integrative sensibility is more broadly based. It stems in part from many of the same people and sources that energized the major photog-

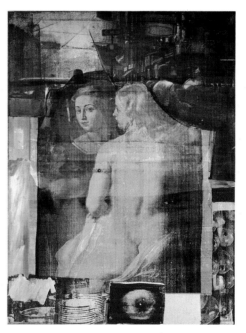

raphers of the fifties. It comes from contact with the same avant-garde Black Mountain, San Franciscan, and New York network of painters, poets, musicians, writers, and dancers. At Black Mountain College Rauschenberg studied with the pioneer abstractionist Josef Albers. Later he worked with other members of the Black Mountain group, including composer John Cage and choreographer Merce Cunningham. From Albers he inherited a delight in visual puzzles and in the inexplicable. The principles of opposition, confrontation of opposites, the accident, and confusion as preached by Cage and taught by the Tao and Zen Buddhism provided the vehicle for Rauschenberg's creative process. In the late fifties, Rauschenberg asserted with Cage that art should be an affirmation of life, not an attempt to bring predetermined order out of chaos. "Painting relates to both art and life," Rauschenberg wrote in his most famous declaration. "Neither can be made. (I try to act in that gap between the two.)"

For Rauschenberg the photograph was the key device that allowed him to literally fill the gap between art and life, since the photograph has unimpeachable footholds in each. Utilizing the photograph allowed Rauschenberg to testify to the

JOSEPH CORNELL. *Sorrows of Young Werther*, 1966. Collage, 8¼ × 11¼"

ROBERT RAUSCHENBERG. *Persimmon*, 1964. Oil and silkscreen ink on canvas, 66 × 50"

nonlogical discontinuities of life rather than to the rational structures of Western high art. Its use became a way to derive art from actual seeing.

Though Rauschenberg's work also has a direct ancestry in the photomontage tradition of the twenties and thirties, it shares more with the work of the photographer than the collage maker. The Berlin Dadaists and the later Surrealists used the photograph to emphasize the polemical and the satirical. Rauschenberg, on the other hand, breaks with the tradition of the political and the fantastic. Rather than using the photograph to imply the extraordinary and the surreal, he implies the ordinary and the immediate. He does this by granting the photographic fragment and the painterly gesture equal weight. The photograph's implicit reality is balanced by color and brushstroke. Rauschenberg presents the photograph with a lyrical matter-of-factness. Unlike the Dadaists, who point to the dream, or Man Ray and Moholy-Nagy, whose collages, photographs, and solarizations point toward abstraction, Rauschenberg always points back to the real, perceivable world. His images are frozen, kaleidoscopic renditions of everyday sight.

FREDERICK SOMMER. *Venus, Jupiter & Mars,* 1949

HARRY CALLAHAN. *Chicago,* 1951

In *Windward* and its sister image, *Estate,* for example, we are taken on a whirlwind, cinematic tour of New York, carried along by photographic images splashed upon the canvas with the same headlong velocity as paint. We move through a world of fast dissolves, multiple images, simultaneous viewpoints, and flashbacks that startlingly contrast the American Eagle and the Sistine Chapel. Both these paintings are breathtaking virtuoso performances of color, integration, and speed. In both the inherent multiple vision of the camera establishes coherence by the imposition of a single frame on random, accidental events.

Rauschenberg managed to modify the extremes of objective and expressive art. In recent American painting and in much of American photography, the personal gesture either overpowers or is totally absent. Photographs in the tradition of Stieglitz purport to be purely personal expressions; photographs in the tradition of the Farm Security Administration purport to be objective views of the world. In his paintings and in his use of photographs, Rauschenberg synthesized the subjective attitude of Abstract Expressionism with the earlier Duchampian objectivity. His work minimizes personal content and personalizes documentary evidence. It is neither a mirror nor a window, being both personal and anonymous, representational and abstract.

134

It is in his activity as a maker of pictures as puzzles, pictures as play, and pictures as process that Rauschenberg anticipates the photographic strategies that came to underwrite the alternatives to straight photography. His conglomerate method suggests the photograph as objective personal gesture, the photograph as combined perception, and the photograph as analytical process. Rauschenberg alternatively obscures and reveals his subject. Working outside the tradition of the "decisive moment," creates images that constantly test the viewer's skill at deciphering.

In the very beautiful *Rebus* (1955), for instance, Rauschenberg uses the photomontage to create a painterly riddle. Here, as the title indicates, an enigmatic constellation of pictures, photographs, and signs stands for words, phrases, and homonyms. This rebus has been variously "read," but, of course, it has no definitive meaning, particularly no clear meaning external to its evocative, visual statement. It is meant to be absorbed both visually and analytically. Its strength lies not in specific references but in its visual puns, its whimsical accumulations, its parodies. The success or failure of all of Rauschenberg's pictures depends more on his wit and

135

visual coherence than on rational inquiry. When they work they do so because of an anarchic playfulness. Their virtuosity amazes and delights. They do not instruct, they are not self-searching. They exist in the realm of ebullient, cosmic yet commonplace humor.

In the fifties Rauschenberg, like his photographic contemporaries, sought a visual idiom that would be both personal and tied to the American experience. With Robert Frank, Rauschenberg shares an abiding belief in the necessity of looking squarely at the commonplace, particularly the public pictorial world. For both these men high art had to go beyond limited content and rarefied motifs. Renoir reproductions, political posters, newspaper images of political leaders, and the highway are part of everyday experience. In Rauschenberg's and Frank's images they mingle together without irony. They are merely visual facts. "Painting is always strongest," Rauschenberg wrote, "when in spite of composition, color, etc., it appears as a fact, or an inevitability, as opposed to a souvenir or arrangement. . . . A canvas is never empty." Rauschenberg, like Frank, sees his job as placing a frame around what already exists.

Like Harry Callahan, Rauschenberg has created an idiom that both incorpo-

AARON SISKIND. *St. Louis,* 1953

ROBERT RAUSCHENBERG. *Rebus,* 1955. Oil, pencil, paper, fabric on canvas, 96 × 131 × 2″

rates and transcends the basic reportorial function of photography. In his work, as in Callahan's, commonplace content and sophisticated form are so merged as to become nearly synonymous. And Rauschenberg shares with Callahan an understanding of the multiple, repetitive motif as a means of forcing the commonplace onto the viewer's psyche.

With Aaron Siskind, Rauschenberg shares an understanding of the beauty inherent in the copious waste of an industrial society. In his combines, he uses materials that are weathered, torn, and faded, much as Siskind focuses his camera on the deteriorated and the fragmented. Rauschenberg, like Siskind, admires gestures of tearing and disintegration and especially the half-hidden typographies of urban signs.

With Minor White, Rauschenberg shares a meditative consciousness that welcomes the collaboration of chance, and an aesthetic fatalism that allows suites of images to be generated almost automatically. For both White and Rauschenberg art is essentially a performance that ultimately leads back to life.

With Frederick Sommer, Rauschenberg shares a delight in audacious construc-

ANDY WARHOL. *Portrait of Lita Hornick,* 1966. Silkscreen and acrylic on canvas, 44 × 88"

tions made from found images and objects. Both have clear allegiances to the surreal, but each transcends the surreal in visual acts that cite the predominance of reality over illusion and of the fact over the symbol. In essence, all these artists—Frank, White, Callahan, Siskind, Sommer, and Rauschenberg—devoted themselves to challenging and reconstructing photography's most cherished preconceptions about the world and about representation.

Photography and Mid-Century Art

Rauschenberg's experiments in the fifties and sixties helped initiate a dazzling array of explorations in the forms, syntax, and styles of modern art. Assemblage, Pop Art, environmental art, Op Art, Minimal art, conceptual art, and Photo-Realism followed each other in quick succession. Each movement, building on and challenging the discoveries of Abstract Expressionism, attempted to find avenues for formal and conceptual innovation. The aesthetic questions that energized these movements were the fundamental issues of modernism: the tensions between art and nonart, abstraction and realism, illusionism and anti-illusionism, media as agent and media as state-

ment. The basic polarities in all these issues were mirrored in the conflict between the painterly and the photographic. The fundamental touchstone for these questions was photographic representation. Both as object and concept, the photograph remained the central catalyst in the development of these new modes. Photography embodied a set of attitudes, forms, iconographies, and strategies that allowed it to provoke as well as to resolve many of the new aesthetic problems.

In its explorations of new issues, painting primarily responded not to the literature of sophisticated photography but rather to the broadly based phenomena of the medium itself: the ubiquitous existence of the snapshot, the advertising photograph, the news photograph. These images formed the folk art of contemporary culture and stood in the popular mind, if not as surrogate reality, then at least as the meeting point of art and life. The art of the fifties through the seventies derived from a growing consciousness of these photographic sources and an awareness of photography's relatedness to many of the central dilemmas of the post-Expressionist era: the studio versus the world, the constructed versus the ready-made, machine art

versus signature art.

Photography was utilized directly by the artists at mid-century in three frequently overlapping ways: documentation, incorporation, and conceptualization. The most traditional use of the photograph was as record or document. Here the photograph merely reproduced the artistic product or event, which took place in another mode. A more radical device was to actually incorporate the photograph into a painting or sculptural form. Incorporation implied the acquisition of an actual bit of the world by a work of art. Here photography acted as a foil for the painterly mode. It became the essential analog of human perception, an allusion to common sight and habitual seeing. Both documentation and incorporation often lead directly to a conceptual use of either the photographic process or the photographic style of representation. Here the photographic mode provided the aesthetic basis for the work itself.

In the first major movement after Abstract Expressionism, Assemblage, the photograph was used as an environmental element. Its presence indicated to both artist and spectator the actual transfer of evidence from the natural world to the synthesized world of the image. The photograph was a bit of untransubstantiated reality, boldly borrowed from the actual world; its illusionary quality was not ques-

ANDY WARHOL. *Orange Disaster #5 (Electric Chair),* 1963. Oil on canvas, 106 × 82″

JAMES ROSENQUIST. *Star Thief,* 1980. Oil on canvas, 17 × 46′

tioned. Its presence directly transferred fact to art.

The movements that grew out of Assemblage—performance art, environmental art, and conceptual art—relied heavily on the photograph's simultaneous references to representation and reality. In these movements the photograph was used to effect the transformation of art from physical object to mental image. Happenings and performance art extended Rauschenberg's notion of collection and chance. Performance art used photography not only as a record, but as an integral element in the event itself. Here photography played the double agent: it was both reality and art. It enabled the artist to meet the world halfway, making art part of the world and the world part of art. In Allan Kaprow's *Pose* (1968–69), Polaroid photos of various staged situations were attached to the spots where the action took place. A Polaroid of a woman astride the railroad tracks, for example, was taped to the track itself and was later to be demolished by a passing train.

At the opposite end of the performance spectrum, photography as technology

JOHN CLIETT. Photograph of Walter De Maria's *Lightning Field, Quemado, New Mexico*, 1977

DENNIS OPPENHEIM. *Cancelled Crop*, 1969. Grain field, Finsterwolde, The Netherlands, 1000 × 500′

played a major part in the light shows, dance environments, and theater pieces staged during the fifties and sixties. Color slides, stroboscopic flash, and electronically controlled projections of still images were used for both informational and psychedelic effect. The Joshua Light Show for the rock opera *Tommy* (1969) by The Who at Fillmore East, the shows at the Electric Circus, and the Experiments in Art and Technology (EAT) initiated by Rauschenberg, Robert Morris, and Claes Oldenburg all relied heavily on the photographic image and process.

Documentation of earthworks pushed the dual nature of the photograph even further. Here the photographic record was more than the proof of the activity. At times it became the most significant product of the project. A series of photographs used to document a sequence of events frequently became a formal and conceptual statement in its own right. In Robert Smithson's *Mirror Displacements* (1969), the photographic record intensifies the visual ambiguity of mirrors placed in the landscape by reducing both landscape and reflection to monochrome and to the flat plane. In Smithson's *A Non Site* (1968), the act of choosing and photographing becomes the work itself. *A Non Site* exists only as an aerial photograph of Franklin, New

Jersey. Photography plays the essential role of witness in Sol LeWitt's *Box in the Hole* (1968), Claes Oldenburg's *Placid City Monument* (1967), Dennis Oppenheim's *Cancelled Crop* (1969), and Les Levine's *Corn Flakes* (1969). These events were staged essentially for the camera. In each event—the burying of a cube, the digging and refilling of a grave-size hole, the mowing of a giant cross through a field of grain, and the pouring of 250 boxes of giant-size Kellogg's Corn Flakes on a meadow—it is photography that simultaneously records the event and underwrites the concept. In general, earthwork projects extensively employed the photograph as map, plan, diagram, and record. In some projects photographs not only documented the work but became powerful statements in their own right. John Cliett's documentation of Walter De Maria's *Lightning Field* (1977), for example, has a strong alliance with the work of the new color landscape photographers.

Pop Art, strongly rejecting painterly abstraction, turned to photography for both its representational image and its process. The Pop artist sought to obliterate—

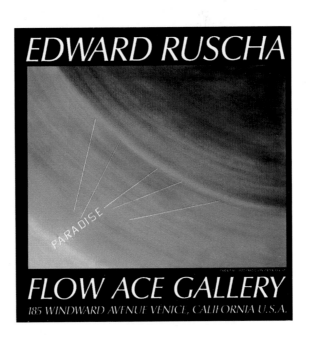

or at least to objectify—the hand of the artist and to reintroduce recognizable subject matter. Warhol, Rosenquist, and Wesselmann employed advertising photographs, photographs of celebrities, news photos, picture postcards, and the halftone screen; Edward Ruscha bypassed the painterly medium entirely and chose as subject matter the uninflected commercial photograph itself. Pop artists chose second-generation photographs, images that had already been reduced by multiple reproduction to the status of commodity. For the Pop artist the photograph was a ready-made object. It was a visual cliché, a facsimile object that could be manipulated like pigment or clay.

Andy Warhol's wholehearted acceptance of the reproduced image as art object made him the most provocative public art figure of the last thirty years. His work is a continual intensification and restatement of our culture's most basic visual commodity: the newspaper and magazine photo. If Rauschenberg is the most synoptic photographic presence of the last decades, then Warhol is the most successful straight photographer. In Warhol's recent work, his role as celebrity photographer has come full circle. The images of the famous which were first rendered by liquitex and silkscreen on canvas are now being presented as unmanipulated, limited edition photo-

ALLAN KAPROW. *Pose,* 1968–69. "Carrying chairs through the city, Sitting down here and there, Photographed, Pix left on spot, Going on." Happening

Back cover of *Artforum,* Summer 1982. Painting by Ed Ruscha, *Paradise,* 1982. Pastel on paper, 35 × 50″

graphic prints. In Warhol's latest work all notions of transference have given way to transcription. Warhol now presents the genuine article itself: the untouched straight photograph.

Where the Pop artist chose to use the photograph, the Minimal artist chose to reject entirely its representational nature. Yet Minimal sculpture's strategy, like photography's, is to produce images that are mechanically regular but at the same time unique. The elementary geometric forms of Minimal sculpture are reproducible yet singular, cooly detached yet specific. Minimal art, like many aspects of contemporary photography, is rooted in Bauhaus experiment; it is a product of the machine age and machine sensibility. Like photography it has strong allegiance to the mechanical handling of surfaces. It deemphasizes traditional forms and content. And in its duplication of manufactured things it shares photography's cardinal attribute and contradiction: the illusion of nonart within the context of artifice.

It was photography's elusive relationship to both thought and sight that pro-

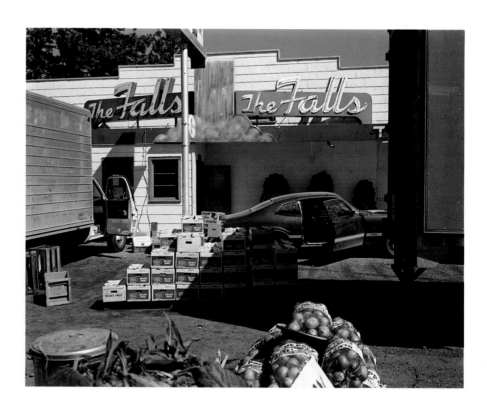

STEPHEN SHORE. *U.S. Route 10, Post Falls, Idaho,* August 25, 1974

vided one of the major models for conceptual art. If the first step in the dematerialization of art was documentation by photography, and the next step the substitution of the photograph for the artwork, then the final step was the elimination of photographic reportage all together. What remained was only the verbal description or the mental image of the visual event. If the photograph could be made to stand for traditional visual precepts, it was merely the next step to allow a verbal statement to stand for the visual. The photograph provided the model and the vehicle for this startling transition. It enabled the artist to synthesize theory and practice in a single entity without employing the traditional means of representation.

Photo-Realism was the apotheosis of all the photographic notions that lay at the root of the new art movements and issues. The Photo-Realist was concerned not with the reproduction of actual objects but with the duplication of the photographic object and the optical complexities of photographic rendition. Continuing Pop's predilection for reproducing facsimiles, Photo-Realism chose second-generation imagery borrowed from casual, vernacular photography. It augmented this subject matter with iconography drawn directly from the more sophisticated American photography,

particularly the iconography of street photography: the automobile, storefront reflections, the long architectural view. Photo-Realist painting finally reversed the century-old time lag between photography and painting. By the seventies advanced art, rather than preceding photography, began to be derived in form and content from advanced photographic work. In reproduction it is impossible to distinguish a Richard Estes from a Stephen Shore.

141

RICHARD ESTES. *Bus Reflections (Ansonia)*, 1974. Oil on canvas, 40 × 52″

Photography as Printmaking

The Challenge to Tradition

The sixties and seventies provided a ripe climate for radical photographic experimentation. During these decades the intense testing of aesthetics and social institutions helped produce an entirely unprecedented array of synthetic and manipulated photographic work, work that would seriously challenge the validity of the straight aesthetic. In the sixties and early seventies this experimentation aligned photographic image making with the art of the painter and printmaker. The distance traveled during these two decades can be measured by the aesthetic gulf between current work and Beaumont Newhall's remark of 1958: "Attempts to mix photography and painting fail. . . . On this point the masters are unanimous: the photographic image must not be tampered with."

The manipulative photographic printmaking of the sixties and seventies may be divided into two distinct categories distinguished almost entirely by the medium in which the image was presented. The first category encompasses work produced as traditional silver prints. The second contains all other work presented in nonsilver processes and media combinations. This distinction may at first seem arbitrary and inconsequential. Indeed during these two decades the tendency was to lump all manipulated imagery together under the rubric of "new forms," "new media," and

PETER BEARD. Two-page spread from *African Diaries*, October 2 and 4, 1978. Collage with drawing: photographs, newspaper clippings, glove, blood, and hair

"challenges to tradition." Yet the philosophical and aesthetic bases of these two categories—in almost every instance—were radically different, even antipodal.

The work of the silver printmakers was based on the silver photograph's credibility. Though these printmakers intervened aggressively in the translation of event to image, their work gives the illusion, at least momentarily, of a seamless, veracious world. While this work was illusionistic, the issues it raised were the same issues of representation and communication with which the new art forms were struggling.

The work of the nonsilver printmakers, on the other hand, was a reaffirmation of the conservative tradition. It frankly insisted upon artifice and the hand of the artist, concerning itself more frequently with issues of design than with issues of concept. For the nonsilver photographer the photograph was only another, though favored, form of visual packaging.

Partially because of this fundamental difference, the work of the silver printmakers has proven more powerful, more convincing, and more lasting in value than

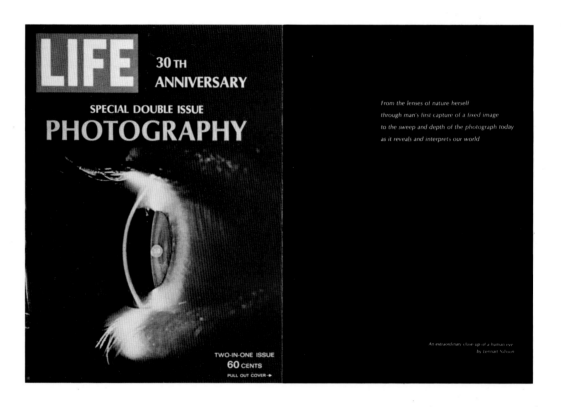

Cover of *Life*, December 23, 1966. Special double issue with pull-out cover. Photograph by Lennart Nilsson, *An extraordinary close-up of a human eye*, n.d. Original in color

that of the nonsilver printmakers. The nonsilver media have not been catalysts for photography of great substance. There are no nonsilver photographic artists of the sixties and seventies—artists whose primary allegiance had been to the photographic community as opposed to the painting community—who have achieved the stature of Rauschenberg or Warhol, or, to give the photographic comparison, of Uelsmann or Metzker. Only a few nonsilver printmakers have managed to use integrative processes with authority, intelligence, and wit. This chapter is in part an attempt to explain this fact.

The major factor influencing the growth of manipulated image making was the movement of photography from the professional and commercial world into the universities and art institutes. This move allowed the remarkable variety of activity in art and culture to energize the photographic community. A new consciousness of painting and printmaking turned the photographer's preoccupation with expression and fact toward a consideration of the inherent qualities and dilemmas of the medium itself. It stimulated many young photographers to defy established conventions and broaden the definitions and possibilities of the medium. It shifted the standards of

photographic production from the commercial world to the world of art.

The most significant American academic institution to teach photography before World War II was Moholy-Nagy's New Bauhaus, which began in 1937 and later became the Institute of Design at the Illinois Institute of Technology. Here a basic photographic curriculum was created by a succession of men who would have significant impact in photography both as educators and photographers: Moholy-Nagy, Frederick Sommer, Henry Holmes Smith, Gyorgy Kepes, Nathan Lerner, Arthur Siegel, Art Sinsabaugh, Edmund Teske, Harry Callahan, and Aaron Siskind.

After the war the movement of photography into the schools began in earnest with the offering of photography as a technical subject. These courses, many following the New Bauhaus's integration of art, technology, and photography, slowly blossomed into full-fledged fine art programs concentrating on "creative photography." The academy's acceptance of photography and the student demand for the field grew without slackening over the next two decades. In 1962 Nathan Lyons, Aaron Siskind,

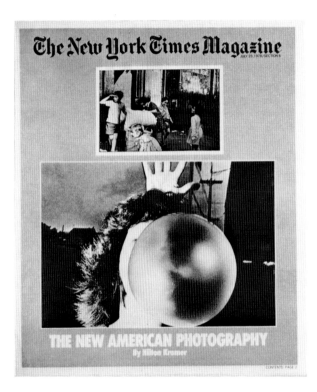

Henry Holmes Smith, Jerry Uelsmann, Minor White, and several other teachers of photography founded the Society for Photographic Education (SPE). In 1964 the University of Texas purchased the enormous Gernsheim photography collection for over a million dollars. In 1965, after a major search, MIT asked Minor White to head a new Creative Photography Laboratory. In 1969 Nathan Lyons established The Visual Studies Workshop in association with the State University of New York at Buffalo. In 1972 the first chair in photography, the David Hunter McAlpin professorship, was offered by Princeton University to Peter Bunnell, former curator at MOMA. In 1974 Cornell Capa established the International Center for Photography in New York. In 1975 the University of Arizona at Tucson founded a major archive and study center, The Center for Creative Photography. In 1979 SPE numbered over fifteen hundred members, while Yale established a memorial chair and named Tod Papageorge the Walker Evans Professor of Photography. By 1980 there were photography and history of photography programs in universities in every state of the union. And as the universities recognized photography, so did newspapers and periodicals tied to the academic establishment. *Art News, Art in America, Artforum, The New*

Cover of *Newsweek,* October 21, 1974. Photographs (clockwise from top) by Emmet Gowin, Donald Mc-Cullin, Hiro, Judy Dater, NASA, and Eugène Atget. Gowin, Hiro, and NASA reproduced in color

Cover of *The New York Times Magazine,* July 23, 1978. Photographs by Helen Levitt (above) and Mark Cohen (below). Levitt reproduced in color

York Times, The Village Voice, Art Week, New York Review of Books, and *Newsweek* began to carry commentary about photography.

The death of the major picture magazines *Life* and *Look* in the early seventies liberated photographic standards even further. Previously the criteria for judging a photograph had been set by the magazines and by the best commercial work. Even Steichen's and Szarkowski's straight aesthetic was related to the conservative magazine standards of the day. Now it was the universities that provided access both to the world of art and to photography's own largely neglected history. Out of this new knowledge new standards developed. Before the sixties very few major photographers had university degrees; in the sixties and seventies almost all the major photographic innovators went through either an undergraduate or graduate fine arts or photography program. The university had become the essential bridge to the art world.

The first major acknowledgment of the manipulative print and of the university's impact on photography was the exhibition *The Persistence of Vision,* organized

 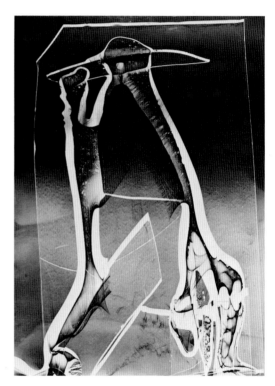

LÁSZLÓ MOHOLY-NAGY. *Collage,* 1925

HENRY HOLMES SMITH. *Growing Up II,* 1951–72. Original in color

by Nathan Lyons for George Eastman House in June 1967. The show included the work of Jerry Uelsmann, John Wood, Ray Metzker, and Robert Heinecken and the collaborative images of the photographer Donald Blumberg and the painter Charles Gill. All these artists, it is important to note, held university teaching positions.

A year later Peter Bunnell, then curatorial associate in the Department of Photography at MOMA, organized *Photography as Printmaking.* This was the first attempt to place the recent manipulative work into historical perspective. Bunnell presented the work of about twenty-five new photographers along with prints by such classic masters as Atget, Stieglitz, and Weston. For Bunnell the show challenged "the traditional critical separation between 'straight photography' which seeks to mirror external reality . . . and the aesthetic that emphasizes the distinctive surface quality of the print itself. . . ." But the show contained both manipulated and totally straight work and raised more issues than it answered. The term "printmaker" was just too encompassing and ambiguous; any flat photograph would have fit Bunnell's definition. At the same time the selection was too parochial, totally ignoring related photographic printmaking in art. Bunnell followed this show with *Photography into*

Sculpture in 1970. This exhibition, concentrating on young artists—only one had been exhibited before—lacked the breadth and excellence of the earlier show. It too ignored the historical and contemporary parallels in art such as Cornell's boxes and Rauschenberg's combines. In retrospect, only a few pieces in the show—such as Douglas Prince's Plexiglas and film constructions—remain more than curatorial curiosities. Nonetheless, like the earlier shows, this exhibition had a signal effect on the photographic community: it indicated the photographic establishment's recognition of manipulative photography.

The most significant though least touted show, *Collage and the Photo-Image*, organized by Bernice Rose of MOMA's Drawing Department for the summer of 1973, finally gave the new ventures in photography a historical context. This show affirmed the coexistence of the painterly and photographic traditions. It defined its purview as "any image made from a juxtaposition of photographic images by any means and in any medium." The show included work by such artists as Grosz,

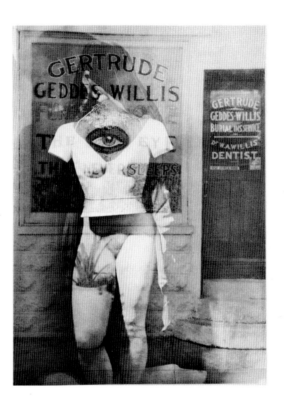

Duchamp, Ernst, Cornell, Mies van der Rohe, Reinhardt, Miró, Johns, Rauschenberg, Lichtenstein, and Wesselmann. To these artists Rose added the photographers Callahan, Friedlander, Man Ray, Metzker, Moholy-Nagy, Barbara Morgan, Sommer, Steichen, and Uelsmann. Rose's selection of only five contemporary photographers out of over forty artists may have seemed meager at the time, but her sense of lasting value was exceedingly just. A partisan of neither art nor painting, Rose was able to winnow the wheat from the chaff.

The photographic precedents for semistraight, manipulated work had been excluded from the canon over which Gernsheim, Newhall, and Szarkowski presided. "The elaborate nineteenth century montages of Robinson and Rejlander, laboriously pieced together from several negatives," Szarkowski wrote, "attempted to tell stories. But these works were recognized in their own time as pretentious failures." Ironically, in this same paragraph in *The Photographer's Eye*, Szarkowski goes on to praise the "heroic documentation of the American Civil War," not realizing that these images had also been "laboriously pieced together." For William Frassanito has shown in *Gettysburg, A Journey in Time* (1975) that in many of the most famous Civil War

ARTHUR SIEGEL. *Photogram*, 1946

CLARENCE JOHN LAUGHLIN. *The Eye that Never Sleeps*, 1946. "One of the negatives for this composite print of a Negro funeral parlor in New Orleans—one which stayed open all night. The picture is a satire on the Puritanism which so long dominated Anglo-American society. So we see the eye of the Puritanical conscience suspended in the network of repressions; the girl's torso becomes lifeless because of restraint; then, inevitably, the natural quality of the flesh manages to emerge: but, finally, the knee becomes like the knee of a doll—since the blighting power of the 'eye' made nearly everyone artificial."

photographs—such as *Home of a Rebel Sharpshooter* and *A Harvest of Death*—the bodies had been moved into position by the photographer. It was not until 1978 that Szarkowski was willing to go on record acknowledging the interactive nature of art and photography. In *Mirrors and Windows* he hinted at this interchange by including the work of Warhol, Rauschenberg, LeWitt, Ruscha, and Samaras.

Gernsheim has taken an even more conservative position. He considered Julia Margaret Cameron's arranged photographs "mawkish, even ludicrous . . . reminiscent of the worst kind of amateur theatricals." And Newhall's revised and enlarged edition of *The History of Photography* (1964), which was the standard reference book on the subject until the publication of his new edition in 1982, does not even mention three of the four major American antecedents of the new manipulated work: Frederick Sommer, William Mortensen, and Clarence John Laughlin. And Newhall treats the fourth—Arthur Siegel—as merely an FSA photographer.

These photographs challenged the purist notions of photography. Laughlin, who evoked his fantastic, preternatural Southern world through the use of double

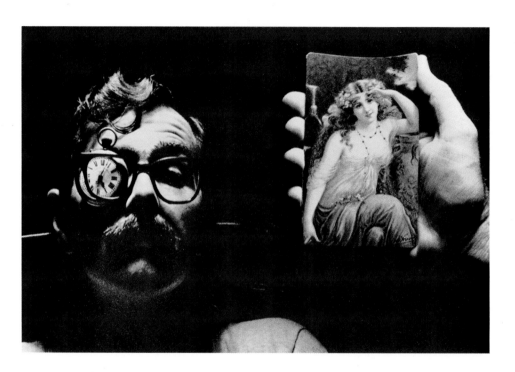

JERRY N. UELSMANN. *Improbable Assignation,* 1964. Self-portrait. Combination photograph

exposures, multiple printing, constructed stage sets, collages, photograms, colored dyes and ink, flipped negatives, found objects, negative prints, and extensive captions, characterized the work of all these photographers:

> . . . since the treatment of such material by such photographers as Ansel Adams has become so familiar and accepted—there was a strong temptation for the photographer to fall into the "Purist" approach. A study of these pictures [Laughlin's own] . . . indicates that the photographer varies the character of his approach in accordance with what the nature of the subject matter suggests to his imagination. He has never tried to force one method of approach on *every kind* of material . . . he has tried to do something more subtle: to incorporate "Purism" *merely as a basis* upon which to build his own special . . . vision.

148

The Silver Printmakers

The major silver printmakers of the sixties were Jerry Uelsmann, Ken Josephson, and Ray Metzker. All three were strongly influenced by the experiments initiated at Chicago's Institute of Design: Josephson and Metzker studied there with Arthur Siegel and Harry Callahan. Uelsmann was a student of Henry Holmes Smith after Smith left the Institute for Indiana University. In the seventies a diverse group working in both black and white and color and influenced both by West Coast and Chicago aesthetics pushed the definition of the straight print even further. Some of the many photographers in this group were Robert Cumming and Tom Barrow, who derived images from conceptual stances; Roger Mertin, who explored the combination of flash and movement; Nancy Rexroth, Gary Hallman, and Linda Connor, who explored enlargement or soft focus; Les Krims, Duane Michals, and Arthur Tress, who created photographic fictions; John Pfahl, William Larson, and John Divola, who manipulated and constructed worlds to be photographed in color; and William

149

DeLappa and Emmet Gowin, who borrowed freely from the snapshot. While the work of these photographers varies greatly in form and expression, all share a fundamental concern: their images are pictures about making pictures in the straight photographic tradition. Each of these photographers works close to the classic straight aesthetic, retaining an almost catholic commitment to the inherent qualities of the medium, while evolving methods for commenting on and expanding its potential.

Jerry Uelsmann's photomontages are perhaps the most significant silver print-making achievement of the sixties. His photographs are a curious hybrid of themes, motifs, and sensibilities. In a single Uelsmann print one might find elements of Pop and Expressionism, photography as comedy, photography as self-knowledge, aspects of surreal and romantic fantasy, and formalist and conceptual experiment. Uelsmann's prints are as pristine and seamless as Ansel Adams's and as expressionistic as the work of his "photographic godfathers," as he calls them, Ralph Hattersley, Minor White, and Henry Holmes Smith. No current photographer has successfully imitated Uelsmann's eclectic vision, but his influence can be traced widely to photographers as divergent as Meridel Rubinstein and Robert Cumming.

JERRY N. UELSMANN. *Apocalypse 1,* 1967. Combination photograph

JERRY N. UELSMANN. *Untitled,* 1969. Combination photograph

Uelsmann owes a great deal to Rauschenberg's and Cornell's notion of photography as a collecting activity, but he may also be seen as photography's first successful answer to Pop Art. His work bears the same ironic and parodic relationship to traditional photographic aesthetics that Lichtenstein's work bears to the aesthetics of traditional painting. Uelsmann's prints are gatherings of the most extreme and frequently outrageous material. Like Rauschenberg and many Pop artists, Uelsmann employs subject matter that is prototypically American and peculiarly Southern. It is quintessential Americana: gimcracks, gewgaws, whim-whams, and whimsies of the nostalgic past. He peoples his photographs with old valentines, humorous ceramic figurines, old photographs, dolls, the American flag, an eagle, amusement park rides, Gothic statuary, and all sorts of bric-a-brac. This basic Americana he combines with the most pretentious, shopworn romantic iconography: seed pods, a painter's easel, floating eyes, decaying ruins, tombstones, cloaked women, dead birds, sunsets, and primary biological forms. At its best, the effect is a dazzling integration of the traditional mythology of art with American popular culture.

150

KENNETH JOSEPHSON. *New York State,* 1970

KENNETH JOSEPHSON. *Honolulu,* 1968. Collage

The critic William Parker has, with good reason, compared Uelsmann to the painter Magritte. The resemblance is, however, only superficial, for Magritte's sensibility is ultimately European and too surreal for Uelsmann. Joseph Cornell is a more fitting analogy. Cornell, like Uelsmann, managed to combine commonplace Americana with the sumptuous textures and images of high art. Both created mysterious objects, souvenirs, and merry amusements.

Uelsmann's work was first read as deeply serious. Yet on reevaluation it can be seen as a gentle mockery of the metaphoric tradition, a body of work equally concerned with visual puns, mental images, game playing, and process. The image of Uelsmann as a purely expressionistic photographer has been unfortunately antithetical to the development of his own work and flamboyant humor. It might be argued that Uelsmann, never having been acknowledged as the master Pop artist and humorist of contemporary photography, began to take his own work too seriously. It now appears that he has backed himself into a corner, merely repeating without comic relief the mannerisms of the earlier work.

Both Ray Metzker and Ken Josephson were far more willing to challenge the notion of photographic veracity and actively interfere with the classic straight pro-

cess. For both, subject matter as such ceases to be of primary importance. Their concern is rather with the fundamental photographic issues of framing, inclusion, exclusion, and selection. Josephson compounds these problems with a constant reference to photographic reproduction itself. His work is literally made up of photographs about photographs. He has chosen to depict the various generations of removal—physical, psychological, and conceptual—between the reproduced object and the thing itself. Josephson has explored a wide variety of essentially conceptual forms. In his best-known group of photographs, a hand, jutting into the frame, holds up a postcard of the scene being photographed. In *The Bread Book* (1973), a loaf is sliced and photographed piece by piece. In another project, photographs are placed in neutral environments and photographed as the major environmental event. More recently Josephson has made montages that explore the interaction between black and white and color or between the rough edges of reality and the torn edges of a photographic print. These works highlight the ambiguities of actual representation and the time lag between perception and reproduction. Even though Josephson repeats

the same gesture in one image after another, he sustains our interest and delights us with the constant tension between reproduction and reality.

In the sixties Metzker used a host of sequential and framing procedures to produce clear, multi-image prints and photographic mosaics. These images are constructed with elegance, a sense of the calligraphic, and a lyrical use of the black frame line. They relate to the contact sheet and to contemporary printmaking's sense of the matrix and the multiple. Metzker has explored, in his own words, "repetition with tonal variation in prints, juxtaposed images formed at different moments but linked in the camera by the interval between frames; and overlapping successive exposures on roll film so that the entire strip is seen as one print."

Metzker's large mosaics gave way in the seventies to a smaller-scale but no less ambitious series of single prints. In a series of New Mexican landscapes from 1972, Metzker allows high-contrast patterns created by buildings, foliage, and his own shadow to interrupt the scene, producing at once ominous forms and an intensely expressionistic image. Here Metzker—in contradiction to all the rules of the smooth, full-scale print—welds together in a single image tonal passages and high-contrast, opaque masses. The notion of the interrupted landscape is continued in *Pictus In-*

RAY K. METZKER. Detail of *Untitled*, 1966. Photograph, 37 × 31"

RAY K. METZKER. *Untitled*, 1972

151

terruptus (1977), a series in which hands and objects close-up and out of focus are thrust into the frame, creating ambiguous, unreadable photographs. Perhaps Metzker's most moving work has been an extended study of sunbathers on the beach at Atlantic City: *Sand Creatures* (1968–75). In these photographs Metzker points his camera down at sleeping and dozing bathers. These images are an extended catalog—not unlike Muybridge's—of human postures, costumes, and physiognomies as well as surreal images of a prone, almost catatonic people. The sunbathers' remote immovability seems at once the sleep of love and the sleep of death. Like the earlier mosaics, *Sand Creatures* has a striking formal beauty: here are incredible patterns and splashes of texture, tone, and shadow. In spite of their great visual complexity, Metzker's images never seem forced, mannered, or academic. While pushing process to its limit, he has never lost sight of the power of fact.

Emmet Gowin's and Duane Michals's photographs represent another type of risk taken in the late sixties and early seventies to expand the boundaries of the medium. Both begin with roots in the straight, metaphysical tradition. Both look for

DUANE MICHALS. From the sequence *The Fallen Angel*, 1968. Plates 1, 4, 5, and 7 of a seven-print series

EMMET GOWIN. *Edith, Danville, Virginia*, 1971

ways to extend the photographic vocabulary for spiritual, psychic, and sexual experience. Both frequently depart from the demands of the straight tradition, readily utilizing the peculiarities of lens and film. They turn to the photographic "accident," the cinematic storyboard, old-time "spirit" photography, the snapshot, and conceptual art. Each uses basic exposure characteristics as a form of visual allegory: blur and brightness symbolize energy and the transformation from body to spirit; the transparency of double exposure suggests the otherworldly and the ethereal; out-of-focus indicates dissolution and dying; totally black or white prints become metaphors for the extremes of knowledge. Both specifically constructed situations to be photographed. For both, the darkened interior room illuminated only by curtained windows becomes a major iconographical symbol of interior life.

Michals's sensibility is essentially cinematic. He is concerned with emotion visualized as a temporal rather than a spatial phenomenon. Where Minor White had used the sequence as a constellation of metaphors, Michals would use sequential photographs as an absolutely narrative form. Michals's early, solely photographic sequences are photo-fables, brief passion plays, ancient theater in modern dress. The best of this work is generated out of the tension between the literalness of photog-

raphy and the artifice of drama. Here Michals shows himself as a master stage director, a master of the ironic point of view and the cinematic presentation of voyeurism and violence. In the more spiritual of these fables, however, the photographic devices become too apparent, creating Pop parodies rather than serious metaphysics. Undoubtedly feeling this limitation, Michals turned more and more to captions, extended written narratives, and literary conceits. But in doing so, he allowed the photographs to degenerate to mere illustrations of the written text. Michals opens the book *Real Dreams* (1976) with an image produced by scrawling words on a blank sheet of photographic paper. We are left with only the written statement of "a failed attempt to photograph reality."

Gowin succeeds precisely where Michals fails. Gowin's simple yet intensely seen daily events take on the quality of ritual. His family and friends, being finely and fully drawn, assume universal significance. Gowin's work may be seen, as may Stieglitz's photographs of O'Keeffe, as an extended sequence or family album in which the viewer comes to know Gowin's world on an intense, intimate basis. We

153

are always aware that the characters in Michals's stories are playacting; in Gowin's work, on the other hand, the photographer seems to merely record reality. Though his images may have begun as fiction, they are presented as fact.

EMMET GOWIN. *Edith, Danville, Virginia,* 1970

EMMET GOWIN. *Sheep fleece, Yorkshire, England,* 1972

Gowin is more successful because his ultimate commitment is to the medium. Michals's commitment is to the idea rather than its embodiment. "I find the limitations of still photography enormous," he wrote. Accepting visible things as sufficient evidence, Gowin believes in the capacity of the medium to express the ineffable, and the camera has rewarded that belief. His more traditional work is tied to the aesthetic of the individual, beautifully made print. Michals, ultimately disbelieving in photography as a means of passionate communication, fails to find adequate substance in visible reality. In the end it is Gowin who deals with "real dreams," while much of Michals's work is indeed "a failed attempt to photograph reality."

In the seventies the work of the silver printmakers provided a running critical dialog, constantly expanding, elaborating, or refuting the orthodox definitions Szarkowski had enumerated in *The Photographer's Eye.* For Szarkowski the photograph of the "thing itself" was a literal illusion. The new silver printmakers would take illusionism one step further and deal in outright tickery, constructed realities, and

seamless combination prints. In their straight photographic prints of fabricated objects, Carl Toth, Robert Cumming, John Pfahl, and others created a new hybrid of photography and construction. Neither purely sculptural nor purely photographic, their work reverses the conventional notions of photography as document and sculpture as three-dimensional object. Their constructions are used only for generating images on a flat plane. Their photographs show objects that exist only to be photographed.

Meridel Rubinstein, Bart Parker, Allen Dutton, and Adál Maldonado, on the other hand, construct their realities not before the camera but in the darkroom, combining negatives or rephotographing collaged prints. While their styles and intentions vary widely, these photographers are united in their desire to preserve the illusion of a unified, single-image surface.

For Szarkowski the photograph existed as an independent, visual form. Many of the new silver printmakers, including Lew Thomas, John Baldassari, Tom Barrow,

BARBARA BLONDEAU. *Untitled*, 1970. High-contrast, manipulated negative

BARBARA CRANE. *Just Married*, 1975. From the Baxter Travenol Lab Series. Film collage, 16 × 20″ contact print

Allan Sekula, and Robert Cumming, insisted that the photograph be seen in a conceptual, linguistic, or political context. Szarkowski saw the "detail" as epitomizing photographic factuality. For the new silver printmakers the detail was frequently a false lead, a distortion of scale, function, and fact. Cumming in particular is a master of the art of hidden distortion. By juxtaposing a factual with a fictional image, he makes us reconsider our allegiance to photographic truth.

For Szarkowski the "frame" was singular and inclusive. The new silver printmakers would explore multiple and extended framing and use the whole contact sheet as an inclusive image. Dale Kistemaker, William Larson, Reed Estabrook, and Gary Beydler make landscapes and interiors out of sequential frames. Eve Sonneman's multiple viewpoints of single events effect a protracted, almost stereoscopic experience. Jan Groover's triptychs juxtapose color and forms as well as shifting perspective and scale. Barbara Crane, Paul Berger, Tetsu Okuhara, and Barbara Blondeau extended the frame into image strips, collaged mosaics, and serial repetition.

Photographic time for Szarkowski was instantaneous, historical, and non-narrative. The new silver printmakers would reinvent natural phenomena by distorting

and prolonging time through juxtaposition, integration of flash and movement, double printing, and double exposure. Roger Mertin, Paul Diamond, and Richard Misrach are only three of many photographers who blasted a flash exposure onto an extended daylight or night exposure. Similarly, Jerry Burchard and Steve Fitch used long nocturnal exposures to produce in a single image successive moments of illumination. Their work is representative of a new photographic attitude toward time that obviated the "decisive moment" and found form and metaphor in the paradox of photography's ability to simultaneously show instantaneity and extended time.

Where Szarkowski's "vantage point" was sharp and logical, emphasizing facts, the new silver printmakers' images were sometimes less than sharp. The issue of softness was explored by a host of photographers, including Nancy Rexroth, Linda Connor, Gary Hallman, Peter De Lory, Eric Renner, and Abigail Perlmutter. Using camera movement, giant enlargements, plastic lenses, long exposures, old, soft portrait lenses, halation, selective focusing, graininess, and infrared film, their work re-

lated both to the psychedelic drug experience and to the rediscovery of older photographic modes. Their softness of form and suppression of detail provided a range of metaphoric and formal potentials that hovered ambiguously between outright pictorialism and a new formalism.

The new silver printmakers would court the ironic and the absurd, the possibilities for misapprehension and misreading, and the illogical. They ignored the traditional dictum concerning the natural world: Do not touch. What documentary evidence would not provide they might add quietly by hand. Szarkowski's print was not only seamless but virtually anonymous. The new silver printmakers would often make the process all but self-evident, pulling back the curtain just enough to reveal the artist's hand but not enough to destroy the photographic illusion. The new silver printmakers would challenge notions both of photographic reality and of reality itself.

RICHARD MISRACH. *Saguaro*, 1975. Plate 51 from *(a photographic book)*. Long exposure with strobe flash

LINDA CONNOR. *Untitled*, 1975. Taken with old 8 × 10″ Century view camera with soft-focus lens. Gold-toned studio proof paper, sunlight developed

The Nonsilver Printmakers: The New Pictorialists

Where the personal journalists of the sixties were on the lookout for new subject matter, the silver printmakers were on the lookout for new strategies built on the assumption of the realist imperative. The nonsilver printmakers on the other hand quickly dispensed with the realist imperative. Where Uelsmann found energy and validity in the older silver collage tradition, posting the sign "Robinson and Rejlander Live" above his darkroom door, Robert Fichter rejected any part of the straight tradition. He emblazoned "Edward Weston is Dead" on his T-shirt and promptly left the darkroom almost entirely, preferring to draw on, paint with tempera, airbrush, and hand-color his photographs. The look of the final product was so unlike the traditional silver print that Uelsmann jested: "Bob Fichter steps on his negatives before he prints them."

Springing from many of the same sources as the silver printmakers, the nonsilver printmakers also wished to integrate the broad concerns of art into photogra-

ROBERT HEINECKEN. *Glamour Magazine,* 1971. Magazine page with black-and-white photo-offset

phy. Yet their intentions and their results differed radically from those of the silver printmakers. In many ways their work is a late-twentieth-century manifestation of the turn-of-the-century Photo-Secession. With the aid of photomechanical, extraphotographic, and heavily manipulative photographic processes, they presented the photograph as art by making it either physically unique or clearly correlative to the forms of traditional printmaking. Ironically, the media they chose to free the work from traditional restraints locked them into conservative modes of presentation. The nonsilver printmakers resurrected techniques from the early Secessionists: cyanotype, gravure, gum bichromate, carbon printing, handcoloring, bromoil transfer. They borrowed from the American craft tradition the use of stitching, hand-binding, embroidery, and handmade fabrics. They explored the new reproduction technologies: photo-offset lithography, photosilkscreen, 3M color transfer, thermofax, xerography. Yet both the old and the new technologies tended to reduce the clarity, density, and richness of visual information, muting the original photographic perception in pastel colors, vagueness, and broad tonal masses. Because of this essentially conservative character, it is difficult to find in their work the elements of surprise or authority. Indeed, their success or failure may be gauged on how well they reject or accept the

pull of the pictorial.

Robert Heinecken, the most influential of the early nonsilver printmakers, is a case in point. Because his intentions were the most ambitious, the failure of his work is the most conspicuous. Since the early sixties Heinecken has been engaged—in his words—in "guerrilla warfare" against the purist aesthetic. "With a strange sense of propriety or humor, I like to go into something, shake it up, and disappear."

Heinecken's assaults have been made against traditional form and against the sexual, political, and social exploitation of the photographic image by the mass media. His technical strategies were adventurous and radical: he presented photographs as picture puzzles, cubes, and stacked blocks. He used magazine pages as negatives, superimposing front and back, photograph and typography, to form a single unit. He altered images with offset printing and rebound new material into existing magazines. He made overscale replicas of 35mm negatives, created photographic environments, and worked on linen, plastic, metal, and canvas. And he has consistently used photographs drawn from forbidden sources: the pornographic and the atrocities of

157

war. Most recently he has made SX-70 narratives about the ongoing war between the sexes.

Yet Heinecken has consistently failed to embody his concerns in anything but superficial ways. Like the personal journalists of the sixties, he relied too heavily on the sensational to carry the burden of discovery. The conceptual insights borrowed from other art became simplistic in his hands: Rauschenberg's rebus became a literal jigsaw puzzle. Thiebaud's, Ramos's, and Wesselmann's bawdy great American nudes became vapid pornography. In the end Heinecken's projects are strangely understated and curiously homogenized: sexual imagery more adolescent than erotic, social commentary more pictorial than political, the idea always more ambitious than the realization. Leaving the path of the straight print, Heinecken lost his way in a maze of pictorial alternatives.

The team of Blumberg and Gill was more successful in visually articulating its ideas. Together they created canvas-size pictures, Gill painting in acrylics over Blumberg's photo-linen image. During the mid-sixties they produced the most interesting integrative work that came directly out of the photographic community. Their images cross realism and Abstract Expressionism. In many pictures a centrally

ROBERT HEINECKEN. *Cliché Vary/Fetishism,* 1974. Photographic emulsion on stretched linen, chalk applied

ROBERT HEINECKEN. *Multiple Solution Puzzle,* 1965. Photographs mounted on twenty-four equilateral triangles which form 10 × 10″ hexagon

placed photographic female figure competes with a complex environment of painterly notations, colors and gestures, autographic marks, and such references to the photographic process as contact sheets and negatives. Unlike much of the similar work that was to follow in the seventies, Blumberg and Gill's images gracefully embodied both media, insisting equally on the experience of painting as gesture and improvisation and the experience of photography as fact. Perhaps because theirs was a genuine collaboration they managed to find an integrated vocabulary which, while related to Rauschenberg's, was individual and unique. Blumberg, it should also be noted, produced on his own several fascinating photographic sequences using, as did Metzker, juxtapositions of images across frame lines. He also produced films shot in the single-frame mode.

John Wood's prints have much the same integrative sensibility of Blumberg and Gill's canvases, although Wood is more lyrical in composition and more overtly political in content. Wood's drawing is spontaneous, intricate, but lucid. In his work

DONALD BLUMBERG and CHARLES GILL. *Untitled*, 1966. Acrylic on photo-linen, 54 × 45″

JOHN WOOD. *Untitled*, 1966. Collage of photographs and drawings, 13 × 33″

the calligraphic ultimately supersedes the photographic.

In retrospect it appears that Heinecken, Wood, and Blumberg and Gill were acclaimed and given extensive exposure precisely because they had direct ties to the photographic community. Though their work did not have the power of the painting community's work derived from photography, acknowledgment of their work as photographic helped legitimate photography's endeavors in mixed media and represented the first major recognition of the possible ties between photography and contemporary art. Photography's own refusal to accept as its own Rauschenberg and the other artists working with photography was partially a testament to its traditional inferiority complex, its constant isolation from vanguard art, and the continuing reign of the straight tradition. Only a few photographers and artists were willing to cross the well-defined social and political boundaries that dominate the American art scene. Among the few examples of mutual recognition during the sixties was the jointly published portfolio of photographs by Lee Friedlander and etchings by Jim Dine, *Work from the Same House* (1969).

Only now that economic and aesthetic approval has been finally given to pho-

tography has some of the old antagonism begun to fade. But, of course, economic competition generates a new hostility, as indicated by the vitriolic attack on photography in the May 1979 issue of *Artforum*. "Whereas photography is only able to provide us with information derived from light," the painter Richard Hennessy bellowed, "painting provides us with an image of the interrelationship of the senses. . . ." And then, grasping for the most profound analogy to protect the integrity of his medium, Hennessy declared: "Photography bears the same relationship to fine art that figure skating does to ballet."

Unfortunately, this type of hostility and lack of understanding between the arts has always been photography's loss. It forced the majority of the nonsilver printmakers to rely on the most conservative and academic traditions. Like the early Secessionists, they were obliged to appropriate the forms and mannerisms of recent art, particularly the additive collage, without appropriating its more radical, ideational intentions. Ironically, in their rush to exploit new media, the nonsilver printmakers

159

abandoned the most basic means of photographic representation—silver printing— but refused to give up the pictorial and the banal.

In the seventies a few nonsilver printmakers began to use their medium with greater sophistication. One of the best examples of such work is William Larson's telephone-transmitted *Fire Flies* (1976). Larson integrates sounds, words, and photographs in staccato, enigmatic carbon burns. His careful use of open space redeems the low resolution and undifferentiated notations of the soft telephone transcripts. His teleprints convincingly convey distance, alienation, and the mysteries of high technology. Bea Nettles, Catherine Jansen, Keith Smith, and Betty Hahn have also used the inherently internalized nature of the soft pictorial processes to explore issues of biography, sexuality, and personal symbolism. Nettles has employed the Kwik-Print process to create highly personal, dreamlike biographical images and narratives. Jansen's ebullient good humor compensates for the inherent drabness of the blueprint fabrics that make up her soft sculpture. And Smith has combined photoetching and hand-coloring to explore issues of interpersonal relationships. Hahn has experimented with gum-bichromate images on stitched fabrics and has added Flair pen

LEE FRIEDLANDER and JIM DINE. Two-page spread from *Work from the Same House: Photographs & Etchings*, 1969

lines to cyanotypes. More than the others mentioned here, she has also sought out the more radical possibilities of using the soft processes as means for formal and graphic statement.

But most of the nonsilver printmakers never learned what Warhol and Rauschenberg knew so well: that one had to juxtapose, not merge, the differences between media. For the most part, the nonsilver printmakers demanded too little from the photograph and too much from its media environment. They reduced the possibilities of form and expression to mannerist techniques. Apparently overwhelmed by the mere pleasure of combination and alternative printing, they failed to ask and solve the most fundamental questions of integration and representation.

It took two relative outsiders, one a commercial photographer, the other a historian, to produce the most successful mixed-media work within the photographic community in the seventies. Michael Lesy's *Wisconsin Death Trip* (1973) is a stunning example of focusing multi-media strategy on history. Lesy's historical analysis utilizes Assemblage techniques, visual manipulation, and the juxtaposition of pho-

BETTY HAHN. *L.R.*, Number 29, 1977. Screen print, 18 × 22"

WILLIAM LARSON. *Telephone Transmission Image,* 1979. Electro-carbon print

tograph and text. The book exploited the role of historian as editor and montage-maker, giving us the other side of the American dream: the American nightmare, a world of death, suicide, murder, madness, fire, and sex. By asserting the historian's role as fabricator, Lesy reversed the accepted notion of the photo-essay as fact. Rather, *Wisconsin Death Trip* proposed the photo-essay as the ultimate mixed-media experience.

Peter Beard's *African Diaries* (twenty of which were lost in a 1977 fire that destroyed his Montauk house) derive from the same undercurrent in American thought that motivated Lesy. Beard, like Rauschenberg and Cornell before him, is a collector obsessively hoarding images that relate to his adopted African home, Kenya. Pasting fragments of photographs together with drawings and writings on thick pages of huge diaries that become over a foot thick, Beard weaves a tapestry of inexhaustible terror and energy. His collaged images contain newspaper clippings, cellophane wrappers, travel plans, SX-70s, African identification photos, snakeskins, and handprints in his own blood. These are placed side by side with images of high fashion, primitive cultures, the last of the African wild animals, and the first twentieth-century pinups. "Like society," Beard said, "the diary is a world of useless secrets.

160

Everything is there, yet there is nothing."

Beard's diaries function both as a dimensional object and as image. They are derived from the photographic scrapbook and relate to the most primitive need for souvenir and memento. At the same time, Beard's intuitive sense of organization and form transforms these mysterious and terrifying personal observations to the level of shared truths. Beard's diaries are some of the most complex and fascinating visual objects since Cornell's boxes and Rauschenberg's combines.

As we move through the eighties, no other photographic territory offers a greater possibility for achievement than nonsilver printmaking. The success of the silver printmakers depended in large measure on the strength of the straight tradition, the clarity with which the straight aesthetic had been articulated, and the vitality of modern art. Perhaps now, after almost twenty years of constant experimentation in mixed media, the nonsilver work will begin to blossom.

MICHAEL LESY. Page from *Wisconsin Death Trip,* 1973. Photographic montage. Original print in the State Historical Society of Wisconsin

PETER BEARD. From the *African Diaries,* 1978. Collage with drawing: photographs, newspaper clippings, and photographs from previous diaries. Original in color

The New American Frontier

Rephotographing America

In the seventies straight photography moved away from documentation of the outcast, the bizarre, and the freak and turned back to the most basic source of American myth and symbol: the American land. The seventies view of the landscape was less sanguine than those visions of the vastness, grandeur, and wildness that had animated American photography for more than a century, from the early views of the West through Paul Caponigro's expressive natural details in the sixties. The land itself had become for several generations of photographers the pictorial repository for all the possibilities and fantasies of the American dream. These photographers closed their eyes to the devastating evidence of decay and corruption, seeing instead a land that on the political level symbolized nationalism, democracy, and economic abundance and on the personal level self-reliance and spiritual regeneration. For these photographers the land often existed more as myth than actuality.

The early photographers of the land stood with the civilized world behind them and looked out toward the wilderness. In the latter half of the seventies the new breed of photographers reversed this orientation. They stood in the open land and pointed their cameras back toward the approaching civilization. Rather than explorers pushing into the unknown, these new photographers were observers doc-

Rephotographic Survey Project, 1978–79. Paired photographs (top to bottom): Timothy H. O'Sullivan, *Austin, Nevada, Reese River District,* 1867, and Gordon Bushaw, *Austin, Nevada,* 1979; Timothy H. O'Sullivan, *Green River, Wyoming,* 1872, and Mark Klett and Gordon Bushaw, *Castle Rock, Green River, Wyoming,* 1979; Timothy H. O'Sullivan, *Tertiary Conglomerates, Weber Valley, Utah,* 1869, and Rick Dingus, *Witches Rocks, Weber Valley, Utah,* 1978

umenting the conflict taking place between man and nature on the new American frontier. They photographed that point in the landscape where the Old West was unceasingly and irreversibly dissolving into contemporary, homogenized America.

The dominant theme of this new photography was the phenomenon of change. The photographers of the new American frontier were fascinated by the change that occurs with the transformation of wilderness, rural territory, and open land into urban environment. The dominant presence in this photography, however, is not the present but the past. The work of these photographers is an almost clinical examination of the relationship between the American past and the American present. It looks at America from the vantage point of the land that was first photographed. From this perspective it describes the land as it has been tamed, conquered, broken, and developed by the advancing line of settlements. The frontier that is photographed is the intersection of reality and myth, technology and wilderness, rural independence and industrial dependence.

In 1975 a major exhibition at George Eastman House, *New Topographics*,

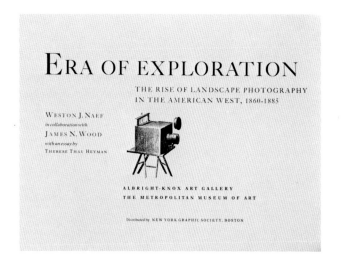

164

Title page from *Era of Exploration*, 1975. Exhibition catalog. Wood engraving, *Simple wet-plate camera for field use*, from *A History and Handbook of Photography*, 1877

Title page from *New Topographics*, 1975. Exhibition catalog

brought together ten photographers of this "man-altered landscape": Robert Adams, Lewis Baltz, Bernd and Hilla Becher, Joe Deal, Frank Gohlke, Nicholas Nixon, John Schott, Stephen Shore, and Henry Wessel, Jr. Because of the strength and radicalness of the images and because of its title, the show became the seminal exhibition of the last half of the seventies. The term *topographics* was the choice of curator William Jenkins. Like the phrase *social landscape* in the sixties, the term summarized a major photographic attitude of the seventies. With its multiple references to the environment, mapping, and image making as well as its slightly obsolete ring, topographics suggested the very sources that were at the heart of this new photography. The term could be associated with nineteenth-century view photography with its large vistas, stand camera, and sense of measurement, light, and form, but it also implied the contemporary issues of conservation and ecology. It signified the objective detachment of both science and modern art. And its implicit reference to artifact, surface, and concept pointed to the presence of the medium itself. In a single word, Jenkins had managed, as the photography itself did, to bring together the directness of nineteenth-century photography with the self-conscious sophistication of late-twentieth-century art.

The implicit comparison between past and present became explicit in two other activities of the late seventies. The first, the exhibition and catalog *Era of Exploration*, an extensive study of the "rise of landscape photography in the American West, 1860–1885," was presented at the Metropolitan Museum of Art in New York during the same year *New Topographics* was exhibited in Rochester. The catalog essays, by Weston Naef, James Wood, and Therese Thau Heyman, probed the relationship between nineteenth-century American photography and the arts, science, and religion of the period, providing the first substantive discussion of one of the roots of the experimental and the sublime in American art and photography. The second activity, the Rephotographic Survey Project (RSP), initiated by Ellen Manchester, Mark Klett, and JoAnne Verberg, began in the summer of 1977 to measure even more emphatically the distance between past and present. The aim of the RSP was to make new photographs from the exact camera and lens positions from which the nineteenth-century photographers William Henry Jackson and Timothy O'Sullivan made their 1860s and 1870s views. The RSP not only located the positions of over

165

eighty-five sites in several states, but also duplicated as closely as possible the hour and the season of the earlier photographs. Both projects—*Era of Exploration* from a curatorial and historical approach and the RSP from an absolutely photographic approach—pointed out not only visible changes in the landscape but the continuing use of the pastoral tradition as a contemporary touchstone. They raised, as well, fundamental conceptual questions about the nature of documentary photography.

The vitality of the land was reaffirmed once again in 1979 when the Friends of Photography published perhaps the most beautifully printed historical document of the decade: a complete reproduction of Carleton Watkins's rediscovered album *Photographs of the Columbia River and Oregon.* Watkins's photographs, juxtaposing austere abstract elements and traces of human presence against images of the powerful river, were particularly compelling in the light of contemporary aesthetics. The publication signaled a critical reevaluation of Watkins and reaffirmed photography's deep ties to both the realities and the aesthetics of the American past.

CHARLES SHEELER. *Classic Landscape,* 1931. Oil on canvas, 25 × 32″. Original in color

LEWIS BALTZ. *The new Industrial Parks near Irvine, California,* Number 12, 1974

New Topographics

Many of the photographers of the new American frontier would have us believe that the essential characteristic of their work is objectivity. Lewis Baltz wrote of his Maryland photographs: "I hope that these photographs are sterile, that there's no emotional content." Joe Deal wrote that he wished to eliminate "the vagaries of sky and horizon." And Robert Adams was "determined, moreover, to stay clear of the mountains. I distrusted the late Victorian passion for mountaintop vistas. . . ." Even in his introduction to *New Topographics*, Jenkins claims that the show's photographs "function with a minimum of inflection in the sense that the photographer's influence on the look of the subject is minimal. . . . As individuals the photographers take great pains to prevent the slightest trace of judgement or opinion from entering their work. . . . [Their] viewpoint is anthropological rather than critical, scientific rather than artistic."

This claim to scientific objectivity and neutrality may be understood more as

166

DOUGLAS SOUTHWORTH. Section of an "Edward Ruscha" elevation of the Las Vegas Strip, 1968. "Learning from Las Vegas" project directed by Robert Venturi, Denise Scott Brown, and Steven Izenour

political gesture than as theory. It was an attempt to disassociate this work from the emotionalism and sentimentality of American popular photography. It was also a reaction to what many perceived as the overheated expressionism of the fifties—as represented, for instance, by Minor White—and to the pictorial excesses of the sixties—as represented by Jerry Uelsmann. The statements by Baltz, Adams, and Jenkins were tacit protests against the contemporary production of images that depicted a traditionally sublime landscape; such photographs were considered anachronistic, naive, and indefensible. These statements wished to emphasize instead the geometric and optical qualities of the work, linking it to the cooler, formal concerns of contemporary art, which saw form as essentially architectonic and viewed the landscape as a geometric, formal element. Such statements chose to underscore the formalist precedents for the work at the expense of its photographic heritage. Rather than acknowledging their antecedents in the photography of Watkins, Stieglitz, Weston, and Ansel Adams, these photographers felt more comfortable pointing to precedents in the aestheticization of the American industrial form and landscape in the Precisionist paintings of Demuth and Sheeler, the ironic machine aesthetic of Duchamp and Picabia, the functional stylizations of the Bauhaus, and the conceptual art of the sixties and seventies.

Many of these new photographers were eminently successful in allying their work with precedents in art rather than in photography. Partially because of this rationale, the seventies saw the first close linking of art and photography in major East Coast galleries, which had traditionally shown only graphics, painting, and sculpture. Castelli signed on Robert Adams, Lewis Baltz, and John Gossage. Sonnabend Gallery represented the Bechers. Other photographers who held a similarly cool viewpoint could be seen at the Robert Freidus, O. K. Harris, Sidney Janis, Marborough, and Pace galleries.

Though these photographers presented their work as formal statement and careful documentation and though they were deeply aware of the difference between undefiled terrain and the developed land, their hallmark was not irony. Neither are their photographs emotionally neutral: these are photographs about taking, exploiting, and raping the land. At the same time they are also about the visual potentials of a damaged landscape. Uncomfortable before the traditionally magnificent view, these photographers self-consciously avoided the overtly dramatic; they were unwill-

ing and unable to make the grand gestures of Muybridge, Weston, and Ansel Adams. Equally uncomfortable before the spiritual ennui of the contemporary landscape, they sought out the sublime aspect of the ordinary. Photography provided a means for creating visual beauty out of material that in reality offered little hope for spiritual redemption. Instead of presenting the distressing suburban world that Peter Blake recorded in 1973 in *God's Own Junkyard*, these photographers took a view closer to that advanced by Robert Venturi in 1972 in *Learning from Las Vegas*. They recognized the beautiful in the disdained and endowed the vulgar and the ordinary with a new pastoralism. In the end, then, the landscape and suburb are both glorified and disparaged in their work. Their photography is torn between being true to the world—which is the basis of documentation—and being true to the medium—which is the basis of art. The essential hallmark of the photography of the new American landscape is ambivalence.

American Light

In the work of the two major photographers of the new American frontier, Baltz and Robert Adams, art, nature, and industrial form become inextricably tangled. Both

photograph the meeting point of land and settlement in such a way that the landscape and the buildings assume qualities traditionally associated with the other. In reality, both the land and the architecture are usually banal, sterile, bleak, and scruffy. Yet in Baltz's and Adams's work the grace that has departed from the land often becomes an attribute of the approaching civilization. Tract houses, industrial buildings, and developments under construction become surrogates for the glowing, monumental Western landscape of the past, even while they are seen as uniform fabrications. The landscape takes on attributes of industrial regularity, urban brutality, and artificiality. It too is both sacred and profane. In this ambiguous world mechanized facts come to stand for natural facts, while nature takes on the characteristics of culture. The presence of American light, grandeur, and beauty permeates Adams's and Baltz's work, but the natural retains its vitality only when joined to and defined by its opposite, the man-made.

It is this constant reversal of roles that fascinates Adams and Baltz. In their work the themes of nature and art are played contrapuntally, inverted, and reversed. The counterpoint is between landscape and cityscape, between the natural world and

WALKER EVANS. *Corrugated Tin Facade, Moundville, Alabama,* Summer 1936

ROBERT ADAMS. *Mobile homes, Jefferson County, Colorado,* 1973

the man-made, between nature and art. "The suburban West is, from a moral perspective," Robert Adams wrote, "depressing evidence that we have misused our freedom. There is, however, another aspect to the landscape, an unexpected glory. Over the cheap tracts and littered arroyos one sometimes sees a light as clean as that recorded by O'Sullivan. Since it owes nothing to our care, it is an assurance; beauty is final."

Adams's *Mobile Homes, Jefferson County, Colorado* (1973) is such an assurance. Here light radiates from the white metallic sides of the boxy homes while the details of power lines and air conditioners become delicate traceries against the stark, open landscape and heavy sky. Baltz's photographs taken at dusk or on cloudy days also have strong references to light as redemptive energy. In one of the photographs from *The new Industrial Parks near Irvine, California* (1974), a half-painted corporate sign reading "Semicoa" glows against an unfinished wall; in another an open garage door becomes a transparent vista through the darkening landscape; and in a third the muted sun throws the delicate leaf patterns of three young trees against a wall which is in itself, through the accidents of stucco and paint, turning into a distant landscape. In all these photographs Baltz sees a natural vitality in an actually hard, concrete world.

Again and again in Baltz's work the accidental quality of plaster, paint, and tungsten light duplicates the form of the natural landscape and the glow of the pastoral. The presence of the landscape in the man-made is most apparent in buildings photographed absolutely head on. Here unfinished swatches of paint and plaster become mountain ranges, and stuccoed facades take on the tonality of deep space against which grillwork and ladders become delicate natural forms. More than this, the medium translates buildings and nature into correlatives of paintings and sculptures. Where the early Western photographers sought out the unique geographical fact, the new photographers, more concerned with art than geography, sought out the unique architectonic fact. Like Siskind before him, Baltz is concerned with the painterly quality found on flat, man-made surfaces. But where Siskind filled the frame with painterly gestures, making an overt emotional statement, Baltz pulls back and places the "found" canvas in a recognizable context. Baltz's work is cooler than Siskind's, but it is no less romantic. Where Siskind shows us only the final product, Baltz always makes us aware of the transformation from fact to abstraction. In spite of Baltz's allegiance to the conceptual and intellectual, his buildings ultimately become

169

highly charged and emotional. Their facades function much as a Rothko canvas; they become objects for contemplation.

For Adams and Baltz the new suburban construction, with its technological uniformity, its regular industrial surfaces, and its minimum of decorative elaboration, provided the perfect structural elements for formal exploration. It allowed for the constant play of minimalism against the density of photographic information. Their buildings derive from ready-mades, found sculpture, and minimal constructions as well as from Abstract Expressionist canvases. The land on which these structures sit takes on the characteristics of contemporary earthworks. Adams and Baltz are equally fascinated with the forms generated by construction scars in the landscape as with the forms generated by the new buildings. Both the scarred earth and the half-completed buildings take on a terrible beauty.

The photographic archetypes that Adams and Baltz follow occur not in landscape photography but in the work of Walker Evans and Robert Frank. Evans produced the first photography in which capitalism came into direct conflict with the American myth of the pastoral. He resolved the conflict by demonstrating that an objective record of man's intrusion into nature could be both a harsh political comment and a visually beautiful statement. Yet, Evans's moral position, like that of the

ROBERT FRANK. *Covered car, Long Beach, California,* 1955–56

LEWIS BALTZ. *The new Industrial Parks near Irvine, California,* Number 39, 1974

new frontier photographers, is ambivalent. For Frank, devastation was less of a premonition and more of a reality, but like Evans he chose at times to insure the victory of nature and myth. The two exemplary photographs to which Adams and Baltz are indebted are Evans's 1936 image of the corrugated tin facade of a contractor's shed in Moundsville, Alabama, and Frank's 1955 photograph of a tarpaulin-covered car in front of an abrupt stucco building in Long Beach, California. In these two images the medium redeems an uncertain world with a cool, silvery beauty.

Consciousness of light is perhaps the quintessential characteristic of American photography. It is precisely the lack of luminosity that sets apart the work of the German photographers Hilla and Bernd Becher in *New Topographics*. Their work stems from a European, Teutonic demand for cataloging, and their world is seen in terms of constructions rather than illuminated objects within a luminescent landscape. Their obsessive concern with the typology of representation stands in marked contrast to the American delight in modeling sunlight. The Bechers use the medium merely to obtain a uniform sizing of disparate objects. Ironically, their work is the

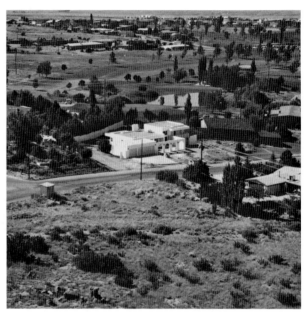

FREDERICK SOMMER. *Gold Mine, Arizona,* 1943

JOE DEAL. *Untitled View (Albuquerque),* 1973

only work in *New Topographics* that literally records topography. For the American photographers, as Robert Adams said, "Light still works an alchemy."

Three other photographers—Sommer, Callahan, and Art Sinsabaugh—influenced the landscape work of the seventies. Sommer's desert photographs of the late thirties and early forties provided a major model for the new work. In these high-angle views, the landscape is seen as a dense, composite whole. These photographs were made against the grain of Weston's and Ansel Adams's reductive idealism. Sommer's world was less hieratic, his viewpoint more inclusive. It recalled O'Sullivan's vast, undifferentiated world. Sommer uses the camera as an objectifying, leveling device that transforms the land into a uniform flat surface. Irregular natural and manmade facts are regenerated as uniform visual facts. In these desert photographs, Sommer sees the landscape both as map and mosaic.

Callahan's understated landscapes and architectural studies provided a formal alternative to the one explored by Frank and Evans. In a series of spare, elegant photographs produced since the early forties, Callahan has used a puritanical minimalism to describe the quiet beauties of ordinary land and buildings. His work anticipated in structure and tonality Baltz's photographs of industrial parks and Robert

Adams's images of suburban development. His photographs taken in the seventies of the beach at Cape Cod and of stucco buildings in Peru parallel the work done in this same period by the New Topographic photographers. Yet, rather than being derivative, it is the logical outcome of his own explorations. Callahan's work continues to be the most accurate barometer of the evolution in twentieth-century photography away from the synthetic and toward that which is irreducibly photographic.

Callahan's approach to the landscape is echoed in the work of one of his early students at the Chicago Institute of Design, Art Sinsabaugh. Sinsabaugh may be seen as the first New Topographic photographer. It was Sinsabaugh who first demonstrated the descriptive possibilities of the panorama camera for contemporary photography. He began in the early sixties to use a banquet camera with a wide, twenty-inch format to describe the rolling Midwestern landscape. His panoramic images show agrarian lands in which man's presence is quiet yet ubiquitous. Sinsabaugh's work of the early sixties places the staccato lines of telephone poles, highway crossing markers, railroad tracks, rooftops, or fields of planted crops against a constantly

white, empty sky and an endless horizon. These photographs are far cooler, more accurate, and more distant than the romantic views that marked the work of Sinsabaugh's contemporary landscape colleagues, Caponigro, William Current, and Paul Vanderbilt. They are topographical studies of an austerely lyrical landscape and a blanched, ominous sky. In the late seventies Robert Adams pursued a similar strategy, showing subtle traces of man against a more dramatic landscape but with an equally blank, disconsolate sky.

Sinsabaugh's long, horizontal format and empty sky recalled the breadth of early Western photography and implied the possibilities of a limitless America. At the same time, his panoramic images addressed distinctly modern issues of form and description. They grew out of the sixties' penchant for the wide-angle view, for inclusion, and for new models and instruments of representation. The panoramic camera has a rich heritage going back to the beginnings of photography, but Sinsabaugh's use of it was distinctly Bauhausian. His strategy for utilizing the extended frame was minimalism: he solved the formal problems posed by the elongated, inclusive frame by including less rather than more. The simplicity of his image resulted in great compositional power.

JAMES ALINDER. *Mt. Rushmore, Black Hills, South Dakota,* 1972

ART SINSABAUGH. *Midwest Landscape,* Number 24, 1961

As the sixties progressed, Sinsabaugh turned his camera more and more to the urban world, at last leaving the landscape almost entirely. And it was this urban scene that would predominate in the images of the younger panorama photographers of the seventies: the Globus brothers, Jerry Dantzic, David Avison, and Jim Alinder.

City Dwellers

In Nicholas Nixon's photographs of the mid-seventies the modern city skyline becomes the new repository for the glories of the Western skyline. But, unlike Robert Adams's and Baltz's images, there is no ambiguity, no sense of disparity in Nixon's view of the urban landscape. His high viewpoints remove any sense of urban chaos or corruption. Technology for Nixon, as it was for Ansel Adams, is totally redemptive. Adams's distant views glorified the interaction of heaven and earth; Nixon's distant, high vantage points find a similar magnificence. His world contains no foreground, no intimate human scale, and hardly a trace of nature. The city is seen

EZRA STOLLER. *60" Solar Telescope, Kitt Peak, Arizona,* 1962. Skidmore, Owings and Merrill, architects

suspended in space. Nixon has moved away from the hand camera and the street-level view, returning to the large-format view camera and the removed vantage point. This is a strategy carefully cultivated to impose a clean, geometric look on the city. Nixon's is the ideal city, just as Ansel Adams's was the ideal landscape.

Nixon's world is chosen for its photogenic potential and its luminescent glow; its status as photographic object outweighs its cultural or social significance. For Nixon the city is a world of significant architecture and elegant formal relationships. Although there does exist an American tradition of city views, rarely has such beauty been discovered in the urban world. Evans never so idealized the city. Even Weston retained some human scale. Only Joel Meyerowitz's idyllic views of St. Louis and the Arch begin to match Nixon's vision of urban purity and beauty. One must look to modern architectural photography, particularly the work of Ezra Stoller, to find precedents for such precise, abstracted seeing.

In his views of grain elevators and Texas houses, Frank Gohlke presents an equally idealized image of rural buildings and small-town Victorian homes. Gohlke, too, is a nostalgic romanticizer of the American past and American light. His vision is closer to William Clift's careful landscapes than to Adams's or Baltz's work. His

photographs powerfully convey, in his own words, that "the world itself is never quite so clear as in a good photograph."

Joe Deal's images take an opposite tack, one directly related to Sommer's undifferentiated, uninflected Arizona landscapes. Deal attempts to render the new landscape as a synthetic pictorial object. But his attempt fails; the cold reality of the new frontier prevails. Deal's work does succeed in pointing out once again those self-contradictory relationships between the frontier and utility, between land and city, between illusion and reality. Photographing the outskirts of Albuquerque, Deal records the intersection of the social and the natural world. This land has not yet solidified into urban center or suburb. It lies uneasily between past and present, still harboring contrasting rural and urban values. It simultaneously embodies the American dream of country living and the nightmare of developer exploitation. The architecture and the land Deal photographs have an uncertain reality: carefully manicured, tree-lined golf courses lie amid the scrub of the remaining desert. A high-style, architect-designed house with a pseudo-Spanish courtyard is set against the

prefab boxes that make up the majority of development housing. Streets and utility poles suddenly appear, incongruously, on empty land. In each single photograph the full transition from open land to suburb happens right before our eyes.

These contradictions in the landscape are mirrored by Deal's stylistic decisions and strategies. The photographs themselves are a cross between the commercial survey photo used by the land developer and the more reverential Western landscape. The photographs, like Nixon's, are made from a high vantage point and purport to give a neutral view. Yet they consciously exclude the "vagaries of sky and horizon" and reduce the natural, long, horizontal purview into a compressed, abrupt square. Each photograph focuses in on a single object—a water tower, a house, a roadway—around which the remainder of the image pivots. The effect of successive photographs is, however, formulaic, repetitive, even serial, as we lose consciousness of the simple, central object and remember only the density. Deal's photographs become undifferentiated images, each, in his words, "equal in weight or appearance to another."

Deal's work harks back to the conceptual strategies of Whitman's catalog, Ruscha's serial books, and Sommer's landscapes. Whitman promised spiritual equality,

ANSEL ADAMS. *Salt Flats, near Wendover, Utah,* c. 1941

NICHOLAS NIXON. *View of Boston from Commercial Wharf,* 1975

ROBERT FRANK. *Backyard, Venice West, California,*
1955–56

JOHN GOSSAGE. *Untitled,* 1976

LEE FRIEDLANDER. *Houston, Texas,* 1973

174

Ruscha raised the banal to the level of irony, Sommer revealed the profundity of uniformity—but Deal merely gives us back sterility. The net result of Deal's pointillism is to create aesthetic uniformity and boredom out of a fractured, differentiated, unharmonious terrain.

Much of John Gossage's photography presents miniaturized landscapes found within arid city streets and back alleyways. With a romantic and ironic nod to both civilization and wildness, Gossage has entitled a portfolio of prints *Gardens* (1978). In these, his extreme close-ups of the entanglements of a scrubby natural world with city fences and refuse show neither actual gardens nor fecund earth. Rather they demonstrate the persistence of nature amid asphalt and concrete, as well as the power of photography to redeem the decrepit with a cold, silvery beauty. The dynamic form in Gossage's work is the grid, usually provided by repetitive man-made shapes: bricks, window sashes, fences, trellises. The precedents for this dense structuralism are found not only in the optical and systematic painting and grid-works of the sixties but, more significantly, in those major photographic visions of cultivation and neglect:

Atget's gardens and Robert Frank's overgrown backyard in Venice, California.

For Gossage the frontier has shrunk to that small piece of land in the backyard or alleyway where the last vestiges of nature intertwine with the detritus of man. Alternatively, his photographs portray greenhouses, city parks, and suburbs as uneasy museums of a distant natural world.

Lee Friedlander's work in the seventies uses a matrixlike complexity, similar to Gossage's, to structure the interaction of the natural and the man-made. Friedlander's images may be seen as the next step in the reclamation of nature. In his work buildings are less obtrusive and less gritty than in Gossage's. The photographs are more lush and lyrical, and represent a return by Friedlander to a natural imagery he had consciously excluded from his earlier work. But here, applying the same intricately formal and romantic parameters used in the street scenes, Friedlander embraces a natural world of quiet refinement. He civilizes nature in a way previously understood only by Atget and Stieglitz. Unlike the younger photographers, Friedlander is more accepting of the refined beauty of the quieter, manicured, urbanized landscape. His book *Flowers and Trees* (1981) and his photographs of American monuments are the outcome of those social, ecological, and aesthetic pressures that pushed

JOHN PFAHL. *Moonrise over Pie Pan, Capitol Reef National Park, Utah,* 1977. Original in color

ANSEL ADAMS. *Moonrise, Hernandez, New Mexico,* 1944

all the photographers discussed in this chapter to reassess the remaining visual evidence of the rapidly diminishing natural world.

Photographically Altered Landscapes

James Alinder's 150-degree panoramic views are perhaps the most conservative work of a host of photographers in the seventies who radically altered and manipulated the traditional photographic landscape. Where Sinsabaugh chose to photograph the still open land, Alinder used the panoramic camera to describe those ironic objects that dot the landscape after the influx of development and urbanization: the world's largest tire; a hole in a blank wall defining a "picture spot" for an invisible Mount Humphreys, highest point in Arizona; the huge "Modess . . . because" sign off the New Jersey Turnpike. Alinder photographs these icons in a distinctly snapshot idiom, but his panoramas extend the family snapshot portrait by 100 degrees. And to make the view even more distressing and playful, Alinder frequently stands his camera on end, producing a long vertical image that resembles the distorted reflection in

NANCY REXROTH. *Boys Flying, Amesville, Ohio,* 1976

STEPHEN DANKO. *Untitled,* 1978. Silver print with light drawing

an amusement park mirror.

The early frontier photographers used the panorama to explore unpeopled vistas; in Alinder's Pop Art landscapes, the natural world is available only when it contains man's own image. There are no pristine Western mountains in these photographs, only the chiseled faces of Mount Rushmore dwarfed by pickup-truck campers. And the landscape-size mirror at Cypress Gardens has been erected not to show the beauties of the Florida vegetation but so that "New Honeymooners and Families Can Take Pictures Together . . . Set Camera for 16 Feet."

As Alinder pitted panoramic intimacy and irony against the tradition of the grand vista, so the manipulative silver printmakers in the seventies approached the landscape with formal and conceptual strategies that ranged from homage through satire to contempt. Like the other photographers of the new American frontier, they saw their radical alterations as a way of commenting both on the land and on the nature of photographic representation. John Pfahl and Robert Cumming build visions that are simultaneously satire and homage to the masterpieces of American Western photography. Pfahl's images, a series of elegant visual puns on earlier landscape work, provide his own version of a Rephotographic Survey. His color photographs have clear resemblances to the work of Ansel Adams and Eliot Porter, but the

world he photographs is subtly changed by the addition of props, pieces of tape, rope, and aluminum foil. His *Moonrise over Pie Pan* (1977) and *Wave, Lave, Lace* (1978) are witty comments on Adams's *Moonrise, Hernandez, New Mexico* (1941) and *Surf Sequence* (1940).

Like Pfahl, Cumming intervenes in the landscape in order to point out both the arbitrariness and the sleight of hand of the earlier views. For Cumming, the landscape in its traditional form is just another stereotype to be questioned. His *Two Explanations for a Small, Split Pond* (1974) calls up Adams's *Moonrise* and also engages the issues of photographic veracity, the pseudo-document, photography as sculpture, and photography as mathematical construct.

Michael Bishop and Gary Hallman generate quixotic landscapes from small details of construction sites. Both approach their work in a way reminiscent of the early geological-survey photographers. In their work, though, the full-blown natural world has ceased to have either spiritual or aesthetic meaning. Only the detail remains. Hallman's soft-focused, diffused images take on characteristics of aerial mapping and surveying and recall misfocused vacation snaps as well. Bishop's small lin-

ear details and stripped highway markers appear as references to scale equivalent to the checkered rulers found in archeological photography. Both photographers see the landscape as an entity to be dissected and analyzed. Their microscopic examinations reconstruct the earth as if it were the surface of an alien planet.

Another kind of reconstruction takes place in the pictorial, luminescent landscapes of Nancy Rexroth and Peter de Lory. Rexroth, using a $1 toy camera with a plastic lens, the Diana—a camera first used in college photography courses in the mid-sixties as a means of teaching the basic aspects of photographic vision—produced perhaps the most coherent and mysterious pictorial work of the seventies. Rexroth is an absolutely intuitive artist. Her beautifully printed and sequenced book of reveries and memories, *Iowa* (1977), is a testament to the persistence of traditional American pictorialism. De Lory and a host of others used the inflamed rendition of infrared film and split-toning to describe glowing foliage, shadow, and light.

Tom Barrow describes the landscape from a much more alienated point of view. In his *Cancellations* (1974–75), intentionally ill-composed photographs of defaced landscapes are further brutalized by cancellation slashes or punctures that are made directly on the negative before it is printed. Barrow's markings derive, of course, from the conventions of printmaking. But, more notably, they point to the economic

THOMAS BARROW. *Pasadena Parallel*, 1974. From *Cancellation Series (Brown)*. Photographic print from cancelled negative

MICHAEL BISHOP. *Untitled*, n.d. From *Tones*, 1972–75

value of both land and photography and to the photographer's self-conscious refusal to repeat the grand gestures of earlier views.

James Henkle, Steve Yates, and Stephen Danko take Barrow's defacement even further by hand coloring the negative or print, abrading and cutting its surface, and drawing with a penlight on the undeveloped paper. The almost haphazard quality of these notations resists any sense of natural order. The marks create schizophrenic objects, maimed documents, violated fragments. These images protest the inhumanity of the actual landscape. And they are self-referential gestures of alienation and solipsism.

Tourists

In Steve Fitch's *Diesels and Dinosaurs* (1976), the mythic presence of the Old West is discovered in today's popular roadside culture. Fitch photographs the diesel trucks, roadside amusements, motels, and hand-drawn signs of the American highway. His

178

BILL DANE. Back of photo-postcard, 1978

BILL DANE. *Las Vegas, Nevada,* 1973. Photo-postcard

work mirrors that paradoxical American duality: a fascination with the efficient machine and a reverence for wildness. His work equates a technological wonder—the diesel truck—with the awe-evoking dinosaurs of the past. The huge eighteen-wheelers that roam the highway are seen not as spoilers of the virgin land but as direct emanations of American independence. Advanced technology has not destroyed the land but returned it to its basic source of power.

For Fitch the American West is dense with the presence of a more primitive experience: Indians, wigwams, snake charmers, savage beasts, dinosaurs, cowboys, and the landscape. Yet none are authentic. The wigwam is plaster and paint, the landscape is painted on drive-in screens and motel sides, the live rattlesnake pales in comparison to the twelve-foot-high snakepit sculpture on Highway 66. For Fitch emblem is more significant than fact. In this highway culture, fact is always overwhelmed by fable. Here the past enters the present not as reality but as a graven image. Actual snakes, bears, and Indians have been banished from the land and have been replaced by images packaged for tourist consumption or by cartoon characters selling products on roadside signs.

In *Diesels and Dinosaurs* the essential device that reconciles past and present

is light. By photographing at dusk and after dark, Fitch makes even the most banal signs seem monumental and radiant. Trucks, motels, and plaster dinosaurs become luminescent. Darkness neutralizes the conflict between man and nature, covers up the essential differences between past and present, and clothes advanced technology and popular culture in the mysteries of blackness. Night and bright roadside lights reconcile the irreconcilable: primitive power and urban expansion. The cartoon figures, the roadside architecture, and the diesel truck, all intensified by the mystery of the night, emanate a primitive energy.

In the late seventies Fitch continued his nocturnal photographs but moved from black and white to color. Other photographers also moved in this direction. Richard Misrach and Arthur Ollman turned to color and flash to make the night even more intense. For these photographers the depleted American landscape is not adequate in itself but must be supercharged by night and the transformational power of the medium.

If Fitch reveals the mythos of the highway, Michael Becotte presents travel in

179

its ironic mode. In *Space Capsule* (1975), Becotte documents a gritty, impersonal highway culture seen through the windows and rearview mirrors of his van. Becotte's highway provides only a series of sardonic references to vitality and adventure: the "space capsule" being pulled by a passing car is only a cement mixer; plastic and cement roadside horses recall a heroic past, but the real horse that wanders into the highway is foundered and swaybacked.

Becotte's vision derives from Winogrand's and Meyerowitz's photographs taken from moving cars and also from Frank's harsh highway world, but Becotte is indebted most of all to Friedlander's picture tactics. Becotte pushes to its limit Friedlander's strategy of framing the landscape in a rearview mirror. In *Space Capsule* the world is known only as it appears fragmented and bisected by the automobile's window frames and mirrors. Becotte's photographs in rain and wet weather fully exploit the accidents of chance reflections and the distortions of highway speed and glass. The energy in these photographs comes not from the landscape or the quality of light but from the vitality of the automobile and the intuitive, spontaneous reflex that drives the car and snaps the shutter. Becotte's photographs are extensions of tourist grab shots. They have the snapshot's power of curiously accurate yet incon-

STEVE FITCH. *Motel, Highway 80, Gila Bend, Arizona,* 1973

MICHAEL BECOTTE. *Untitled,* c. 1974

sequential description. In the end, however, in spite of Becotte's visual agility, the highway becomes exceedingly claustrophobic. One longs for the land over the hill, beyond the reach of the highway, the vans, and the eighteen-wheelers.

Bill Dane is the archetypal tourist. His work consists of self-made postcards sent back from his travels. Dane's cards are not "mail art" or "concept art." They are the real things: true souvenirs of the road and visual experience. Like the best commercial travel postcards, Dane's photographs record specific visual character without embellishment. His subjects are almost always public attractions: zoos, parks, city streets, fairs, monuments, hotels, fountains, and highways—places properly civilized and certified for tourist consumption. In this civilized world the landscape becomes merely one more element in a host of visual elements. Telephone poles and palm trees are described with the same understated equanimity, both being merely visual facts.

American photography has always focused on the commonplace, the inelegant day-to-day world. Yet Evans, Callahan, Frank, Winogrand, and Friedlander repre-

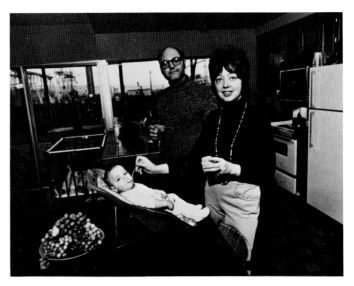

ROBERT ADAMS. *Untitled,* 1973

BILL OWENS. *"We're really happy. Our kids are healthy, we eat good food and we have a really nice home."* Page from *Suburbia,* 1973

sented the ordinary with a subtle invocation of myth, spirituality, politics, or beauty. Dane refuses to divulge anything but the visual shape of experience. His style is free from metaphors and metaphysics; he gives us back the surface of the world with consummate understatement. More than any other contemporary photographer, Dane has demonstrated Lewis Baltz's dictum: "The ideal photographic document would appear to be without author or art."

Suburbia

Bill Owens's book *Suburbia* (1973) gives an interior view of those impersonal tract houses the New Topographic photographers described only from the outside. By pairing image and text, and by focusing on the inhabitants, Owens provides a much more devastating picture of the new frontier. He looks at the inhabitants and their personal surroundings: their backyards, living rooms, streets, and cars. He shows people living suspended between the urban and the rural worlds, people with neither urban nor rural values. Suburbia is a place of pervasive uniformity, a world out of touch with the roots of culture. "Because we live in the suburbs," explains a Chinese

family clustered around a Danish Modern dining table, "we don't eat too much Chinese food. It's not available in the supermarkets so on Saturday we eat hot dogs." And suburbia is a world out of touch with natural facts. "I bought the lawn in six foot rolls," the new homeowner states proudly. "It's easy to handle. I prepared the ground and my wife and son helped roll out the grass. In one day you have a front yard." Technology and utility have forced a sterile life-style upon the inhabitants and an insensitive architecture upon the land. "This isn't what we really want—the tract house, the super car, etc. . . . But as long as we wound up in this high speed environment, we will probably never get out of it! We don't need the super car to be happy. We really want a small place in the country where you can breathe the air." Rather than finding space, the residents find Tupperware parties, community projects weeding the median strip, and long hours sitting watching TV and the traffic. "Our house is built with the living room in the back, so that in the evenings we sit out front of the garage and watch the traffic go by."

Owens shows us a world in which man is so overpowered by his technological

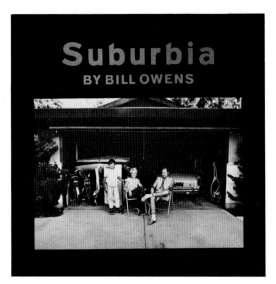

181

extensions that he has lost all capacity to interact directly with the natural world. In his forays into the wilds, suburban man brings along his electronic and mechanical inventions. He experiences the land only through the intermediaries of the camper, the fiberglass powerboat, the motorcycle, and the portable refrigerator. Adventure is measured in terms of horsepower and convenience. The landscape becomes just another commodity to be merchandised, used, and discarded. In this milieu the natural world is neither adversary nor friend. It is manicured and decorated beyond recognition.

Although Owens's work purports to be neutral and objective, his final pronouncement is much harsher than that of the New Topographic photographers. He does not redeem sterility with a brave light or a photographic grace. His conservatively anecdotal and reportorial style documents a visual environment unrelieved in its superficiality. For Owens, suburbia is beyond redemption. The last two images of his book show a bulldozer breaking ground and the newly poured concrete roadways stretching relentlessly into farmland and wilderness.

ROBERT ADAMS. Dust jacket of *The New West,* 1974

BILL OWENS. Cover of *Suburbia,* 1973

The New American Luminism

The Color Renaissance of the Seventies

The straight color photography of the seventies arose precisely at that moment in time when the notions of idealism and realism intersected. This photography integrates the most deeply held American concepts of the potentials of the wilderness and the pastoral with the American commitment to quotidian reality. It builds on and extends the New Topographic vision, charging it with an even greater degree of romance and emotionalism. The aesthetic of this new photography was most succinctly characterized by the definition John I. H. Baur, then director of the Whitney Museum, used in 1954 when he coined the term "Luminism" to describe the lush, atmospheric style of mid-nineteenth-century American landscape painting:

> . . . a polished and meticulous realism in which there is no sign of brush work and no traces of impressionism, the atmospheric effects being achieved by infinitely careful gradations of tone, by the most exact study of the relative clarity of near and far, and by a precise rendering of the variations in texture and color produced by direct and reflected rays.

Top
JOEL MEYEROWITZ. *Porch, Provincetown,* 1977

Left
THOMAS COLE. *The Voyage of Life: Old Age,* 1840. Oil on canvas, 51¾ × 78¼"

Right
JULES OLITSKI. *Pink Shush,* 1965. Water-miscible acrylic on canvas, 79 × 66"

It is exactly this concern for "meticulous realism," "atmospheric effects," and "precise rendering" of color that sustains the sensibility and animates the palettes of the straight color photographers of the seventies. For these photographers the fact of first importance is that the world exists in light and color. Light and color are the primary visual characteristics of their imagery.

The Coming of Age of Color

The straight color photography of the seventies brings together major traditions in American photography and painting. It combines aspects of classic view photography, small-camera street photography, snapshot photography, mid-nineteenth-century landscape painting, and twentieth-century color-field painting. The new color photography has deep ties to those moments in the history of American visual expression when various permutations of realism, idealism, color harmony, and luminosity combined.

184

STEPHEN SHORE. *Kimball's Lane, Moody, Maine,*
July 17, 1974

JACK DELANO. *Stonington, Connecticut,* November 1940

Color snapshots and *National Geographic* travelogs provide one of the major aesthetic precedents for the straight color work of the seventies. These vernacular images were prompted by a genuine fascination with actual color phenomena: sunsets, autumn foliage, rainbows, breathtaking vistas, and exotic people and places. A Kodachrome slide by Jack Delano taken in 1940 in Stonington, Connecticut, for the Farm Security Administration grows out of this casual yet direct impulse for image making and encapsulates in its very existence the problems of legitimization that surrounded the color photography of the seventies. The slide, taken in the spotty sunlight of a November afternoon, records an urban street lined with houses painted in various shades of mustard and white. It is an unpretentious but compelling statement of the way a certain slant of light captures the complexion of a scene. Yet Delano's image and nearly seven hundred other color slides have gone virtually unnoticed in the FSA archive of the Library of Congress and have only recently been rediscovered by the historian Sally Stein. The reasons for this neglect are many, but the most obvious is that there simply was no aesthetic that would legitimize these slides as art. They were merely snapshots, untransformed bits of reality, compiled by the FSA photographers in the midst of more important business. Their color was

the color of the world, and the aesthetics of photography at the time demanded decorative color. Reality was not sufficient material for art.

Up until the seventies serious expression in photography, with few exceptions, used color as an arbitrary, imposed overlay on an essentially graphic, black-and-white world. Such work is represented by the color photography of advertising and fashion and by some more personal, expressive work that imitated painting or strived for the most exaggerated special effects. In all these endeavors, color is used to call attention to itself: Art Kane and Pete Turner used dazzling primary colors; Paul Outerbridge and Erwin Blumenfeld used color as cubistic form; Bert Stern and Hiro used audaciously inventive color displays; Ernst Haas and Syl Labrot sought out real color situations that could be photographed to look like Abstract Expressionist painting. All these photographers use color in a synthetic, decorative manner. Color allows them to make photographs instantly recognizable as art. In their work color is seen as form not light, as a graphic not a photographic phenomenon. Their photographs have very little to do with the way the world actually looks or feels.

185

The aesthetic precedents, then, for the style and subject matter of the straight color work of the seventies come not from previous color photography but from American street photography, and particularly the heritage of Walker Evans. The possibility of looking squarely at ordinary buildings, unadorned streets, and commonplace landscapes absolutely derives from the legitimacy given to vernacular iconography by Evans, Frank, Winogrand, and Friedlander. More than this, the philosophy and work of the street photographers made possible the straight color photographers' acceptance of reality itself as a fitting subject and the inherent characteristics of the medium as a fitting means of rendering that subject. It was out of this tradition that Helen Levitt produced the first major body of color street photographs in New York City in 1959 and 1960.

In the fifties and sixties the advent of Polaroid cameras and film, pocket-sized Kodak Instamatics, and inexpensive color processing virtually wiped out the black-and-white snapshot and provided another activity that would mature into the new color work. Color television, too, contributed to a growing familiarity with a two-dimensional colored image of ordinary life. The Polaroid SX-70 system was the apotheosis of this snapshot world, the ultimate snapshot machine. It offered color,

HARRY CALLAHAN. *Providence,* 1977

JOEL MEYEROWITZ. *7th Street, St. Louis,* c. 1977

instantaneity, immediacy, and privacy and fulfilled Edwin Land's dream of making "the process non-existent for the photographer, who, by definition, needs to think of the art in the taking and not the making of photographs." Fully automatic in a way no other camera had ever been, the SX-70 could be used without any consciousness of aesthetic traditions. It became the perfect camera for do-it-yourself investigations of visual facts. It is precisely this egocentric, uncensored quality of the SX-70 that Lucas Samaras, Emmet Gowin, and Les Krims explored in their SX-70 work of the seventies.

Recent color work has also been significantly affected by the long-standing American tradition of idealism, as epitomized by Ansel Adams and Weston. This tradition has exercised its direct influence on the new color work through the practice of architectural photography and through the remarkable, intense but accurate color landscape views of Eliot Porter. Porter's work and the best architectural photography, particularly the work of Ezra Stoller, stand as prototypical American examples of the

LUCAS SAMARAS. *Photo Transformation,* March 31, 1976. Manipulated SX-70 Polaroid

MARIE COSINDAS. *Still Life,* 1976. Polacolor

fusion of technology and descriptive clarity. They achieve an idealized yet persuasively authentic image. For Porter and Stoller photography represented a commitment to lucid description, to the full utilization of the medium, and to beauty, grace, and elegance. The world that enters into their photographs is substantial and fastidiously factual. Their photographs pay tribute to the presence of facts and the evocative possibilities of light.

Color Photographs

The photographic material of the color snapshot—particularly the sixty-second Polacolor of the sixties and the Polaroid SX-70 film of the seventies—created a wide audience for color experimentation. Marie Cosindas's muted, baroque still lifes produced on the early Polaroid color film were the first contemporary color photographs to be accorded extensive museum exhibitions. In the late sixties her work was shown at the George Eastman House and the Museum of Modern Art. Skillfully arranging old dolls, Oriental rugs, Spanish shawls, antique knickknacks, and beautiful people,

she created an intensely lush, quietly nostalgic world. Her sensibility, so deeply tied to the style and palette of the seventeenth-century Dutch and Flemish masters, so limited by the miniaturized size of the Polaroid material, and so idiosyncratic, had no direct pictorial influence on the color photography of the seventies, though hints of her work may be felt in the finely crafted still lifes of Olivia Parker and the portraits of Rosamond Purcell. But Cosindas opened the door to an acknowledgment of color photography in general, and the instant processes in particular, as expressive media.

Cosindas's success was due in some measure to the novelty of using an ordinary, snapshot medium to produce extraordinary, exotic images. Ten years after her first Museum of Modern Art show of 1966, another major exhibition would raise even more fundamental questions concerning the relationship of fine art to everyday recording. Szarkowski heralded his presentation of seventy-five dye-transfer prints by William Eggleston in 1976 as the "discovery of color photography." The show and

Szarkowski's statements prompted a series of querulous, uncomprehending denunciations, not unlike those hurled at the first Walker Evans and Robert Frank presentations. During the previous three-and-one-half decades, sophisticated color photography had consisted of gaudy abstract compositions or overtly colorful objects. Eggleston's work, on the other hand, was extremely understated. He showed apparently offhand, snapshot views of Memphis and the Deep South. These photographs, like Jack Delano's Kodachrome slides, did not show exaggeratedly colorful objects, but heightened instead the viewer's perception of actual color and reality.

WILLIAM EGGLESTON. *Jackson, Mississippi,* 1971

Eggleston's work demonstrates in the extreme the aesthetic stance taken in the seventies by the straight photographers of the color renaissance. It is an approach that utilizes the uncontrived viewpoint to engage the emotions. It reflects a romantic realism that accepts the actual world as both legitimate subject matter and expressive material. What Eggleston is attempting is no less than the perennial photographic search: the construction of an expressionism out of the most realistic, vernacular idiom. This search, of necessity, always treads dangerously near the narrow line that separates triviality from mystery and beauty. Eggleston's investigations are no excep-

tion. At his least successful, he is too ingenuous, too sentimental, too much of the tourist and the casual snapshooter. At his best, however, as in *peanut fields near Friendship* (1976), he is a genius of understatement. Here the photograph becomes the matrix that holds a naturally delicate, yet highly evocative statement about both actuality and color itself. His best work brings about a reconciliation of photography and life.

Paradoxically, for Eggleston and the other new straight color photographers, objective color has become the basis for a new subjectivity, allowing for the production of the most emotionally and personally charged photography since the early work of Callahan, Siskind, and White. Yet in this work the expressionistic vocabulary has shifted from one of symbolic metaphor to one of color, light, and chromatic saturation. For the new color photographers, expressionism no longer means the search for symbols of self-discovery but rather the discovery of charged moments of luminescence in the real world.

A primitive snapshot quality also gives a compelling, intimate presence to Wil-

188

Top
Page from *Aperture*, Number 81, 1978. Photograph by William Christenberry, *Hale County, Alabama*, 1977

Left
WILLIAM EGGLESTON. *peanut fields near Friendship, Georgia*, October 1976

Right
WILLIAM EGGLESTON. *Thomasville, Georgia*, c. 1977

liam Christenberry's early color work taken of Walker Evans's motifs in the Deep South between 1959 and 1977. The Brownie camera Christenberry used for that work has now been replaced by a large-format view camera. This transition, from snapshot camera to view camera, represents an essential of the new color photography's aesthetic approach. The snapshot's immediacy, directness, and lack of subterfuge seem best intensified not by 35mm photography but by large-format work. This has caused the curious phenomenon that most straight color work today is taking place on the extremes of available equipment: either on the popular 3⅛-inch-square SX-70 or on the more esoteric 8-by-10 Deardorff. This constant crossing back and forth between the SX-70 and the view camera has become both usual and fruitful. Walker Evans himself, during the last years of his life, photographed seriously with the SX-70.

The primary example of this return to the roots of American vernacular photography is Joel Meyerowitz. His evolution as a photographer recapitulates almost all of the influences on current color. Moving slowly away from his early association with hectic street work, Meyerowitz has progressed steadily from the social landscape to the chromatic landscape. In the process he has given up irony, then overt social

commentary, then black-and-white film, and then the small camera, recapturing at each step more of Evans's transparent, anthropological eye. His latest large-camera work, rather than documenting a split-second episode, provides a lingering description of an extended moment in time and color. His recent beach studies in *Cape Light* (1978), the series on the Empire State Building (1978), and his book *St. Louis & The Arch* (1980) concentrate on the interactions of buildings with the glowing tones of land, sea, and sky. In these studies, Meyerowitz, like Hokusai in his *Thirty-six Views of Mount Fuji*, subtly blends mythology and fact. His latest work leaves far behind the earlier ambiguities of visual puns and wry juxtapositions, returning to the purity of description that Evans shared with Weston and Adams.

Stephen Shore's vision of America provides the most expansive and direct link to the descriptive traditions of Weston, Adams, and the Luminist landscape painters. With these predecessors he shares a concern for clarity, a sharpness of detail, and a handling of color as atmosphere, perspective, and space. But where the Luminists and Adams strove to record a pure landscape, virtually untouched by the intervention

of man or culture, Shore seeks to expand the notion of the virtues of the American landscape in a less sacred, more secular vein. Rather than withdrawing to the wilderness, Shore is able to find profoundly Luminist vistas within the daily, civilized world: color and light still radiate both in downtown El Paso and in Manhattan. Eggleston and Meyerowitz have found similar moments in the environments of Plains, Georgia, or on the beach at Cape Cod. But most of all, it is Shore's uncompromising vision of the beauty that radiates from the common street that convinces us that frontier light and color still warm our world.

Pure Color

The Kodak color materials introduced in the seventies were unprecedented in terms of fidelity, range of control, and luminosity. The seventies straight color photography depends totally for immediacy and transparency on the new Kodak palette and technology. The combination of Vericolor negative film and Ektacolor paper, especially in bright daylight, allows close approximation of the colors and the color atmosphere before the camera. The persuasiveness of the film undoubtedly accounts for the con-

Top
WALKER EVANS. Polaroid SX-70 photograph, c. 1970

Left
JOEL MEYEROWITZ. *Untitled*, c. 1967

Right
STEPHEN SHORE. *El Paso Street, El Paso, Texas,* July 5, 1975

tinual fascination with the colors of bright days and natural light. Shore photographs on bright, pellucid days. Eggleston frequently documented the subtle color interactions between field, road, and sky. My own photographs have been taken in the bright, hot summer sun of Miami and New Orleans. In *Cape Light,* Meyerowitz devotes much of the book to the qualities of daylight on sand and sea.

These photographs are reaching for special effects, but these are not the exaggerations of the manipulative photographer but the special effects of natural light: deep color space, elegant fields of light, color falling on and radiating off the natural and man-made. While the effect of this work is essentially romantic, it is not sentiment that these photographers are after. Their goal is capturing in accurate or believable terms the grand light show of reality itself.

The color materials are not limited to bright sunlight and blue sky, however. Color renditions under other conditions are also exceedingly rich, allowing photographers the possibility of choosing more individual palettes. Meyerowitz has, for example, intentionally warmed the color of his images by shooting long exposure,

LANGDON CLAY. *New York City,* 1977

JOEL MEYEROWITZ. *Provincetown,* 1976

tungsten-balanced Vericolor in daylight and then corrected the color shift while printing. Meyerowitz and Richard Misrach have mixed natural light and flash. And several photographers have elected to retain the color shift caused by mixed light sources or long exposures. Eggleston's parking lot lit by mercury vapor, Jan Staller's photographs at dusk along New York's West Side Highway, Arthur Ollman's San Francisco cityscapes, Langdon Clay's electric interiors, and Meyerowitz's *Cape Light* are all testaments not only to the beauty of existing light but to the range of color available to the medium. Besides being factual descriptions, these photographs are experiments in pure color, a collaboration of the world and the medium.

Color Painting

The primary structural issue of this new photography is color. Its concern is to resolve photographically the same issues of flatness, color relationship, rendition, and scale that have occupied the color-field painters during the last few decades. The photographers, however, are solving these problems with a vocabulary made up from intractable visual facts rather than with synthetic visual forms. Like color-field paint-

ings, these photographs are documents of chromatic interaction: the world photographed directly produces ranges, fields, swatches, and grids of color. The photographer's challenge is to use color as deep space and as a realistic attribute while at the same time letting it function coherently as two-dimensional texture, form, and field. For both the color-field painters and the new color photographers, color is not an accent or a precise attribute of a singular object. It is not selective but pervasive. There are no hierarchies of color within the frame. These are fields bathed in envelopes of radiating light. The new color photographs certainly derive from the Luminist painters and from Weston, Adams, and Evans, but they are also a homage to Rothko, Olitski, and Newman.

These ties to Luminist painting, color-field painting, classic photographic description, and vernacular subject matter are perhaps best exemplified not by a photographer at all but by the most photographic of contemporary painters, Richard Estes. Estes paints his large urban landscapes from color photographs. His meticulous realism is the optical realism (carefully reorganized and edited) of the camera's

191

lens. His palette is precisely the color rendition of modern photographic color materials. His subject matter is the photographer's idealized, carefully framed city view. His concern is the interaction of architecture, light, and photographic materials.

In Estes's paintings the sublime has been reinterpreted in a medium and form appropriate to our time. In his work and in that of the new straight color photographers the cityscape has become the new repository for idealized form, numinous surfaces, and chromatic mystery.

STEPHEN SHORE. *Holden Street, North Adams, Massachusetts,* July 13, 1974

MARK ROTHKO. *Four Darks in Red,* 1958. Oil on canvas, 102 × 116"

Shooting America

Susan Sontag

*"Fotografa di un'Epoca:
Ghitta Carell"*
Special issue of *Skema*
Anno V, Numero 8/9,
Agosto-Settembre, 1973,
65 pp., 1,500 lire

**Men Without Masks:
Faces of Germany 1910-1938**
by August Sander,
with an introduction by Golo Mann.
New York Graphic Society,
314 pp., $27.50

**Dwellers at the Source:
Southwestern Indian Photographs
of A. C. Vroman, 1895-1904**
by William Webb and
Robert A. Weinstein.
Grossman, 226 pp., $25.00

**In This Proud Land:
America 1935-1943
As Seen in the Farm Security
Administration Photographs**
by Roy Emerson Stryker
and Nancy Wood.
New York Graphic Society,
208 pp., $17.50

As They Were
by Tuli Kupferberg and Sylvia Topp.
Links Books, 160 pp., $2.95 (paper)

Down Home
by Bob Adelman,
text edited by Susan Hall.
McGraw-Hill, 168 pp., $16.95

Wisconsin Death Trip
by Michael Lesy,
with a preface by Warren Susman.
Pantheon Books, 264 pp.,
$15.00; $5.95 (paper)

I

Photography has the unappealing reputation of being the most realistic of the mimetic arts. In fact, it is the one art that has managed to carry out the grandiose, century-old threats of a Surrealist takeover of the modern sensibility—while most of the pedigreed candidates have dropped out of the race.

In painting, the Surrealists were handicapped from the start by practicing a fine art, with each object a unique, handmade "original." A further liability was the exceptional technical virtuosity of those painters usually included in the Surrealist canon, who seldom imagined the canvas as other than figurative. Their paintings looked sleekly calculated, complacently well made. They kept a long, prudent distance from Surrealism's contentious idea of blurring the lines between art and so-called life, between objects and events, between the intended and the unintentional, between pros and amateurs, between the noble and the tawdry, between craftsmanship and lucky blunders.

In painting, therefore, Surrealism amounted to little more than the "contents" of a meagerly stocked dream world: a few witty dreams, mostly wet dreams and agoraphobic nightmares. (Only when its libertarian rhetoric helped to nudge Pollock and others into a new kind of irreverent abstraction did the Surrealist mandate for painters finally seem to make wide

creative sense.) Poetry, the other art to which the early Surrealists were particularly devoted, has yielded almost equally disappointing results. The arts where Surrealism *has* come into its own are prose fiction (only as a "content," but a much more immoderate and more complex one than that depicted in painting), theater, the arts of assemblage, and—most triumphantly—photography.

That photography is the only art that is natively surreal by no means identifies it with the destinies of the official Surrealist movement. On the contrary. Those photographers (many of them former painters) consciously influenced by Surrealism count almost as little today as the nineteenth-century photographers who copied the look of Beaux-Arts painting. Even the loveliest *trouvailles* of the 1920s—solarized photographs and Rayographs of Man Ray, the multiple exposure studies of Bragaglia, the photomontages of John Heartfield and Alexander Rodchenko—are regarded as marginal exploits in the history of photography. The photographers who interfered with the supposedly superficial "realism" of photographs were those who most narrowly conveyed the surreal properties of photography.

Surrealist photography became trivial as Surrealist fantasies devolved into a repertoire of images and props which was rapidly absorbed into high fashion. In the 1930s Surrealist photography was mainly a neo-mannerist style of portrait photography, recognizable by its use of the same decorative conventions introduced by Surrealism in other arts, particularly painting, theater, and advertising. The mainstream of photographic activity has shown that Surrealist distortion and theatrics are unnecessary, if not actually redundant. Surrealism lay at the heart of the photographic enterprise itself: in the

very creation of a duplicate world, of a reality in the second degree, narrower but more dramatic than the one perceived by natural vision. The less doctored, the less patently crafted, the more naïve—the more surreal the photograph was likely to be.

Surrealism has always courted accidents, welcomed the uninvited, flattered disorderly presences. What could be more surreal than an object which virtually produces itself, and with a minimum of effort? An object whose beauty, fantastic disclosures, power to be moving, are likely to be further enhanced by any accidents that might befall it? It is photography that has best shown how to juxtapose the

sewing machine and the umbrella, whose fortuitous encounter a great Surrealist poet hailed as the essence of beauty.

Unlike the fine art objects of pre-democratic eras, photographs don't seem to be deeply beholden to the intentions of an "artist." Rather, they owe their existence to a loose cooperation (quasi-magical, quasi-accidental) between photographer and subject—mediated by an ever simpler and more automated machine, which is tireless, and which even when capricious can produce a result that is interesting and never entirely wrong. (The sales pitch for the first Kodak, in 1888, was "You press the button, we do the rest." The purchaser was guaranteed that the picture would be absolutely "without any mistake.") In the fairy tale of photography the magic box insures veracity and banishes error, compensates for inexperience and rewards innocence.

The myth is tenderly parodied in a 1928 silent film, *The Cameraman*, which had an inept dreamy Buster Keaton vainly struggling with his dilapidated apparatus, knocking out windows and doors whenever he picks up his tripod, never managing to take one

decent picture, yet finally getting some great footage (a photojournalist scoop of a Tong War in New York City's Chinatown)—by inadvertence. The hero's pet monkey actually loads the camera with film and operates it part of the time.

The error of the Surrealist militants was to imagine the surreal as universal, that is, a matter of psychology, when it turns out to be what is most local, ethnic, class-bound, dated. Thus the earliest surreal photographs come from the 1850s, when photographers first went out prowling the streets of London, Paris, and New York, looking for their unposed slice of life. These photographs, concrete, particular, anecdotal (except that the anecdote has been effaced)—slices of lost time, of vanished customs—seem far more surreal to us now than any photograph rendered abstract and "poetic" by superimposition, underprinting, solarization, and the like. Believing that the images they sought came from the unconscious, whose contents they assumed, as loyal Freudians, to be timeless as well as universal, the Surrealists misunderstood what was most brutally moving, irrational, unassimilable, mysterious—time itself. What renders a photograph surreal is its irrefutable pathos as a message from time past, and its class realism.

As an artistic politics, Surrealism opts for the underdog, for the rights of a disestablished or unofficial reality. But the scandals flattered by Surrealist aesthetics generally turned out to be just those homely mysteries obscured by the bourgeois social order: sex and poverty. And eros, which the early Surrealists put at the center of the tabooed reality they sought to rehabilitate, was itself a class mystery. While it seemed to flourish luxuriantly at extreme ends of the social scale, both the lower classes and the nobility being regarded as naturally libertine, middle-class people had to toil to make their sexual revolution. Class was the deepest mystery: the inexhaustible glamour of the rich and powerful, the opaque degradation of the poor and outcast.

A view of reality as an exotic prize to be tracked down by the diligent hunter-with-a-camera has informed photography from the beginning, and makes the confluence of the Surrealist counterculture and middle-class social adventurism. Photography has always been fascinated by social heights and lower depths. Documentarists (as distinct from courtiers) prefer the latter. For more than a century photographers have been hovering about the oppressed, in attendance on scenes of violence—with a spectacularly good conscience. Social misery has inspired the comfortably-off with the urge to take pictures, the gentlest of predations, in order to document a hidden reality, that is, a reality hidden from *them*.

To return to *The Cameraman*: a Tong War among poor Chinese is an ideal subject. It is completely exotic, therefore worth photographing. Part of

Only a Language Experiment

"Strictly speaking," Susan Sontag announced in October of 1973 in the first of her seven *New York Review of Books* essays on photography, "it is doubtful that a photograph can help us to understand anything." Less than a year later, Allan Sekula began a series of articles in *Artforum* that applied an equally harsh dictum to the photographic document. For Sekula documentary photography had "contributed much to spectacle, to retinal excitations, to voyeurism, to terror, envy and nostalgia, and only a little to the critical understanding of the social world."

Sontag's oracular essays, gathered together in the book *On Photography* (1977), and Sekula's polemical analyses helped initiate a major change in the way photographs were made and read. During the middle to late seventies these two critics and a new group of photography commentators—including Max Kozloff, James Huginin, Howard Becker, LeRoy Searle, and A. D. Coleman—shifted the emphasis of discussion from formalist aesthetics to ethical, conceptual, and sociopolitical issues. Their discussions challenged the photograph's ultimate value as art and questioned its role as an instrument of knowledge, communication, and culture.

Page from *The New York Review of Books*, April 18, 1974. Third in a series of Susan Sontag essays on photography

While there had been attempts in the past to deal with the political nature of photography, the dominant strategy of associating photography with the fine arts had tended to obscure its social function. Up until the seventies the major critical texts on American photography were ostensibly apologies for photography as art and histories of connoisseurship. Even the social photography of the thirties was discussed in terms of aesthetic quality. Art took precedence over social, economic, and cultural meaning. In the seventies renewed interest in philosophy and politics focused the disciplines of linguistics, sociology, anthropology, and Marxist thought on the photographic enterprise, revealing photography as social history and pointing out the paradoxes at the heart of photographic reality, observation, and art. The critics of the seventies were out to raise fundamental questions of epistemology and ontology. They wanted nothing less than to pin down the moral and ideational content and structure of the medium. Perhaps only once before—in the early teens when Stieglitz rejected photo-impressionism for a photography that synthesized actual observation and formalism—had American photography undergone such a radical restructuring

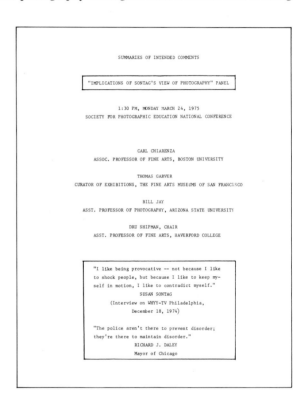

"Implications of Sontag's view of Photography." Panel discussion, Society for Photographic Education national conference, March 24, 1975

of critical thought.

In large part, the political, artistic, scientific, and intellectual climate of the seventies brought about this new critical attitude. The Vietnam conflict and the growing awareness of continuing societal problems like racism, sexism, and an endangered environment tended to politicize the artist and intellectual. The rebirth of political, and especially Marxist, criticism in the United States was nourished by the counterculture of the late sixties during the last stages of the war. At this time a younger generation of critics and artists emerged who, for the most part, had not directly experienced the fear and repression of McCarthyism. As students they had been encouraged by the universities to look at the more radical and politically conscious European criticism and philosophy. It was these young critics and artists who slowly revived the notions of a radical American egalitarianism that had quietly smoldered beneath the surface of American intellectual life since the end of World War II. The subversive protest art and literature practiced by only a few during the fifties and early sixties now became more open and exerted a pervasive influence.

The reappearance of Marxist scholarship and linguistics during the past decade was also, perhaps, subtly motivated by the new electronic age and the increasingly

194

ubiquitous computer technology. The new Marxist writings and the new linguistics reflected a profound distrust of abstract analysis and an abiding concern with information theory and a systems aesthetic. The goal of both Marxist aesthetic criticism and linguistic criticism was to see a work of art as the expression of a social or textual situation, just as the goal of the new electronic technology was to systematize the structural relationships between components and the whole.

This new criticism also derived, of course, from the concept and idea art that decades of modernism had fostered. Some measure of social consciousness and political commentary has always been the inevitable outgrowth of modernism, as abstract and expressionistic ideas are displaced onto concrete political issues. One of the major principles of modernist thought has been the creation of an art that would force reflection on the conditions of its own construction. Investigations of those conditions necessarily brought about a rediscovery of the culture that generated the structure of the art.

Yet, ironically, more than any other single factor, it was perhaps photography's

success in the commercial marketplace and the image-centered connoisseurship represented by John Szarkowski and the Museum of Modern Art that in the end forced a reevaluation of photography's status as commodity and language.

In retrospect, it appears that the photographs in two exhibitions served as the chief catalysts for the new criticism: the Diane Arbus MOMA retrospective of 1972 and the showing at the Scott Elliot Gallery in 1974 of aerial reconnaissance photographs attributed to Steichen. Both exhibitions raised fundamental questions concerning the nature of photography within society. In an extraordinary and inescapable way they forced a confrontation with issues of morality, biography, genius, consumerism, technology, and social rank. And they provided the first major occasions for Sontag and Sekula to comment on the medium. The Arbus and Steichen shows, promoted by a photographic establishment dominated by a formalist aesthetic, supplied the opportunity to take modernism to task. While Sekula's and Sontag's comments were first seen to be aggressively antiphotographic, they were in reality much more aggressively antimodernist and anticapitalist. Their commentary was an attack on the formalist aesthetic, which had buttressed the photographic canon, and on photography as an instrument of class, property, and consumption.

Two-page spread from *Artforum*, January 1975. Essay by Allan Sekula. Photograph by Alfred Stieglitz, *The Steerage*, 1907

Where Szarkowski—on the dust jacket of the Aperture monograph accompanying the Arbus show—saw Arbus as "not a theorist but an artist . . . concerned with the private rather than social realities," Sontag and Sekula claimed Arbus could be understood only in the context of social history. Sontag used Arbus's own biography as the touchstone. Arbus, Sontag believed, was in revolt against her upper-middle-class, privileged, Jewish background and against "the Jews' hyper-developed moral sensibility." She was also rebelling against the uses of commercial photography: "Who could have better appreciated the truth of freaks than someone like Arbus, who was by profession a fashion photographer—a fabricator of the cosmetic lie that masks the intractable inequalities of birth and class and physical appearance."

Sekula, too, saw Arbus in terms of sixties politics and "the symbolic disintegration of civil society and the real crisis of gender identity." Arbus's photographs became a "fetishistic cultivation and promotion of the artist's humanity" at the expense of the " 'ordinary' humanity of those who have been photographed." For Seku-

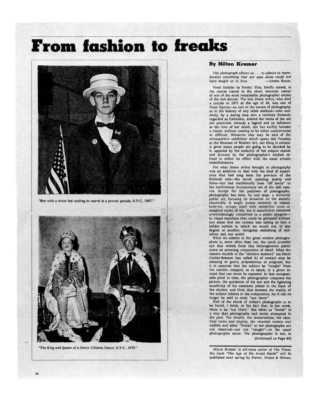

Page from *The New York Times Magazine,* November 5, 1972. Article by Hilton Kramer. Photographs by Diane Arbus, *Boy with straw hat waiting to march in a pro-war parade, N.Y.C.,* 1967; *The King and Queen of a Senior Citizens Dance, N.Y.C.,* 1970

la the presentation of Steichen's aerial reconnaissance photographs as art was an even more dangerous confusion of photographic roles: a pernicious distortion of the actual social uses of images. Sekula found it unconscionable that photographs originally used as tools in the process of wartime destruction could be promoted as examples of artistic abstraction and as "elevated moments" in Steichen's career. "By promoting the war photographer as a 'concerned' and 'innocent' witness, liberal ideology promotes an image of its own bogus humanism, while denying the fact that information, too, has been mobilized." For Sekula the photographic beautification of war was only the most extreme example of Steichen's modernist sensibility, which "contributed to a falsified image of the family, of woman, of consumption, of war and international politics, and of cultural freedom." "Every work of photographic art," he would later write, "has its lurking, objectified inverse in the active files of the police. Every portrait of a 'man of genius' made by a 'man of genius' has its counterpart in a wanted poster. Every landscape finds its deadly echo in the aerial view of a targeted terrain."

For Sontag and Sekula, modernism—with its ahistorical perspective and its

tendency to subsume any visual activity under the rubric of abstraction—had distorted the social uses and social nature of photography, hiding from both the photographer and the viewer the essentially propagandistic and exploitative character of the process. From their point of view, photography is the preeminent modernist medium, the fitting product of a society that is ethically and morally bankrupt. Because of its intrinsic characteristics, photography necessarily packed a heavy baggage of psychological and transactional ills. The myth of photographic knowledge and photographic reality, the cult of photographic genius and authorship, and the non-narrative, ambiguous intention of the photographer were all seen as destructively antithetical to a more generous notion of human responsibility, equality, community, and reality. "The camera is a kind of passport that annihilates moral boundaries and social inhibitions, freeing the photographer from any responsibilities toward the people photographed," Sontag wrote. "To photograph people is to violate them, by seeing them as they never see themselves, by having knowledge of them they can

never have; it turns people into objects that can be symbolically possessed. Just as the camera is a sublimation of the gun, to photograph someone is a sublimated murder—a soft murder, appropriate to a sad, frightening time."

Page from *Artforum*, December 1975. Essay by Allan Sekula. U.S. Air Force, American Expeditionary Force photograph, *Aerial bombs dropping on Montmédy*, c. 1918

If the articulated critical centers of photography were *Aperture* in the fifties and the pronouncements of John Szarkowski in the sixties, then Sekula's articles and Sontag's *On Photography* may be understood as defining the critical center of the seventies. Their hard-hitting condemnations of photography's inherent characteristics provided a new set of parameters for "reading" photographs. To "read" a photograph, as Minor White first demonstrated in *Aperture*, meant to form connections between the image and the actual world. "Reading" implied that these connections were obscure and needed to be explicated: photographic truth was not self-evident. Photographic intention lay as much in the verbalization as in the visual statement. In the sixties, Szarkowski shifted photography's critical center by essentially refusing to "read" the image. Not to read a photograph meant to leave the image as a totally private, self-contained, self-referential, formal system of meaning, a system that was difficult to explicate or translate into any other language.

In a curious way, Sontag and Sekula pulled the critical center back toward *Aperture*'s belief in the importance of the extraphotographic. But where *Aperture* had seen photographic meaning as lying beneath the surface of appearances in a personal and symbolic context, Sontag and Sekula placed the photograph in a historical perspective. Photographic interpretation was obliged to take the culture, politics, and even the language that surrounded a photograph with great care and seriousness. In actuality Sontag and Sekula wished to dispense with both *Aperture*'s metaphorical reading and Szarkowski's modernist emphasis. Their context for photographic "reading" was neither the interior, expressive life nor the life of forms; it was the exterior political life. All photography was a societal act, and truth the intersection of photographic description and ideology.

Sontag and Sekula grounded their approach in the tradition of European belles lettres, especially in the work of several European literary and structuralist critics who had modified the thought of Karl Marx with borrowings from existentialism, linguistics, and psychology. The German literary critic Walter Benjamin, the French literary and social theorist Roland Barthes, and the English novelist and art critic John Berger are the three most obvious sources. All these men shared the common Marxist belief that art is the expression of social structures and economic consequences, and all developed aesthetics of contextual and cultural determinism. The three continually investigated the blurring of producer and consumer in the modern technological society and wrote of photography as an agent of mass communication that affects contemporary economics, aesthetics, and sociology.

Berger, perhaps the most evenhanded and broad-minded of these three critics, could be strongly critical both of the liberal aesthetic, which posits the artist as genius and art as truth, as well as of the Marxist reductionist doctrine, which sees all of Western culture as regressive. While firmly grounded in Marxism, Berger is always willing to vigorously engage each act of art as both ideology and history, expression and document. From him Sontag and Sekula drew a concern for the moral and ethical implications conveyed by the deceiving objectivity of the photograph.

From Barthes they inherited a concern for structural analysis and for the impact of fundamental cultural signs and mythologies upon all modes of communication. In Barthes's view, photographs fascinate because of their dual nature as truth teller and as fiction. The photographic paradox can be seen as resulting from the coexistence in each photograph of two messages, one without a code (the actual subject matter), the other with a code (the photographic treatment). For Barthes each image thus has two simultaneous meanings. The first is associated with the truism "a photo cannot lie." This is the photograph's veracity, its claim to truth, its surrogate reality, its analogical relationship to the world. The second meaning is embedded in the photograph's construction, which is willed partially by the photographer's style and consciousness and partially by the unconscious imposition on the photograph of a general cultural presence. It is this coded message that Sontag and Sekula wish to explicate.

In Benjamin, Sontag and Sekula found a champion of the critic as activist. Benjamin mirrored that curious love-hate relationship with photography that brands their own writings. He recognized photography's insidious banality, its inherent leveling of all experience, and its destruction of traditional aesthetic and humanistic values. He saw photography's tie to capitalist consumption and its necessary surrealism. While Benjamin was a harsh critic of photography's ability to transform negative social situations and values into positive desires and commodities, he was also an admirer and close reader of the photographs of Atget, Sander, and Hill. Benjamin's writings, like Sontag's and Sekula's, were responsive to the avant-garde and at the same time conducted a direct attack on modernism and twentieth-century power politics.

While Sontag and Sekula carefully acknowledge their European influences, the

Canadian media analyst Marshall McLuhan provides another subtle and generally unacknowledged precedent for their thought. In 1964 his brief chapter on photography in *Understanding Media* articulated many of the themes that became pivotal for Sontag and Sekula, as well as for their mentor, Roland Barthes. In an aphoristic style not unlike the one that both Sontag and Sekula later developed, McLuhan crystallized his thoughts on photography:

> [Cameras] tend to turn people into things and the photograph extends and multiplies the human image to the proportions of mass-produced merchandise

and,

> [In the age of photography] the world itself becomes a sort of museum of objects that have been encountered before in some other museum

and,

> To say that "the camera cannot lie" is merely to underline the multiple deceits that are now practiced in its name.

Both Sontag and Sekula and their European antecedents are essentially essayists, men and women of letters who approach a visual phenomenon—photography—from a traditionally literary point of view. McLuhan suggested that confrontations between literary and visual culture would be inevitable in the new world of mass media and pervasive visual communication. McLuhan's observation holds the key to both the success and the failure of Sontag's and Sekula's commentaries. Their writings succeeded as the first major critical analysis to place photography within the intellectual framework of the other arts. The central flaw in their work, however, is that they too frequently imposed a verbal and ideological hierarchy on nonvisual information. They see photography, in McLuhan's words, from the "fragmentary perspective of literary culture. . . . Literary man is not only numb and vague in the presence of film and photo, but he intensifies his ineptness by a defensive arrogance and condescension to 'pop kulch' and 'mass entertainment.' . . . But the logic of the photograph is neither verbal nor syntactical, a condition which renders literary culture quite helpless to cope with the photograph."

What is fundamentally in question in Sontag's and Sekula's commentaries, and in McLuhan's *Understanding Media,* is the source of knowledge in the modern world. What is at issue is the relationship between two fundamentally different means of evaluating experience: image and language, the visual and the verbal. What finally prevails in Sekula's and Sontag's writings is the ideational over the visual: the word triumphs over the photograph. As Sontag would succinctly put it: "Only that which narrates can make us understand."

In spite of themselves there are several instances, all autobiographical, in which their commentaries are overwhelmingly informed by photographic, as opposed to literary, knowledge. Sontag's finding photographs of the Bergen-Belsen and Dachau concentration camps at the age of twelve was, in McLuhan's terms, a loss of visual virginity and her coming of age in the new visual "global village." "Nothing I have seen—in photographs or in real life—ever cut me as sharply, deeply, instantaneously. Indeed, it seems plausible to me to divide my life into two parts, before I saw those photographs (I was twelve) and after, though it was several years before I understood fully what they were about." To a great degree Sontag's reaction to the Arbus photographs twenty-seven years later was triggered by the visual trauma of those earlier images. And Sekula's *Meditations on a Triptych* (1978) becomes a geographical journey through his family album in which his own visual memory outweighs ratiocination.

Despite these experiences, both Sontag and Sekula ultimately lack faith in the analytical power of images in general and photographs in particular. For them, neither the photographer nor the viewer of photographs can understand the world with-

out the aid of verbal reasoning. While Sekula and Sontag judge the photograph in terms of its moral efficacy, as a function of moral imperatives, they hold that these imperatives can be perceived and articulated only through the literary and the historical. Their judgments are in essence antivisual, inimical to the exercise of the visual imagination. The visual becomes subservient to the ideological, and the ideological can be manifest only in words and through the narrative of history. Sontag and Sekula have been deceived by the very failure of human sense awareness that McLuhan predicted: they have accepted the characteristics of one specific medium—language—as the model for thought, refusing the possibility that visual imagery, specifically photography, is also a road to reality and truth.

Sekula's demand for a new photo practice—"a critical representational art, an art that points openly to the social world and to the possibilities of concrete social transformation"—is curiously like Sontag's version of Chinese photography:

The Chinese don't want photographs to mean very much or be very interest-

Two-page spread from *Life*, May 7, 1945, from the photographic essay "Buchenwald and Bergen-Belsen." Photographs by George Rodger (left and above right) and Margaret Bourke-White (below right)

ing. They do not want to see the world from an unusual angle, to discover new subjects. Photographs are supposed to display what has already been described. . . . For Chinese authorities there are only clichés—which they consider not to be clichés but "correct" views.

Photography's primary function, for Sekula, is to promote "correct" views. Thus the aerial photographs can be seen only in the context of armament and exploitation, Stieglitz's *The Steerage* (which Sekula analyzes at length in another *Artforum* article) only in the context of immigration and class consciousness. What Sekula fails to realize is that the information necessary to change society is actually embedded in these images. The aerial photographs are at once fascinating formal designs and incredibly strong images of terror and the reign of destruction. And *The Steerage*, both politically and formally, is a visual testament of separateness and inequality. In the case of Arbus, both Sontag and Sekula go out of their way to deny the possibility of a carnal visual understanding of her work. But their extended protest suggests an uneasiness not only with Arbus's morality but with the power of visual knowledge;

it suggests that on some level they understand that Arbus was overwhelmed not by tract or doctrine but by the visual discovery of terror.

If Sekula's rhetoric is Marxist, it is also stridently Puritanical. Photography is conceived to be not the discovery of truth but the elaboration of doctrines already known. His objections to modernism and his praise for the plain style parallel the Puritan encouragement of an ethical art that would provide the widest possible comprehension. The Puritan insistence on iconography rather than visual invention or perception is also shared by Sekula. He writes that the "meaning of an art work ought to be regarded as contingent," but he makes that contingency wholly dependent on language and ideology, ignoring the visual contingencies supplied by the entire history of visual representation.

Both Sekula and Sontag finally succumb to the most American of values: a Puritanical distrust for graven images. Sontag's exegesis, in particular, is hostile to American idealism. With a profound distrust for the democracy of photography's use, Sontag fears Whitman's visionary egalitarianism. Behind her prose is a subtle elitism that assumes the hierarchy of the intelligentsia over the proletariat. In the end, both Sontag and Sekula believe in the superiority of the literary artist over the visual one.

216 E 3 St.
Block 385 Lot 11
5 story walk-up old law tenement

Owned by Harpmel Realty Inc., 608 E 11 St., NYC
Contracts signed by Harry J. Shapolsky, President('63)
 Martin Shapolsky, President('64)
Principal Harry J. Shapolsky(according to Real Estate
Directory of Manhattan)

Acquired 8-21-1963 from John the Baptist Foundation,
c/o The Bank of New York, 48 Wall St., NYC
for $237 600.-(also 7 other bldgs.)

$150 000.- mortgage at 6% interest, 8-19-1963, due
8-19-1968, held by The Ministers and Missionaries
Benefit Board of the American Baptist Convention,
475 Riverside Drive, NYC (also on 7 other bldgs.)

Assessed land value $25 000.-, total $75 000.- (includ-
ing 212-14 E 3 St.) (1971)

228 E 3 St.
Block 385 Lot 19
24 x 105' 5 story walk-up old law tenement

Owned by Harpmel Realty Inc. 608 E 11 St. NYC
Contracts signed by Harry J. Shapolsky, President('63)
 Martin Shapolsky, President('64)
Acquired from John The Baptist Foundation
c/o The Bank of New York, 48 Wall St. NYC
for $237 000.- (also 5 other properties) , 8-21-1963

$150 000.- mortgage (also on 5 other properties) at 6%
interest as of 8-19-1963 due 8-19-1968
held by The Ministers and Missionaries Benefit Board of
The American Baptist Convention, 475 Riverside Dr. NYC

Assessed land value $8 000.- total $28 000.-(1971)

The Political Reconstruction of Photography

Photography and Language

During the seventies the strategy of associating written language and the photograph became the fundamental mode by which photographic production confronted the political, social, and structural issues raised by the new critics. Image and text, traditionally isolated as caption, story line, and illustration, became incorporated in each other, forming a single integral message. The use of words and photographs moved toward political statement, propaganda, and document as well as toward formal and media exploration. And both political and structural concerns were articulated with unexpected regularity from a radical, left-of-center social and philosophical perspective bent on criticizing the dominant ideology. "The political construction of photography," to use the title of a 1981 article in *Afterimage*, had become for the late seventies and early eighties what Zen was to the fifties and early sixties. It became the defining characteristic and basic strategy for both criticism and production.

The new photography and language experiments derived from three major centers of activity: the social-linguistic concerns that were fundamental to Sontag, Sekula, and the European critics, most notably Roland Barthes; the conceptual and performance practices in painting; and the "mixed-media" and "nonsilver" experiments in photography. But where language had become a way to generalize the me-

HANS HAACKE. Excerpt from *Shapolsky et al. Manhattan Real Estate Holdings—a Real Time Social System as of October 1, 1971,* 1971

dium of painting, providing for a more broadly based aesthetic experience, it became a way to particularize and, at times, de-aestheticize the photographic experience. Language intensified the myth of photographic objectivity. It helped confirm the gnawing suspicion that photography, like language itself, functioned more as an idea than as an image. It helped move photography-as-art closer to the quintessential form of communication in the modern world: photography-as-language. In a Mc-Luhanesque way, the new language and photography experiments were a radical attempt to subsume all previous denotative communication under the rubric of photographic imagery.

It is helpful to categorize three of the strategies utilized by the photographers who merged photograph and text as Corporate Realism, Biographical Narrative, and Social Realism. A fourth strategy, Scientific Realism, will be looked at in the next chapter. All these modes have substantial histories of use outside of art. Each is generally associated with conventions of mass visual communications rather than with expressive photography. The radicality of their use lies precisely in their ex-

FRED LONIDIER. *Manufacturing Engineer's Heart*, c. 1975. "The company that I'd worked for is noted for the amount of heart attacks in their people . . . I have known in the past four years of one heart attack death and about seven heart attacks had open-heart surgeries from this particular company." From *The Health and Safety Game*, 1976

ploiting the distance between media and art: the merging not only of word and image but the synthesizing of universally understood modes of communication with an aesthetic didacticism.

Corporate Realism

Corporate Realism is a strategy derived from the cool, objective commercial and industrial photograph. Its objectivity is tied to the most conservative photojournalism and the least inflected examples of the photo-essay. Its archetypes are the photo-essay, the newspaper, the clinical and sociological document, and the annual report. A photography concerned with public experience and social fact, it uses photographs and texts that are factual, straightforward, and immediately accessible. Illustrations and texts both maximize content and minimize any sense of experimental subjectivity or pictorial abstraction.

At its best the corporate mode is employed by the contemporary artist with biting wit and irony. It is used powerfully in Donna-Lee Phillips's feminist polemic *Anatomical Insights* (1978), in which a series of thirteen identical 16-by-20-inch fe-

male torsos presented in medical-textbook fashion are overlayed with diagrams and texts related to female surgical procedures. The presentation of fact as art jolts the viewer into reassessing the depiction and use of women's bodies and the corporate control over that use.

Hans Haacke's photographic pieces are also animated by the unexpected use of the corporate mode as a work of art. Haacke has written that he chooses "an aggressive and cunning participation" in the very culture he wishes to subvert, thus attacking corporate exploitation by its own established systems approach. Haacke's presentation of *Shapolsky et al. Manhattan Real Estate Holdings—a Real Time Social System as of October 1, 1971* (1971) juxtaposed photographs of real estate in Manhattan with written descriptions of each property and its ownership, revealing the interrelationship of church and slum-landlord holdings. In Phillips's and Haacke's work the elegance of the presentation and the overt, yet nonexplicit social criticism become both aesthetically and politically provocative. Their work argues against Sekula's dictum: "Social truth is other than convincing style." For it is precisely the

205

"style" of these pieces that makes their social truth accessible and convincing.

A similar approach is less successful in Fred Lonidier's *Health and Safety Game* (1976), which points out the fact of violence in the workplace. Here, bland photography and an uninflected biographical text distance rather than provoke, and methodical description ignores the complexities and ambiguities of individual identity. Haacke's willingness to put himself on the line, to name names and stand as the accuser, does give his presentation human specificity in the midst of corporate anonymity; it suggests the hidden yet stridently uncompromising voice behind the work. But Lonidier's voice is lost in a corporate form that substitutes economics for individuality and reduces people to abstract entities. Perhaps Lonidier has accepted the corporate form too fully to allow it to function as art. Without the spark of an idiosyncratic voice or presentation, the corporate form becomes just another casebook study, pacifying and mollifying rather than promoting class struggle. Sekula admires Lonidier's work for its very blandness, noting that "the subjective aspect of liberal aesthetics is compassion rather than collective struggle." Yet this is a flawed notion. Communication must take place on a personal level: class struggle is born out of compassion and individual anger. Individuals are not reached by bland clinical analysis.

DONNA-LEE PHILLIPS. Installation view and detail from *Anatomical Insights: The Abdomen,* 1978

Out of Fashion

Haacke and others utilized corporate strategy as a way to subvert the corporate enterprise, as a means toward radical aesthetic and political ends. Fashion photography, on the other hand, has always accepted corporate morality and been dominated and coerced by corporate mentality. Fashion photography represents a corporate action exercised for corporate ends masquerading under the guise of art. Since its inception early in the century, fashion photography has acted as the medium's ultra-right wing, a stance incompatible with a high order of culture or expression. Its goals have been a one-dimensional presentation of women, the merchandising of false ideals, and the promotion of image rather than substance: youth, glamour, luxury, narcissism, and sex. Even fashion's apologists, such as *Vogue*'s editorial director, Alexander Liberman, will admit to some shortcomings:

> What still is missing from most fashion photography is a sense of the sacred. We are in the realm of the ornament of the profane, and this lack is the reason

206

WALKER EVANS. *Floyd Burroughs and Tengle Children, Hale County, Alabama,* Summer 1936

DIANE ARBUS. *Two men dancing at a drag ball, N.Y.C.,* 1970

why fashion and its documentation are often considered frivolous, non-essential elements in the human puzzle.

But more emphatically Liberman posits fashion photography's objectives as being a truthful view of women, an honest documentation of society, and the creation of an authentic art form:

> The real achievement of [fashion] photography is its ability to create a memory bank of the way women at a given moment in certain societies have looked. . . . A real social change has been recorded in fashion photographs. . . . Fashion photography has played an extremely important role in the emancipation of women. . . . There are in the history of fashion photography unforgettable images created by the few extraordinary artists.

Yet, rather than social history, fashion photography chronicles the narrow history of social elegance and decadent aristocratic taste. It conceives of art as the promotion of the pretty and the beautiful rather than the insightful. And it bears little relationship to the activities and dress of actual women. In 1912, while De Meyer was photographing the Marchesa Casati, Bellocq was photographing Storyville

whores, and Hine Italian immigrants. In 1936, while Steichen was preparing *White*, in which three mannequins posture in evening gowns next to a white horse in a white-tiled bath (a motif Turbeville would resurrect thirty-nine years later in her images of New York public baths), Evans was photographing Allie Mae Burroughs, the wife of a Hale County sharecropper. In the mid-fifties, while Penn photographed Lisa Fonssagrives languorously stretched out in the grass of a Long Island beach reading a pink copy of Gertrude Stein's *Picasso*, Frank was traveling across America stopping at the beach at Belle Isle, Detroit, where he photographed dour pregnant women tending their children. And in 1967 Avedon put Twiggy and Penelope Tree through their paces while Arbus photographed grotesque ladies at masked balls and a seated man in bra and stockings. Like the relationship between romance and reality, the relationship between fashion photography and social documents is always surreal, traumatic, and ironic.

Fashion's claim to art provides another accurate barometer of the sensitivity of popular culture to vanguard art experiments and meaning. Fashion has consistently

used predigested avant-garde modes, modes that have filtered down to the level of popular belief and acceptance. The change in clothing fashions is precisely what mass culture perceives as the avant-garde. And this notion is encouraged not by aesthetic and intellectual discourse but by corporate merchandising and marketing. In 1980 one out of every four magazines sold dealt with fashion; there were more than 50 million subscribers to America's thirteen major glamour magazines.

If photography in general has been a decade behind advanced sensibilities in painting, fashion photography is always three decades in arrears. Early in the century, when Cubism represented the blossoming of modernism, De Meyer and Steichen introduced luminescent impressionism to fashion photography. During the forties, as art moved through Abstract Expressionism, Horst, Blumenfeld, and Penn derived images from cubist formalism. In the fifties and sixties Avedon's concern with motion and physical movement paralleled Martin Munkacsi's, Cartier-Bresson's, and Kertész's experiments of thirty years earlier. And the late-seventies images of Newton, Turbeville, Bourdin, and Von Wangenheim read like stills from the late-fifties cinema of Resnais, Antonioni, and Fellini. The air of menace, violence, corruption, and ennui in the new fashion photography represents the slow transformation over the

RICHARD AVEDON. *Margot McKendry and China Machado with Members of the French Press*, Paris studio, August 1961. Dresses by Lanvin-Castillo and Heim

past two decades of a once-radical social commentary into a palatable, homogenous popular taste. Significantly, the essentially bankrupt world of fashion photography described by Antonioni in the film *Blow Up* (1966) was reinterpreted by popular taste as a world of photographic mystique. Ironically, *Blow Up* helped initiate the age of photographic chic.

Photography does have a long history of idealizing feminine beauty; yet its most persuasive chronicles are not fictional projections of blessed damosels but taut photographic testaments to the individuality of the sitter and the contextualizing power of the camera. Atget's, Cartier-Bresson's, and Bellocq's prostitutes; Brassaï's Parisian ladies of the night; Stieglitz's O'Keeffe; Weston's Tina Modotti; Lange's American country women; Bullock's introverted nudes; Ulmann's black women; Callahan's Eleanor and his Chicago women; Gowin's Edith; Meyerowitz's New York shoppers and secretaries; Papageorge's Sonia and his California surfer girls; Nixon's Bebe; even, at times, Winogrand's beauties, and Welpott and Dater's San Franciscan

RICHARD AVEDON. *Jacob Israel Avedon, Father of the Photographer,* Sarasota, Florida, August 25, 1973

ladies—all are both real women and symbols of the eternal feminine. They are defined not by dress but by the intensity of their presence and the truthfulness of their photographic presentation.

As if in rebellion against fashion's exploitation and superficiality, many fashion photographers have felt compelled to make for themselves another type of image, an image antithetical to the promotion of beauty and elegance, one obsessed by disease, disintegration, and death. This more private work may be understood as a form of sacrament: a confession, penance, and hoped-for redemption from complicity in fashion's cheap idolatry. As early in his career as 1959 and 1964, Avedon presented in two photographic books, *Observations* and *Nothing Personal,* the empty bodies and faces of mental patients and a series of grim, astringent portraits that pierced the makeup of manufactured celebrities and international beauties. Here Avedon revealed age and abnormalities. Ten years later, he focused his camera on his terminally ill father. In Duane Michals's photo-stories, the beautiful bodies found in his fashion work are curiously metamorphized into agents of primal fear, violence, carnal knowledge, and death. For himself, Penn photographed deglamourized, fat-enfolded nudes,

cigarette butts, and street trash. Though Penn's results are still stamped with his Victorian formalism, these images of discarded objects and earthy, unfashionable women serve the same redemptive function as Avedon's gestures: they mark a return to reality in the face of what Sontag called "the cosmetic lie." Sontag used that phrase to characterize Arbus and her vision of the freak and the absurd as nothing more than an acute pathological reaction to fashion's fabricated world. In the end, then, fashion—like the primordial snake—devours itself.

Significantly, while recent American humanism and traditional puritanism seem to have demanded some redemptive gesture from American photographers, the Europeans, such as Newton and Bourdin, appear thoroughly unperturbed about continuing fashion's exploitative manipulations. Indeed, fashion's voyeurism, sadism, kinkiness, and ultimate vulgarity become the basis for Newton's books *Sleepless Nights* (1978) and *White Woman* (1976). Many of these images, rather than finding their way back to *Vogue*, end up in girlie magazines (more fitting and less pretentious

IRVING PENN. *Cigarette No. 37*, 1972

vehicles of corporate greed).

Certainly fashion photography has produced some photographic triumphs. And fashion's tie to the statesman, the star, and the celebrity has produced, at the very least, a visual catalog—mannered though it may be—of the famous faces of our time. More than this, advertising photography in general and fashion specifically have prompted the current interest in the fabrication of elaborate still-life constructions utilized as photographic sets and objects. Finally, fashion has provided a constant source of visual parody for diverse artists and photographers, ranging from Warhol to Allen Dutton.

Yet the triumphs of fashion photography are merely the triumphs of corporate illusionism. They are characterized by the re-promotion of already attractively packaged commodities. The same qualities that make a fine automobile advertisement mark a successful Steichen, Avedon, Penn, or Turbeville image: good design, flair, sex appeal, easy recognition, and intimations of class. The end result of fashion photography is not art, but increased sales and increased corporate control.

Biographical Narrative

The strategy of the Biographical Narrative is the direct antithesis of that of Corporate Realism. Personal in both content and form, Biographical Narrative uses images and text drawn from private experience and autographic sources to provide anecdotal narration. Its impact is direct and subjective. Its approach builds on the extended portrait work done by Stieglitz, Callahan, and, more recently, Gowin. And its language antecedents lie in the text experiments and episodic, sexually confrontational images of Minor White. All these experiments have their basis in the family album and the snapshot.

The Biographical Narrative's most immediate ancestors were several publishing experiments carried out in the late sixties and early seventies, most notably a series of loose, spontaneous, scrapbooklike books published by Lustrum Press, founded by the photographer Ralph Gibson. In Daniel Seymour's energetic autobiography, *A Loud Song* (1971), Robert Frank's hauntingly confessional *The Lines of*

MINOR WHITE. From the sequence *Amputations*, 1942–43 and 1946–47. This version published in *Mirrors Messages Manifestations*, 1969

DANIEL SEYMOUR. From *A Loud Song*, 1971

My Hand (1972), and Larry Clark's brutally direct *Tulsa* (1971), the use of contact sheets, snapshots, newspaper clippings, film clips, handwritten texts, and an aggressive spontaneity produces immediacy and personal involvement. These chronicles differed radically from the traditional photo-essay, for they were statements by the photographers themselves telling about and photographing their own lives.

The practitioners of the Biographical Narrative followed these experiments with work in which the album and scrapbook continued to be explored as a matrix that could contain personal experience. Snapshots, souvenirs, diaristic notations, and bits and pieces of verbal and visual experience coalesced in a collage form integrated more by the psyche and the burdens of desire than by politics. Yet, in the broadest sense, this form is political. It actively explores notions of self-definition, self-esteem, and the formation of the individual against the determinations of society and family. It is a form energized by its potential for personal rebellion.

Significantly, the majority of its practitioners in the middle to late seventies were women who used biography and narrative to confront issues of feminism, particularly the relationship of women to culture and the family. Wendy Snyder MacNeil's extensive work *Biographies* (1970–80) gives intimations of the ways pho-

tographs function in our society as both actual and ideal images. Her multiprint presentations juxtapose her own portraits with family snapshots, commercial portraits, and identification photographs to explore an individual's visual, genetic, and psychological continuity. MacNeil offers a study of both personal transition and the passage of time. Her work considers the subtle politics of defining one's self and one's visual presence against the coercions of social taste, corporate control, family pressures, and personal expectations. One of the constant themes in her work is how corporate and state IDs define the self and measure both the passage of time and the effects of socialization. MacNeil's *Biographies* are deeply moving on both a personal and a social level.

Meridel Rubenstein weaves together in a single print snapshots, poems, postcards, and letters as well as the two distinct genres of portrait and landscape photography. Rubenstein blends her photographs together much in the manner of Uelsmann, but rather than concentrating on fantasy, she seeks images that point to biographical and political fact. They create an incisive word and image symbol for

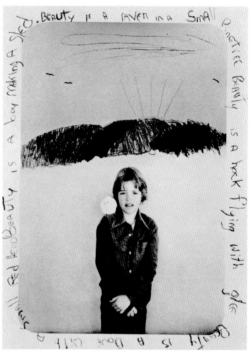

the person photographed. In a recent project, Rubenstein has photographed the Low Riders of New Mexico, a club of American Indians who have rebuilt their lavishly decorated automobiles over low-suspension chassis. Her direct, uncondescending admiration for these people and their artwork—their cars—forces us to confront traditional assumptions concerning the nature of high art and the class and ethnic ties of the artist.

Bucking a variety of traditions, Jacqueline Livingston presented a series of photographs exploring male sexuality and focusing on her son, husband, and father-in-law. Her photographs were presented in the form of large mail posters (a technique she used to bypass the gallery system). The strength of their sociopolitical impact may be gauged by the fact that two major art periodicals, *Art in America* and *Art News*, refused to advertise the posters because they showed the penis. Livingston's photographs reverse, or at least equalize, the usual relationship of male dominance and female submission; they also invert the method of the traditional extended portrait, in which the male photographer focuses on the nude female. They reflect a woman's perception of sexuality and explore such issues as male nudity, masturbation, and male bonding. Although more powerful in its radical gesture than in its

WENDY SNYDER MACNEIL. *Ronald,* 1975

MERIDEL RUBENSTEIN. *Joe wants to fly, Cerrillos Flats, New Mexico,* 1978

visual articulateness, Livingston's work remains one of the major confrontational efforts of the seventies.

Two men who have worked with great success in the Biographical Narrative form are Alex Traube and Joel Slayton. Traube's *Letters to My Father* (1976) were conceived after his father's death. Using childhood snapshots, self-portraits, metaphorical photographs, and a text composed of recollections and direct address, Traube creates an atmosphere charged with love, alienation, and loss. Slayton places his friends in fictional, melodramatic, soap-opera situations. By means of various constructed and found images, which he unites on a single sheet printed on an offset press, Slayton looks at issues of friendship, privacy, media hype, and fame.

Allan Sekula's works *Aerospace Folktales* (1973) and *This Ain't China* (1974) fall in the Biographical Narrative mode and juxtapose photographs with novelistic texts, taped interviews, and extended captions. Sekula has written that his photographic work:

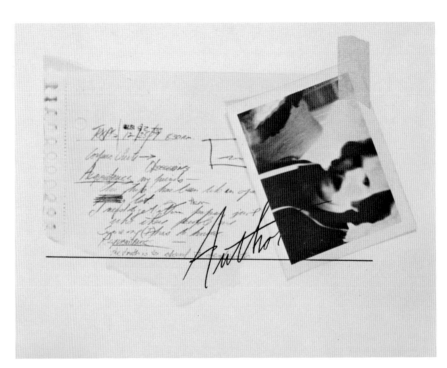

JACQUELINE LIVINGSTON. *Photographposter Mail Exhibition,* Number 12, 1979

JOEL SLAYTON. Page from *Acquaintances,* 1979. Photo-offset on paper

revolves around relationships between wage-labor and ideology, between material demands and our imaginary coming-to-terms with those demands. I use "autobiographical" material, but assume a certain fictional and sociological distance in order to achieve a degree of typicality. My personal life is not the issue; it's simply a question of a familiarity that forms the necessary basis for an adequate representational art.

Yet Sekula's prose usually overwhelms his photography; his images seem to be at times merely distractions from the flow of the text. His verbal virtuosity makes his mild-mannered, uninflected photographs appear irrelevant, a set of casual footnotes on a powerful text.

Sekula's work displays that curious disparity between a demand for style in the text and an antimodernist dismissal of style in the photographs that marks the work of many radical social commentators. The great challenge of the Biographical Narrative—indeed of all these socially oriented modes—is the achievement of a balance between imagery and text. Without this integration the work turns into political or narrative tract, more ideology or theoretical discourse than art; it becomes the con-

temporary inverse of the classic *Life* photo-essay in which the photographs overwhelmed the text.

In the late seventies a host of photographers began to arrange elaborate still-life constructions before their cameras. These photographers were responding to several major influences: a renewed interest in the view camera; the availability of large-format 8×10 and 20×24 Polaroid color material; the rediscovery of still lifes by Paul Outerbridge, Frederick Sommer, and Nickolas Muray; and a reappraisal, brought about by the new social criticism, of the studio tradition of advertising photography. Most of the new work was primarily decorative and nostalgic, packing kitsch objects and personal souvenirs into the frame of the image. In these images the strategies of the advertising close-up are focused on the detritus of personal experience, and corporate schemes are used to construct biographical narratives. Much of the better work in this newly emerging genre utilizes the ability of the large-format view camera to synthesize in a single exposure a multitude of icons, mementos, texts, and images.

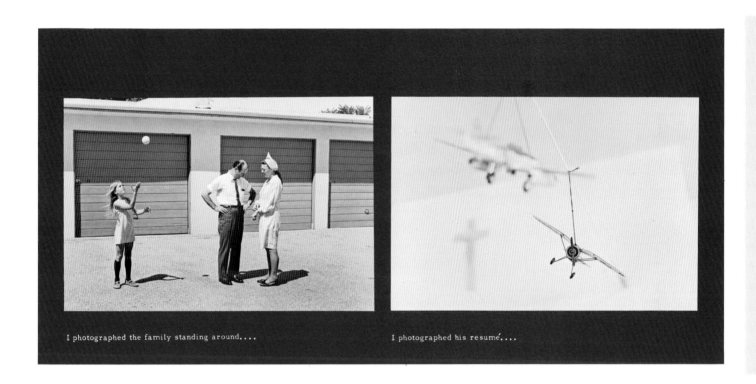

I photographed the family standing around.... I photographed his resume....

213

Some of the more interesting work is being done by Bart Parker, Robert Fichter, Olivia Parker, Ardine Nelson, and Harry Bowers.

ALLAN SEKULA. From *Aerospace Folktales*, 1973. Original version: 142 black-and-white photographs, 75-minute audiotape, and text

Social Realism

Both Corporate Realism and the Biographical Narrative rely heavily on language as a means of surrounding the photograph with an unambiguous political context. Social Realism, the most traditional of these strategies merging text and photographs, frames its political discourse in almost purely visual terms. It relies on the power of the single, straight image to convey personal, political, and aesthetic messages. Its antecedents are the politically charged images of Paul Strand, Russell Lee, Walker Evans, the Photo League photographers, and Robert Frank: photographers who self-consciously experimented with the possibilities of making political reality visible. Social Realism relies entirely on visual intelligence, eschewing all text except for brief titles or a contextual framing by an introductory essay or postscript. Without the advantages of narrative, Social Realism is the most difficult approach by which to generate an effective political art, since literal photographs can often be curiously

anonymous and opaque. Yet, conversely, the straight print can become photography's most powerful political weapon, for it speaks directly to our belief in photographic truth and in the photograph's incontrovertible relationship to history.

The most successful practitioner of this traditional form during the seventies, the photographer whose work most subtly yet articulately demanded social change, was Chauncey Hare. Like Evans in the thirties and Frank in the fifties, Hare provided the view from within. His *Interior America* (1978) strips away the facades of affluence and the stereotypes promoted by advertising and the media to reveal the wasteland of ordinary life. Juxtaposing people and the rooms they inhabit, Hare's photographs create haunting documents of American exploitation and malaise. Where the New Topographic photographers looked at the built environments of the new frontier and were seldom concerned with the inhabitants, Hare, by concentrating on the residents of the old mill, mine, and refinery cities—industrial backwaters in America's new electronic age—delivers a much less romantic, much more politically embattled message.

Interior America is the seventies version of Walker Evans's *American Photographs,* but Hare lacks Evans's ultimate optimism. His vision of America forty years later is even cleaner, more clarifying, more penetrating than Evans's. Desperation is unattenuated by the glow of American light or the warmth of natural materials. Hare's harsh flash reveals even the deepest corners, blanching all with a pallid wanness. Washed-out faces and expanses of bare white walls and ceilings are each illuminated with devastating equality. In these photographs of entrapment, small details of the domestic environment and a constant visual poverty become symbols for terror and desolation. Hare's world has been described by Theodore Roszak as one of "claustrophobic ordinariness . . . the America where cracks in the plaster, dishes in the sink, stains on the linoleum are the hieroglyphics of despair."

The inhabitants quietly wait in these interiors, their hands laid heavily on lap or thigh. The interiors become extensions of themselves and of their oppressors as well. Evans's natural-light chiaroscuro has given way to a merciless, sterile sameness; his impoverished yet proud sharecroppers have given way to comatose victims. This is the cold, contemporary apotheosis of Evans and Agee's *Famous Men.*

As if to visually acknowledge his debt to Evans, Hare, driven by the same regard for the past that animated many photographers in the seventies, conducted his own rephotographic survey from 1968 to 1973. He returned to the upper Ohio and Monongahela River valleys and the Appalachian highlands near Bethlehem, Pennsylvania, where Evans had first photographed. Replicating Evans's strategies, Hare shot over the rooftops of the steep mill cities and recorded the interiors of workers' homes. But Hare's most remarkable photographic homage was made in 1972 at the same location in Bethlehem from which Evans, in November 1935, shot two of his most memorable photographs: a view across the graveyard and hillside houses toward the steel mills and—the one Hare chose to follow—a view turned almost ninety degrees to the left, looking over the graveyard and down the street toward town. Rather than adopting the Rephotographic Survey's procedure of shooting from the very same tripod holes, Hare readjusts Evans's view to convey his own rendition of visual complexity and his own sense of the equivalence of tombs and tenement rooms. Hare's photograph is a visual exegesis of the earlier view, a testament to the fact of stasis within change. His wider-angle lens takes in a broader vista, showing new buildings in the distance and newer automobiles on the street. Yet the same two-family houses lead down the street. The marble cross encrusted by ornate stone roses still faces the houses and, while the balustrades surrounding the other cross in Evans's view have crumbled away and been removed, the cross itself still stands. By stepping back and moving further up the graveyard hill, Hare has caused a new presence to appear. A marble angel now spreads a silent benediction over the crumbling cemetery posts, the failed lives, the hollow selves, and the insidious sameness.

Evans's secular juxtaposition of white crosses and dark telephone poles has now been given sacred meaning.

Interior America's references to other achievements of American photography may not be as explicit, but they are always present. There are photographs reminiscent of Frank's tilted framing of wall decorations; Russell Lee's harshly lit, frontal views of kitchens and parlors; Friedlander's American monuments; Davidson's East 100th Street; Owens's suburbia; and Weston's Armco steel towers. Mill and stack configurations not unlike Weston's presentations of Middletown, Ohio, appear in two of Hare's images of Mingo Junction, Ohio. It is against these allusions that Hare's portrayals take on even greater power.

Hare's references to past work are analogous to the Biographical Narrative's use of the snapshot, since in both instances earlier images are employed to stimulate memory and establish continuity. But where the Biographical Narrative's intention is personal, Hare's is cultural, racial. The viewer is simultaneously made aware of history and actuality: descriptions from the past, which have been legitimized as myth, are subliminally juxtaposed with images of the present, which are presented

215

as concrete experience. Hare presents his world not as ideology but as fact. Yet the facts are so richly drawn and so deeply referential that they demand political explanation and political action.

William Klein's photographs of New York in the mid-fifties and his photographs of Rome, Moscow, Tokyo, Paris, and Madrid taken over the next twenty years emerged in 1981 as the most aggressively expressionistic documents in the medium's history. They stand in marked contrast to Chauncey Hare's quiet, reasoned, and understated studies and to the entire tradition of American documentation. Klein himself represents a curious anomaly: a New York–born photographer living in Paris, so famous in Europe that he was voted, at Photokina in 1963, one of the thirty most important photographers in history, yet so unknown in the United States that he has been omitted from virtually every study of American photography. Klein photographed in New York at the same time Frank was traveling across America, and he published his study of New York, *Life is Good and Good for You in New York: Trance Witness Revels*, in Paris in 1956, two years before Frank made his Paris debut with *Les Américains*. While his European admirers claimed that he dynamically influenced a generation of photographers, that influence has been conspicuously absent from the American scene. American photography's neglect of Klein was finally re-

WILLIAM KLEIN. *Hamburger 40¢*, New York, 1955

WILLIAM KLEIN. Contact sheet. Photographs made in New York City, 1954–55

dressed in 1980 by a large retrospective at the Museum of Modern Art and in 1981 by the publication of an Aperture monograph.

The exclusion of Klein from photographic discussions in the United States points to the essential reticence and puritanism of American social realist photography, indeed of American photography in general. It took the combined influence of the more aggressive work of Winogrand and Friedlander, Arbus's obsession with deviates and freaks, Charles Gatewood's startling—but ultimately unrewarding—obsession with the human sideshow, and the rawer tenor of American society to pave the way for Klein's acceptance. And it took the growing search for alternative modes of documentary expression and political action to make Klein's photographs more accessible. Only in recent years has violence emerged as a legitimate photographic theme, as war and fashion photography and punk images by Krims, Clark, Samaras, and others have elicited a taste for the disturbing. "In the 1950s," Klein said, "everyone I showed them to said, 'Ech! This isn't New York—too ugly, too seedy, too one-sided.' They said, 'This isn't photography. This is shit!'"

Klein's photography is matched in visual intelligence only by Friedlander's

WILLIAM KLEIN. *Pray-Sin, Broadway and 48th Street, New York,* 1954

WILLIAM KLEIN. *Gun 2, Italian Neighborhood, New York,* 1954

and in immediacy only by Winogrand's and Weegee's. In fact, Klein is all three rolled into one—and more. His prints are raw. In typically European fashion he dismisses the fine, smooth, virtually grainless print, substituting instead the inherent qualities of grain, blur, contrast, and harshness. Such print characteristics—all anathema to the American tradition—gain for Klein another order of nuance and psychological impact. In addition, American photography, being predicated on pictorial structure, has minimized the personal presence of the photographer. Yet Klein was able to brilliantly fuse structure and presence: his graphic sense is boldly dramatic and his personal presence a provocation.

In general, American documentary photography avoids eye contact, a condition necessary to insure the *otherness* of the world. When eye contact occurs, as it does at times in Evans, Davidson, and Arbus, it signals a wary, apprehensive watchfulness, a recognition of distance, not involvement. Neither photographer nor subject is willing to reveal too much. Klein's photography, on the other hand, as Max Kozloff observed, is "filtered through a visual war of nerves, a fact which makes it quite outrageous. The complete city man, both intrusive and obtrusive, Klein often incited his subjects. . . . When you view his books, you feel that you yourself are a conspicuously uncalled-for presence. . . ."

The fact is that, during the past twenty-five years, there has been no aesthetic that could justify Klein's presence in American photography. Frank himself was accepted reluctantly and only because his vision meshed in some degree with the reticent American mold established by Strand and Evans. Compared to Klein's vision, Frank's was spare, stark, singular, and sufficiently distanced from the recorded world. Only in a very few instances in *The Americans*—such as *Candy Store, New York City,* and *Convention Hall, Chicago*—does Frank achieve Klein's sense of packed information and his graphic and confrontational audacity. Compare the pictures the two took aboard the Staten Island ferry, for instance. In Frank's a drab, distant, depressing calmness pervades the image. Klein's camera much more energetically wrenches from the world hulking presences, dark silhouettes, and a glowing, halated flag against the blinding New York skyline.

And Klein's fascination with and almost barbaric use of commercial billboards, signs, tabloid headlines, and radical techniques of layout and montage (more apparent in Klein's original publications than in the Aperture monograph) were more closely related to film than to photography. They produced distinctly uncomfortable reac-

217

tions in the years before Pop Art and before the resurgence of interest in photography and language. When Klein's books first appeared, the ultraformal layout of *The Family of Man* set the standards for the juxtaposition of words and pictures. Even *The Americans* followed the conservative one-to-a-page spread.

In the long view of history, Klein will be awarded his just place alongside Frank as one of the two masters of the American fifties. But for the moment his work will exert its influence as a mode of social commentary that came of age in the early eighties. Just as Peter Beard's dense diaries developed out of a cosmopolitan, extra-American sensibility, and Stieglitz's and Frank's photographs integrated European expressionism with American pragmatism, so, too, William Klein's smoldering confrontational images derive from a cross between the New York *Daily News* and French radical satire. Klein's work will surely add new hybrid vigor to American photography.

ROBERT FRANK. *Yom Kippur, East River, New York City,* 1955–56

WILLIAM KLEIN. *Staten Island Ferry, New York,* 1954

Scientific Realism

The New Objectivity

Unlike painting, which has a synthetic, coded relationship to the world, photography is an analogical activity, requiring only the catalyst of the viewfinder. Like verbal thinking it occurs directly in the mind or in the mind's eye. As such it is inherently a conceptual activity, or at the very least an activity that resides halfway between gesture and thought. In the sixties and seventies artists stressed the concept as being more important than the visual result. And photography provided the conceptual artist with the perfect medium for the presentation and preservation of his art. By being merely a record, it minimized the work as object. By being an ideational gesture itself, it maximized the intellectual discourse.

In the seventies this strategy was taken over from the painters by the photographers. This most dramatic break with precedents in fine-art photography was generally referred to as "conceptual photography." Yet it may be more descriptively labeled Scientific Realism, for its primary concerns were not the idiosyncrasies of subjective conception but objective measurement, scientific procedure, and technological method. It was a photography based on analytical investigation rather than on personal expression. It relied on the inherent properties of the photographic process to discover, document, gather, formalize, and organize raw data into coherent

Opposite, from top
REED ESTABROOK. Excerpt from *A Photograph of America: North American Cross Section*, 1977

SOL LEWITT. Two-page spread from *PhotoGrids*, 1977

EDWARD RUSCHA. Pages from *Colored People*, 1972

information. Sol LeWitt, a serial artist and photographer, whose 1977 book *Photo-grids* presented a series of 414 uninflected square color photographs of grates, door-ways, and windows, summed up the objective impulse ten years earlier when he wrote that the artist's aim is

> not to instruct the viewer, but to give him information. . . . The artist would follow his predetermined premise to its conclusion, avoiding subjectivity. Chance, taste, or unconsciously remembered forms would play no part in the outcome. The serial artist does not attempt to produce a beautiful or mysterious object but functions merely as a clerk cataloging the results of his premise.

Scientific Realism appropriated Sontag's positivist dictum: "Only that which narrates can make us understand." But unlike Sontag, it allowed the narrative con-nections to be at times exclusively visual. Scientific Realism is, of course, also a sister mode to Corporate Realism, but it is fundamentally investigative, while Corporate Realism, behind its cool exterior, is overtly propagandistic. Scientific Realism's dis-

220

HAROLD EDGERTON. *Cutting the Playing Card Quickly,* 1964. Stroboscopic photograph

EADWEARD J. MUYBRIDGE. Plate from *Animal Locomotion,* 1887

coveries are conditioned more by process and concept than by ideology. Its revelations are antithetical to the traditions of illusion, being determined instead by the tradi-tions of fact.

In our time, Dr. Harold Edgerton's experiments in stroboscopic photography provide the archetypal scientific model of photographic investigation. And Edward Ruscha's series of fifteen small-format books of photographs provides the contem-porary model of Scientific Realism's aesthetic and conceptual reworking of objective photographic models. Ruscha's books began with the publication in 1962 of *Twenty-six Gasoline Stations.* This book consisted of twenty-six photographs of randomly selected gas stations. It was followed by such titles as *Some Los Angeles Apartments* (1965), a series of apartment buildings, identified by address; *Every Building on Sun-set Strip* (1966), an accordion-folded nine-foot-by-seven-inch photograph made with a motorized camera from the back of a pickup; *Thirty-four Parking Lots* (1967), aerial views; *Nine Swimming Pools* (1968), photographed in color; *Real Estate Opportuni-ties* (1970), vacant lots with "For Sale" signs; and *Colored People* (1972), fifteen color photographs of cacti.

Ruscha's books provided one of the first truly conceptual gestures in both

painting and photography. Each study enumerates, with bland neutrality and dry irony, a catalog of objects. The photographs, many made for Ruscha by commercial photographers, are casual, purely informative, and devoid of traditional beauty. Ruscha's attitude toward these objects was surgically analytical. When asked, "Why did you, Ed Ruscha, choose gas stations?" he replied, "Because they were there." But rather than being catalogs in the spirit of science, these are catalogs in the spirit of art. Ruscha, like the early Pop artists, realized that scientific records and documents presented in the context of language and art could become a genuine tool for generalizing the paradoxes and potentials of the medium.

Eadweard Muybridge's studies in animal locomotion a century earlier may be understood as the seminal photographic activity in Scientific Realism. Muybridge's intention was to examine as accurately and completely as possible the underlying structures of animal movement. In collaboration with other scientists and engineers, he conceived a strategy to exploit the camera's potential for instantaneous sight in order to document realities that were beyond normal perception. Photography pro-

221

vided the tool that could make the invisible visible, that could dissect and codify empirical observation. Muybridge's high-speed sequential photography not only recorded slices of movement; more profoundly, it extended photography's ideational potential. It used photography as a means of realizing a notion that originated not in the visual world but in the mind. The final images were derived not from the appearance of things, but from an intellectual construct: the possibility of measuring motion by analyzing its discrete parts. Rather than serving as an end in itself, photography was used as an instrument for the representation of facts and ideas.

Left and right
ROBERT CUMMING. *Leaning Structures,* 1975

It was this radical notion of an uninflected, objective record that animated those photographers in the seventies whose work may be seen as an analysis of the medium's structure and semiology. In practice, Scientific Realism was used both for investigative purposes and as a premise for making art. As a "pure science" it provided a metacritical strategy for exploring photography's function within various social and aesthetic contexts. It allowed for an investigation of the primary operations of the medium and, further, of the impact of these operations on culture. Additionally, as a strategy drawn from science, it provided a rich model for aesthetic experimentation.

Like Whitman, Muybridge viewed his catalogs, with their extensive breadth and completeness, as a new species of both science and art. The Whitmanian catalog—an enumeration so complete as to have value as both fact and expression—provided one of the basic strategies for conceptual inquiry. In 1978 Reed Estabrook, fulfilling Whitman's belief that "the United States themselves are essentially the greatest poem," drove from New York to San Francisco and shot six hundred rolls of film frame by frame for the entire length of Route 80. Combining the 21,000 negatives together into a single print three and a half inches high by three and a third miles long, Estabrook produced the longest and largest photograph in history. While Estabrook's epic project has direct links to both Frank's cross-continental journey and the nineteenth-century survey expeditions, it is more properly seen in the context of a scientific experiment: the statistical gathering of geographical and demographical data, which when finally assembled—like the 100,000 photographs taken by Muybridge—have the impact of both information and art.

JAN GROOVER. *369.23*, *269.24*, and *367.19*, 1976. Three images mounted on 6 × 20″ mat

Exploiting a concept of equally epic scale, Douglas Huebler proposed in 1971 to "photographically document, to the extent of his capacity, the existence of everyone alive in order to produce the most authentic and inclusive representation of the human species. . . . Editions of this work will be periodically issued in a variety of topical modes: '100,000 people,' '1,000,000 people,' '10,000,000 people,' etc." Estabrook's and Huebler's experiments both relied on the fundamental photographic characteristics of objectivity, ease, and repeatability. More profoundly, they replaced the hierarchy of the single image with the democratic interrelationship of all parts. Photography's inherent seriality and capacity to accept all visual information equally were used to forge a testament to the democracy of vision.

Serial Photography

Among the many photographers in the seventies who experimented with serial procedures were Peter D'Agostino, Richard Long, Michael Snow, Victor Landweber, Barbara Crane, Paul Berger, John Baldassari, Robert Cumming, and Lew Thomas

(who also edited an important series of publications on conceptual photography). All shared a concern for grids and geometric structures as operating devices by which to explore the accommodations of concept, word, and image. Many demanded that their work rigorously satisfy a set of given conditions and frequently employed such mathematical concepts as progression and permutation.

Repetition in itself, with little or no overt linguistic reference, became the mode by which Gary Beydler, Jan Groover, Robbert Flick, and Eve Sonneman explored photography's formal, spatial, and temporal potentials. While these photographers use techniques such as comparison, indexing, and cataloging, they still maintain the traditional artist's prerogative to enter his or her own artwork.

In both these cataloging modes, the photographer first works out a conceptual premise and then allows the equipment to generate the final product. This procedure, with its insistence on the materiality of photography—its optical and chemical nature and its peculiarities of presentation—steps beyond Szarkowski's parameters of the

"thing itself," the "detail," the "frame," "time," and "vantage point." Where Szarkowski emphasized the single print, the "photographer's eye," and the eye's formal control over the machinery, the conceptualists emphasized multiple prints and the machinery's control over the photographer. The balance between the act of photographing and the resultant print had shifted: the photograph had now become the primary phenomenon; structure and concept had taken precedence over content and perception. The "photographer's eye" and the "decisive moment" had been relegated to secondary importance.

Yet the tension between the photograph and the world remains. The photograph continues to imply the existence of actual fact. But the serial method of recording necessarily imposes discrete moments on a world that exists as a flowing continuum. The allegiance of a serial presentation, perhaps even more than that of a single image, is deeply divided between fiction and fact. Serial images are both conceptual fictions determined by the photographic procedure and seemingly accurate representations of natural phenomena that exist quite independently of observation. As such, these catalogs call into question the aesthetic and epistemological

EVE SONNEMAN. *Coney Island,* 1974. Two Ektacolor prints and two silver prints

premises behind the traditional romantic cataloging of America that we have come to know in *American Photographs, The Americans,* and *Interior America.*

The serial form, dealing in repetition and redundancy, necessarily created its own syntax and grammar and was used by several photographers as a way to investigate photography as a visual language. This relationship is explored in its most abstract and evocative form in Paul Berger's *Mathematics* (1976), a series of sixty-three prints derived from chalk-drawn diagrams and formulas on blackboards in mathematics classrooms at the University of Illinois. Berger photographed the blackboards over a period of a year, exposing successive rolls of 120 film through a series of close-ups in which the film would be only partially advanced after each exposure. This procedure created a continuous, overlapping series of image strips. The developed roll would be cut into thirds and presented as a tripart contact sheet. At times, thirds of various rolls would be juxtaposed on a single image sheet. In this stark, yet lyrically calligraphic mode, Berger's serial art explores such notions as grid, progres-

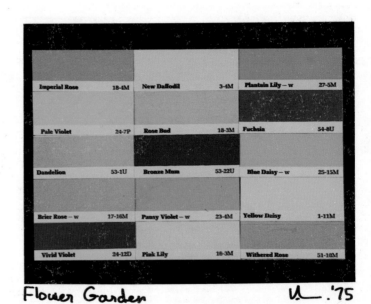

VICTOR LANDWEBER. *Flower Garden, Treasure Tones, Number 2,* 1975

sion, permutation, and rotating reversals. It alludes to primitive linguistic markings, musical notations, and architectural forms. Paradoxically, these images transform actual scientific notation and information into art, while the series itself examines with almost scientific accuracy notions of photographic representation, tonality, time, space, and scale.

Berger's work is perhaps the most extreme contemporary transformation of the Muybridge series. Information, sequence, repetition, abstraction, multiple permutations, and indexing all weave together to form a beautifully coherent image. Each parameter becomes multiplied by the next, creating a density of both scientific and aesthetic allusion. *Mathematics* is founded on the most fundamental characteristics of the medium but is realized with an elegance and density associated with traditional representation.

Several of John Baldessari's pieces explore notions of seriality and language. In *Blasted Allegories* (1978), Baldessari asked friends to assign single words to black-and-white photographs taken at random from a television screen. The photographs were then tinted arbitrarily or with a color that matched the first initial of the word chosen:

"yield" was tinted yellow. Then, with the words superimposed, the photographs were placed into linguistic and mathematical units. The relationship between these images was thus augmented by color, by word, and by sequence. Baldessari further specified their relationships by adding algebraic notation and captioning each unit. The effect of all these contexts, signifiers, and semantic codes is to posit logical continuities. Each component in the unit, the work implies, stands in some sort of analogical, allegorical, or structural relationship to each other. The pieces are intended to convey their meaning contrapuntally and narratively, visually and linguistically. And on the most simple level they do function as illustrated sentence diagrams.

Yet the units ultimately withhold their meaning altogether, functioning as puzzles and pseudoscience. The word "allegory" implies a one-to-one relationship. The impact of Baldessari's work, however, is to show that such direct cognitive association is overly simplistic, or "blasted." Analogy and decoding take place on much more complicated levels. The work seems to have been created to raise perceptual ques-

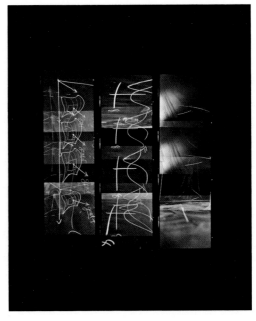

tions, not to solve them. The accouterments of mathematics and linguistics are used ironically and humorously to point out how little we really understand. We are left only with the questions. Like Rauschenberg's *Rebus, Blasted Allegories* is finally unintelligible but fascinating.

In much the same ironic way in which Baldessari's work is predicated on a linguistic basis, many of Robert Cumming's photographs are derived from scientific procedures for gathering evidence. Cumming's overt visual strategies are drawn from high-speed and serial photography, engineering drawings, the analytical tools of comparative and propositional analysis, and the stylized codes of engineering and scientific graphics. The captions he gives his photographs read like objective descriptions of natural phenomena or the positing of logical propositions. They purport to give scientific information concerning such phenomena as retinal afterimage, the relationship of energy to matter, the sheer stress on leaning bodies, statistical probability, and the discrete stages in a blast explosion. The words and the images are, in fact, fictions and pseudoevents: clever paraphrases of scientific information, visual puns, and parables of scientific facts. Cumming imitates the scrupulous documentary man-

JAMES FRIEDMAN. From *The History of the World,* 1981. Original in color

PAUL BERGER. From *Mathematics,* Number 18, 1976

ner only to produce antidocuments. And the tension between scientific accuracy and spoof is augmented by understatement. Absolutely banal events are used to demonstrate the most imposing facts: Einstein's theory of relativity is illustrated by photographs of a barbecue grill and a steak.

Cumming's photographs are obvious constructions and puzzles. They are not meant to present the illusion of reality—to deceive the viewer—but to challenge the viewer to discover the subtle flaw in the visual logic. Each view, for example, in the sequence *Three Sides of a Small House, the Fourth Being Obscured by a Low Wall and Some Foliage* (1974) turns out on close inspection to be the identical facade. No building actually exists. By reconstructing and deconstructing photographic icons and methodology, Cumming characterizes alternative modes of visualization and posits the photographer's capacity to fabricate and stylize information. His work suggests that experience emerges from both the world and the imagination. Objective reality is only one facet of photographic information. Alternative explanations for facts and events can be conceived and, with the aid of appropriate props, represented photographically.

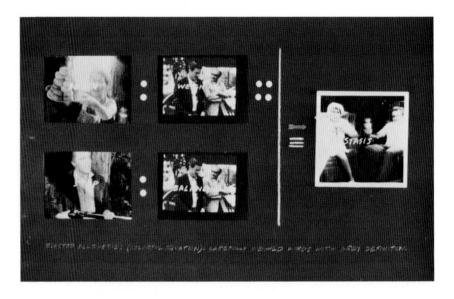

JOHN BALDESSARI. *Blasted Allegories (Colorful Equation): Carefully Weighted Words with Grey Definition,* 1978. Photographs and pencil. Original in color

In the portfolio *Studio Still Lifes* (1978), Cumming examines the movie industry's "special effects" and sets. In these straight shots of the machinery and constructions used by cinema, Cumming makes it clear that film and photography can be used as a propositional system as well as a deductive, mimetic record. For Cumming as for Muybridge, photography is not bound by realist or empirical assumptions but can be employed to portray a nonvisual event.

Cumming's elaborate procedures for making photographs are not unlike Muybridge's conceptual and technological preparations. But unlike Muybridge, Cumming links his work to the underlying assumption that the observer changes the nature of the observed. Cumming's intervention into the observable world makes the viewer constantly question the relationship between photographic fact and fiction, objectivity and subjectivity, the camera as the recorder of reality and the camera as the fabricator of new information.

While the interrelationships of words and images pose major theoretical challenges, a more direct route for exploring images and their tie to social meaning is found in James Friedman's photographs of 35mm slides. The standard art-history method of arranging related slides on a light table in preparation for a class lecture supplies the conceptual process by which Friedman rewrites and reinvestigates the

history of photography and, in his words, "the history of the world." This process becomes another instance of a rephotographic survey. Here, however, acknowledged photographic masterpieces are demythologized and shown to be equivalent in meaning and impact to mass-culture, commercial, and vernacular imagery. In Friedman's work the 35mm slide becomes the great leveler of pictorial differences. All photographs are equivalently packaged. Distinctions of surface and treatment are eradicated by successive generations of reproduction. The slides become a standardized inventory of forms and constitute a uniform indexing grid, an infinite series of identical objects. In Friedman's prints, the slides themselves—the mounts, the colors of the plastic, the annotations of time, place, and artist, and only incidentally the content—become the photographed art objects.

Friedman's work posits a rudimentary semiology of images: a limited but poignant directory of those photographic icons, subjects, and gestures that have accrued obsessive status in our culture. Paradoxically, his cool conceptual procedure ends up by discovering that behind the superficial inequalities of form lie constellations of the most primitive themes: birth, sex, death. As in Muybridge's series, the

repeatability and detachment of the photographic process ultimately uncover both scientific fact and the most fundamental truths about human needs.

If one mode of understanding the photograph's relationship to language is Baldessari's schematic diagraming, the antithetical mode would be to dispense with the visual image entirely, completely replacing the pictorial by the literary. Following the lead of painters who in the sixties made up canvases simply of verbal data without visual form, photographers in the seventies explored the notion of the nonvisual photograph. Their desire to pare the photograph down to its essential narrative meaning derives as well from precedents in theoretical mathematics and science, where it is assumed that logic, without visual proof, provides sufficient justification. Vision is exercised in a relatively limited universe and is not to be trusted. More fundamentally, nonvisual photographs are affirmations that photography, as Clement Greenberg once observed, "is literary art before it is anything else."

At one extreme, in a gesture of the ultimate romantic angst, Duane Michals scrawled on a blank piece of photographic paper:

How foolish of me to have believed that it would be that easy. I had confused the appearances of trees and automobiles and people with reality itself and believed . . . a photograph of these appearances to be a photograph of it. It is

DUANE MICHALS. *A Failed Attempt to Photograph Reality,* c. 1974

DONNA-LEE PHILLIPS. Detail from *The Photograph,* 1976

227

a melancholy truth that I will never be able to photograph it and can only fail. I am a reflection photographing other reflections within a reflection. To photograph reality is to photograph nothing.

Taking another approach to the nonvisual image, Allan Sekula, Donna Lee Phillips, and various others have attempted to call up an image through pure literary form. In *Meditations on a Triptych* (1978), Sekula transforms three snapshots into sociological observation and personal anecdote. And in *The Photograph* (1976), Phillips, using a cool, objectively descriptive style borrowed from Robbe-Grillet, effectively calls up a photograph by verbal catalog and poetic musings.

At the other extreme, Victor Landweber made Polaroid photographs in 1975 of colored paint chips produced by the Treasure Tone paint company. These chips, with their color names and color numbers attached, were blocked into regular grids of nine or fifteen units and became both the verbal and the visual content of the photographs. Landweber built these units out of the tensions set up among visual antecedent, verbal antecedent, nonrepresentational image, and technical code. The paint chip's name alludes to idyllic subject matter—*Autumn Bronze, Dawn Blue, Pink Masterpiece*—while its number refers to a technical inventory control number—*16-5M* for example—beyond our knowledge. In reality there are no visual analogs for *Treasure Tones;* their visual meaning must be conceived wholly in the imagination. In the end Landweber has reduced all photographic experience to pure tone and language.

Viewed from one perspective, Landweber's *Treasure Tones* are conceptual failures: their premise seems to call for pure idea, yet they end up presenting a catalog of facts. Though abstract in comparison to representative images, they are nonetheless tied to color, language, and manufactured fact. They are not a collection of ideas but a collection of things. Landweber's work underscores the fact that in American photography what begins as the most conceptual of gestures frequently returns to empirical statement. Ultimately, the American sensibility is not receptive to totally abstract theory or practice. While both American painting and photography have flirted with pure concept, the most intensely American abstract art has been deeply expressionistic, the most conceptual has been deeply literal. America's most powerful social statements have not been theoretical manifestos but carefully rendered portrayals of individual lives.

The new social critics have rightly made us more conscious of the necessary tie between photography and politics and between photography and corporate ethics. But it is doubtful that America will ever produce an ideologically motivated social photography, just as it has never produced a purely conceptual photography. The roots of American utilitarianism, Puritanism, and pragmatism run deep. Despite its flirtation with dispassionate description, conceptual imagery, and neutrality, contemporary American photography is still more deeply committed to the material world than to the world of ideas.

The American sensibility—perhaps more than any other in the twentieth century—has been extraordinarily receptive to the photographic enterprise, precisely because of photography's inherent commitment to fact and to the democracy of sight. In America photography has become a birthright for both popular expression and sophisticated exploration of the land, the inhabitants, and the sorely tried but seemingly invincible myths. As we move through the eighties, William Carlos Williams's creed for American expression rings true. It still appears that American photography will continue to present "no ideas but in things."

Appendices

230

———— . Basic Photo Series: 1. *Camera and Lens*, 1948. Revised edition, 1970. 2. *The Negative*, 1948. 3. *The Print*, 1950. 4. *Natural-Light Photography*, 1952. 5. *Artificial-Light Photography*, 1956. 6. *Polaroid Land Photography*, 1963. Hastings-on-Hudson, N.Y.: Morgan & Morgan. Series currently revised and published Boston: New York Graphic Society.

———— . *Photographs of the Southwest*. Boston: New York Graphic Society, 1976.

———— . *The Portfolios of Ansel Adams*. Boston, New York Graphic Society, 1977.

———— . *Yosemite and the Range of Light*. Boston: New York Graphic Society, 1979.

Newhall, Nancy. *Ansel Adams: The Eloquent Light*. San Francisco: Sierra Club, 1963.

Zakia, Richard, and Dowdell, John. *Zone Systemizer*. Dobbs Ferry, N.Y.: Morgan & Morgan, 1973.

WALKER EVANS

Agee, James, and Evans, Walker. *Let Us Now Praise Famous Men*. Boston: 1941. Revised with 31 more photographs Boston: Riverside Press, 1960.

Evans, Walker. *American Photographs*. With an essay by Lincoln Kirstein. New York: MOMA, 1938. Reprinted by MOMA, 1962; by East River Press, 1975.

———— . *Walker Evans*. With an introduction by John Szarkowski. New York: MOMA, 1971.

———— . *Walker Evans at Work*. Essay by Jerry L. Thompson. New York: Harper & Row, 1982.

———— . *Walker Evans: First and Last*. New York: Harper & Row, 1978.

———— . *Walker Evans: Photographs for the Farm Security Administration 1935–1938*. New York: Da Capo Press, 1973. Complete catalog of all prints in the Library of Congress.

———— . *Walker Evans: Photographs 1930–1971*. New York, Robert Schoelkopf Gallery, 1977. Exhibition catalog.

LEWIS HINE

Hine, Lewis. *America & Lewis Hine: Photographs 1904–1940*. Foreword by Walter Rosenblum, biographical notes by Naomi Rosenblum, essay by Alan Tractenberg. Millerton, N.Y.: Aperture, 1977.

C H A P T E R I

General Texts and Collections

Gassan, Arnold. *A Chronology of Photography. A Critical Survey of the History of Photography as a Medium of Art*. Athens, Ohio: Handbook Company, 1972.

Great Photographers. Life Library of Photography. New York: Time-Life Books, 1971.

Photography in America. Edited by Robert Doty. Published for the Whitney Museum of American Art. Introduction by Minor White. New York: Random House, 1974. Prepared to accompany an exhibition of the same title.

Taft, Robert. *Photography and the American Scene. A Social History, 1839–1889*. New York: Dover, 1964. Reprint of 1938 edition.

Witkin, Lee D., and London, Barbara. *The Photograph Collector's Guide*. Boston: New York Graphic Society, 1979.

Individual Photographers and Artists

ANSEL ADAMS

Adams, Ansel. *Ansel Adams*. Edited by Liliane De Cock. Foreword by Minor White. Hastings-on-Hudson, N.Y.: Morgan & Morgan, 1972.

———— . *Ansel Adams: 50 Years of Portraits*. Edited by James Alinder. Carmel: Friends of Photography, 1978. Published as number 16 of *Untitled*.

TIMOTHY H. O'SULLIVAN

Naef, Weston J. *Era of Exploration: The Rise of Landscape Photography in the American West, 1860–1885.* Buffalo and New York: Albright-Knox Art Gallery and The Metropolitan Museum of Art, 1975. Extensive material on Watkins, O'Sullivan, Muybridge, Russel.

Snyder, Joel. *American Frontiers: The Photography of Timothy H. O'Sullivan, 1867–1874.* Millerton, N.Y.: Aperture, 1981.

EDWARD STEICHEN

"Edward Steichen: His Photographs and Achievements," New York: *U. S. Camera 1956,* 1955. Extensive commentary on Steichen and *The Family of Man* by Tom Maloney, Mary Steichen, Nelson Rockefeller, Victor Jorgensen.

Longwell, Dennis. *Steichen: The Master Prints 1895–1914. The Symbolist Period.* New York: MOMA, 1978.

Steichen, Edward. *A Life in Photography.* Garden City, N.Y.: Doubleday, 1963.

ALFRED STIEGLITZ

Alfred Stieglitz: Photographs and Writings. Edited by Sarah Greenough and Juan Hamilton. New York: Callaway Editions, 1982.

America and Alfred Stieglitz. A Collective Portrait. Edited by Waldo Frank, Lewis Mumford, Dorothy Norman, Paul Rosenfeld, and Harold Rugg. New York: Doubleday, Doran & Company, 1934. New revised edition, Millerton, N.Y.: Aperture, 1979.

Bry, Doris. *Alfred Stieglitz: Photographer.* Boston: Museum of Fine Arts, 1965.

Camera Work: A Critical Anthology. Edited with an introduction by Jonathan Green. Millerton, N.Y.: Aperture, 1973. Selected plates and texts from Stieglitz's quarterly magazine.

Norman, Dorothy. *Alfred Stieglitz: An American Seer.* New York: Random House, 1972. Prepared and produced by Aperture.

PAUL STRAND

Strand, Paul. *Paul Strand: A Retrospective Monograph.* Millerton, N.Y.: Aperture, 1971.

_____ . *Paul Strand: Sixty Years of Photographs.* Millerton, N.Y.: Aperture, 1976.

_____ , and Newhall, Nancy. *Time in New England.* New York: Oxford University Press, 1950.

EDWARD WESTON

Laughlin, Clarence John. *Edward Weston and Clarence John Laughlin: An Introduction to the Third World of Photography.* Essays by Laughlin and Bullard. New Orleans: New Orleans Museum of Art, 1982. Exhibition catalog.

Maddow, Ben. *Edward Weston: Fifty Years.* Biographical text by Maddow. Millerton, N.Y.: Aperture, 1973. New expanded edition reissued as *Edward Weston: His Life and Photographs,* Millerton, N.Y.: Aperture, 1979.

Weston, Edward. *Edward Weston: The Flame of Recognition.* Edited by Nancy Newhall. Rochester: Aperture, 1965. A revised edition New York: 1971.

Whitman, Walt. *Leaves of Grass.* Illustrated by Edward Weston. New York: Limited Editions Club, 1942. Reprinted New York: 1976.

Wilson, Charis, and Weston, Edward. *California & the West.* Millerton, N.Y.: Aperture, 1978. Reprint of 1940 edition.

CHAPTER 2

General Texts and Collections

The Family of Man. The Greatest Photographic Exhibition of All Time. New York; MOMA, 1955. Exhibition created by Edward Steichen for the Museum of Modern Art.

Great Photographic Essays from LIFE. Boston: New York Graphic Society, 1978.

LIFE Goes to War: A Picture History of World War II. Edited from *Life* photo essays by David E. Scherman. Boston: Little, Brown & Co., 1977.

Stott, William. *Documentary Expression and Thirties America.* New York: Oxford University Press, 1973.

U. S. Camera 1940. New York: Random House, 1939. Includes essays by Edward Steichen, Elizabeth McCausland, and a portfolio "Of the West: A Guggenheim Portrait" by Edward Weston with text by Charis Wilson Weston.

Individual Photographers and Artists

MARGARET BOURKE-WHITE

Bourke-White, Margaret. *The Photographs of Margaret Bourke-White.* Greenwich, Conn.: New York Graphic Society, 1972.

Brown, Theodore M. *Margaret Bourke-White: Photojournalist.* Ithaca, N.Y.: Cornell University Press, 1972.

Silverman, Jonathan. *For the World to See: The Life of Margaret Bourke-White.* Preface by Alfred Eisenstaedt. New York: The Viking Press, A Studio Book, 1983.

WYNN BULLOCK

Bullock, Wynn. *Wynn Bullock.* San Francisco: Scrimshaw Press, 1971.

DOROTHEA LANGE

Lange, Dorothea. *Dorothea Lange: Photographs of a Lifetime.* Millerton, N.Y.: Aperture, 1982.

Meltzer, Milton. *Dorothea Lange: A Photographer's Life.* New York: Farrar, Straus & Giroux, 1978.

JACOB A. RIIS

Alland, Sr., Alexander. *Jacob A. Riis: Photographer & Citizen.* Millerton, N.Y.: Aperture, 1974.

W. EUGENE SMITH

Smith, W. Eugene. *W. Eugene Smith: His Photographs and Notes.* Millerton, N.Y.: Aperture, 1969.

_____ . *W. Eugene Smith: Master of the Photographic Essay.* Edited by William S. Johnson. Millerton, N.Y.: Aperture, 1981.

_____ , and Smith, Aileen M. *Minamata.* New York: Holt, Rinehart & Winston, 1975.

EDWARD STEICHEN

"Edward Steichen: His Photographs and Achievements," New York: *U. S. Camera 1956,* 1955.

CHAPTER 3

Individual Photographers and Artists

HARRY CALLAHAN

Callahan, Harry. *Callahan.* Edited with an introduction by John Szarkowski. Millerton, N.Y.: Aperture, 1976. Prepared in association with MOMA.

_____ . *Harry Callahan.* Introduction by Peter C. Bunnell. New York: American Federation of Arts, 1978.

_____ . *Photographs: Harry Callahan.* Santa Barbara: El Mochuelo Gallery, 1964.

_____ . *Water's Edge.* Lyme, Conn.: Callaway Editions, 1980.

IMOGEN CUNNINGHAM

Cunningham, Imogen. *Imogen Cunningham: Photographs.* Introduction by Margery Mann. Seattle: University of Washington Press, 1971.

CLARENCE JOHN LAUGHLIN

Laughlin, Clarence John. *Clarence John Laughlin: The Personal Eye.* Introduction by Jonathan Williams. Millerton, N.Y.: Aperture, 1973.

AARON SISKIND

Chiarenza, Carl. *Aaron Siskind: Pleasures and Terrors.* Boston: New York Graphic Society, 1982.

Siskind, Aaron. *Aaron Siskind: Photographer.* Edited with an introduction by Nathan Lyons. Essays by Henry Holmes Smith and Thomas B. Hess. Rochester: George Eastman House, 1965.

_____ . *Aaron Siskind: Photographs.* Introduction by Harold Rosenberg. New York: Horizon Press, 1959.

_____ . *Aaron Siskind: Photographs, 1966-1975.* Introduction by Thomas B. Hess. New York: Farrar, Straus & Giroux, 1976.

_____ . *Harlem Document: Photographs 1932-1940 by Aaron Siskind.* Providence: Matrix, 1981.

_____ . *Places: Photographs 1966-1975.* New York: Light Gallery and Farrar, Straus & Giroux, 1976.

_____ , and Logan, John. *Aaron Siskind Photographs, John Logan Poems.* Rochester: Visual Studies Workshop, 1976.

MINOR WHITE

Frajndlich, Abe. *Lives I've Never Lived: A Portrait of Minor White.* Cleveland: Arc Press, 1983.

Hall, James Baker. *Minor White: Rites & Passages.* Millerton, N.Y.: Aperture, 1978.

White, Minor. *Light 7. Photographs from an Exhibition on a Theme.* Cambridge and New York: MIT Press and Aperture, 1968. The first of four theme exhibitions at MIT published in book form. This show followed by *Being Without Clothes,* 1970, *Octave of Prayer,* 1972, and, with Jonathan Green, *Celebrations,* 1974, all New York and Millerton, N. Y.: Aperture.

_____ . *Mirrors Messages Manifestations.* Millerton, N.Y.: Aperture, 1969. Reissued Millerton, N.Y.: Aperture, 1982.

_____ . *1000 Photographers Doing Their Own Thing 1984.* Cambridge: MIT Creative Photography Gallery, 1974.

_____ . *Zone System Manual: How to Previsualize Your Pictures.* Hastings-on-Hudson, N.Y.: Morgan & Morgan, 1967. Revised edition issued as *Visualization Manual,* 1973.

C H A P T E R 4

General Texts and Collections

Aperture. Published quarterly under the editorship of Minor White, New York and Millerton, N.Y.: 1952-1975. Michael E. Hoffman, editor, 1975 to date.

Charters, Ann. *Scenes Along the Road: Photographs of the Desolation Angels, 1944-1960.* New York: Gotham Book Mart & Gallery, 1970.

Gee, Helen. *Photography of the Fifties: An American Perspective.* Tucson: Center for Creative Photography, 1980.

Individual Photographers and Artists

CLARENCE JOHN LAUGHLIN

Laughlin, Clarence John. *Ghosts along the Mississippi.* New York: Bonanza Books, 1961. Reprint and revision of 1948 edition.

FREDERICK SOMMER

Sommer, Frederick. *Frederick Sommer.* Philadelphia: Philadelphia College of Art, 1968.

_____ . *Frederick Sommer at Seventy-Five: A Retrospective.* Long Beach: California State University, 1980. Exhibition catalog for show organized by Leland Rice.

_____ . *Venus, Jupiter & Mars: The Photographs of Frederick Sommer.* Edited by John Weiss. Wilmington: Delaware Art Museum, 1980. Exhibition catalog.

C H A P T E R 5

General Texts and Collections

Charters, Ann. *Scenes Along the Road: Photographs of the Desolation Angels, 1944-1960.* New York: Gotham Book Mart & Gallery, 1970.

Individual Photographers and Artists

ROBERT FRANK

Frank, Robert. *Les Américains.* Paris: Delpire, 1958.

_____ . *The Americans.* Introduction by Jack Kerouac. New York: Grove Press, 1959. Revised editions: Millerton, N.Y.: Aperture, 1969, 1978.

_____ . "Ben James: Story of a Welsh Miner." New York: *U. S. Camera 1955,* 1954. Annual also contains portfolios by Strand, Avedon, Ansel Adams, Porter, Capa, and Bischof.

_____ . *The Lines of My Hand.* Rochester: Lustrum, 1972.

"Guggenheim Fellows in Photography: Robert Frank." Essay by Walker Evans. Statement by Frank. Reproduction of 33 photographs. New York: *U. S. Camera 1958,* 1957.

Kerouac, Jack. "On the Road to Florida." Photographs by Robert Frank. New York: *Evergreen Review,* Number 74, January 1970.

Papageorge, Tod. *Walker Evans and Robert Frank: An Essay on Influence.* New Haven: Yale University Art Gallery, 1981.

C H A P T E R 6

General Texts and Collections

The Snapshot. Edited by Jonathan Green. Millerton, N.Y.: Aperture, 1974. Contains portfolios and text by Winogrand, Friedlander, Frank, and others.

Individual Photographers and Artists

JOHN SZARKOWSKI

Eggleston, William. *William Eggleston's Guide.* Essay by John Szarkowski. New York: MOMA, 1976.

The Photographer and the American Landscape. Edited by John Szarkowski. New York: MOMA, 1963. Exhibition catalog.

Szarkowski, John. *The Face of Minnesota.* Minneapolis: University of Minnesota, 1958.

_____ . *From the Picture Press.* New York: MOMA, 1973.

_____ . *The Idea of Louis Sullivan.* Minneapolis: University of Minnesota Press, 1956.

_____ . *Looking at Photographs: 100 Pictures from the Collection of The Museum of Modern Art.* New York: MOMA, 1973.

_____ . *Mirrors and Windows: American Photography Since 1960.* New York: MOMA, 1978. Exhibition catalog and essay.

_____ . *The Photographer's Eye.* New York: MOMA, 1966.

GARRY WINOGRAND

"Monkeys Make the Problem More Difficult: A Collective Interview with Garry Winogrand." *Image.* Vol. 15, No. 2., July 1972.

C H A P T E R 7

General Texts and Collections

Contemporary Photographers: Toward a Social Landscape. Edited by Nathan Lyons. Photographs by Davidson, Friedlander, Winogrand, Lyon, and Michals. Rochester: Horizon Press in collaboration with George Eastman House, 1966.

Documentary Photography. Life Library of Photography. New York: Time-Life Books, 1972. Includes portfolios on FSA, The Photo-League, Frank, Friedlander, Winogrand, and Arbus.

New Documents. Photographs by Arbus, Friedlander, Winogrand. New York: MOMA, 1967. Exhibition catalog.

Photojournalism. Life Library of Photography. New York: Time-Life Books, 1971.

The Snapshot. Edited by Jonathan Green. Millerton, N.Y.: Aperture, 1974.

Twelve Photographers of the American Social Landscape. Waltham, Mass.: Rose Art Museum, Brandeis University, 1966.

Individual Photographers and Artists

HENRI CARTIER-BRESSON
Cartier-Bresson, Henri. *The World of Henri Cartier-Bresson.* New York: Viking, 1968.

LEE FRIEDLANDER
Friedlander, Lee. *The American Monument.* New York: 1976.

_____ . *Factory Valleys.* New York: Callaway Editions, 1982.

_____ . *Flowers and Trees.* New York: 1981

_____ . *Lee Friedlander Photographs.* New City, N.Y.: Haywire Press, 1978.

_____ . *Self-Portrait.* New City, N.Y.: Haywire Press, 1970.

_____ , and Dine, Jim. *Work from the Same House: Photographs & Etchings.* London: Trigram Press, 1969.

ANDRÉ KERTÉSZ
Kertész, André. *André Kertész: Sixty Years of Photography 1912–1972.* New York: Grossman Publishers, 1972.

WEEGEE
Weegee. *Naked City.* New York: 1945.

_____ . *Weegee.* Edited by Louis Stettner. New York: Knopf, 1977.

_____ . *Weegee.* Millerton, N.Y.: Aperture, 1978.

GARRY WINOGRAND
Winogrand, Garry. *The Animals.* Afterword by John Szarkowski. New York: MOMA, 1969.

_____ . *Public Relations.* Introduction by Tod Papageorge. New York: MOMA, 1977.

_____ . *Stock Photographs: The Fort Worth Fat Stock Show and Rodeo.* Austin, Texas: University of Texas Press, 1980.

_____ . *Women are Beautiful.* With an essay by Helen Gary Bishop. New York: Light Gallery, 1975.

C H A P T E R 8

General Texts and Collections

Coleman, A. D. *The Grotesque in Photography.* New York: Ridge Press, 1977.

Documentary Photography. Life Library of Photography. New York: Time-Life Books, 1972.

Leekley, Sheryle, and Leekley, John. *Moments: The Pulitzer Prize Photographs.* Introduction by Dan Rather. New York: Crown Publishers, 1978.

Individual Photographers and Artists

DIANE ARBUS
Arbus, Diane. *Diane Arbus.* Millerton, N.Y.: Aperture, 1972. Text edited from tape recordings of a series of classes Diane Arbus gave in 1971 as well as from some interviews and some of her writings.

E. J. BELLOCQ
Bellocq, E. J. *Storyville Portraits. Photographs from the New Orleans Red-Light District, Circa 1912.* New York: MOMA, 1970. Reproduced from prints made by Lee Friedlander.

LARRY CLARK
Clark, Larry. *Tulsa.* New York: Lustrum Press, 1971. Reissued 1983.

BRUCE DAVIDSON
Davidson, Bruce. *Bruce Davidson Photographs.* Introduction by Henry Geldzahler. New York: Agrinde Publications, 1978.

_____ . *East 100th Street.* Boston: Harvard University Press, 1970.

CHARLES GATEWOOD
Gatewood, Charles, and Burroughs, William S. *Sidetripping.* New York: Strawberry Hill Book, 1975.

PHILIP JONES GRIFFITHS
Griffiths, Philip Jones. *Vietnam Inc.* New York: Collier Books, 1971.

CHARLES HARBUTT
Harbutt, Charles. *Travelog.* Cambridge: MIT Press, 1974.

RICHARD KIRSTEL
Kirstel, Richard. *Pas de Deux.* Introduction by Nat Hentoff. New York: Grove Press, 1969.

LES KRIMS
Krims, Les. *The Deerslayers,* 1972; *The Incredible Stack O'Wheat Murders,* 1972; *The Little People of America,* 1972. Boxed portfolios.

_____ . *Fictcryptokrimsographs.* Introduction by Hollis Frampton. Buffalo: Humpty Press, 1975.

_____ . *Making Chicken Soup.* Buffalo: 1974.

DANNY LYON
Lyon, Danny. *The Bikeriders.* New York: Macmillan, 1968.

_____ . *Conversations with the Dead.* New York: Holt, Rinehart & Winston, 1971.

_____ . *The Destruction of Lower Manhattan.* New York: Macmillan, 1969.

_____ . *Pictures from the New World.* Millerton, N.Y.: Aperture, 1981.

DONALD McCULLIN
McCullin, Donald. *Is Anyone Taking any Notice?* Cambridge: MIT Press, 1971.

RALPH EUGENE MEATYARD
Meatyard, Ralph Eugene. *The Family Album of Lucybelle Crater.* Text by Jonathan Williams et al. Louisville: The Jargon Society, 1974.

_____ . *Ralph Eugene Meatyard.* With notes by Arnold Gassan and Wendell Berry. Lexington, KY.: Gnomon Press, 1970.

_____ . *Ralph Eugene Meatyard.* Edited with text by James Baker Hall. Millerton, N.Y.: Aperture, 1974.

LISETTE MODEL
Model, Lisette. *Lisette Model.* Tucson: Center for Creative Photography, May 1977.

_____ . *Lisette Model.* Millerton, N.Y.: Aperture, 1979.

IRVING PENN
Penn, Irving. *Worlds in a Small Room.* New York: Grossman, 1974.

BURK UZZLE
Uzzle, Burk. *Landscapes*. New York: 1973.

MAX WALDMAN
Waldman, Max. *Waldman on Theater*. Introduction by Clive Barnes. New York: Doubleday, 1971.

CHAPTER 9

General Texts and Collections

Coke, Van Deren. *The Painter and the Photographer: From Delacroix to Warhol*. Albuquerque: University of New Mexico Press, 1964. Revised and enlarged 1972.

Individual Photographers and Artists

HARRY CALLAHAN
Callahan, Harry. *Harry Callahan: Color*. Providence: Matrix, 1980.

JOSEPH CORNELL
Cornell, Joseph. *Joseph Cornell*. Edited by Kynaston McShine. New York: MOMA, 1980. Essays by Dawn Ades, Carter Ratcliff, P. Adams Sitney, Lynda Roscoe Hartigan.

Waldman, Diane. *Joseph Cornell*. New York: George Braziller, 1977.

RICHARD ESTES
Estes, Richard. *Richard Estes: The Urban Landscape*. Essay by John Canaday. Boston: New York Graphic Society, 1978.

ROBERT RAUSCHENBERG
Rauschenberg, Robert. *Photos In + Out City Limits: Boston*. 46 black-and-white photographs. New York.

———. *Photos In + Out City Limits: New York C*. 70 black-and-white photographs. New York.

———. *Robert Rauschenberg*. Essay by Lawrence Alloway. Washington: National Collection of Fine Arts, Smithsonian Institution, 1977. Exhibition catalog.

———. *Robert Rauschenberg: Photographs*. New York: Black-and-white photographs from 1945–46 and 1979–80.

ANDY WARHOL
Warhol, Andy. *Andy Warhol's Exposures*. New York: Andy Warhol Books/Grosset & Dunlap, 1979.

———. *Portraits of the 70s*. Essay by Robert Rosenblum. New York: Random House in association with The Whitney Museum, 1979.

CHAPTER 10

General Texts and Collections

Afterimage. Rochester. A newspaper-format monthly from Visual Studies Workshop. Rochester.

Attitudes: Photography in the 1970's. Santa Barbara: Santa Barbara Museum of Art, 1979. Exhibition catalog.

Contemporary Trends. Essays by Van Deren Coke, A. D. Coleman, and Bill Jay. Chicago: The Chicago Photographic Gallery of Columbia College, 1976. Exhibition catalog.

Cultural Artifacts. Palatka, Fla.: Fine Arts Gallery, Florida School of the Arts, 1979.

Electroworks. Rochester: International Museum of Photography at George Eastman House, 1979. Exhibition catalog.

Exposure. A quarterly journal of the Society for Photographic Education. Published since 1968.

Frassanito, William A. *Gettysburg: A Journey in Time*. New York: 1975.

Frontiers of Photography. New York: Time-Life Books, 1972.

Into the 70's: Photographic Images by Sixteen Artists/Photographers. Akron: Akron Art Institute, 1970. Includes work by Fichter, Hahn, Heinecken, Hyde, Parker, Keith Smith.

The Less Than Sharp Show. Chicago: The Chicago Photographic Gallery of Columbia College, 1977. Exhibition catalog.

Lyons, Nathan. *Photography in the Twentieth Century*. Rochester: George Eastman House, 1967.

The Multiple Image. Introduction by Bart Parker. Providence: University of Rhode Island, 1972. Exhibition catalog.

Newhall, Beaumont. *The History of Photography*. New York: MOMA, 1964 (fourth revision). New expanded edition Boston: New York Graphic Society, 1983.

The New Vision: Forty Years of Photography at the Institute of Design. Millerton, N.Y.: Aperture, 1982.

The Photographer's Choice. A book of portfolios and critical opinion. Edited by Kelly Wise. Danbury, N. H., Addison House, 1975.

Photographers on Photography. Edited by Nathan Lyons. New York: Prentice Hall, 1966.

Szarkowski, John. *Mirrors and Windows: American Photography Since 1960*. New York: MOMA, 1978. Exhibition catalog.

Vision and Expression. Edited by Nathan Lyons. New York: Horizon Press, 1969.

Individual Photographers and Artists

ADAL (MALDONADO)
Adal. *The Evidence of Things Not Seen*. New York: 1975.

BARBARA BLONDEAU
Blondeau, Barbara. *Barbara Blondeau*. Rochester: 1976.

LINDA CONNOR
Connor, Linda. *Solos*. Millerton, N.Y.: Aperion Workshops, Inc., 1979.

BARBARA CRANE
Crane, Barbara. *Barbara Crane: Photographs 1948–80*. Tucson: The Center for Creative Photography, 1981.

ROBERT FICHTER
Fichter, Robert. *Robert Fichter: Photography and Other Questions*. New York: Freidus Gallery, 1982.

LEE FRIEDLANDER
Friedlander, Lee, and Dine, Jim. *Work from the Same House: Photographs & Etchings*. London: Trigram Press, 1969.

RALPH GIBSON
Gibson, Ralph. *The Somnambulist*. New York: Lustrum, 1970.

EMMET GOWIN
Gowin, Emmet. *Emmet Gowin: Photographs*. New York: Alfred A. Knopf, 1976.

ROBERT HEINECKEN
Heinecken, Robert. *Heinecken*. Edited by James Enyeart. New York: The Friends of Photography in association with Light Gallery, 1980.

KENNETH JOSEPHSON
Josephson, Kenneth. *The Bread Book*. Chicago: 1974.

WILLIAM LARSON
Larson, William. *Fire Flies*. Philadelphia: Gravity Press, 1976.

MICHAEL LESY
Lesy, Michael. *Wisconsin Death Trip*. New York: Pantheon, 1973.

NATHAN LYONS

Lyons, Nathan. *Notations in Passing.* Cambridge: MIT Press, 1974.

RAY K. METZKER

Metzker, Ray K. *Sand Creatures.* Millerton, N.Y.: Aperture, 1979.

DUANE MICHALS

Michals, Duane. *Real Dreams.* Danbury, N.H.: Addison House, 1976.

――――. *Sequences.* Garden City, N.Y.: Doubleday, 1970.

LÁSZLÓ MOHOLY-NAGY

Moholy-Nagy, László. *Photographs of Moholy-Nagy.* Edited by Leland D. Rice and David W. Steadman. Essays by Lloyd C. Engelbrecht and Henry Holmes Smith. Claremont, Ca.: Galleries of Claremont Colleges, 1975.

BEA NETTLES

Nettles, Bea. *Breaking the Rules: A Photo Media Cookbook.* Rochester: Inky Press, 1977.

――――. *Dream Pages.* Rochester: 1975.

――――. *Flamingo in the Dark.* Rochester: Inky Press, 1979.

――――. *Of Loss and Love.* Poetry by Grace Nettles. Rochester: 1975.

ARTHUR SIEGEL

Grimes, John. "Arthur Siegel: A Short Critical Biography." *Exposure,* 17:2, Summer 1979.

JERRY N. UELSMANN

Uelsmann, Jerry N. *Jerry N. Uelsmann.* Introduction by Peter Bunnell. Fables by Russell Edson. New York: Aperture, 1970.

――――. *Jerry N. Uelsmann: Silver Meditations.* Introduction by Peter C. Bunnell. Dobbs Ferry, N.Y.: Morgan & Morgan, 1975.

――――. *Jerry N. Uelsmann: Twenty-five Years. A Retrospective.* Boston: New York Graphic Society, 1982.

C H A P T E R 11

General Texts and Collections

Altered Landscapes. Introduction by Jim Alinder. Palatka, Fla.: 1978. Exhibition catalog. Photographs by Barrow, Levine, Pfahl, Patterson, Berens, Danko, Hallman, Crawford, Henkel, Wilson, and Yates.

American Images: New Work by Twenty Contemporary Photographers. Edited by Renato Danese. New York: McGraw-Hill, 1979. Portfolios by Robert Adams, Baltz, Callahan, Clift, Connor, Davies, DeCarava, Eggleston, Erwitt, Fink, Gohlke, Gossage, Green, Groover, Mark, Meyerowitz, Misrach, Nixon, Papageorge, Shore.

14 American Photographers. Introduction by Renato Danese. Baltimore: Baltimore Museum of Art, 1974. Exhibition catalog. Portfolios by Robert Adams, Baltz, Caponigro, Christenberry, Connor, Cosmos, Cumming, Eggleston, Evans, Friedlander, Gossage, Hallman, Papageorge, Winogrand.

The Great West: Real/Ideal. Edited by Sandy Hume, Ellen Manchester, and Gary Metz. Boulder: 1977.

Landscape & Discovery. Hempstead, N.Y.: Emily Lowe Gallery, Hofstra University, 1973.

Landscape: Theory. New York: Lustrum, 1980. Photographs and essays by Robert Adams, Baltz, Callahan, Caponigro, Fulton, Garnett, Porter, Sinsabaugh, Tice, and Brett Weston.

Naef, Weston J. *Era of Exploration: The Rise of Landscape Photography in the American West, 1860–1885.* Buffalo and New York: Albright-Knox Art Gallery and The Metropolitan Museum of Art, 1975.

New Landscapes. Essay by Mark Johnstone. Carmel: The Friends of Photography, 1981. Published as number 24 of *Untitled.* Photographs by Skoff, Lown, Connor, Robert Adams, Hammerbeck, Dusard, Volkerding.

New Topographics: Photographs of a Man-Altered Landscape. Introduction by William Jenkins. Rochester: International Museum of Photography at George Eastman House, 1975. Exhibition catalog. Photographs by Robert Adams, Baltz, B. & H. Becher, Deal, Gohlke, Nixon, Schott, Shore, Wessel.

Pare, Richard. *Court House. A Photographic Document.* New York: Horizon Press, 1978.

The Photographer and the American Landscape. Edited by John Szarkowski. New York: MOMA, 1963. Exhibition catalog.

Szarkowski, John. *American Landscapes.* New York: MOMA, 1980.

Venturi, Robert, Brown, Denise Scott, and Izenour, Steven. *Learning from Las Vegas.* Cambridge: MIT Press, 1972.

Individual Photographers and Artists

ROBERT ADAMS

Adams, Robert. *Denver: A Photographic Survey of the Metropolitan Area.* Boulder: Colorado Associated University Press, 1977.

――――. *The New West: Landscapes Along the Colorado Front Range.* Boulder: Colorado Associated University Press, 1974.

JAMES ALINDER

Alinder, James. *Consequences: Panoramic Photographs.* Lincoln, Neb.: 1975.

LEWIS BALTZ

Baltz, Lewis. *Maryland.* Introduction by Jane Livingston. Washington: The Corcoran Gallery of Art, 1976. Exhibition catalog.

――――. *The New Industrial Parks Near Irvine, California.* New York: Castelli Graphics, 1974.

――――. *Park City.* New York: Castelli Graphics.

MICHAEL BECOTTE

Becotte, Michael. *Space Capsule.* Carlisle, Mass.: Pentacle Press, 1975.

MICHAEL BISHOP

Bishop, Michael. *Michael Bishop.* Edited with an introduction by Charles Desmarais, essay by Charles Hagen. Chicago: Columbia College, 1979. Exhibition catalog.

HARRY CALLAHAN

Callahan, Harry. *Callahan.* Edited with an introduction by John Szarkowski. Millerton, N.Y.: Aperture, 1976.

PAUL CAPONIGRO

Caponigro, Paul. *Paul Caponigro.* New York: Aperture, 1967. Second enlarged edition 1972.

ROBERT CUMMING

Cumming, Robert. *Cumming Photographs.* Edited with an essay by James Alinder. Carmel: The Friends of Photography, 1979. Published as number 18 of *Untitled.*

WALKER EVANS

Evans, Walker. *Walker Evans: First and Last.* New York: Harper & Row, 1978.

STEVE FITCH

Fitch, Steve. *Diesels and Dinosaurs: Photographs from the American Highway.* Berkeley: Long Run Press, 1976.

LEE FRIEDLANDER

Friedlander, Lee. *Flowers and Trees.* New York: 1981.

JOHN R. GOSSAGE

Gossage, John R. *Better Neighborhoods of Greater Washington.* Washington: Corcoran Gallery of Art, 1976. Exhibition catalog.

ROGER MINICK

Minick, Roger. *Hills of Home: The Rural Ozarks of Arkansas.* Text by Bob Minick, drawings and etchings by Leonard Sussman. San Francisco: Scrimshaw Press, 1975.

BILL OWENS

Owens, Bill. *Suburbia.* San Francisco: Straight Arrow Books, 1972.

JOHN PFAHL

Pfahl, John. *Altered Landscapes.* Introduction by Peter Bunnell. Carmel: The Friends of Photography, 1981. Published as number 26 of *Untitled.*

NANCY REXROTH

Rexroth, Nancy. *Iowa.* Albany, Ohio: 1977.

FREDERICK SOMMER

Sommer, Frederick. *Venus, Jupiter & Mars: The Photographs of Frederick Sommer.* Edited by John Weiss. Wilmington: Delaware Art Museum, 1980. Exhibition catalog.

EVE SONNEMAN

Sonneman, Eve. *Real Time: Eve Sonneman 1968-1974.* New York: Printed Matter, 1976.

EZRA STOLLER

Stoller, Ezra. *Ezra Stoller: Photographs of Architecture 1939-1980.* New York: Max Protetch Gallery, 1980. Exhibition catalog.

CARLETON E. WATKINS

Watkins, Carleton E. *Photographs of the Columbia River and Oregon.* Edited by James Alinder with essays by David Featherstone and Russ Anderson. Carmel: The Friends of Photography, 1979.

EDWARD WESTON

Maddow, Ben. *Edward Weston: Fifty Years.* Millerton, N.Y.: Aperture, 1973.

C H A P T E R 1 2

General Texts and Collections

American Images: New Work by Twenty Contemporary Photographers. Edited by Renato Danese. New York: McGraw-Hill, 1979.

The Art and Technique of Color Photography. Edited and designed by Alexander Liberman. New York: Simon & Schuster, 1951.

Color as Form: A History of Color Photography. Rochester: International Museum of Photography at George Eastman House, 1982.

Eauclaire, Sally. *The New Color Photography.* New York: Abbeville Press, 1981.

Light/Color. Ithaca, N.Y.: Handwerker Gallery, Ithaca College, 1981. Exhibition catalog.

Pare, Richard. *Court House. A Photographic Document.* New York: Horizon Press, 1978.

Stein, Sally. "FSA Color: The Forgotten Document." New York: *Modern Photography,* January 1979.

Individual Photographers and Artists

HARRY CALLAHAN

Callahan, Harry. *Harry Callahan: Color.* Providence: Matrix, 1980.

Stein, Sally. *Harry Callahan Photographs in Color: The Years 1946-1978.* Tucson: The Center for Creative Photography, 1980. Exhibition catalog.

LANGDON CLAY

Clay, Langdon. *Langdon Clay: Color Atlas.* Including *Flat Lands & Related Views.* Introduction by Lloyd Fonvielle. Washington: The Corcoran Gallery of Art, 1979. Exhibition catalog.

MARIE COSINDAS

Cosindas, Marie. *Marie Cosindas: Color Photographs.* Essay by Tom Wolfe. Boston: New York Graphic Society, 1978.

Polaroid Close-Up. Volume 14, Number 1, April 1983. Cambridge: The Polaroid Corporation, 1983. Articles on Tucson's Center for Creative Photography, Kasten, Halsman, Enos, Cosindas.

WILLIAM EGGLESTON

Eggleston, William. *Election Eve.* Washington: Corcoran Gallery of Art, 1977. Exhibition catalog. Seven copies of a limited edition book of the same title published by Caldecot Chubb, 1977.

―――― . *William Eggleston's Guide.* Essay by John Szarkowski. New York: MOMA, 1976.

RICHARD ESTES

Estes, Richard. *Richard Estes: The Urban Landscape.* Essay by John Canaday. Boston: New York Graphic Society, 1978.

LES KRIMS

Krims, Les. *Fictcryptokrimsographs.* Introduction by Hollis Frampton. Buffalo: Humpty Press, 1975.

JOEL MEYEROWITZ

Meyerowitz, Joel. *Cape Light.* Boston: New York Graphic Society, 1978. Contains interview by Bruce MacDonald.

―――― . *St. Louis & The Arch.* Boston: New York Graphic Society, 1980.

―――― . *Wildflowers.* Boston: New York Graphic Society, 1983.

PAUL OUTERBRIDGE, JR.

Outerbridge, Paul, Jr. *Paul Outerbridge, Jr: Photographs.* New York: Rizzoli, 1980.

ELIOT PORTER

Porter, Eliot. *In Wilderness Is the Preservation of the World.* San Francisco: Sierra Club, 1962.

―――― . *The Place No One Knew: Glen Canyon on the Colorado.* San Francisco: Sierra Club, 1963.

LUCAS SAMARAS

Samaras, Lucas. *Lucas Samaras: Photo-Transformations.* Long Beach: The Art Galleries, California State University, 1975. Exhibition catalog.

―――― . *Samaras Album: Autointerview, Autobiography, Autopolaroid.* New York: The Whitney Museum and Pace Gallery, 1971.

STEPHEN SHORE

Shore, Stephen. *The Gardens at Giverny.* Millerton, N.Y.: Aperture, 1983.

―――― . *Uncommon Places.* Millerton, N.Y.: Aperture, 1982.

C H A P T E R 1 3

General Texts and Collections

Artforum. New York. Published monthly except July and August. Since the mid-sixties has carried frequent commentary on photography.

Photography Within the Humanities. Edited by Eugenia Parry Janis and Wendy MacNeil. Danbury, N.H.: Addison House, 1977. Lectures by Morris, Taylor, Mili, Frank, Wiseman, Szarkowski, W. E. Smith, Sontag, Penn.

Sontag, Susan. *On Photography.* New York: Farrar, Straus, & Giroux, 1977. Publication of essays, in slightly different form, which first appeared in the *New York Review of Books.*

C H A P T E R 1 4

General Texts and Collections

The Art and Technique of Color Photography. Edited and designed by Alexander Liberman. New York: Simon & Schuster, 1951.

Devlin, Polly. *Vogue Book of Fashion Photography 1919-1979.* Introduction by Alexander Liberman. New York: Simon & Schuster, 1979.

Maddow, Ben. *Faces: A Narrative History of the Portrait in Photography*. Boston: New York Graphic Society, 1977.

The Portrait Extended. Edited with an essay by Charles Desmarais. Chicago: Museum of Contemporary Art, 1980. Exhibition catalog.

Individual Photographers and Artists

RICHARD AVEDON

Avedon, Richard. *Avedon: Photographs 1947–1977*. New York: Farrar, Straus and Giroux, 1978. Published concurrently with the opening of a retrospective exhibition at The Metropolitan Museum of Art.

———. *Portraits*. New York: Farrar, Straus & Giroux, 1976.

———, and Baldwin, James. *Nothing Personal*. New York: Atheneum, 1964.

———, and Capote, Truman. *Observations*. New York: Simon & Schuster, 1959.

JUDY DATER

Dater, Judy, and Welpott, Jack. *Women and Other Visions*. Introduction by Henry Holmes Smith. Dobbs Ferry, N.Y.: Morgan & Morgan, 1975.

ALLEN DUTTON

Dutton, Allen. *The Great Stone Tit*. Tempe, Az.: Little Wonder Press, 1974.

HANS HAACKE

Haacke, Hans. *Framing and Being Framed*. Halifax, N.S., and New York: Nova Scotia College of Art and Design and New York University Press, 1975.

CHAUNCEY HARE

Hare, Chauncey. *Interior America*. Millerton, N.Y.: Aperture, 1978.

WILLIAM KLEIN

Klein, William. *Life is Good and Good for You: Trance Witness Revels*. Paris: Editions du Seuil, 1956.

———. *William Klein: Photographs*. Millerton, N.Y.: Aperture, 1981.

HELMUT NEWTON

Newton, Helmut. *Sleepless Nights*. New York: Simon & Schuster, 1978.

———. *White Woman*. New York: Stonehill Publishing Co., 1976.

IRVING PENN

Penn, Irving. *Flowers*. New York: Harmony Books, 1980.

———. *Worlds in a Small Room*. New York: Grossman, 1974.

MERIDEL RUBINSTEIN

Rubinstein, Meridel. *La Gente de La Luz: Portraits from New Mexico*. Santa Fe: Museum of New Mexico, 1977.

DANIEL SEYMOUR

Seymour, Daniel. *A Loud Song*. New York: Lustrum, 1971.

JOEL SLAYTON

Slayton, Joel. *Acquaintances*. Cambridge: Visible Language Workshop, MIT, 1980.

LEW THOMAS

Thomas, Lew. *Photography and Language*. Donna-Lee Phillips, design. San Francisco: Camerawork Press, 1976.

CHAPTER 15

Individual Photographers and Artists

ROBERT CUMMING

Cumming, Robert. *Cumming Photographs*. Edited with an essay by James Alinder. Carmel: The Friends of Photography, 1979.

———. *Robert Cumming*. Washington: The Corcoran Gallery of Art, 1976. Exhibition catalog.

HAROLD EDGERTON

Edgerton, Harold. *Moments of Vision: The Stroboscopic Revolution in Photography*. With James R. Killian, Jr. Cambridge: MIT Press, 1979.

JAMES FRIEDMAN

Friedman, James. *James Friedman: Color Photographs 1979–1982*. Introduction by Jonathan Green. Afterword by Bertha Urdang. Columbus, Ohio: The Ohio State University Gallery of Fine Art, 1983. Exhibition catalog.

JAN GROOVER

Groover, Jan. *Jan Groover*. Washington: Corcoran Gallery of Art, 1976.

SOL LEWITT

LeWitt, Sol. *PhotoGrids*. New York: Rizzoli, 1978.

MIKE MANDEL

Mandel, Mike. *Myself: Timed Exposures*. Los Angeles: 1971.

EADWEARD MUYBRIDGE

Muybridge, Eadweard. *Animal Locomotion: An Electro-Photographic Investigation of Consecutive Phases of Animal Movement*. 11 Volumes. Philadelphia: University of Pennsylvania, 1887. *Animals in Motion*, 1899, and *The Human Figure in Motion*, 1901, contain selected plates from *Animal Locomotion*. These were reprinted New York: Dover Publications, 1957 and 1955.

———. *Eadweard Muybridge: The Stanford Years, 1872–1882*. Introduction by Anita Ventura Mozley. Palo Alto: Stanford University, 1972. Exhibition catalog.

DONNA-LEE PHILLIPS

Eros & Photography. Edited by Donna-Lee Phillips. Lew Thomas, associate editor. San Francisco: Camerawork/NFS Press, 1977.

EDWARD RUSCHA

Ruscha, Edward. Series of 12 books including: *Twenty-Six Gasoline Stations*, 1967; *Nine Swimming Pools*, 1968; *Every Building on the Sunset Strip*, 1968; *A Few Palm Trees*, 1971; *Colored People*, 1971.

EVE SONNEMAN

Sonneman, Eve. *Real Time: Eve Sonneman 1968–1974*. New York: Printed Matter, 1976.

LEW THOMAS

Thomas, Lew. *Structural(ism) and Photography*. San Francisco: NFS Press, 1978.

32 As published in *Camera Work*, 1903. / *Lt. Edward Steichen and His Daughter, Mary:* Collection, Department of Photography, The Museum of Modern Art, New York.

33 Victor Jorgensen, for the U. S. Navy, print courtesy the Department of Photography, The Museum of Modern Art, New York. / Wide World Photos.

C H A P T E R 2

36 Frontispiece and page one from *The Family of Man*, copyright © 1955, The Museum of Modern Art, New York; photographs courtesy the Lick Observatory and The Wynn Bullock Archive.

38 Title page, as published in *The Snapshot*, Aperture, Millerton, 1974, photograph from the collection of Wendy Snyder MacNeil. / Robert Frank, as published in *The Snapshot*, Aperture, Millerton, 1974.

39 Courtesy of the Xerox Corporation. / Copyright © 1939, T. J. Maloney, courtesy T. J. Maloney.

40 Dust jacket for *Jacob A. Riis: Photographer & Citizen*, copyright © 1974, Aperture, Millerton, 1974; photographs printed by Alexander Alland, Sr., from the original Riis negatives he discovered and rescued from oblivion in 1946. These prints and negatives are now in the Jacob A. Riis Collection in the Museum of the City of New York; reproduced courtesy of Alexander Alland, Sr. Photographs copyright © 1974, Alexander Alland, Sr.

41 Photograph courtesy Life Picture Service. / *Let Us Now Revisit Famous Folk*, copyright © 1980, The New York Times Company.

43 From *Life* Magazine, copyright © 1951, 1979, Time, Inc.

46–47 Pages 13, 23, and 180–81 from *The Family of Man*, copyright © 1955, The Museum of Modern Art, New York; photographs courtesy Wayne Miller, Magnum Photos, Inc., and Raphel R. Platnick.

50 Ezra Stoller, copyright © 1955, 1983, ESTO.

51 Wayne Miller, Magnum Photos, Inc.

C H A P T E R 3

52 Aaron Siskind.

54 Clarence John Laughlin as published in *Clarence John Laughlin: The Personal Eye*, Aperture, Millerton, 1973. / Aaron Siskind as published in *Aaron Siskind: Photographs*, Horizon Press, New York, 1959.

55 Copyright © 1982, The Trustees, Princeton University, courtesy The Minor White Archive, Princeton University. / Harry Callahan, as published in *Callahan*, Aperture, Millerton, 1976.

56 Frederick Sommer as published in *Venus, Jupiter & Mars*, Delaware Art Museum, Wilmington, 1980. / Aaron Siskind as published in *Aaron Siskind: Photographs*, Horizon Press, New York, 1959.

57 Harry Callahan, as published in *Photographs: Harry Callahan*, El Mochuelo Gallery, Santa Barbara, 1964. / Copyright © 1982, The Trustees, Princeton University, courtesy The Minor White Archive, Princeton University.

58–59 Copyright © 1982, The Trustees, Princeton University, courtesy The Minor White Archive, Princeton University.

61 Philadelphia Museum of Art, courtesy Georgia O'Keeffe. / Copyright © 1982, The Trustees, Princeton University, courtesy The Minor White Archive, Princeton University.

62 Abe Frajndlich.

63 Aaron Siskind.

65 Harry Callahan, as published in *Photographs: Harry Callahan*, El Mochuelo Gallery, Santa Barbara, 1964. / Harry Callahan, as published in *Callahan*, Aperture, Millerton, 1976.

66–67 Harry Callahan, as published in *Callahan*, Aperture, Millerton, 1976.

C H A P T E R 4

68 Copyright © 1961, Aperture, Inc., courtesy The Minor White Archive, Princeton University.

70 Cover of *Afterimage*, courtesy Visual Studies Workshop; cover of *Aperture*, copyright © 1980, The Trustees, Princeton University, courtesy The Minor White Archive, Princeton University; photograph courtesy Estate of Dorothea Lange. / Copyright © 1969 by the Imogen Cunningham Trust.

71 Copyright © 1961 and 1962, Aperture, Inc., courtesy The Minor White Archive, Princeton University.

73 Copyright © 1962, Aperture, Inc., courtesy Frederick Sommer.

74 Copyright © 1959, Aperture, Inc., courtesy The Minor White Archive, Princeton University, and Aaron Siskind.

75 Pages 110–11 from *The Family of Man*, copyright © 1955, The Museum of Modern Art, New York.

76–77 Robert Frank, as published in *The Lines of My Hand*, Lustrum Press, New York, 1972.

78 Copyright © 1959, Big Table, Inc., courtesy Aaron Siskind and The University of Chicago Library.

79 Courtesy New Directions Publishing Corporation and Harry Callahan. / Copyright © 1960, Grove Press, Inc., courtesy of the publisher and Robert Frank.

C H A P T E R 5

80 Robert Frank, as published in *The Lines of My Hand*, Lustrum Press, New York, 1972.

83 Copyright © 1938, 1962, The Museum of Modern Art, New York, courtesy The Estate of Walker Evans. / Courtesy Yale University Art Gallery, Tod Papageorge, the Estate of Walker Evans, and Robert Frank.

84 Robert Frank, courtesy The Art Institute of Chicago.

85 Published as the cover to *The Americans*, Aperture, New York, 1969, courtesy the publisher and Robert Frank. / Published as the back cover to *The Americans*, 1959, courtesy Grove Press, Inc., Alfred Leslie, and Robert Frank; from the collection of Jerome Liebling.

86 Allen Ginsberg, as published in *Scenes Along the Road*, Gotham Book Mart, New York, 1970, reproduced with permission of the artist and Ann Charters. / As published in *Scenes Along the Road*, Gotham Book Mart, New York, 1970, from the collection of Allen Ginsberg, reproduced with permission of Allen Ginsberg and Ann Charters. / John Cohen.

87 Two photographs by Robert Frank, copyright © 1970, Grove Press, Inc., reproduced courtesy Grove Press, Inc., and Robert Frank. / Page from *Evergreen Review* copyright © 1970, Grove Press, Inc., text copyright © 1970, Jack Kerouac, reproduced courtesy Grove Press, Inc., and The Sterling Lord Agency, Inc.

88–89 Robert Frank, as published in *The Americans*, Aperture, Millerton, 1978.

90 Robert Frank, as published in *The Americans*, Aperture, Millerton, 1978.

91 Robert Frank, as published in *The Americans*, Aperture, Millerton 1978. / Bruce Davidson, Magnum Photos, Inc.

92 Robert Frank, as published in *The Americans*, Aperture, Millerton, 1978. / Joel Meyerowitz, as published in *Looking at Photographs*, copyright © 1973, The Museum of Modern Art, New York, from the Ben Schultz Memorial Collection, gift of the photographer.

93 Robert Frank, as published in *The Americans*, Aperture, Millerton, 1978. / Lee Friedlander.

C H A P T E R 6

94 As published in *American Photography,* text courtesy of Sean Callahan; photograph by John Runk courtesy The Museum of Modern Art, New York; photograph by Lee Friedlander courtesy the photographer.

96 As published in *Camera Work,* 1912. / John Szarkowski.

97 Garry Winogrand, as published in *The Animals,* The Museum of Modern Art, New York, from the Ben Schultz Memorial Collection, gift of the photographer.

98 Garry Winogrand, private collection.

99 As published in *Public Relations,* copyright © 1977, The Museum of Modern Art, New York.

100 Ansel Adams. / Paul Huf, print courtesy the Department of Photography, The Museum of Modern Art, New York.

101 Jerry N. Uelsmann. / Judy Dater.

C H A P T E R 7

104 Copyright © 1978, ARTnews Associates; text courtesy Gene Thornton, photograph courtesy Garry Winogrand.

106 *Toward a Social Landscape,* copyright © 1966, George Eastman House, Rochester, photograph courtesy Garry Winogrand. / Cover *New Documents,* copyright © 1967, The Museum of Modern Art, New York; photograph copyright © 1972, Estate of Diane Arbus. / Lee Friedlander as published as the cover of *Self-Portrait,* Haywire Press, New City, New York, 1970.

107 Philadelphia Museum of Art, gift of the Friends of the Philadelphia Museum of Art. / Lee Friedlander as published in *Lee Friedlander: Photographs,* Haywire Press, New City, New York, 1978.

108 Lee Friedlander as published in *Lee Friedlander: Photographs,* Haywire Press, New City, New York, 1978. / Copyright © 1981, Arizona Board of Regents, Center for Creative Photography, University of Arizona.

109 Lee Friedlander as published in *Lee Friedlander: Photographs,* Haywire Press, New City, New York, 1978. / Copyright © 1982, The Trustees, Princeton University, courtesy The Minor White Archive, Princeton University.

110 Garry Winogrand, private collection. / Garry Winogrand, as published in *The Animals,* copyright © 1969, The Museum of Modern Art, New York, from the Ben Schultz Memorial Collection, gift of the photographer.

111 Garry Winogrand, as published in *Public Relations,* copyright © 1977, The Museum of Modern Art, New York. / Garry Winogrand, as published in *Stock Photographs: The Fort Worth Fat Stock Show and Rodeo,* University of Texas Press, Austin, 1980.

112 Garry Winogrand, as published in *Public Relations,* copyright © 1977, The Museum of Modern Art, New York.

C H A P T E R 8

114 Eddie Adams, Wide World Photos.

116 Stephen Frank, as published in *Diane Arbus,* Aperture, Millerton, 1972. / Huynh Cong (Nick) Ut, Wide World Photos.

117 John Filo. / Garry Winogrand, as published in *Public Relations,* copyright © 1977, The Museum of Modern Art, New York, purchase.

118 Philip Jones Griffiths, Magnum Photos, Inc. / Copyright © 1975 Aileen and W. Eugene Smith, Black Star.

119 Copyright © 1962, Estate of Diane Arbus as published in *Diane Arbus,* Aperture, Millerton, 1972. / Robert Jackson, Wide World Photos.

121 Irving Penn, copyright © 1967, Irving Penn.

122 Bruce Davidson, Magnum Photos, Inc. / As published in *Ralph Eugene Meatyard,* Aperture, Millerton, 1974, courtesy the Estate of Ralph Eugene Meatyard.

123 Copyright © 1972, Estate of Diane Arbus, as published in *Diane Arbus,* Aperture, Millerton, 1972. / Copyright © 1983, Max Waldman Archives.

124 Copyright © 1969, 1970, 1971, Danny Lyon, as published in *Conversations with the Dead,* Holt, Rinehart & Winston, New York, 1971.

125 Larry Clark, as published in *Tulsa,* Lustrum Press, New York, 1971. / Larry Clark.

126 Courtesy Lee Friedlander.

128 Courtesy American Geographical Society Collection, University of Wisconsin–Milwaukee Library. / Bruce Davidson, Magnum Photos, Inc.

129 Copyright © 1955, 1971, 1976, The Paul Strand Foundation, as published in *Paul Strand: Sixty Years of Photographs,* Aperture, Millerton, 1976. / Bruce Davidson, Magnum Photos, Inc.

C H A P T E R 9

130 Courtesy the collection of Mrs. Robert B. Mayer.

132 Courtesy the collection of Jasper Johns. / As published in *Camera Work,* 1910.

133 Courtesy The Hirshhorn Museum and Sculpture Garden, Smithsonian Institution, Washington, D.C. / Courtesy Leo Castelli Gallery, New York, collection of Mr. and Mrs. Leo Castelli.

134 Frederick Sommer, as published in *Venus, Jupiter & Mars,* Delaware Art Museum, Wilmington, 1980. / Harry Callahan, as published in *Harry Callahan: Color,* Matrix, Providence, 1980.

135 Aaron Siskind as published in *Aaron Siskind: Photographs,* Horizon Press, New York, 1959. / Courtesy the collection of Mr. and Mrs. Victor W. Ganz.

136 Collection of Mr. & Mrs. Morton J. Hornick, New York.

137 Courtesy The Solomon R. Guggenheim Museum, New York. Gift, Harry N. Abrams Collection, 1974. / Courtesy Leo Castelli Gallery, New York.

138 *Lightning Field* by Walter De Maria, copyright © 1980, Dia Art Foundation, photograph by John Cliett. / Dennis Oppenheim.

139 Allan Kaprow. / Courtesy of *Artforum Magazine,* Flow Ace Gallery, and Edward Ruscha.

140 Stephen Shore.

141 Courtesy Allan Stone Gallery, New York.

C H A P T E R 1 0

142 Peter Beard.

144 Lennart Nilsson, courtesy Life Picture Service.

145 Copyright © 1974, Newsweek, Inc. / Copyright © 1978, The New York Times Company.

146 As published in *Aperture,* Number 87, 1981, from a private collection. / Copyright © 1972, Henry Holmes Smith, courtesy the artist and the Henry Holmes Smith Archive, Indiana University Art Museum.

147 Courtesy of Edwynn Houk Gallery, Chicago. / Clarence John Laughlin as published in *Clarence John Laughlin: The Personal Eye,* Aperture, Millerton, 1973.

148 Jerry N. Uelsmann as published in *Contemporary Photographers: The Persistence of Vision,* George Eastman House, Rochester, 1967.

149 Jerry N. Uelsmann as published in *Jerry N. Uelsmann,* Aperture, New York, 1970.

150 Kenneth Josephson.

151 Ray K. Metzker as published in *Contemporary Photographers: The Persistence of Vision,* George Eastman House, Rochester, 1967. / Ray K. Metzker as published in *The Photographer's Choice,* Addison House, Danbury, N.H., 1975.

152–53 Duane Michals as published in *Real Dreams*, Addison House, Danbury, N.H., 1976. / Emmet Gowin as published in *Emmet Gowin: Photographs*, Alfred A. Knopf, New York, 1976.

154 Courtesy the Barbara Blondeau Archive, Visual Studies Workshop, Rochester. / Barbara Crane.

155 Richard Misrach as published in *(a photographic book)*. / Linda Connor.

156 Robert Heinecken, private collection.

157 Robert Heinecken as published in *The Photographer's Choice*, Addison House, Danbury, N.H., 1975. / Robert Heinecken as published in *Contemporary Photographers: The Persistence of Vision*, George Eastman House, Rochester, 1967.

158 Donald Blumberg and Charles Gill as published in *Contemporary Photographers: The Persistence of Vision*, George Eastman House, Rochester, 1967. / John Wood as published in *Contemporary Photographers: The Persistence of Vision*, George Eastman House, Rochester, 1967.

159 As published in *Work from the Same House: Photographs & Etchings*, Trigram Press, London, 1969; photograph courtesy Lee Friedlander, etching by Jim Dine courtesy Pace Gallery, New York.

160 Betty Hahn. / William Larson.

161 Michael Lesy, montage from negative WHi (V24) 1851 in the Charles Van Schaick Collection, State Historical Society of Wisconsin, Madison, as published in *Wisconsin Death Trip*, Pantheon, New York, 1973. / Peter Beard.

CHAPTER 11

162 Courtesy Rephotographic Survey Project.

164 Courtesy The Metropolitan Museum of Art, New York. / Courtesy International Museum of Photography at George Eastman House, Rochester.

165 Courtesy Kennedy Galleries, Inc., Hirschl & Adler Galleries, and Meredith Long. / Lewis Baltz courtesy Castelli Graphics, New York.

166–67 Douglas Southworth courtesy Venturi, Rauch, and Scott Brown.

168 Department of Prints and Photographs, The Library of Congress. / Robert Adams as published in *New Topographics*, International Museum of Photography at George Eastman House, Rochester, 1975.

169 Robert Frank as published in *The Americans*, Aperture, Millerton, 1978. / Lewis Baltz courtesy Castelli Graphics, New York.

170 Frederick Sommer as published in *Venus, Jupiter & Mars*, Delaware Art Museum, Wilmington, 1980. / Joe Deal.

171 James Alinder. / Art Sinsabaugh courtesy of the artist and the Art Sinsabaugh Archive, Indiana University Art Museum.

172 Ezra Stoller, copyright © 1962, 1983, ESTO.

173 Ansel Adams. / Nicholas Nixon as published in *New Topographics*, International Museum of Photography at George Eastman House, Rochester, 1975.

174 Robert Frank as published in *The Americans*, Aperture, Millerton, 1978. / John Gossage as published in *Better Neighborhoods of Greater Washington*, from the series *The Nation's Capital in Photographs, 1976*, The Corcoran Gallery of Art, Washington, D.C., 1976. / Lee Friedlander as published in *Lee Friedlander: Photographs*, Haywire Press, New City, N.Y., 1978.

175 John Pfahl. / Ansel Adams.

176 Nancy Rexroth. / Stephen Danko as published in *Altered Landscapes*, Fine Arts Gallery, Florida School of the Arts, Palatka, Florida, 1978.

177 Thomas Barrow as published in *The Photographer's Choice*, Addison House, Danbury, N.H., 1975. / Copyright © 1975, Michael Bishop, as published in *Michael Bishop*, Chicago Center for Contemporary Photography, Chicago, 1979.

178 Bill Dane.

179 Steve Fitch as published in *Diesels and Dinosaurs*, Long Run Press, Berkeley, 1976. / Michael Becotte as published in *Space Capsule*, Pentacle Press, Carlisle, Mass., 1975.

180 Robert Adams as published in *Denver*, Colorado Associated University Press, Boulder, 1977. / Bill Owens as published in *Suburbia*, Straight Arrow Books, San Francisco, 1975.

181 Robert Adams as published in *The New West*, Colorado Associated University Press, Boulder, 1974. / Bill Owens as published in *Suburbia*, Straight Arrow Books, San Francisco, 1975.

CHAPTER 12

182 Joel Meyerowitz. / Thomas Cole painting courtesy Munson-Williams-Proctor Institute, Utica, New York. / Jules Olitsky painting, private collection.

184 Stephen Shore. / Department of Prints and Photographs, The Library of Congress.

185 Harry Callahan, as published in *Harry Callahan: Color*, Matrix, Providence, 1980. / Joel Meyerowitz as published in *St. Louis & The Arch*, New York Graphic Society, Boston, 1980.

186 Lucas Samaras courtesy Pace Gallery, New York. / Marie Cosindas.

187 William Eggleston as published in *William Eggleston's Guide*, The Museum of Modern Art, New York, 1976.

188 William Christenberry as published in *Aperture*, Number 81, 1978. / William Eggleston as published in *Election Eve*, The Corcoran Gallery of Art, Washington, D.C., 1977. / William Eggleston, private collection.

189 Joel Meyerowitz as published in *Aperture*, Number 76, 1977. / Stephen Shore. / Courtesy the Estate of Walker Evans.

190 Langdon Clay. / Joel Meyerowitz as published in *Cape Light*, Museum of Fine Arts, Boston, 1978.

191 Stephen Shore. / Courtesy Whitney Museum of American Art, New York, gift of the Friends of the Whitney Museum of American Art, Mr. and Mrs. Eugene M. Schwartz, Mrs. Samuel A. Seaver, Charles Simon, and purchase.

CHAPTER 13

192 Copyright © 1974, 1977, Susan Sontag, courtesy *The New York Review of Books* and Farrar, Straus & Giroux, Inc.

194 Collection of Jonathan Green.

195 Copyright © 1975, Artforum International Magazine, Inc., courtesy the publisher and Allan Sekula; photograph as published in *Camera Work*, 1911.

196 Copyright © 1972, The New York Times Company, photographs copyright © 1967 and 1970, Estate of Diane Arbus.

197 Copyright © 1975, Artforum International Magazine, Inc., courtesy the publisher and Allan Sekula.

200 Copyright © 1945, 1973 Time, Inc.

CHAPTER 14

202 Hans Haacke.

204 Fred Lonidier.

205 Donna-Lee Phillips as published in *Still Photography: The Problematic Model*, NFS Press, San Francisco, 1978.

206 Department of Prints and Photographs, The Library of Congress. / Copyright © 1970, Estate of Diane Arbus.

207 Richard Avedon, copyright © 1961, Richard Avedon, all rights reserved.

C H A P T E R 15

Text references are indicated by numerals in roman type, illustrations by **boldface** numerals, and portraits by *italic* numerals.

243

246